99 Ways to Make Money From Your Photos

from the editors of
PHOTOPRENEUR

NEW MEDIA ENTERTAINMENT LTD

Book design by DesignForBooks.com

About the Editors

Photopreneur's editors are a group of best-selling marketing experts and specialists with decades of experience at the highest level of professional photography. Together, we combine rigorous research, marketing creativity and a deep understanding of the photography business to help photographers—professional, enthusiast and occasional—earn income from their images.

Photopreneur's blog can be found at blogs.photopreneur.com. Active since 2007, the blog's feature stories, interviews and expert marketing advice has made it one of the leading photography sites on the Web and a trusted source for photographers.

Contents

Introduction

Not everyone who picks up a camera wants to be a professional photographer. Just about everyone who has shot a picture that makes them proud and gives them pleasure though, has dreamed of making money from their photography.

They may have dreamt of seeing their action photos on the front or back pages of newspapers.

They may have fantasized about viewing their art prints hanging on gallery walls . . . and being bid on by collectors.

They may have wondered why art directors aren't asking them to shoot the ads that fill billboards on the highways and the commercials in magazines.

Once, image sales were solely the province of professionals. Commercial buyers only wanted to deal with image-makers who could guarantee supply and who had access to equipment that was professional quality, difficult to use and too expensive for most.

Today, that's all changed. Professional quality camera equipment is available to anyone willing to spend just a few hundred dollars. Outlets, both commercial and artistic, are willing to take pictures from anyone willing to submit them.

And buyers are prepared to consider solely the quality of the image and not the length of the photographer's experience or the breadth of his professional education when they consider making a purchase.

In this book we've brought together 99 different methods that photographers can use to sell their photos.

Professional quality camera equipment is available to anyone willing to spend just a few hundred dollars. Outlets, both commercial and artistic, are willing to take pictures from anyone willing to submit them.

Most of the ways described here are strategies that have been proven and tested. Photographers are using them and making money from them.

Occasionally, we've also included ideas that seem to us workable even if we're not aware of anyone putting them to work yet. Feel free to give them a try and break new ground.

And we've arranged those ways in different categories. You'll find traditional ideas here, such as stock photography and photojournalism; photography products, such as mousepads and Moo cards; websites, from Flickr to eBay; marketing methods, from nicheing to upselling; joint ventures, with partners such as cafes and nurseries; specialties from underwater to high-speed photography; and a number of different ways of creating photography books.

Some methods are also easier than others and more potentially lucrative than other. Each chapter then contains a rough key that indicates the level of difficulty, the size of the competition and the method's expected earning power. The key is not meant to be scientific—much will depend on the kind and the quality of the images you're shooting—but they should give you an indication of what you can expect.

Ultimately though, the best way to sell photos is to shoot well and market hard. And do it again and again.

Key

DIFFICULTY

Anyone can do it.

You'll need a touch of camera knowledge.

Fine for the knowledgeable enthusiast.

You might need some advanced knowledge or sharp marketing.

Doable, but difficult. You'll need complete mastery of your camera and top-rate selling skills.

COMPETITION

You'll be almost alone.

You'll be part of a small community.

You'll need to be better than average.

You'll need to be good, very good, to stand out.

Only the best will survive.

INCOME POTENTIAL

We're talking pennies.

You might make the odd buck.

Enough to make you feel happy.

This is a real income. Enough to make you consider giving up the day job.

A top-earning day job with the salary of a professional.

Sell Stock Photos

1

DIFFICULTY

COMPETITION

INCOME POTENTIAL

Stock allows professional photographers to focus on the image-taking while the agency handles the sales.

What It's All About

Stock photography has long been the leading edge of the professional photography world. Photographers place their images with a company that markets them on their behalf to commercial and editorial buyers. The images may end up being used on billboards across the country or illustrating articles in magazines and newspapers.

The buyer pays for a license—a right to use the image for a specific purpose—and the agency then shares the fee with the photographer, often on a 50/50 basis but the cut may vary. The amount charged by an agency will depend on the photograph and what the client wants to do with it but the fees in the past have been respectable. Photographers may even expect to receive thousands of dollars from a single deal while retaining the right to sell licenses to other clients in the future.

Stock allows professional photographers to focus on the image-taking while the agency handles the sales. Many photographers have come to see their stock portfolio as a kind of pension fund, an asset that can continue bringing in revenues in the form of royalties long after they've hung up their camera strap.

It's not surprising then that agencies choose their photographers very carefully and gaining entry isn't easy.

This old model of stock photography—with its relatively high royalties and exclusive entry requirements—still exists, but in the last few years, it's come under pressure from online newcomers charging as little as $1 for a license and allowing clients to do almost anything they want with the photos short of selling them themselves.

The result is that fees have fallen—both for agencies and for photographers—but stock photography can still be very remunerative for any photographer who can make it through the door.

SUMMARY

Traditional stock photography is now dominated by Getty Images. It's still a nice job if you can get it, but it's almost entirely professional and the relatively high rates are being driven down by microstock agencies.

What You'll Need to Shoot to Make Money with Stock

The best way to understand the sort of images that stock agencies are looking for is to spend time browsing their online libraries and leafing through magazines (pay as much attention to the ads as to the articles.)

In general, you'll often find that stock images tend to be dramatic rather than realistic. Skies are blue, colors are bright, and models tend to be emotive, letting the image tell a clear story that can easily reflect an ad or an article. The compositions might also appear a little off-balance to provide space for the buyer to add text or other elements—stock images are meant to be used, not just seen.

In addition to shooting the right sort of commercial images though, you'll also need model releases signed by anyone recognizable who appears in an image, and you may need property releases for some trademarked buildings. Both of these can be downloaded from the website of the American Society of Media Photographers (http://www.asmp.org/commerce/legal/releases/), which also has a useful introduction to the legal aspects of stock photography.

And you'll need to know the difference between Royalty-Free (RF) licenses—like those usually offered by microstock sites and which let the buyer use the image multiple times—and Rights-Managed (RM) images for which the buyer must pay for every use.

Creating a Stock Portfolio

A stock portfolio takes time to build. While microstock companies are willing to accept any number of images from any number of photographers, the mainstream stock companies such as Getty Images and Corbis want photographers with large image libraries which they can keep up to date with a stream of new images.

This is an opportunity for established, experienced photographers not for hobbyists who only shoot occasionally.

One common way for photographers to build a stock portfolio is to keep the outtakes from commissioned shoots. Only a small fraction of the shots taken on a shoot are ever actually used and many of the remainder can form the core of a stock library.

For hobbyists, a stock library containing enough professional quality images to interest an agency is likely to take some time to put together.

One way to shorten that period though is to look for a specialization and skip the big boys. There are plenty of small stock companies that specialize in photographic niches. PhotoResearchers, for example, offers scientific images; Gogo supplies photos of minorities.

Photographers with small portfolios should find it easier to approach these agencies than the more general services.

How to Break into Stock Photography

If stock photography were a nightclub, it would be the sort of place that has velvet ropes, long lines of disappointed hopefuls and bouncers the size of small houses.

Stock photography is a pretty exclusive enterprise. It's aimed at dedicated professionals—the sort of people who make a living out of photography, who understand the sort of images that buyers need and have the time, the motivation and the skills to supply them.

But that doesn't mean you can't try to get in. Getty Images, the biggest of the two giants of the stock industry, has a page on its website at http://contributors.gettyimages.com/ where photographers can apply to be a contributor. Corbis, the other big boy, doesn't even do that. They'll call you.

Other ways into stock photography include building a name for yourself as a microstock photographer. Anyone can contribute to a microstock site and at least one top microstocker has received an offer from a stock company. (He turned it down, arguing that he could make more money selling tens of thousands of licenses a month for a dollar a time.)

Or you can target specialized sites which might have lower submission demands and be less fussy about your professional background.

TIPS
FOR SUCCESS

Successful stock photography has a number of requirements. It's essential to shoot high-quality, commercial images, of course, but you also have to invest in the shoots, count your expenses and look to the long term.

Professional stock photographers note that it can take up to two years for a stock photo to cover the cost of its production with the profits coming in the next three years.

GETTING STARTED

The best way to get started in stock photography is to focus on the shooting.

Browse the stock agencies, understand the market and aim at building your own portfolio. Submit some images to microstock companies, like www.istockphoto.com, to get a feel for what buyers are looking for, then approach specialized stock sites before making your pitch at the major stock agencies. Be prepared for the long haul.

You can also look at the main stock companies: Getty Images at www.gettyimages.com and Corbis at www.corbis.com.

Sell Your Images "Royalty Free"

What It's All About

Sell a bar of soap and you no longer own it. You own some money instead. Sell an image though and you still own it. You can still print it, you can still sell prints to other people and you still possess all of the rights to that image.

Photographers might talk about selling their photos but what they're actually describing is selling permission to use their photos.

It's a vital distinction and it's one that every photographer needs to understand before they start making their images available for sale.

You have to know what you're selling.

Whenever an artist creates a work of art, they own the copyright to that work. No one can use that work, reproduce it or sell it without the artist's permission. The artist doesn't have to do anything to claim that copyright; they receive it automatically (although registering the work at the US Copyrights Office should improve damages in event of a breach of copyright).

Sell a print then, and the buyer doesn't buy the rights to your image. He can't reproduce it or allow other people to do so. The most he can do is sell that print again, and hopefully make a profit from that sale.

Sell an image for someone to use though—on a website, in a magazine, on an ad or anywhere else—and you're only selling them your permission to use it.

That permission usually takes one of two forms. Rights Managed (RM) licenses are complex. They define precisely what the user is allowed to do and charge for each use. Royalty Free (RF) licenses are much simpler and often much cheaper. They usually allow the buyer to pay a flat fee to use the image repeatedly in a range of different ways, short of selling it themselves.

Photographers might talk about selling their photos but what they're actually describing is selling permission to use their photos.

(continued on next page)

RF licenses have become one of the most common ways for photography enthusiasts to sell their photos.

SUMMARY

Royalty free licenses have benefits and costs. The main benefit is their simplicity. Buyers can understand exactly what they're buying and the amount they're buying it for. They then have the flexibility to use the image any way they want and even if they choose not to use the image more than once, the knowledge that they can creates the impression of added value.

For photographers too, royalty free licenses are often an easy way into making sales. Many stock companies have responded to the rise in competition by offering them on images sourced from both professionals and enthusiasts, saving the rights managed licenses for images from their top photographers.

But the fees are usually far lower than those demanded for rights managed licenses. Microstock companies, for example, which only sell royalty free images, may charge just a dollar for a license, delivering cents to the photographer.

Nonetheless, some photographers are managing to earn six-figure incomes by selling thousands of royalty free licenses to the same set of images.

What You'll Need to Shoot to Earn with Royalty Free Images

When it comes to royalty free stock photography, the sky's the limit—and is also the subject in many royalty free stock photos.

Licenses have been sold for photos that range from "man at a desk" to "children playing." If it's possible that someone, somewhere might want to use the image for some purpose then it's possible to sell a royalty free license for it.

One of the most popular images sold under a royalty free license, for example, shows goldfish leaping from one bowl to another.

You'll be amazed at some of the photos that have sold licenses.

How to Create and Market Royalty Free Images

There are two approaches to creating images that can be sold on a royalty free basis.

The first is to shoot the images you want and make the shots that are most likely to sell available to the public. The easiest way to do that is by submitting them to a stock site and keywording them carefully so that they can easily be found.

That will probably be the most enjoyable way to make money from your images but it might not be the most profitable. Without a systematic way of producing sellable images, your sales will only ever be sporadic.

The alternative approach is to look at what sells, which images are being used and what sort of images you'd like to shoot. Produce large numbers of them on a regular basis and add them to as many inventories as possible.

That requires work and effort but as always, the more work you put in, the greater the rewards you can take out.

The marketing of royalty free images is even easier than shooting the pictures. Although making your photos available on your own websites or through Flickr can help to increase sales, neither strategy is necessary. It is possible to upload your images to a stock site and let the site do the selling.

GETTING STARTED

Begin by looking at the royalty free images available at microstock site www.istock.com and at stock site Getty at www.gettyimages.com.

The Stock Artists Alliance at www.stockartistsalliance.org is also packed with useful information about both royalty free and rights managed stock photography.

TIPS
FOR SUCCESS
(continued)

Put Them Everywhere

You can choose whether to make your images available on an exclusive basis or retain the right to sell them through multiple outlets.

Stock companies prefer that their contributors sign up on an exclusive basis so that their inventories remain unique. They're usually prepared to offer higher commissions and more prominent marketing in return for that agreement.

Usually though, you'll make more money overall retaining your right to sell your images royalty free wherever you want.

3

Sell Your Images "Rights Managed"

DIFFICULTY

COMPETITION

INCOME POTENTIAL

$ $ $ $

What It's All About

The alternative to selling usage rights on a royalty free basis is to sell them on a rights managed basis. This is much more complicated but it delivers much more accurate pricing.

The buyer will be paying a rate based on the full value that he's receiving for the image.

Sell a photo royalty free, and the same image could be used by that buyer to illustrate a blog post seen by twenty readers and on a billboard campaign seen by millions.

The photographer would receive the same flat rate, which might amount to no more than a handful of dollars.

An image sold on a rights managed basis would receive a fee that takes into account precisely how it's going to be used. The amount will vary according to the size of the audience, the geographic area, whether the usage is editorial or commercial and a number of other factors besides. While there are guidelines that make quoting easier, choosing the correct rate for a rights managed photograph is rarely simple, especially for non-professionals. One photo library, for example, has 1,447 different price points for the pictures it offers.

While that might make the selling harder, it does mean that the prices are usually higher for rights managed photos and they represent the real value of the image too.

What You'll Need to Shoot to Earn with Rights Managed Images

Like any kind of stock photography, you can shoot any type of image and sell it on a rights managed basis, and the usual demands remain true.

3 Sell Your Images "Rights Managed"

SUMMARY

Until digital photography and the Internet changed how images are bought and sold, rights managed licenses were the standard way that photographers granted permission to use images.

Photographers understood that they were getting the right price for their photos, and buyers understood that they had little choice but to pay relatively large sums for professional images.

As digital photography has made it possible for anyone to shoot usable photos and make them available for sale though, the supply of images has increased and prices have fallen. Low-cost royalty free images are now used by outlets as small one-man websites and as large as international media outlets.

But there is still a role for rights managed photographs. Buyers looking for images of the highest quality and for uses which demand a level of exclusivity still turn to major stock companies and pay the full price.

Those prices though might not be as high as they used to be, and placing your images in a rights managed inventory rather than a royalty free store may be even harder than ever. But for any photographer hoping to sell permission to use their images, rights managed licenses are often the goal.

Buyers still want business shots. Healthcare photographs are popular too. And images with models, particularly older models, can sell well.

But those images alone won't be enough to move an image from a royalty free inventory to an exclusive rights managed company with the sales prices to match.

To win a place with one of the rights managed giants, you'll need to shoot high quality stock images of sellable subjects, consistently, in large numbers and have a track record of selling them.

That is something that can come as a result of picking up high royalty free microstock sales—some top microstock photographers have received invitations from major stock companies (and the fact that they turned them down is revealing). It can also be done by registering with a stock site and hoping that your work is strong enough to meet their requirements.

And it can be done by skipping the big companies and turning to one of the few open source rights managed outlets.

TIPS
FOR SUCCESS

Be Flexible with the Prices

Although software programs such as fotoQuote can provide estimates of the correct price of an image, few rights managed deals are exactly the same. Audience numbers for the images change and so do the budget, the precise usage, the quality of the image itself and the price the photographer is willing to accept.

While there's little point in accepting a lowball offer for a rights managed photo, the standard rate can act as a guideline around which it's possible to negotiate.

Be Realistic

Deals for rights managed basis usually take place at the top end of the stock photography world. If you're not shooting on a regular basis, don't expect sales to happen all the time—at least not until you have a reasonably-sized portfolio. It takes time for the sales—and the profits—to start coming in.

How to Create and Market Rights Managed Images

Creating images that can be sold on a rights managed basis is as easy—or as hard—as producing any professional grade photographs.

It's the marketing—both of the images and of yourself as a reliable supplier—that's going to be difficult.

If rights managed stock photography was always a difficult field for a non-professional to break into, the rise of royalty free images have made it even harder. With so many clients choosing to pay smaller amounts for images that give them greater flexibility, stock companies have become choosier than ever.

Two companies that allow anyone to sell their images on a rights managed basis though are fotoLibra, the UK-based photo library, and Photo-Shelter, a kind of online storage center which also allows photographers to sell licenses for their images. PhotoShelter even incorporates fotoQuote, a software program that provides automatic quotes based on usage.

While both of those sites provide instant access to the world of rights managed photography sales and the opportunity to sell your images in a way that delivers their full value, fotoLibra is relatively small and Photo-Shelter does very little, if any, sales marketing of its own.

Neither delivers the marketing punch of Getty or Corbis and for Photo-Shelter, you'll need to do all of the marketing yourself, bringing potential customers in to look at your portfolio and using fotoQuote or the site's communication system to negotiate a price and the image's usage limitations.

Some of those users can come from marketing your own website but in practice, many of the sales on PhotoShelter are made to people the photographer knows. The site functions as a tool that allows them to continue making deals with people they've dealt with before. You'll still need to do the hard work of showing your images to buyers.

GETTING STARTED

You can begin selling your images on a rights managed basis immediately by submitting images to fotoLibra at www.fotolibra.com or by creating a portfolio at www.photoshelter.com.

If you're really feeling ambitious, you can also begin the process of applying to Getty at imagery.gettyimages.com/AboutGettyImages/contributors.

Submit Your Pictures To Competitions

4

DIFFICULTY

COMPETITION

INCOME POTENTIAL

$ $ $

What It's All About

Usually, selling an image is prize enough. You won't get a trophy but you will get some cash, and that's the most important goal.

Sometimes though, you can get both money and an award, which is even better.

Photographic competitions might not be the most obvious way to earn money from photography, and they're certainly not the most regular way, but there are increasing numbers of contests, the odds of winning vary dramatically, the kudos is always huge (you only have to win one to call yourself an award-winning photographer) and the prize money can be reasonably lucrative.

Obviously, you wouldn't want to depend on winning competitions as a main source of photography income, but as a method of turning your images into cash, it's certainly one of the most satisfying.

SUMMARY

Entering photography competitions is a fun thing to do in your spare time and a good way to boost your skills. Winning a few prizes will also increase your confidence and make your resume look more persuasive. But it's not the most reliable way to earn from your images.

What You'll Need to Shoot to Enter Competitions

The type of images demanded by photography competitions varies tremendously. Subjects can be as closely defined as a request by Nivea, issued through a sponsored Flickr group in the fall of 2008, for photographs of

TIPS
FOR SUCCESS

Each competition has its own particular quirks but there are some general strategies that can increase the chances that you'll pick up a prize. Perhaps the most obvious is to enter plenty of competitions. Forget about picking and choosing the best. Enter as many as you can bear. Like a lottery, the more you enter, the greater your chances. No less important though is to make sure your images match the topic. It might be tempting to submit any old picture and just hope, but that's what many people do. Match the topic or the category and you'll go a long way towards standing out.

kisses (for which the prize was a trip to New York) to the British Automobile Association/ *Sunday Times'* request for photographs of the British landscape. They were giving away £10,000. While you can choose to specialize in a particular field then, you might find that it's more enjoyable—and more rewarding—to spread your net widely and enter competitions that cover all sorts of different topics.

That might sound like you could be wasting your time but it depends on the nature of the competition. Enter the Wildlife Photographer of the Year competition, for example, and you'll be competing against people who know how to build hides and what to do while waiting for a deer. It's the sort of photography that requires specialized knowledge. But you don't have to be a specialist to shoot a good landscape photograph or to take a photograph that portrays "now," a request submitted through another Flickr group by Ford.

Obviously, you will have to shoot good pictures to enter competitions but you might not have to shoot the best ones. That because judging photography is very subjective. Often, you'll be hard-pressed to tell the difference between the winner and the runners-up and you'll struggle to understand why your photograph didn't make the grade. Usually, it comes down to the personal taste of the judges.

Becoming a Winning Competitor

Winning competitions—and this includes photography competitions—isn't just about entering the right submissions, although that's clearly important. It's also about doing the right things.

That starts with reading the rules carefully. Every competition has rules of varying complexity but they all have to be read and noted. Even the rules of competitions you've entered before should be re-examined each year to make sure that nothing has changed.

What you're looking for in particular are notifications about exclusivity and licensing. It's not unusual for a competition to demand the right to use a winning image—and even all submitted images—in the competition sponsor's publicity. But if they also demand exclusivity, then losing that competition could cost you an asset.

This is something that's come up frequently in photographic competitions. Companies offer a small prize and in return build a large library of free images supplied by willing entrants who fail to recognize that they're giving up something of value in return for a slight chance of winning a prize.

Competitions that claim exclusive rights over submitted photographs—even those that don't win—should be avoided. Always read the small print in any competition that you enter and understand exactly what the competition wants to do with your photographs. Using them for publicity purposes may be acceptable. Owning all rights to them is not.

There's one more thing you'll need to become a winning photography competitor. In fact, you'll need this in every aspect of photography—a thick skin. Even the best photographers will only win a handful of the competitions they enter. That means most of the time you're going to lose. Let those rejections dishearten you and you might find that it affects your photography.

Rarely is a competition only a judgment on the quality of your photography. It's also a judgment on how close the image came to the sponsor's goal. If your photograph doesn't win, it's more likely to be because the image was wrong for the sponsor's intended use than because the image was poor.

How to Break into Competitive Photography

Competitive photography is probably one of the easiest ways to at least put yourself in the running to make money with photography. It's almost as simple as buying a lottery ticket—even if it is only a little easier to profit from. These days, there's no shortage of competitions which allow open submissions from anyone who wants to enter. Here are just three of the most important competitions that are open to anyone and award prizes worth winning.

Pilsner Arquell International Photography Awards

The Pilsner Urquell International Photography Awards is actually two competitions held each year. One is for professional photographers and the other is for non-professionals. Any photographer, anywhere in the world, can enter but submissions cost $25 per photograph for non-professionals and $35 for professionals. The grand prize is $10,000 for professionals, while non-professionals may receive $5,000 and the title Discovery of the Year.

Smithsonian Annual Photo Contest

The Smithsonian's Annual Photo Contest is open to all photographers and accepts non-published images in five categories: the Natural World, Americana, Altered Images, Travel and People. The prize for category winners is $500. The grand prize winner picks up a three-night Smithsonian Journeys Grand Canyon Weekend Adventure—and a great deal of prestige.

Sony Photography Awards

The Sony Photography Awards are also divided into categories for professionals and amateurs. The eight categories include architecture, conceptual & constructed, fashion, landscape, sport and more. The overall winner receives two tickets to Cannes, two nights' accommodation in a luxury hotel, VIP tickets to the awards ceremony, a prize of $5,000 and a Sony gift.

These are just three of the biggest competitions. There are plenty of others of all sizes. It's also a good idea to check out art fairs. While these aren't exactly competitions, they can be juried and prizes may be offered.

GETTING STARTED

Choose your competition, read the rules and enter! Choose a small competition to begin with to get your feet wet, then make searching for and entering competitions part of your routine. The Pilsner Arquell competition is at www.photoawards.com, the Smithsonian's contest can be found at photocontest.smithsonianmag.com, and you can enter Sony's contest at www.worldphotographyawards.org.

Become a Local Photojournalist

5.

DIFFICULTY

COMPETITION

INCOME POTENTIAL

$ $ $

What It's All About

Photojournalism is one of the most prestigious branches of professional photography but it's not always a job for the fainthearted. In some cases, it can be risky work that might involve going to dangerous places to shoot pictures while trying not to get shot in return. More usually though, it means going to news events such as press conferences and demonstrations, and sending the images back quickly.

It's also a job that's in decreasing demand. The rise of video means that even the *New York Times* now asks its press photographers to shoot movie footage when they're on assignment—and it's issuing fewer of the sort of commissions that photojournalists entered the profession to complete.

But the press does still need images and that's true too of the local newspapers and online outlets too. For these sorts of images you don't need to embed yourself with the Marines or buy a ticket to the Middle East. You just need to know where to find the images—and where to sell them.

SUMMARY

If you can find yourself a niche and a regular outlet, then shooting pictures for the press—even the local press—can be enjoyable and may be relatively lucrative. Prices vary, depending on whether the photos are sold through media stock sites or independently. Payment in the region of $250–$300 for a picture of a demonstration, for example, may be considered a good amount.

What You'll Need to Shoot to Become a Local Photojournalist

The best way to understand the sort of photographs the press might want from a local photographer is always to open the local newspapers and take a look at the pictures.

What you'll probably find is that many of the photos come from the wire services like AP and Reuters. You won't be able to supply those. But plenty of others come from staff photographers, who can't be everywhere, and occasionally from freelancers who just happened to have the sort of photographs the media outlet wanted.

Ideally, these will be photographs of incidents such as robberies, police actions, accidents and so on. You can't plan for those so you just have to make sure you're in the right place at the right time with a camera.

But you can make sure that you're present at planned events. A local media channel can't send a photographer to all of those so if the images are good enough, they might be interested in hearing from a photographer who has them. These events might include:

Demonstrations

Demonstrations are always advertised in advance so you can tell where they're going to be and what you can expect. According to amateur photographers who regularly sell these kinds of images, the press is looking for photographs that show the size of the demonstration and what it was about. Crowd pictures with signs often work.

Publicity Events

Stores and businesses hold publicity events all the time. They could be grand openings, author readings, celebrity signings or any one of a million other ways to get people to look in their direction. The press often skips them though, uncertain whether they're really going to contain anything newsworthy. If the local press photographer isn't there—and you are—you might find that you have something worth selling.

PHOTOPRENEUR

Sports Events

Local sports are really a community event. Again, with so many sports matches taking place each weekend for different age groups, the local press can't be present at each one. Even a good picture from the right event won't be an easy sell but if you have an image that captures the game or the community, you're in with a shout.

Clearly though, even producing the right photographs doesn't mean the press will take them.

Becoming a Local Photojournalist

The best way to become a local photojournalist is probably not to try. Shoot for your portfolio. Shoot for fun. But shoot to make sales and you're likely to encounter a great deal of disappointment.

It's not necessarily the competition. Unless you're applying for a full-time job as a photojournalist, you're unlikely to find yourself running up against too many other photographers. But what you will find is that there's very little demand. A local newspaper might use just twenty images in each issue. Many of those will be paid for by a subscription to an agency and the bulk of the remainder shot by staff photographers. That could leave you trying to fill just the one or two spots that might remain open for a freelance photographer.

It can happen. But it's best to consider the sale of a news image as a bonus rather than a goal.

How to Make the Sales

For budding photojournalists, the hardest sale is always the first. It's always going to be easier to call an editor you know and tell him that you have an image he might be interested in than to cold call an editor out of the blue and hope he'll listen to you.

But cold-calling can work. You won't win commissions this way—no editor is going to give a job to a photographer he doesn't know—but he might be willing to look at pictures you've already taken if the subject is interesting.

You will have to be fast though. A news image can grow cold within half an hour, so if you're taking a camera to an event and hoping to make a

sale, make sure that you're packing the phone number of your local newspaper and the name of the picture editor too.

There are alternatives to cold calling. Some photographers choose to specialize, shooting only demonstrations, for example. They then upload their images to their Flickr stream where potential buyers know where they can find them and enquire about licensing. They also offer them to news sites which has taken their images in the past. Both of those methods have produced sales.

GETTING STARTED

Find an event to shoot—a demonstration is a good start—take pictures that are professional quality then immediately call your local newspaper to ask if it's interested. You can also add the pictures to your Flickr stream and make it clear that they're available for licensing. In time, you might find that buyers come to see your stream as a source of a particular type of news image.

You can see Philippe Leroyer's images at www.flickr.com/photos/philippeleroyer/ and he sells many of his images to www.rue89.com.

Attend Art Fairs

DIFFICULTY

COMPETITION

INCOME POTENTIAL

What It's All About

Most print-selling involves finding a middle man to do the selling for you. That's not easy. Galleries are choosy and stores buy from a short list of big suppliers. Although selling your images yourself is possible, especially across the Web, the marketing is tough and the competition even tougher.

You'll always struggle to find an audience and persuade it to buy.

One option then is to attend art fairs. These are held regularly in towns and cities across the country. Selling all sorts of arts, including photography, they can attract tens of thousands of people keen to pick up a rare artwork and are prepared to pay for it.

Although art fairs are usually open to everyone, most have more applicants than space available, some are juried, which keeps the quality high, and vendors usually have to pay a fee. That can range from a nominal amount to hundreds and sometimes even thousands of dollars.

SUMMARY

Art fairs can be a good way for an amateur photographer to generate some extra cash. Because each fair is usually only held once a year, they're not going to be regular sources of income—and appearing at a fair one year doesn't guarantee a place the next. If you expand the area you're willing to travel to attend an art fair though, you might be able to squeeze in several each year, giving your annual income a useful extra boost.

Art fairs have a second advantage. They're also fun. You'll be able to meet buyers first-hand, answer questions about your images and see their reactions right away. That's not something you can usually enjoy when selling art and it can be a very rewarding experience.

TIPS
FOR SUCCESS

Selling art is never easy. If you've been accepted into an art fair though—and especially a juried fair—you'll be in a prime position to place your works in front of the people most likely to buy it. There are a number of strategies you can use to increase your sales:

Vary Your Sizes and Prices.

Buyers come with all sorts of budgets so make sure you have a wide range of options available. Those should include large framed prints with big price tags as well as plenty of postcards that browsers can pick up for a few bucks.

Price Your Images Carefully.

One of the biggest challenges of selling at an art fair is that you'll have to set your own prices. That can always be difficult to do so look at what other photographers at the fair are charging and aim for the middle. Overprice and you'll lose sales; underprice and you'll lose profits and invite the anger of other sellers. Make sure too that you include all of the costs of production including printing, matting and framing.

(continued on next page)

In return though, it's not unusual to generate $1,500-$2,000 in sales during the course of a fair and the start-up fees are still much lower than those involved in creating your own gallery or opening a store.

What You'll Need to Shoot to Make Money at an Art Fair

The types of images that are most likely to sell varies from art fair to art fair. At the Napa Valley Wine and Crafts Faire, for example, which is held each fall in California, originality and creativity are encouraged but all things wine-related tend to sell better.

The Evergreen Arts Festival however, which takes place in Evergreen, Colorado, deliberately looks for a wide range of different works and chooses the best photographers in a variety of different categories.

If a fair has a particularly strong theme then, you might find that it pays to ensure that your inventory includes plenty of pictures that match that topic. Otherwise, submit your best images and check your sales at the end of the fair to see which subjects sold best. That should make you better prepared for your next fair.

While the type and quality of images you make available at the fair are clearly going to be crucial, how you present them will be important too. The photographs will need to be matted and placed in protective covers so that they aren't damaged as visitors leaf through them. Some will also need to be framed so that buyers can understand how the images will appear on their own walls. And you'll also need a display tent and bins to hold the prints.

All of that requires capital outlay but most of it is a one-time expense much, if not all, of which can be recouped with your first successful fair.

How to Break into Art Fairs

Each event has its own requirements but because art fairs tend to be fairly open and often even pride themselves on providing opportunities for up-and-coming artists, breaking into them isn't difficult. The fairs themselves will list their requirements and explain how to apply.

Bear in mind though that fairs are often massively oversubscribed, a problem that's particularly acute among photographers.

The Evergreen fair, for example, receives up to 500 entries each year, with jewelers and photographers together making up around 40 percent of applicants.

6 Attend Art Fairs

The fair only accepts ten entries in each category.

A good strategy then is to try to find as many fairs as possible within a comfortable traveling distance and apply to all of them. You might not be accepted into all of them, but the more your apply to, the higher your chances of being accepted to some.

Another particularly useful strategy is to target juried shows. These are a combination of art fair and art competition, and while the prize itself might not be very important, juried shows do tend to be marketed towards buyers rather than browsers. They might also automatically accept award winners from previous years and, of course, winning an award at a fair will do wonders for your sales.

An additional bonus is that winning awards at juried art fairs can be a head-turner for gallery owners who will see that you have already been recommended by your peers and create images that can sell.

GETTING STARTED

The best way to learn how to sell photographs at art fairs is to do it. Make a list of all the art fairs within a comfortable driving distance of your home and read their requirements carefully. Make your submissions and see which accept you. Once you've been accepted, you'll need to invest in the tent and display materials, and print and prepare your images. That will require some funds up-front—but it should also give you some extra motivation to make sales and earn that money back!

You can look at the requirements for the Evergreen Arts Festival at www.evergreenartists.org. The Napa Valley Wine and Crafts Faire can be found at www.napadowntown.com and www.festivalnet.com has list of fairs around the country.

TIPS
FOR SUCCESS
(continued)

Find a Mentor.

Art fairs aren't just good places to meet buyers, they're also good places to meet other artists. The quickest way for a new art fair exhibitor to understand how to get the most out of a fair is to talk to people who have been doing it for years and learn from their experience. Although strictly speaking, other exhibitors are competitors, you should find that there's a warm camaraderie among artists which makes the whole thing a lot more fun.

Quality Work Sells.

Ultimately, the greatest test of whether you're creating the sort of photographic art that people will want to buy is to put it in front of them. Quality work sells so keep a careful record of what people are buying and make sure that you keep producing work of that type and caliber.

7

Approach Galleries

DIFFICULTY

COMPETITION

INCOME POTENTIAL

What It's All About

While there are lots of different ways of selling your images, few have the cachet, the satisfaction or the profitability of selling them through a gallery. You'll have the pleasure of being able to walk into an art space and see your photographs printed, framed and hanging on the wall.

You'll also see your name on the label, a price tag that's likely to be higher than anything you might have had the courage to ask for yourself . . . and if you're very lucky, a red dot in the corner of the frame that indicates the image has been sold.

When that happens, you're not just a photographic artist—you're a professional photographic artist who makes money out of their creativity.

Once you've been accepted by a gallery, you'll also find it easier to continue making that money because a good gallery will do more than place your photos on the wall and let its list of buyers know where to find them. It will also provide career advice, guidance and pricing strategies, letting you focus on what you do best: producing beautiful photographs that sell.

Of course, there's a price to be paid for all this. Galleries are usually very selective, only choosing the best artists and those whose works are most likely to sell. And they take a share of the sale price too, a share that's usually as high as 50 percent.

Although that can sound expensive, the benefits in terms of sales, prices, freedom and reputation make gallery representation well worthwhile

7 Approach Galleries

SUMMARY

Gallery representation is the goal for many photographic artists who see exhibitions—even shared exhibitions—as a vote of confidence in their abilities as both artists and photographers.

Despite the high cost of the gallery fees, it can also be very profitable. Gallery owners succeed by keeping track of collectors and keeping them informed of new artists and works that might match their collections. While the exhibition space is the most visible part of a gallery, their networks and their access to buyers is likely to be the most valuable part of a gallery.

Of course, all of this means that access to galleries is very competitive. It's not impossible for photographers with the right talent and the right portfolio to get their foot in the the door and their images on the walls but you'll have to follow the rules—and know what they are.

What You'll Need to Shoot to Make Money with Galleries

Different galleries sell different types of images to different kinds of markets. Irvine Contemporary, a gallery in New York, finds that its buyers are interested in works that are "edgy" and "nostalgic." Its photographers include Marla Rutherford, a fashion, editorial and advertising photographer whose photographs include fetish images that have been exhibited at SCOPE Miami Art Basel.

The Kirchman Gallery, however, a small space in Johnson City, Texas, says that its Texas Hill clientele aren't looking for images that are "overly edgy," preferring images that "they can live with."

Whatever your type of photography, you should be able to find a gallery out there somewhere that matches it (although that doesn't necessarily mean they'll take it.) Your local galleries would be good places to browse to see what sort of images they take but if you can't find anything locally that matches your photography, look further afield.

The best solution then is to shoot the images that excite you and when you find a gallery willing to exhibit it, listen to the advice they provide about creating images within that niche that are most likely to sell.

TIPS
FOR SUCCESS

Even small galleries are a few steps up the ladder for beginning photographers so before making your approach, it's a good idea to start building your reputation. For art or photography students, that's relatively easy: the exhibitions your school holds can help to fill your resume and put you in touch with gallery owners and buyers.

But you can also start small by entering juried art fairs; awards at these can go a long way towards impressing gallery owners. Organizing your own exhibitions—and inviting local gallery owners—can also help to put you in touch with the people that matter and show them your images.

How to Get Your Images into Galleries

Galleries can be fairly forbidding places. With their quiet, empty rooms and large, framed prints, they appear to be places that are only accessible to established artists who already have a reputation, a market and a good knowledge of what to do at an opening.

For the most part, that's fairly true.

Gallery owners sell works not just based on the quality of the images but based on the reputation of the artist. They'll only make money if the images they put on their walls sell so they have to choose carefully, minimizing the risk of lost income.

To persuade a gallery owner that you are indeed a good bet, there are a number of thing you can do:

Read the Rules

Most galleries these days have websites where they describe how they want artists to approach them. Make sure you read those submission requirements and stick to them. Few things are likely to irritate a gallery owner more—and cut short the meeting—than someone who visits unprepared to show their work.

Make an Appointment

As you look at the submission requirements for different galleries you should find that they vary at least slightly from gallery to gallery. One requirement that turns up frequently though—and it's one that many photographers tend to ignore—is the need to make an appointment.

Few galleries appreciate walk-ins. Call ahead and make an appointment so that the gallery owner knows what to expect.

Write a Resume and Artist's Statement

Galleries will also often demand resumes and artist's statements. The resume you show a gallery owner though isn't the same as the resume you'd show the HR department of a computer company. It's intended to show the gallery owner that even if you're an emerging photographer rather than an established one, you are at least on the way to becoming established.

So it should include any shows you've already held—even if they weren't held at major galleries or were held with other artists—and any prizes and awards you might have won.

Your artist's statement should be easier. This simply describes the sort of work you produce and explains why you choose to produce it. It helps the gallery owner to understand exactly what you're offering.

Create a Portfolio

And, of course, you'll need an impressive and well-organized portfolio of images that shows the sort of art you'd like the gallery to exhibit.

GETTING STARTED

If you've already had a few shows, then your first steps will be to create a resume, write your artist's statement and put your portfolio in order. Next, visit local galleries and make appointments with those that look promising. If you don't have any experience, then check art fairs first and approach cafes and restaurants. The Kirchman Gallery can be found at www.kirchmangallery.com. You can see the Irvine Gallery at www.irvinecontemporary.com.

8

Host Your Own Exhibition

DIFFICULTY

COMPETITION

INCOME POTENTIAL

$ $ $

What It's All About

Photographers who want to people to see their images—and buy them too—often find themselves caught in a Catch 22: they can't get exhibitions until they have a track record of sales but they can't develop a track record of sales until they get the exhibitions.

One solution is to organize your own exhibition. It's a solution that takes a lot of work. It will require plenty of preparation, at least a little expense and some tough marketing to make it all happen but it is something that a number of photographers have done and in a number of different ways.

The benefits are clear. Your fate as a photographer is in your hands. You won't have to persuade a gallery owner that your images can sell or absorb the rejection when you fail to make the case. This is one time when your determination is more important than the level of competition.

You might also be able to pocket all of the sales price instead of splitting it with the gallery owner, it can supply the sort of resume details that important gallery owners are looking for when they consider taking an artist, and the people who attend the exhibition may well be exactly the sort who can really move you forward.

What You'll Need to Shoot to Make Money with Your Own Exhibition

When you're thinking of selling art, there's no simple answer to what sells and what doesn't. Tastes vary tremendously and the market ranges from the avant-garde to the sort of mainstream pieces that even your grandmother would love.

That means you've got two choices.

8 Host Your Own Exhibition

SUMMARY

Organizing your own exhibition involves plenty of difficult challenges, from finding a venue to printing and framing your images and from creating the works to filling the venue with buyers and important cultural figures.

But it can be very effective, both for making sales and developing the connections you need.

Best of all, you're in control. Whether your exhibition succeeds or fails will have nothing to do with the marketing power of the gallery or the whim of the gallery owner. It will depend on your skill at bringing people in, and the quality of your photographs.

When it all works out, you'll have the satisfaction of being able to stand back and say "I did that."

TIPS
FOR SUCCESS

A successful home-made exhibition really relies on two elements: the right images; and the right marketing. If you have the talent and the photography skill, shooting the right images should come naturally.

The marketing tends to be a little less familiar but the golden rule is to be inclusive. Make sure that as many people as possible know about your exhibition and are invited. This isn't a time to be shy.

You can shoot the images that excite you and hope that there are enough people in your area who share your taste to buy them.

Or you can browse your local galleries, look what's selling and produce images that it appears your local market wants.

Perhaps the most sensible solution is to do both: to find a topic that interests and shoot it in a style that appeals to local buyers, but when you're in the art world—and more to the point, when you're just starting out in the art world—life's too short to shoot the sort of pictures that don't give you a thrill.

Creating your own exhibition is going to be a lot of work so whether it succeeds or it doesn't, you'll want to feel that the exhibition was genuinely yours. When you find a gallery owner willing to take you under their wing, he or she will help to point out which of your images are most likely to sell in the future.

How to Put on Your Own Exhibition

Choosing the images you want to shoot is always going to be the easy part. The tough bit is going to be organizing the exhibition and the toughest bit of all will be finding a venue.

In recent years, that has become easier. Increasing numbers of cafes and restaurants have come to realize that their wall space is also a resource. By allowing local artists to display their works on it, they get some free decoration and appear to be serving their local community.

The publicity too, especially the opening, can help to drive up business and raise their profile.

The pitch shouldn't be too difficult either. Café owners are likely to be much more approachable than gallery owners who will expect you to make an appointment and bring a resume and artist's statement. Offer them a share of the sales price—an amount lower than the fifty percent usually demanded by galleries—and you'll give them an added incentive to agree.

An alternative to a café or restaurant is to use a private space such as a home or a garage. Some photographers have done this with success even though it does have its limitations. The biggest is that you'll need a space large enough to hang your pictures and still allow plenty of people to mingle and view. It's also likely that the exhibition won't last very long. While a café will be happy to have your images on the wall for months, a homeowner will likely want his living room back as soon as the opening has closed.

On the other hand, if your own home is large enough or your garage empty enough, it's the sort of thing you can do without asking anyone's permission.

Once you've found a venue, you'll need to prepare the images, which will mean printing and framing them. You'll then need to do the marketing and this is the part of the exhibition that requires the most work.

You'll need printed invitations that you can send to select figures such as the art critic of your local newspaper, gallery owners, any collectors you might happen to know of and even photography teachers at your local college. You'll want to make the invitations as broad as possible so that you both increase the number of potential buyers and open up new networks that can help you in the future.

Friends are going to be particularly helpful here. They can distribute invitations to their clients, colleagues, family and email lists. Local stores can leave them on the counter where people can pick them up and any cultural outlet such a museum, theater or art center is also likely to be willing to make the invitations available to their members, spreading the word even further.

Social networking websites such as Facebook and MySpace have proved to be good places to make announcements of these sorts of events

too. The further you can spread the invitations, the better. You could even write a press release announcing the details of the opening and fax it to the local media.

All of this will cost money, of course. Even if you're not paying for the venue, you'll have to pay for the framing and the printing . . . unless you can create a joint venture with those suppliers in which they receive free publicity in return for free frames and printing. That's been done successfully too.

GETTING STARTED

Begin by putting together a portfolio of your works, then find a venue to show them—a café or restaurant might be the easiest place to start. Once you have their agreement, you'll have the motivation and the incentive to do the marketing to make it a success.

Jeremy Mason McGraw is one photographer who has managed to put on his own exhibition. You can see his work at www.jeremymason mcgraw.com.

Win Assignments for Magazines and Commercial Shoots

DIFFICULTY

COMPETITION

INCOME POTENTIAL

What It's All About

Assignments for magazines and commercial shoots are among the most high-paying of professional photography jobs. They often involve travel to interesting places, the opportunity to create images that may make a difference and are frequently exciting and prestigious.

You could be crawling through a cave in Mexico to photograph bats for *National Geographic*, flying in a helicopter to a North Sea oil well to shoot an annual report for Shell or trying to persuade the chief executive of one of the world's largest multinationals to sit still so that you can take his portrait.

The cost of shoots like these tend to run to five figures so it's no surprise that there are relatively few of them and that they tend to go to professional photographers who can show that they're among the best in their profession.

SUMMARY

The costs of commissioning a photographer to shoot for a magazine or a company can be huge. The client has to pay the photographer's *per diem* rate as well as travel expenses and lodgings. Although it's often possible to find a top-quality photographer who happens to live locally—giving an occasional advantage to professionals based in out-of-the way places—the high expenses mean that clients want to be absolutely certain they'll get the results they want.

That means they choose carefully, turning to agencies who select photographers based on experience and the quality of their portfolios.

What You'll Need to Shoot to Win Commissions

Mostly, you'll need to shoot well—exceptionally well. The subject of the pictures should clearly match the kind of images that you'll be asked to shoot, so they could consist of portraits of various VIPs, architectural images of corporate buildings or advertising tear sheets.

Remember though, that large clients often turn to agencies to choose their photographers for them. That means you'll be trying to impress a selector who sees a dozen or more high-end portfolios every week. The person looking at your portfolio will assume that the images themselves will be well-lit, technically perfect and with good color composition so they'll be looking for something more.

That may be creativity—the best portfolios often show original works and a clear personal style helps the client to understand exactly what he will receive—but they'll also be looking for a personal touch. "Photos should speak for themselves but editors want to know who the photographers are," says one agency executive.

It all comes down to trust. Photographers sent on assignment tend to work either alone or as leaders of a crew created to complete the shoot. An art director may be present but often it will be up to the photographer to think on his or her feet and make the decisions necessary to land usable images. That requires abilities beyond the photographic skills themselves. It requires maturity, confidence, drive and reliability. Assignment photographers have to be able to think and act independently.

The agency will be looking for signs of those qualities in two places.

One of them is the bio. Photographers' bios often talk about how the photographer has been shooting since he received his first camera at the age of five, loves taking pictures and thinks that photography is the highest art form in the world. All of that might be true of you too but it's not what the agency is looking for. The agency wants to know how you approach a shoot, what sort of images you're trying to create and why.

They want to understand exactly what sort of pictures you're going to bring back when they send you off to Brazil to shoot a rainforest or Singapore to take a portrait of the head of the local port authority.

That's why your personal projects are important too.

Your professional projects will show what you have achieved when you were hired to shoot images, but your personal projects reveal what you do when you're on your own. They show the way you approach photography, the styles you like to experiment with and the way you use light and

TIPS
FOR SUCCESS

Be Prepared.

If you're approaching a magazine, know what sort of stories they run and how they use the images. Large publications will often have more than one photo editor with different editors working in different fields. Know who you're talking to and which field they specialize in.

Network

It will always be easier to win assignments when the people with the jobs know who you are. That's not always going to be easy but attending events can help. At least one amateur photographer has won regular magazine assignments after meeting an editor at a car show.

Be Your Own Editor

Photo editors see the same pictures time and time again. Assignment photography is for photographers who can go beyond those basics. Instead of showing the sort of images that any photographer can shoot, focus on the images that only you would capture. That might limit your range but it shows who you are and what the client can expect for a specific job.

composition. From the point of view of the agency, they reveal how the photographer thinks and most importantly, what will influence the final pictures.

All of these things have to be viewed quickly and easily. Editors and agencies work on deadlines and don't want to wait while a Web page filled with the latest bells and whistles finishes downloading. They want to see your talent, not your Web designer's.

When showing off your portfolio then, choose the best and most representative images, include a personal section and a well-written bio—and keep your website fast and efficient.

How to Become an Assignment Photographer

Assignment photography isn't the sort of niche that a new photographer can just walk into. You'll need to have enough experience to reassure editors and agencies that they can trust you to do the job. It also helps to have contacts and a good relationship with editors and agents. Although those first contacts have to be made some time, editors and agencies tend to be most comfortable working with photographers they already know.

Becoming an assignment photographer then is a process that begins with shooting your first small commercial or editorial images, builds up through bigger jobs and leads eventually to large publications and the top agencies. It is possible to make a cold approach though, especially to magazine editors, but it has to be done carefully. Assume that photo editors at magazines receive thousands of enquiries every year; yours has to stand out.

That means keeping it short. An email is fine but don't fill it with large attachments that clog up the mailbox and which will later have to be deleted, and don't simply direct the editor to look at your portfolio. Instead, include one small-sized image for reference, include a link to your portfolio, and provide a brief description of the particular project you'd like to do.

That specificity is important. You should be pitching an assignment as much as you're pitching yourself as an assignment photographer.

GETTING STARTED

Life as an assignment photographer really begins in the trenches. This is a mid- to late-career job not a first job in photography. Begin by learning the trade. Build contacts and experience, then contact agencies, such as Magnum at www.magnum.com and Black Star at www.blackstar.com, that you want work for to discover how they like to view portfolios. Expect a hard slog, but expect a wonderful career too if it works!

Making Moo Cards

10

DIFFICULTY

COMPETITION

INCOME POTENTIAL

What It's All About

Moo, a UK-based printing company, began selling its minicards in 2006. The cards were half the size of regular business cards, came in packs of 100 for just $19.99, and allowed buyers to place images of their choice on one side and text on the other.

The idea behind the cards was to provide a way for people to share information about their online identities with the same ease with which they used business cards to share their professional information. Second Lifers could place a picture of their avatar on one side, for example, while Flickr users could show off samples from their photo stream while placing their Flickr URL on the back.

The cards' exceptionally small size was intended to help them stand out but also to increase the efficiency of the printing; they allowed more cards to be included on a single sheet.

It soon became clear that the cards' uniqueness made them exceptionally attractive while the ability to place a unique image on each card made them wonderfully versatile. They've been used to make products that range from lampshades to fridge magnets. One photographic artist even mounted an exhibition of his images using Moo cards, allowing the audience to take a sample home and see the remainder of the exhibition—including the missing cards—by following the Flickr link on the back.

Moo has since expanded its product range to include notecards, greeting cards and even regular business cards, but it's the minicards that still generate the greatest excitement, functioning both as attractive products and useful marketing tools.

10 | Making Moo Cards

SUMMARY

Moo cards were never intended to be a product that photographers could sell. Company founder Richard Moross simply wanted a way to enable his printing firm to stand out with a range of cards designed specifically to promote online contact details.

It has, however, become a lot more than that. Moo has created an opportunity for photographers to create unique and interesting photo products—and of course, to market their skills and show off their portfolio in a memorable way.

What You'll Need to Shoot to Sell Moo Cards

The images that you choose to place on your Moo cards will depend entirely on what you plan to do with them—and you can have a lot fun figuring out what to do with them!

The most obvious use is as photography business cards that also function as samples. Be sure to choose your best pictures and to make each card in your pack different. Pull one card out of your box and there's a good chance that the person you're presenting your card to will want to flip through the rest of the box. You'll be showing off your portfolio without even having to ask.

Moo also offers mosaic frames that allow photographers to show off multiple cards—or to divide one image into multiple sections. Shoot images that look good spliced and you could have one attractive product type.

You could shoot sets of collectible images. Create Moo sets dedicated to local wildflowers, for example, or certain car models, and you could have highly targeted products that are easy to market to niche audiences.

How to Market Your Moo Cards

And it's the marketing that's going to be key. These aren't the kind of products that you can currently find in your average store, so you'll have to work hard to persuade sellers to market them on your behalf and to talk buyers into reaching for their wallets.

The methods you choose, of course, will depend on what exactly you're selling.

TIPS
FOR SUCCESS

Use The Numbers

Moo gives you 100 cards in each set and while you can use the same image on every card, that would just be a huge waste. People will want to look through your cards so make them all different.

Use the Back

The front of the card shows off your talent but it's the back of the card that tells people where they can learn more. Make sure that you include your real name, a website URL and contact details. Don't be surprised if you're asked for prints or commissions!

Match the Format

Mini cards are tiny—just half the size of typical business cards so make sure that the image suits the size. Facial expressions might be lost but fragments of pictures can be interesting, especially if the URL lets the recipient see the whole picture.

Be Creative

The strength of Moo cards is in their flexibility and it's their uniqueness that will make re-sellers take notice. So be creative in how you use the cards and the images you put on them. The more original your use, the easier you'll find it to share or sell them.

If you're just using Moo cards as a kind of creative business card to show off your images, then it's simply a matter of networking. You'll need to keep your cards with you wherever you go and pass them out freely. That's usually how Moo cards are used but if you make sure that the text on the back includes the URL of your online gallery, there's also a chance that the recipient will order a print.

Products such as mosaic images can be hawked directly to retail stores, especially design and home furnishing stores. Make an appointment with the manager, bring a few framed samples and show how your portfolio could provide a wide product range with images to suit the store's style.

Better still, form a joint venture. These are marketing relationships in which sellers promote a product to their customer in return for a benefit, usually a share of the profits.

In the case of a photography enthusiast that could take the form of an agreement with an interior designer looking for unique pictures to decorate clients' walls but if you're producing sets of collectible images, it could be a partnership with other experts in your niche.

A photography enthusiast who was keen on cars, for example, could create a set of Moo cards featuring pictures of muscle cars. Each set of 100 cards would cost him $19.95 to produce. He could approach a seller of toy cars or car accessories and suggest that the seller promotes the sets to his buyers for $29.95. The two partners would split the difference.

Creating sets like these are a good way to bring together a photography hobby with a second interest. You probably have suitable images already and wouldn't need to look too hard to find a joint venture partner with access to the market you want.

GETTING STARTED

Begin by surfing to www.moo.com and taking a look at how Moo cards appear. Then spend some time on Moo's Flickr group at www.flickr.com/groups/moo/, looking at how people are actually using the cards.

Although most people use minicards as small business cards, you should be able to find some creative and inspiring uses there too.

Next decide what *you* want to do with the cards. Do you want to distribute them as samples, sell them as products, or pass them out as collectible kits? Make your decision, select your pictures, order the cards . . . and start selling!

Make Your Own Mouse Pads

DIFFICULTY

COMPETITION

INCOME POTENTIAL

What It's All About

They've been around since 1969, sold countless millions of units and sit on almost every desk in offices around the world. But while mousepads might have been invented to make moving the cursor easier, they can also function as canvases for art—and for photographic art in particular.

Once, that might have meant taking a gamble with a massive order of one particular design and hoping that there was enough of a market for it to sell.

But no longer.

Today, just as it's possible for photographers to sell single prints on demand, they can also offer printed mousepads on demand. There's no risk, no need to deal with inventory or mailing, and if you find a design doesn't sale, no cost in replacing it with a different one.

SUMMARY

There's still a huge demand for mousepads and—until touch screens take over—that's likely to remain. But there's also no small supply of them, and they're already available in a range of designs to suit just about every taste and interest you can think of.

The challenge though is that a designer mousepad isn't something that many people plan to buy. It's an impulse buy based on the realization that something that neat would look much better on the desk than the grey slab currently filling up the space by the keyboard.

Making money out mousepads then will depend on the ability to choose exceptional images and to actively place the products in front of the people most likely to be interested in them.

Break the Mould

Just because mousepads are rectangular, it doesn't mean that your image has to be too. There's nothing wrong with running your picture through Photoshop, adding some whiz-bang effects and including a frame, for example, that breaks out of the rectangular mould. Remember, people don't really want a new mousepad; they want a cool image so get creative and break some rules.

Track Your Sales Stats

Whether you're selling your mousepads through an online product store, putting them in an office stationery shop or offering them at specialist fairs and other events, be sure to keep a record of which images sell best where.

The more you can learn about what your buyers want and which are most likely to buy which items, the faster you'll be able to improve your sales.

(continued on next page)

You'll still need to do some good marketing but if you can match the right images to the right audiences, then photographic mouse pads can be one more way for you to turn your photos into cash.

What You'll Need to Shoot to Sell Photographic Mousepads

The design, of course, is always going to be key. Choose something generic, like a pretty landscape or a cute cat and you're going to find yourself facing some pretty stiff competition. You'll also be faced with a lack of strong desire.

A pretty mousepad might be a nice improvement to a desk but is that improvement worth the $15 or $20 that you're going to be asking someone to pay?

Rather than creating a mousepad that simply looks a little nicer on the desk then, try to use an image that expresses the buyer's identity. That will create a much greater desire to buy.

So instead of photographing a cat and placing the image on a mousepad, photography a Siamese cat and market it to Siamese cat breeders.

Instead of offering a mousepad with a beautiful landscape, shoot a local scenic spot and offer it for sale at nearby souvenir shops.

You're now no longer selling a mousepad with an attractive design; you're selling an attractive image that's also useful.

How to Produce and Market Your Mousepads

Print-on-demand services apply to mousepads too. The easiest way to produce products like these then is to use one of the main customized product stores on the Web: CafePress, Zazzle and Etsy.

Each of the companies is slightly different. CafePress has a certain pedigree and a reputation that comes in part from being the first; Zazzle has a huge range of products that includes shoes and embroidery as well as established brands; and Etsy is craft-oriented and charges a subscription fee to keep the quality high.

All of the sites though, allow you to add an image to a mousepad and sell it through the site.

The company handles the logistics. It takes the order, does the printing and even packs and ships the products for you. At the end of the month, you receive your share of the sales commissions.

But that just means it leaves contributors with the tough stuff: bringing in the buyers.

Product stores simply provide the store front. They actually do very little to bring in buyers, leaving the marketing work to the sellers themselves.

The most common reason then that creators of photographic products sold on these sites struggle to make more than a few hundred dollars a month is that they don't know how to market their products.

There are a number of ways to do that (and you can discover some of the most effective methods later in this book) but when you're looking specifically to sell mousepads on these sites, the best bet again is to keep it niched. Focus on creating a specialized series of images based around one specific theme then pitch it to members of that club.

GETTING STARTED

Start by choosing your market, not your images. Who would you like to sell your mousepads to? To other hard rock enthusiasts? To fellow horse-lovers? How about local cyclists who might like to keep an image from the best bike trail close at hand?

Select a handful of images that might appeal to that market and join one of the online product sites such as www.cafepress.com, www.zazzle.com or www.etsy.com. Follow the site's instructions to create an offer for a mousepad. Become active in online forums used by your market and ask them what they think of your mousepads. From there, expand into offline marketing such as fairs, concerts and events.

TIPS

FOR SUCCESS

(continued)

Sell the Image Not the Product

It's likely that whoever you're pitching a mousepad to has already got one. The products themselves last for years (with a little regular cleaning) so the only reason that someone will pay up for a new one is if the image on yours is really special.

Instead of focusing on selling your mousepad in office stores then, sell your specialized designs at specialized places. Fairs and concerts might be good spots for certain kinds of images but anything with a theme can be a good opportunity if the images on your mousepad match that theme.

Put the Link Everywhere

When you're selling the mousepads online, success will depend on making sure that everyone knows your website URL. That means putting it everywhere it can be seen: in your email, in your forum posts, on your blog, on your social media pages and certainly on your website.

12 Earn Every Day with Calendars

DIFFICULTY

COMPETITION

INCOME POTENTIAL

$ $

What It's All About

They're practically a classic. Whether they contain pictures of fluffy dogs, national parks or Sports Illustrated bikini girls, calendars are a golden opportunity for photographers.

Or at least, they are for the photographers who manage to fill the limited shelf-space in major book chains every year.

The rest of us are faced with a struggle.

That's a shame because it's never been easier to create photographic calendars—even if the result will take some hard selling—and so many people buy them.

What makes it all even more frustrating is that people tend to buy the calendars with the cheesiest images and the most appalling pictures simply because they happen to be the easiest available.

But that just means that if you can shoot better images and make them available too, you should be able to sell your calendars without too much of a struggle.

What You'll Need to Shoot to Sell Photographic Calendars

Marketing photographic calendars comes down to two approaches.

The first is to do what most calendar publishers do: pick a topic then pitch the product. So you could choose twelve of your best photos that show beautiful local nature spots, famous crime scenes re-created with Lego men, shots of Civil War battlefields or anything else you can think of.

The images in the calendar will be yours. They'll be of a topic that interests you—and it will be up to you then to find other people interested in those topics who would like to buy them.

12 Earn Every Day with Calendars

SUMMARY

In the right season, well-shot calendars delivered to the right crowds should be sure-fire winners. Millions of calendars are sold in the last few months of every year and major distributors tend to go for the most conservative designs leaving plenty of room for niched images and photos with more creative imagery.

And creating calendars today is easy. While it's possible to use an online product store, a local printer should be able to do it relatively cheaply and for very small runs, you could even try printing your own calendars—just be sure that the price you demand for the calendar includes the cost of ink and paper.

The challenge, as always, is to shoot calendars that people want to buy and that you're able to put them in front of that audience.

The alternative approach is to act as a kind of assignment photographer. Instead of shooting the images you want then trying to persuade multiple buyers that they want them too, ask one buyer of multiple calendars what kind of images he'd like then persuade him to let you shoot them for him.

Clearly, you'll want to make sure that the buyer is going to order a large number of the calendars but buyers like these shouldn't be too difficult to find. Calendars, after all, aren't just valuable appointment-keeping tools; they're also valuable marketing tools.

When a company passes out free calendars to its clients, for example, it isn't just trying to be nice to its customers. It's making sure that they look at their company's name every day and remember to buy from it.

It's a very easy, low-cost and effective way to advertise a business.

Offer to shoot images that would suit a business that wanted—or could be persuaded to want—to give calendars to its customers and while you might not be creating the kinds of pictures you might shoot in your spare time, you could still be earning money from your photography.

And bear in mind that those images don't have to be of the company's products, office buildings and employees (although they might be). They could be of flowers, cats and horses too, if that's what their customers would like to look at.

TIPS
FOR SUCCESS

Keep Your Calendars Unique

Calendars might be easier than ever to produce but that just means there are more of them out there than ever. To stand out, you'll want to make sure that your pictures are exceptional. Fluffy cats are a dime-a-dozen so find a topic that's usually ignored and you should be able to find a market that's usually left in the cold.

Count the Costs

Keep a close eye on the expenses. One of the most common mistakes made by non-professional photographers when selling images is not understanding costs. Calendars cost money to print and produce. Make sure you're getting that money back first.

How to Produce and Market Your Calendars

Producing calendars today really isn't difficult. In fact, you'll be spoiled for choice and that's where things can get tricky. When you're selling the calendars, you have to make sure that the price includes the cost of production.

That means that even a limited run at a local printers will probably be cheaper than using an online product store and will almost certainly be less expensive than printing them yourself.

Online product stores though will be the least risky—they won't cost you anything up front and production expenses are automatically factored into the price; it's up to you to add your mark-up. But the marketing will be harder, especially when the buyer has no way of seeing the physical product before he buys.

If you're planning to shoot a calendar on behalf of a business make sure that you ask the printer beforehand how much a print run will cost so that you can supply an accurate quote that also includes your fee.

Marketing your own calendars produced on spec involves using the same sort of strategies that you'll probably want to use for other niched products. Make appointments to speak with the managers of specialist stores. Offer your calendars to sellers at events and fairs in return for a share of the sales price. And promote them online, of course, through dedicated websites, forums and through social networking.

Selling commercial calendars for businesses might be a little easier. Create samples then start calling marketing managers around August or September at the latest. You'll want to have plenty of time to shoot the calendars, print them and have the company distribute them in time for the new year. Emphasize not just the quality of the calendar and the images but the benefits of having a piece of promotional material sitting on a client's desk for twelve months. You should find that sales renew themselves each year.

12
Earn Every Day with Calendars

GETTING STARTED

Begin by checking the market. Make a list of websites or stores that might be interested in selling your calendars and take a look at the products they currently offer. Once you've decided what kind of calendar you want to create, choose your production method. You'll want to find a balance between the up-front expenses of using a commercial printer and the low-risk but hard sales of an online product site. That should give you an idea of the final price . . . and the ability to start pitching. American Greetings's site www.photoworks.com may help to get you started.

13

Create Photographic Trading Cards

DIFFICULTY

COMPETITION

INCOME POTENTIAL

What It's All About

Kids have loved them since the days of Babe Ruth, and grown-ups still treasure, collect and pay ridiculous sums of money for them. But trading cards are little more than photographs with a bit of text.

That means they're an opportunity for savvy photographers who can produce sets that sell.

Like many other kinds of printing, creating picture cards now is no longer something best left to giant firms with presses the size of buildings. You can even produce them at home.

The challenge as always though remains creating sets on topics that people want to buy, marketing them to customers—and shooting the kinds of attractive images they'll want to hold onto.

SUMMARY

It's unlikely that you're going to produce your own super-rare trading card that you can sell at an auction for a four-figure sum. Unless you're hired by the NBA to shoot a set of basketball trading cards, that's not going to happen. But what you can do is create collectible sets of images for fans and enthusiasts.

Get the images and the price point right, find some good resellers and once your marketing channels are in place you should find that the sales—and the money—flow in.

What You'll Need to Shoot to Sell Photographic Trading Cards

The tools that allow photographers to print their images as trading cards were really created as a gimmick. They were intended to allow proud parents to turn their children and their friends into instant sports stars, complete with tradable accessories.

That might be fun but products like these aren't going to generate much income. Few children—or even parents—will want to pay for trading cards of the school soccer team.

But there are plenty of young enthusiasts who might want to collect images of local animals or types of motorbikes or even surfers or funny road signs.

One good place to look for the sorts of cards you might want to create is activity clubs, especially those clubs that allow families to participate in events together. If young people are going to be buying your cards, ideally you want them to be doing it with the support and encouragement of their parents. They're the ones, after all, who will be handing out the cash.

If your town has an active nature club, for example, you could shoot a selection of wildlife images, print them as cards and suggest that the club sells them in return for a commission.

You'd get a profit from the sale; the club gets the funds to recruit new members; kids get a fun present; and parents get to feel that they're buying their children something educational. Everyone wins.

Remember though that the images themselves won't have to be too stylish or artistic. Sports cards were always just the kind of heads-and-shoulders portrait that any mall shooter could put together. It's more important that the subject of the image is clear than that you show off your talent for photography.

How to Produce and Market Your Trading Cards

There are a number of ways that you can create photographic trading cards. Here are a couple of the easiest:

Use Hewlett Packard's Online Activity Center

HP has good reason to encourage people to work their printers and tries to help them to do it. Their old website includes some simple instructions to

TIPS
FOR SUCCESS

Choose Your Themes Carefully

When most people think of trading cards, they think of sports. But the major sports all have their card schemes sewn up while you'll struggle to make sales in a league that's so small everyone knows each other. Cards like these might possibly raise a little money for a small team but they're not really going to do much for an individual photographer.

You'll do much better choosing educational subjects that parents will actually want to buy for their children and distributing them through local nature and science clubs.

Keep Some Cards Back

It sounds a bit naughty but collectibles rely on rarities. Print the same number of each card and people will have little reason to keep buying, let alone to swap.

Pick four or five cards from each set and print fewer of them. You'll give customers a reason to keep coming back and those who do get lucky receive a reward for their loyalty.

(continued on next page)

TIPS
FOR SUCCESS

(continued)

Watch the Legal Stuff

The reason you can't just hang around outside a sports stadium, snap the stars leaving and turn those photos into cards is that sports stars' images are protected by copyright.

But the same is true of many items.

If you wanted to create a set of car-related cards, for example, you'd need the owners to sign property release forms. You'd certainly need model release forms to sell photos of any person who appears on the cards. And any well-known brands such as Mickey Mouse or Coca Cola are definitely no-gos too.

You should be pretty safe with wildlife and landscapes though.

create attractive photographic trading cards and comes complete with five sports-oriented templates.

Experiment in the Big Huge Labs

Alternatively, John Watson, a creator of applications for Flickr lets people create trading cards using the images they've posted on the photosharing site. Just pick the image, tell the program how to crop, choose a background color, add the text and toss in a few icons if you want.

There are no sporty themes here so you can make the cards match just about any topic you want.

Marketing, as always, will be a little harder but the best bet again will be to team up with a partner. Ideally, you want to find an organization with access to your customers so that you can be the supplier and they can do all the selling.

You'll then be able to outsource the printing and just enjoy the royalties on the sales.

GETTING STARTED

There are three stages to creating and selling photographic trading cards but the first is to choose your theme.

Try to pick a subject you know with a market you're familiar with and re-sellers you can name without too much thought. This is supposed to be fun, so don't make it too hard.

The second stage will be to shoot and print the pictures. To do that with Hewlett Packard, you can follow this link: http://tinyurl.com/5e4bun. Add the images and text, and hit print.

And you can find BigHugeLabs' tool at www.bighugelabs.com/flickr/deck.php.

Turn Your Pictures into Wallpapers

14

DIFFICULTY

COMPETITION

INCOME POTENTIAL

$ $

What It's All About

With more than 164 million computers sitting on desks in the United States alone, there's a huge amount of potential demand for images to decorate computers screens.

True, every PC comes with backgrounds built-in (and Vista users might be interested to know that some of those photos were shot by amateurs spotted on Flickr) but few people use the sample versions. Most opt either to use their own photos—often a family shot—or they swap it for a theme that they find interesting.

It's an important choice. The desktop is one of the most effective ways we personalize our workspace. It says a great deal about who we are . . . and what we want to see when we sit down to work in the morning.

SUMMARY

You might not make a living out of your wallpapers but you might be able to sell enough of them to make shooting and creating them both fun and lucrative.

The biggest challenge to selling wallpapers though is the size of the competition. Any image can be turned into a wallpaper and there are probably millions of images available for free online that are pre-formatted and ready to download.

To persuade someone to part with cash for your wallpapers then, your pictures will have to be exceptionally desirable. That's only going to happen with a combination of excellent image-making and keen marketing.

TIPS
FOR SUCCESS

Create a Series

Buyers often have pretty conservative tastes when it comes to wallpaper. They might be prepared to pay for a design they like but they might decide to change it only for another design that's fairly similar.

Create a series of similar images and you'll give customers a reason to subscribe—they'll have immediate access to the new image—and changing their wallpaper won't mean completely redesigning the look of their computer.

Use Freebies to Promote Your Commercial Products

Your biggest competition won't be other photographers selling their images as computer wallpaper. It will be the gazillions of free images available at the click of the Google search button.

People will download your wallpapers though because they're better than everyone else's.

To make sure they know that, don't be afraid to give low resolution samples away for free. The kind of users who are satisfied with low resolution won't buy anyway; the others will get to know your work and wonder where they can find better versions.

(continued on next page)

Although there's no shortage of free images available, there is still a market—and a business model—for pictures that are attractive, well-made and unique.

Some designers and photographers are even making a living out of them.

What You'll Need to Shoot to Sell Photographic Wallpaper

The easiest kinds of photos to sell as wallpaper are rare images—the kind of photos that buyers can't find anywhere else and which, by putting them on their screen where others can see them, shows that they too are different.

One designer, for example, has built a fan base for himself by creating wallpapers hand-drawn in a fun, faux naïf style. But he's also a keen photographer and has been able to expand his range by selling a series of wallpapers showing traditional wooden houses in his native Siberia. The pictures themselves were beautifully shot then Photoshopped and placed on an attractive background. Most importantly, there was nothing else like them available.

You might not live in Siberia but you should be able to find images that are equally rare, and create a similar series. Traditional adobe houses could work, for example, as could church architecture, Chinese porcelain or underwater shipwrecks.

Just try to steer clear of anything generic such as flowers or sunsets. There are too many of those available for nothing—and too many people able to shoot them for themselves—for you to be able to make any money selling them.

How to Produce and Market Your Wallpapers

Creating your wallpapers shouldn't be too difficult. The images themselves are just JPEGs—like so many other images—but they do need to be formatted to fit different screens. There are as many as fifteen different kinds of screen formats from 800 x 480 to 2560 x 1600 widescreen.

And that's before you include dual monitors and make your wallpapers available for mobile phones as well.

Obviously you don't need to format your wallpaper for all of those sizes but the more you cover, the greater the opportunity to make sales.

You then have a choice of two ways to deliver them.

The first is to put together a bunch of different wallpapers, burn them onto discs and sell the discs. You can probably find these kinds of products in computer stores. They'll sell for about five bucks each, look cheap and you'll have to work pretty hard to persuade the store manager to stock yours.

You could succeed though and you might do better offering your discs at specialist stores that match the subject of your wallpapers.

A better model though involves selling subscriptions. Make low-resolution versions of your wallpapers available for nothing to bring users in but let subscribers download as many high resolution wallpapers as they want.

You can set up different kinds of subscription plans to suit different budgets. A three-month plan, for example, could cost $8.99 while a lifetime plan could go for $29.99.

One wallpaper seller has sold over 11,000 subscriptions using this model.

The free wallpapers will help to attract users, many of whom will then convert into paying members, but it will also help to be active on craft sites as well as forums used by people who appreciate the subject of your images.

GETTING STARTED

Spend some time initially browsing wallpaper sites to see what people are offering and what kind of images are most popular. Bear in mind though that most of these images will be free. To sell your wallpapers, you'll need to produce something much more original such as those offered at www.vladstudio.com.

Build a website that will allow buyers to purchase subscriptions. That could take some time but just consider it an extension of your online presence.

Have fun! Selling wallpapers won't be easy, especially while you're still building your name. Focus on enjoying yourself and talking about your design. In time, you should find that you're generating interest—and sales.

TIPS

FOR SUCCESS

(continued)

Teach

The quality of your images is clearly going to be important but it's their uniqueness that will really sell them. You can reinforce that uniqueness by providing information as well a picture. That could be information about how you created the image—if the design is particularly unique—or you could write website articles about the subject of the wallpaper if it's the subject of the images that's particularly important.

15

Let Buyers Eat Your Pictures

DIFFICULTY

COMPETITION

INCOME POTENTIAL

What It's All About

Marie Antoinette might have told the poor that they can eat cake but at least she didn't suggest that they dine on the pictures of gateaux.

That's a shame, because they could have been quite tasty.

New inks made of food dye and special paper made of rice flour means that it's now possible to print photos that are edible. You might not want to serve one up as a meal but they can be placed on the top of cakes as a special form of decoration.

Usually that means printing a picture of the birthday girl or anniversary couple and being careful where you make the first cut but there's plenty of opportunity for more creative fun images—and to produce prints that sell.

SUMMARY

Edible images are a novelty product that relies on producing fun images. In effect, you'll be making decorations that help cake-sellers sell more of their products.

That means it's not the quality of the image that counts—in fact, the printing quality tends to be fairly poor—but the extent to which your image can help to raise a smile and encourage a customer buy a unique item.

You'll need to create partnerships with cake-sellers, something that some photographers may find easier to do than others.

What You'll Need to Shoot to Sell Edible Images

The printing systems used to produce edible images were really intended to enable families to print pictures of their loved ones and place them on birthday and wedding cakes.

You're not going to have pictures of other people's kids to sell them so to make sales, you'll need to produce a creative range of photos that will impress cake sellers and show customers that their purchase is exceptional, unique and above all, fun.

So think out of the box!

Try scooping out the middle of a cake, photographing what's left from above and placing the image on top of a new cake.

Or take a picture of a hand reaching out of the center of the cake to help itself to some of the icing.

Or maybe you could shoot eight different images and Photoshop them into slices so that people can choose which picture they want to eat.

Or yes, you could even try producing a standard range of landscapes, animals and specialized photos and seeing if they sell. At least one cake craft company, for example, offers a mixture of decorative textures and clip-art style cartoons.

This is a pretty new field so it's not entirely clear what kind of images buyers might want on their cake. The only way to find out for sure is to start with a broad range and see what sells.

How to Produce and Market Your Edible Images

Usually it's the marketing that causes most of the headaches for photographic products but in the case of edible images, it's the production that can be a little tricky too. There are a number of options:

IcingImages.com

The simplest might be to order the prints through a company like Icing Images.com. Upload your photos and they'll mail the printed sheets back to you.

But they're not cheap. A standard sheet cost $13 plus a $5 delivery fee, although additional prints are half price. That still means that a print run of fifty images, for example, would cost $6.73 each. You might be able to negotiate lower prices for bulk orders but you'll still be left with a hefty addition to the price of a cake.

TIPS
FOR SUCCESS

Track What Sells

This isn't a field with a great deal of competition. While that means you should be able to dominate your local market fairly easily, it also means that you'll have to do your learning on the job— including learning about which kinds of products are most likely to sell.

You might want to begin with a broad catalog of images then whittle it down as you discover which types of pictures customers want to bite into.

Track Your Expenses

The materials for creating edible images aren't cheap, although you can reduce the costs by ordering in bulk. You will need to calculate exactly how much you're spending and how many images that outlay produces. You should find customers are prepared to spend an extra $6-$9 for a cake with an attractive image. Deduct the cost of production and you'll be splitting what's left with the bakery.

(continued on next page)

Form Joint Ventures

These sorts of images really need to be sold in bakeries so you'll need to set up partnerships with local cake-sellers.

Stress how much more attractive your images will make their cakes appear and point out too how profitable the sheets can be.

IcingImages though also sells production kits as well as the inks themselves, suitable for Canon printers. A complete system, including printer, starts at $399 and runs to $899 for a wide format.

KopyKake.com

Alternatively, KopyKake.com also sells edible printing equipment suitable for both Canon and Epson printers, allowing you to produce your own images from home.

Again though, with cartridge sets starting at around $50 and rising to more than $100 and the sheets starting at just over a dollar each, it's important to track the real price of each image so that you're making a profit on each one.

The marketing at least should be fairly straightforward.

Print out a bunch of sheets, take them to a local bakery and ask if they'd be interested in including them as options on the cakes they sell. You can supply them with a catalog that they can show clients and print to order. Add a healthy mark-up to the cake and both of you will profit.

Event photographers too can offer unique cake images as part of their services.

GETTING STARTED

Take a look at your local cake-sellers to see what kinds of cakes they produce and who's likely to be selling your images.

Choose your designs and print them on rice paper with edible inks either from www.kopykake.com or www.icingimages.com. Take them to the bakeries, ask to speak to the manager and show what sort of images you'd like them to offer.

Be sure to explain how the photos can both increase sales and provide a valuable mark-up.

Illustrate Recipes

DIFFICULTY

COMPETITION

INCOME POTENTIAL

$ $

What It's All About

Good chefs know we eat with our eyes as much as with our mouths so they put a great deal of effort into plating, garnishing and color.

That's fine for chefs but for recipe-writers, it's a problem.

While cookbooks filled with color photographs always look much more inviting, they're also a great deal more expensive to produce, which is why publishers tend to keep the glossiest cookbooks for the most well-known names.

And not everyone who knows how to use a spatula understands what do with a camera. Producing attractive food images is something of an art so even online publishers can struggle to create beautiful photos that illustrate their recipes.

Photography enthusiasts who also like cooking though can fill the gap by following recipes, photographing the result, then sharing the images with the chef who produced the directions.

The fee could either be paid per image or it could be linked to the increase in ad views and additional sales made on a Web page.

What You'll Need to Shoot to Sell Recipe Images

You'll need to shoot good images, as always, but you should also shoot food that you actually want to eat and from chefs you admire.

Because monetizing these images is so difficult, much will depend on the relationship you're able to create with the recipe author and with other people who like this type of food. It's not something you're really going to be able to do unless you're genuinely enthusiastic about the dishes you're preparing.

TIPS

FOR SUCCESS

Cook for Fun

Yes, this book is all about selling your photographs rather than enjoying them but the two are usually connected and that's especially true here. While it's often a good idea to look for a gap in the market then shoot images that fill it, for this product, think about what you want for supper and shoot that instead. Do it well, and you should be able to put your images to use—and if they are useful to others, you should find that they're prepared to pay for them.

Take Your Time

It's unlikely that you'll start making sales right away. To persuade a food blogger or recipe writer to give you the share of cash that your images are bringing in, he'll first have to see the value of your images. He'll also have to like you enough to want to partner with you. Begin as a fan and let the money come later.

Build a Community around Your Images

The same is true of any image viewers you're trying to persuade to buy your affiliate products. Gush about the food you've eaten and let other people enjoy looking at the photos of your dinners.

(continued on next page)

SUMMARY

For photography enthusiasts who are also foodies, shooting the results of recipes should be a great deal of fun.

You'll get to cook food you want to eat, enjoy the thrill of taking a picture of the result—and then enjoy eating your cooking even more.

And food photography is a very special photography niche so you'll be able practice and improve your skills in one important specialization and one large photographic challenge.

The monetization though will be difficult. Few people will be interested in buying pictures of your dinner . . . although they might want to help you eat it.

But there is a potential opportunity in working with the recipe writers to help make their products more attractive. It's likely to take time and a good relationship but if the writer benefits from your images, then you should both be able to benefit from the co-operation.

While the quality of the photography is certainly going to be important, no less important will be your place in the cuisine.

It's also a good idea to choose a cuisine which lacks good photography. If there are plenty of well-illustrated blogs about barbequing, for example, then you'll struggle to make your images stand out. Pick a type of Creole cooking for which there are plenty of recipe writers but very few images and you'll have a much better chance of finding spots for your photos.

How to Produce and Market Your Recipe Images

Producing the images shouldn't be too difficult, although producing good images may be. Food photography is a very particular professional niche within photography and has a range of tricks and techniques that stop ice melting under lights, for example, or which keep strawberries looking shiny and fresh even after they've been photographed for hours.

You don't have to do any of that stuff because when you've finished shooting, you'll also want to start eating.

It's a good idea then to make sure that you've got your camera on hand and a place to shoot the plate—or the pot (however you're planning to do it)—before you start cooking. You don't want your food to get cold while you're setting up the equipment.

As soon as the dish is ready then, you can run off a few quick frames then tuck in.

And once you've finished eating, you can start selling, and here, there are really two approaches.

The first is to work with a food blogger or recipe writer who's clearly missing images. Initially, mail in your photographs as a favor so that the chef can improve their blog or their recipes. Later, once they recognize the value of a good photograph linked with a recipe, you might want to point out that your images have helped them to improve their page views and increased their ad clicks.

You can also point out that taking these pictures takes quite a bit of time and while you enjoy doing it, you don't think you'll be able to do it for too much longer without a share of the additional revenue.

The alternative is to set up your own ad-based revenue system. You could do that by writing your own food blog and filling it with ads, but you could also set up a Flickr stream in which you show off all the images you've taken of the meals you've cooked, and affiliate link the descriptions to the cookbooks at Amazon.

Network like mad to bring people into your stream and you should find yourself picking up regular views and a flow of affiliate commissions.

It might even earn you enough to pay for your supper.

GETTING STARTED

The first steps are the easiest: cook, shoot and send in your images! But take a look at vegandad.blogspot.com and www.epicurious.com. Neither would be the same without the pictures.

TIPS
FOR SUCCESS
(continued)

In time, as they see that you understand food and wish you'd invite them for dinner, they'll come trust you. And they'll follow your recommendations for cookbooks and even pots, pans and other affiliate cooking accessories.

Look at Examples

There are plenty of good food blogs out there that are almost as dependent on the quality of their images as the tastiness of their recipes. Copy them.

17 Create Publicity Photos for Businesses

DIFFICULTY

COMPETITION

INCOME POTENTIAL

$ $

What It's All About

As photojournalism—and newspapers shrink—more photography enthusiasts who'd like to be hired by editors to shoot news events are going to be disappointed.

But this changing news environment might also provide an opportunity.

As the media hires fewer photographers, more photo-worthy events are being ignored. If you can turn up to them with a camera and take the kinds of images that they might want, you could end up being published.

Pitching your images to editors isn't easy though and has a high failure rate. The world is filled with worried freelance photographers hoping to make enough sales to pay the rent.

An alternative then is not to charge the newspaper for your image but charge the business that benefits.

Many events covered in newspapers are publicity events organized by businesses to win free coverage in the media. The companies write press releases, organize something suitably eye-catching and hope reporters turn up to write about it—and photograph it.

It doesn't always happen. The media has lots of things to cover and doesn't have the staff to report and shoot every celebrity opening and charity do. But you can turn up to publicity events, take pictures and let the company know you have them. When they send in a follow-up release to the media announcing how the event went, they can state that they also have images.

The media is unlikely to want to pay for those images but in return for coverage in a newspaper, the business may agree to pay you for them if the newspaper agrees to run them.

SUMMARY

Shooting publicity events will let you feel a little like a news photographer but it's rarely as exciting as covering a major demonstration or a small war.

Nor will every event you photograph result in publicity or publication but you might occasionally score a success. Just make sure you let the organizer know that you have good images and leave him with your details in case he needs them for the press.

What You'll Need to Shoot to Sell Publicity Images

When shooting publicity events, you'll be serving two masters. On the one hand, the press is only going to run a publicity image if it's dramatic, eye-catching and tells a story. Editors understand that they're getting the image for free—and therefore filling up a third of a page for no effort—because the company in the picture benefits, but their first job is to entertain and inform the public.

If the image doesn't tell a story and look good, they're not going to run it, no matter how free it might be.

But on the other hand, a publicity image also has to help promote the company that's paying for it. The firm is hoping for a free ad with the added halo effect that comes from a write-up in a trusted source. If there are going to real, measurable benefits from the publicity though, the public has to be able to see their name and remember it.

As you're shooting your publicity images then, try to include the company's logo or name in your shots. Don't place them front and center so that they become the dominant feature. Just keep them in the background where they can be seen without interfering with the story-telling quality of the image.

Ideally, you want an image that's dramatic and informative, and with a logo placement that's about as subtle as a product placement in a movie.

And when you tell the business owner that you have images that he can supply the press, don't forget to point out the location of the logo!

TIPS
FOR SUCCESS

Don't Bank on the Cash

This is a slightly off-beat way of earning money from images. Businesses won't expect to pay photographers to get a photo in the press; they'll expect the media to send their own photographer and be happy with a good picture.

But don't let the surprise of business owners dent your confidence. If your picture of their event appears in the media, they're getting something very valuable. There's no reason they shouldn't share that value with you but it might take a little time before it happens. In the meantime, enjoy the shooting.

Remember Who You're Working For

Businesses will only pay for images that serve them and the media will only take images that serve the audience. As you shoot remember to make sure that your pictures aren't just good but functional too.

How to Produce and Market
Your Publicity Images

The key to successfully creating publicity images is always going to be finding the events to shoot. Public relations executives and businesses alert the press about upcoming events by sending them press releases. Those releases go out to reporters who have written about them in the past, they're faxed to news rooms and they're distributed on the Web.

They're not usually sent to photography enthusiasts looking for an opportunity.

That means you're going to have to break into the chain.

One place to do that is by looking at events columns. Publicity events that are open to the public may also be announced in newspaper columns that list upcoming events. You might also find events like these listed on your local Craigslist.

A quick browse before the weekend may toss up the odd interesting occasion.

But you can also read press releases by regularly checking websites such as PRNewswire and even Google News. You'll have to search carefully so that you skip past announcements from pharmaceutical firms in Nebraska to find small businesses in your area holding fundraisers for local firefighters but with a little practice you should find that focus faster.

And after you've turned up once, you can ask to be added to the business's mailout list so that the searching is easier next time.

Making the sale should be relatively easy—if only because one option is to let the business do all the work for you. Before you leave the event, ask to speak to the organizer, tell him that you have a bunch of images that he might want to give to the press and offer to email him low-res versions as soon as you get him home.

Let him know too that if the press wants to use one, you'll be happy to send along a high-res version . . . for a small fee of say $75. If he balks, point out that each image you supply will have his company logo and that whatever price you've selected is still far lower than the cost of a similar-sized newspaper ad.

Alternatively, you can do the selling yourself.

Call your local newspaper, ask to speak to news editor and tell them that you have some images they might be interested in. You're not likely to get too many sales this way, but you might pick up a few.

GETTING STARTED

Breaking into publicity photography is fairly easy. Search for press releases from local businesses or find a corporate event that's about to take place in your area. PR Newswire at www.prnewswire.com is a good place to look.

Turn up, shoot and make your first pitch!

Shoot Local Stock

18

DIFFICULTY

COMPETITION

INCOME POTENTIAL

What It's All About

Traditional stock photography is a difficult business and it's unlikely to get any easier. While the barriers have now been lowered so that anyone with talent and a reasonably good camera can make their images available for sale and earn a little income, that also means greater competition and more photos competing for the same number of buyers.

One way to stand out is to shoot niche subjects. Promote yourself as a creator of sports stock or wildlife stock and you should find that agencies come to rely on you and buyers come back to you.

There is one specialization that anyone can use though: their local area.

Wherever you live, there will be demand for images shot in your neighborhood. Clearly, the size of the demand will depend on your location—shots of Los Angeles or New York will always find more buyers than scenes of Smalltown, Arizona—but municipalities will need them and so will local businesses.

And the biggest advantage of all is that you don't have to travel too far to shoot them.

What You'll Need to Shoot to Sell Local Stock

Your local area can provide you with two kinds of images.

The first is pictures that are intimately linked to your area. These could include local landmarks such as the court building, the town's main street or the promenade.

Photos like these can be helpful to anyone looking for pictures that show exactly where they were shot.

18 Shoot Local Stock

SUMMARY

Shooting stock images in your local neighborhood is a good way to solve stock's biggest challenge: lots of available images and few buyers.

Few photographers know your neighborhood better than you do. You know where the best landscapes are and the best times to shoot them. You know the sites of the most interesting buildings and the scenes that speak loudest about your location.

And you have no problem traveling back to retake images and to build your inventory.

While there may not be massive demand for images that are specifically local, it's also possible to shoot generic scenes with mass appeal—such as parks or beaches—and expand your buyer base.

In short, your local area is filled with saleable stock images. All you have to do is shoot them.

The other kind of local stock image that you can shoot will be made up of more general subjects. These will be part of the local identity but they show scenes that can be found in other places too.

If you live in an area known for winter sports, for example, then you could certainly shoot people snowboarding down mountains or falling over on ice rinks. That would be a part of where you live. But images like these could be useful to any buyer looking for winter sports images, regardless of where they were taken.

As you're shooting then, try to make sure that your portfolio contains images that are both quintessentially local as well as other pictures that can have a broader appeal too.

How to Produce and Market Local Stock Images

Creating local stock images should be simple enough. You won't have to do any more than turn up with your camera and tripod and snap away. (Although you will still need to pay attention to copyright issues and model permissions.)

But you will need to know where to shoot.

You can probably run off a list of local scenic spots without thinking too hard but you might find a local guidebook helpful in increasing the list to include places that you don't usually visit.

TIPS
FOR SUCCESS

Keyword Carefully

Successful stock photography depends on taking good commercial images that are flexible enough to be used many times in many different ways. But they also have to be found and that means taking the time to keyword each image carefully.

The terms have to be relevant—so no spamming—but they should be comprehensive too so that they're available to as many buyers as possible.

Keep Shooting

Stock images do cost money to produce, even if that expense is only visible to an enthusiast in the form of time and travel. And as we've seen, it can take a year or two for an image to break even and longer before it starts to turn a profit.

In the meantime keep shooting and building your inventory. The more sellable images you have, the more money you can make.

More challenging will be making sure that you cover all of the different categories that images from your local area could illustrate and which stock buyers might need.

Create two headings: one for stock topics that are quintessentially local; and a second for the more generic images that you can shoot without traveling too far.

Under each heading, list all of the different types of images you can shoot. So your quintessentially local list might include landmarks, the annual solstice parade and the shape of the bay.

The more generic categories could include shopping, fairs and the sea.

You don't have to shoot images for all of these categories at once but over time, you'll want your portfolio to cover as much of your area as possible.

And there are two ways to market these images.

The first is simply to submit to general microstock and mid-stock companies such as Dreamstime, iStock and fotoLibra. Tag them with all the relevant keywords, both generic terms and location tags.

The company will do the marketing for you and anyone tossing in the name of your hometown, county or special sites should be offered your images.

The alternative is to create your own local stock site. That can take some building and you'll have to market it yourself too. But it will mean that you'll get all of the sales price, rather than just a fraction of it, and you'll be able to target it specifically to buyers of local images.

GETTING STARTED

You can begin by creating your list of possible image subjects, but you probably already have sellable local stock images on your hard drive. (Remember, they have to be good; snaps won't sell!)

You can start then by uploading them to a stock site but make sure the keywords include local location tags. You'll already be on your way towards selling local images because of their location.

You can find a couple of examples of photographers who have created their own sites at www.coloradopics.com and www.parkcitystock.com.

Sell Posters

19

DIFFICULTY

COMPETITION

INCOME POTENTIAL

$ $

What It's All About

Every photographer dreams of creating pictures that are so beautiful, people will line up to buy them, place them on their walls and just be happy to look at them every day.

It doesn't happen often though.

There just aren't enough people willing to dish out large sums of money on top-of-the-range prints.

But there are a lot more people willing to spend relatively small amounts of money on posters.

In fact, step into any teenager's bedroom or peer through the windows in any student town and you'll find posters filling up every available space,

SUMMARY

Like any photography product, the biggest difficulty in creating and selling posters is that the production costs are relatively high and the margins appallingly low.

Choose to print in bulk to keep the costs down and you'll increase the risk of losing money.

Choose to print on demand or in small runs and you'll reduce your profit margins.

And that's before you've worn your feet out taking your posters to stores and trying to persuade the owners to stock them.

There are ways though to square the circle—at least a little—keep risk relatively low, the profit margins at a sustainable level, and the posters placed on display.

TIPS
FOR SUCCESS

Think Long Term

The hardest times when you're trying to make money out of posters is at the beginning. You won't know which images are most likely to sell, which outlets are most likely to sell them or how much you can charge for them.

Expect to make mistakes and expect to pay for those mistakes too.

That's just the cost of doing business though, so think long term and expect to make your money back as the posters start to move.

Produce Posters That Sell, Not Just Posters You Like

It would be great if everyone shared your taste and bought the photos that you're proudest of.

Life doesn't work that way. In fact, many of the photos that you'll find in stores and on walls can be pretty cheesy. They might not be the kinds of images you most want to shoot but they don't have to be. They just have to sell.

including much of the ceiling. While many of those images will be of major bands and celebrities—photos that you're just not going to be able to shoot—others may be of landscapes or Photoshopped fantasies.

One of the most popular posters ever produced was of a female tennis player scratching her behind. It sold over two million copies.

It's unlikely that you'll produce a poster that will sell two million copies. But you might be able to produce a series of posters that earn you sales and income.

What You'll Need to Shoot to Sell Posters

Part of that comes from shooting the right images in the first place. Again, generic images are going to be very difficult to sell. You'll be competing with major distributors who can print their posters by the thousands, lowering the cost of production to a level that you can't compete with.

So refine your niche and your market.

Students are the people most likely to buy posters so take a look at what's on offer in the stores in your nearest student town. Many of these stores are also independent rather than branches of large chains so their owners will have more flexibility about what to stock and where to source their supplies.

What you'll probably find is that each university town has its own atmosphere and offers a particular type of image. The University of California at Santa Barbara, for example, lies right next to a popular surfing spot. Many of the posters on offer at its local bookstore then are focused on surfing and beach scenes.

The images that you offer should be fairly similar.

That might sound wrong. If the store already has images like these, why would they want more of the same?

The answer is that they know they sell. Store owners have little reason to take risks and while they might appreciate looking through a unique portfolio, experience has shown that when it comes to laying out the cash, commercial buyers tend to go for the styles that have proven themselves in the past.

That's as true of posters as it is of stock.

One option then is to shoot images that fit the local market and match the sorts of posters that are already on offer.

Another is to shoot images that only you can sell.

You might not have access to the band that's currently riding high at the top of the charts, but you do have access to the local bands that are currently riding high at colleges. Attend some gigs, talk to the band and offer to shoot them exclusively in return for sharing the royalties on each sale.

It's unlikely you're going to be selling thousands of prints but you might just be able to capture your local music market.

How to Produce and Market Posters

It's the production of the posters that will pose the biggest headache. Again, one option is to use an online product store to print on demand. You'll be free to set a price of your choosing above the cost of production ensuring that you make a profit on each sale.

But the marketing will be difficult. Most posters are sold in stores where people can see them life-size rather than online, although it could work for very special images that can't be bought anywhere else.

The alternatives are to print in bulk, pay large costs up-front but a small amount per poster and hope that you can sell enough copies to enough stores to make a profit; or to print a few copies, pay more per poster because you're not buying bulk, but lower the risk of losing a lot of money.

Or you can combine the two methods. Order a small print run of a number of posters, hawk them to a small number of stores and see which ones sell. You'll lose money on the images that don't sell but you'll have bought knowledge of your market—and that's a valuable thing.

You can then step up production of the posters that do sell and hope, in time, to make up your initial losses.

GETTING STARTED

Start by looking around local stores to see who might potentially stock your posters. Also pay attention to the kinds of posters they sell. Then do the math. Compare the costs of the posters you've seen with the costs you'll have to pay to print each poster at a site like www.cafepress.com or www.kwikopy.com. Once you know your profit margin, print some samples and start hawking.

20

DIFFICULTY

COMPETITION

INCOME POTENTIAL

What It's All About

Usually, successfully selling any product—including photography products—requires two things: the right product; and the right distribution.

You need to create good quality images that people will want to own and you'll need to find a way to place that product in the hands of those happy buyers. (Usually, for photographers, creating good products is easy; it's the distribution that creates the headaches.)

Sometimes though, a third element can help to sell a product: the right time.

Seasonal periods see sudden, and temporary, demand for particular kinds of images and they tend to happen when there's a general increase in demand for images too.

In the run-up to Christmas, for example, retailers will be looking for images to promote their goods while consumers will want to send Christmas cards and gifts.

That's a huge opportunity for a photographer with talent, time, a willingness to do the work involved in selling—and a way of moving those images from the hard drive to the store.

If you can be ready with a sizable supply of those kinds of photos and photography products, you can give yourself a sudden income boost just when you need it most.

What You'll Need to Shoot to Sell Seasonal Images

Clearly, the subjects you'll need to shoot will depend on the seasons you're targeting.

20 Get Seasonal — Halloween, Thanksgiving and Christmas Products

SUMMARY

Seasonal images and products should be one part of your inventory. They might only sell for a few weeks each year but the demand for wintry images at Christmas and scary photos at Halloween means that it's a waste of an opportunity not to try cash in on them.

These products don't need new distribution channels. They'll simply be a way for you satisfy the special demands of your regular buyers at particular times in the year.

This is one type of photography product in which the subject of the image is the most important element so have fun thinking up compositions to match the seasons.

Christmas images could include snow scenes, Christmas trees, presents, decorations, stockings and even more generic winter subjects such as log fires and hot cocoa.

Thanksgiving has fewer obvious images but if you can build up a collection of images of pumpkins and turkeys, you should be able to create photographic products you can sell in November.

And Halloween can include pictures of carved pumpkins, fancy dress costumes, gothy teenagers and if you can find a haunted house—or manage to snap a picture of a ghost—so much the better.

A quick search through a stock library for each season's keyword should provide a huge range of inspiring seasonal image ideas.

How to Produce and Market Seasonal Images

Creating the images is always going to be the fun bit. You should be able to give yourself some interesting photographic challenges shooting Christmas tree decorations without the camera reflection and finding the best way to light a lit pumpkin.

Selling the images is likely to be a lot less enjoyable.

The easiest method will always be to upload them to microstock sites like iStockPhoto, Fotolia or Dreamstime. Tag the images with keywords such as "Christmas," "Yuletide," "holiday" or "Thanksgiving" and at the very least, your images will be in the running for a sale.

TIPS
FOR SUCCESS

Merge Seasonal Images into Your Distribution Channels

Creating distribution channels takes time. Normally that isn't a huge problem. Your images will start to sell as your channels are being built and they'll continue selling once those channels are up and running. You can consider the time and effort spent talking to sellers as investment against future earnings.

Although taking your time setting up specific distribution channels for your seasonal goods, by the time they're running, the products could be out of date.

It's best then to consider seasonal images as one way to boost income that you're already earning rather than as a way to begin earning from your photography.

Do the Research

Straining your head to come up with ideas for Christmas and Thanksgiving image could be a little painful . . . so don't. A quick browse through Christmas editions of magazines and an even quicker search of stock sites should give you a valuable education in how other photographers have approached the annual challenges.

(continued on next page)

TIPS

FOR SUCCESS

(continued)

Be Original

But you don't have to copy those photographers. While producing generic images for the holidays will make usual buyers and resellers happy, you might find it easier to sell niched holiday themed images—such as tinsel-covered Harley Davidsons or pumpkin wallpapers—by marketing them to a small but carefully-chosen market.

Online stores like Zazzle and CafePress are also easy distribution systems but you will need to market them to bring in customers. That will involve partnerships with other websites and resellers, and it could include spending money on pay-per-click advertising too, so keep an eye on those expenses.

And if you have a distribution system already set up for cards, then making sure your range includes seasonal themes shouldn't be too difficult and should give your sales a boost at certain times of the year.

But you can also go a little further.

Photojojo, a newsletter stuffed with creative photo ideas, once came up with a neat plan to make photographic snow globes. Simply clean a bottle, place two photos back to back and waterproof them by covering them in sticky tape. Insert the pictures into the bottle and fill it with a 50/50 combination of corn syrup and water with glitter.

Will you get rich selling snow globes like these at Christmas?

Not even close. But you—or your kids—might be able to make enough extra money to pay for a proper gift.

GETTING STARTED

The best way to start selling seasonal photo products is probably to start selling non-seasonal photo products. You'll want to make sure that you know how to reach buyers so that when you enter the two- to three-month window for seasonal sales, your marketing system is already up and running. You can do that at www.zazzle.com and www.cafepress.com.

If this is going to be your first attempt selling images though, begin by looking at the sort of Christmas images that are used on cards, advertisements and in magazines, and produce some of your own. Photojojo's snow globes can be found by searching the archives at www.photojojo.com.

Build Your Own Commercial Website

DIFFICULTY

COMPETITION

INCOME POTENTIAL

What It's All About

When you're looking to sell images, few tools are as valuable—or as easy to create—as a website. You'll be able to make your photos available for sale in almost any way you please, offer them to buyers and take orders.

Just about every photographer these days has a website and they use them to market all sorts of photography services, from commissions and stock licenses to postcards and photographic products.

With the costs relatively low—and even free—it's a must-have tool for any photographer hoping to earn income from their images.

SUMMARY

Building a photography website can be as easy or as complex as you want to make it. There are plenty of templates available designed specifically for photographers. They allow photographers to add their images, create portfolios and may even allow them to take orders for prints.

Alternatively, it's also possible to build a website entirely from scratch and use a program like SlideShowPro to show off your photos, or to go even further and put together a completely unique site complete with whiz-bang graphic frills.

The result though should be a store front through which potential buyers can see your images, discover the kinds of photos you like to shoot, contact you regarding licensing and commissions, and place orders for prints.

Provided that is, you can present your images to them.

Because a website is such a basic tool for a photographer, the competition is fierce so you will need some very effective ways to bring users—and buyers—in to see your photos.

TIPS
FOR SUCCESS

Choose Your Images Carefully

While your stock portfolio can be large, the other images on your website should be representative. They should show your skills, not your photos. Show too many images on a website and you could scare potential buyers off.

Post Your Bio

A website should also contain a bio that explains how you approach photography. People looking at your website might not want to buy an image you've already created; they could want to commission you to produce something original such as an editorial shoot or their wedding photos. Your bio will help them to understand what to expect.

Understand Prices

You should include at least some prices on your website. (The prices for things like image licensing depend on use so you might want to negotiate that on a case-by-case basis). Spend some time then looking at other sites to see the correct market rate.

What You'll Need to Shoot for a Website

The best part of creating a website is that you need only shoot the images you want.

The whole idea of a website, after all, is to show what you can do so you won't need to shoot anything fresh. Just pull out the best images from your inventory.

But as far as the images are concerned, that's your first—and perhaps your biggest—challenge.

One of the most common mistakes that photographers make when creating their websites is to toss up as many images as they can so that the viewer can choose what they want to look at.

Usually though, the viewer has limited time so rather than plough through a large portfolio, he'll choose to look elsewhere.

While you can shoot whatever you want then, bear in mind that the website should act like a well-selected portfolio.

Choose images that show off your skills in particular areas—in lighting, for example, portraiture or landscapes—and be sure to include a section demonstrating your personal projects. These tell buyers thinking of commissioning you how you think and what your preferred style may be.

While a stock portfolio on a website can be reasonably large, sections on the site dedicated to prints or your portfolio should selective rather than comprehensive.

How to Produce and Market a Photography Website

If you want to place your images online, there's really no shortage of options. While you can use a photo-sharing site like Flickr or a portfolio site like PhotoShelter, these both require very special marketing to turn your online presence into sales and neither gives you your own URL.

An alternative option is to build your own site from scratch, or ask a designer to do it for you.

The advantage is that your site will be unique and, depending on your budget, you'll be able to throw in all sorts of fancy animation and graphics.

The disadvantage, of course, is the expense which could easily run into four—and for a really sophisticated site, even five—figures. And you probably won't need all those whiz-bang graphics either. A simple site with good images can often be more effective than a slow-loading site with effects that get in the way of the pictures.

Ⓟ PHOTOPRENEUR

You can build a site like this very simply and very cheaply too. Once you've registered a domain name using a service like GoDaddy, ifp3 will give you a Flash-based photography site from $20 per month plus a $45 set-up fee. The site includes a shopping cart linked to Paypal to make selling easier.

PhotoBiz does much the same for as little as $15 per month but limits the number of images you can upload.

Whichever method you use to create your website though, you'll still be faced with the difficulty of marketing it.

Search engine optimization will obviously be important and while you can pay for advertising using Google's AdWords system or other ad channels, bear in mind that the competition will be intense.

A better option then is to use your website as a commercial space where people who already know you can learn more and place orders. And people can get to know you through social media.

Once your site is set up, make sure your URL appears on your Flickr stream, your Facebook account and on any other social networking systems you use. Target potential buyers on those systems and you should be able to build a community which will visit your website to learn more.

It's a process that can take time but the conversion rate should be particularly high even if the overall numbers are low—and you'll have found a way around the masses of other photographers clamoring for attention.

GETTING STARTED

Begin by registering a domain name at www.godaddy.com or a similar service then decide whether you want to create your own site or use a template service. (Unless you're already handy with coding, a template service will get you up and running faster and you can always change it later).

With your site up, you'll then have to choose and add images, and start marketing!

You can find ifp3 at www.ifp3.com, PhotoShelter at www.photoshelter.com and SlideShowPro at www.slideshowpro.com.

Sell Your Services on Freelance Sites

DIFFICULTY

COMPETITION

🐎 🐎 🐎

INCOME POTENTIAL

$ $

TIPS

FOR SUCCESS

Bid Often

Using freelance sites can be a surprising business. You'll see jobs that you know you can do with your eyes closed, make a competitive bid . . . and see the work go to someone with no experience and apparently no skills either. On the other hand, you might make a bid on a job just because it's there and find that you've beaten out some massive competition to win the work.

That's why it pays to bid on everything—or rather everything you can reasonably do.

(continued on next page)

What It's All About

Unless they're on staff for some media outfit (and there are fewer and fewer of those) most photographers these days are freelancers. They pitch their services to people who need them and hope to win enough jobs to make up for the precarious nature of the work.

And they try to supplement that work with other more regular revenue streams such as licensing and product sales.

With so much of a photographer's income dependent on freelance work then, surely it would make sense to use one of the many online freelance services such as Elance or Guru.

These allow employers to advertise temporary jobs and invite providers, including photographers, to apply by bidding a price for the work and explaining why they would be the best person for the job. The winner then pays the site a small commission of the job's fee.

In practice though, while photography jobs are occasionally filled on these sites, few buyers turn to Elance to look for a photographer. When there are so many dedicated photography sites to look at, they don't need to bother.

That doesn't mean you can't make any money out of a site like this though. You certainly can.

You just have to box a little clever . . .

What You'll Need to Shoot for a Freelance Site

Freelance sites always have plenty of space for portfolios so it's important, as always, to make sure that you choose your images carefully.

For freelance sites though, make sure too that you include plenty of before and after images showing the post-production work that you've

22 Sell Your Services on Freelance Sites

SUMMARY

Photography jobs do turn up occasionally on freelance websites and even though they may be made up of requests for specific shots, it's probably not worth paying membership fees of even the minimum $9.95 per month in order to win them.

Even when a job does turn up, you can be sure that everyone on the site with photography skills will bid on them and that there will always be someone willing to bid a lowball price just to get the experience.

Freelance sites are known among providers for their competitive rates. Depending on the skill set, they can be good places to find clients, but they're rarely good places to find jobs.

But if photography jobs are relatively rare, jobs that require photography skills such as image editing do turn up relatively frequently. This might not be the sort of work you were thinking of doing as a photographer but if you're hoping to make a little extra cash out of your skills and you don't mind spending a little time in front of Photoshop, freelance sites can be one good way to generate some extra income.

done. Because these jobs turn up more frequently than the sorts of jobs that ask for images of the Hollywood sign, for example, or a picture of a beer glass for a book, they're likely to prove your most important sales tools.

And do make sure you include the "before" photo. Potential buyers will always be impressed by a big difference between two images.

How to Create and Market a Presence on a Freelance Site

Creating your profile on a freelance site is relatively easy. The two biggest sites are Elance and Guru but in truth, Elance probably generates more business than any of the others. In the same way that eBay dominates the online auction world, Elance's critical mass of providers gives it more clout than anyone else when it comes to bidding for freelance work.

Make sure that you complete your profile carefully. Answer all the questions as fully as you can and try to describe particularly challenging jobs that you've done and successes you've accomplished.

While the competition on freelance sites is usually pretty intense, the standard of the self-marketing tends to be pretty low. Invest some time

TIPS
FOR SUCCESS
(continued)

Don't Cut and Paste Your Bids

But that doesn't mean you should use the same pitch on every job. Cut-and-paste bids just show you're not really interested in the work and are an easy way to put yourself out of the running. Read the job description carefully and make sure that your pitch shows that you can meet the challenges the job describes. And make sure your examples are relevant too.

Read Other Bids if You Can

Some bids are sealed, which means only the employer can read them, but do take the time to browse open bids, especially those made by top providers. They'll provide you with great examples of what a winning pitch looks like and they'll also show you how much you can reasonably demand. If you already have experience selling photography or editing services, you might well find that those rates are lower than you expected.

Turn New Clients into Steady Clients

Because anyone can join a freelance site and bid for

(continued on next page)

work, the competition is stiff and the prices are often about as low as you can imagine. In fact, you can be reasonably sure that each job will include several bidders saying that they're new to the site and that they'll do the job for a song just to pick up the feedback.

That means that if you want to earn the right rate for your work, don't lowball your bids. You might have to wait a while to win your first job but it will be worth it and you'll know you're doing it at a fair price. And try to turn those clients into regular off-site clients too.

That should happen anyway. Clients should come back to you next time they need a job but if you do see them advertising another job on the site, bid again and make it clear that you're available for regular work. You'll save on the site's commissions and you'll fill your schedule book until you no longer need to use the site at all.

and effort into selling yourself through your profile and you will start to stand out.

Unfortunately, when you're starting out, you will be at a major disadvantage.

Freelance sites tend to use feedback systems that encourage previous clients to leave reviews for other users to read. Until you've landed your first jobs, you won't have those reviews so you'll be dependent on finding someone willing to take a little risk.

The temptation here is to lower the price to build experience but that's a mistake. It just shows your lack of experience. It's a much better idea to keep your bid competitive, include any testimonials you might have from previous clients in your profile and wait for those first jobs to come in.

GETTING STARTED

Freelance sites cost money to join so spend a little time surfing www.elance.com and www.guru.com to get a feel for how the sites work and how frequently jobs turn up. Assume that you can win maybe one job in seven, calculate how much that would bring you each month and decide whether that income is worth the membership fee and the time spent bidding.

Blog About Your Pictures . . . And Get Paid for Them

DIFFICULTY

COMPETITION

INCOME POTENTIAL

What It's All About

The usual way to make money out of photography is to find someone willing to pay you to shoot for them or who wants to buy your images. Sometimes though, you can get paid just for talking about photography.

For top photographers, that's always meant teaching their skills in a college or even as after-dinner speakers. These days though, anyone can launch a blog, talk about photography, and provided that what they have to say is interesting enough, get paid for it too.

Clearly, that doesn't mean your readers will pay you. Everyone expects content on the Internet to be free these days and even the mainstream media has given up on charging for online subscriptions.

SUMMARY

In theory, blogging about photography can generate very handsome revenues. Darren Rowse, a well-known professional blogger, makes six figures with a blog that discusses camera reviews and offers photography tips.

It can happen, but it won't happen overnight and it does take some specialized knowledge.

You'll need to know how to write interesting articles about photography—or at least know people who can and are willing to contribute. You'll need to know how to generate traffic and you'll need to know about all the different advertising systems.

If you can get all of those things together, you might well find yourself publishing a very popular blog about photography and earning a pretty packet in advertising revenue too.

TIPS
FOR SUCCESS

Optimize Your Ads

One of the biggest reasons that bloggers fail to maximize their earnings is that they don't optimize their ads. Blend them into the page so that they look like content and your clickthroughs should rise.

Bring in Other Writers

Content is everything on blogs, so once your blog is up and running, look for help. As long as you're paying less than the page earns, you're making money for less effort.

But good content, plenty of readers and clever advertising programs can bring in a steady income for doing little more than writing regular articles about photography.

What You'll Need to Shoot to Earn with a Photography Blog

It might be a surprise to find that you don't actually need to shoot anything to produce a successful photography blog. Darren Rowse rarely shows his own images on his blogs. He simply discusses interesting topics about photography that other people want to read. There are three topics that are always easy to blog about:

Your Photography Experience

You don't to be a pro to have interesting stories to tell about photography. If you just shoot once a week, you can still write a blog that talks about the projects you're working on, the spots you like to shoot, your equipment and anything else that takes your fancy.

Just try to keep it interesting and universal. Lots of photographers' blogs are filled with accounts of the latest wedding they shot. A potential client might read one or two to get a feel for the photographer but those sorts of posts aren't going to win a regular audience.

They might though if they're also filled with interesting stories about the things that happened at the weddings, or on the way to the event or the shoot or whatever you happened to be photographing.

If the story is interesting, it doesn't need to have too much photography content to bring in readers.

Photography Tips

David Hobby is a professional photographer who is probably better known for his blog Strobist than for his images. His site is jam-packed with valuable advice about lighting shots, and thousands of photographers follow his suggestions.

This is always going to be easier for professionals to do than for amateurs, but you can still offer tips about photographing a particular niche.

Few photographers, for example, know anything about photographing surfers or skateboards or speed chess champions. If that's what you like to shoot, then you too have valuable tips that you can share and earn from.

Articles About Photography

And finally, you can also write general articles about whatever is happening in the photography world at the moment. You'll face some stiff competition doing this—there's no shortage of other sites that offer photography news— but if you can carve a place out for yourself by discussing a particular type of photography news, you might just be able to build a following.

How to Create and Market a Photography Blog

Creating a blog is very simple. Free sites like Blogger and WordPress.com mean that you can be up and running with your first post in minutes—be ad-ready within a day or two.

Once you've got the hang of writing posts, you can then start thinking about buying a domain of your own and moving to your own unique site with a commercial blogging platform like Movable Type or Wordpress.org. A successful, profitable blog though will always depend on three things:

Good Content

It's an old cliché that content is king on the Internet, but that doesn't make it less true. Write garbage and no one will want to read it; produce interesting posts and word will spread, bringing you a large and growing audience.

Monetization Systems

You can't charge your readers for reading your content but what you can do is create various advertising and sales systems.

Ideally, your advertising set-up should have three revenue streams: a pay-per-click (PPC) system such as Google's AdSense that pays a certain amount whenever someone clicks an ad; a cost-per-mille (CPM) system such as banner ads that pay for every thousand impressions the ad receives; and affiliate advertising such as Amazon's Associate program that gives

you a share of a sale. Placing one of each system on each blog page will increase the chances that you'll earn from that page.

Traffic

Traffic generation is always the hardest part of creating a blog. You'll have to market your posts constantly. While it's possible to buy traffic using Google's AdWords system, if you're looking to earn from ads, you'll need to make sure that you're always paying less for your ads than the income you're receiving from your advertisers.

A better option is to network. Swap links with other photography blogs, contribute to the comments in their posts, be active on Flickr and social marketing sites and do whatever you can to build a community around your articles. There are no shortcuts and traffic generation does take time. But you can still earn—and enjoy yourself—in the meantime.

GETTING STARTED

Start by signing up at www.blogger.com, www.wordpress.com or www.movabletype.com. It's free and it will give you a feel for writing posts—even if no one is reading them yet! Later, you can expand to more commercial pages, show what you've written and start earning. www.strobist.com and www.digital-photography-school.com are both good examples to follow.

BritePic
Your Pictures

DIFFICULTY

COMPETITION

INCOME POTENTIAL

$ $

What It's All About

Google and its AdSense system has made it possible for anyone to make money out of the words they place online. AdSense "reads" the words on the page, looks for ads in its giant inventory that match that content and places them on the page.

Because the ads are relevant—and because the publisher was smart enough to blend the ads into the page so that they look like content—readers click through, generating income.

But photographers deal with images, not words. Google might be smart, but it's not smart enough to look at a photograph, recognize what it's about and serve up relevant ads on a similar topic.

BritePic can do that.

BritePic is a service that adds interactivity to images. Users seeing an image can choose to zoom in, read captions and comments as well as email, link and print the photo too.

More importantly, an ad also appears above the image, giving the photographer a way to earn revenue.

What You'll Need to Shoot to Earn with BritePic

You won't need to shoot any particularly special images to earn with BritePic. Take the photos you usually create, place them on your website then tell BritePic where they are.

BritePic will then give you a new URL for the image which lays an ad over the photo together with all of the other fun functions.

In theory then, just keep shooting the same stuff that always entertains your users and you should find that you've simply added a new way of making money to your Web pages.

TIPS

FOR SUCCESS

Calculate the Costs

BritePic might be a free service for publishers and photographers but it does exact a price. Your images will come with a little menu button in the corner and they will come with an ad at the top of the photo.

That obtrusiveness may bother your users. You might find that as a result of using BritePic, your traffic levels fall and it ends up costing you money.

Alternatively, you might also find that the extra ads, placed right on your images where your users are most likely to look gives you hundreds or even thousands of extra dollars a month. The only way to know for sure is to try it . . . and track the figures.

Share the Images

And encourage people to take your photos too. You wouldn't want to use your very best images for this but if you're making money with BritePic, tell other bloggers that your images are available and make money from their users too!

SUMMARY

BritePic solves one problem that photographers have when trying to earn from their websites: their sites are image-heavy while ad systems prefer text.

It allows photographers to earn directly from their photos rather than indirectly from what they have to say about their photos, and it adds a number of useful new functions to the image itself, making it more attractive and more likely to be looked at and played with.

That's the good news. The bad news is that some publishers have reported that pages with BritePic images load slower than other pages and that because of the way the images are retrieved, traffic may be reduced.

It's not entirely clear that the potential extra income from the ads would always make up for those losses but it is worth testing to find out whether it pays for your site.

Part of building a profitable website involves experimenting with different revenue models and methods of earning income.

BritePic, which is part of online ad firm AdBrite, is yet another way that photographers can turn their images into cash online.

But it's not quite that simple.

If you want to make the most money you can out of your images, it pays to keep track of the amounts you're earning so that you can target particular keywords.

You might find, for example, that taking pictures of cars gives you higher-paying BritePic ads than taking pictures of landscapes. You'll have to use the stats to compare the revenues earned from each set of keywords, and you'll have to compare those figures too with the amounts you earn overall for the Web page.

It's not straightforward but it's not too complicated either and once you've found high-paying subjects that you want to photograph, you should be able to relax, enjoy yourself and make some money.

How to Create and Market BritePic Images

To create images overlaid with AdBrite's images, click the registration link at www.britepic.com. You'll be taken to AdBrite's website where you'll be

asked for all sorts of basic information such as your name and an address for them to send your checks.

You'll also be able to start creating ad-rich images.

Tell AdBrite where the image is hosted (the address will look something like this: http://www.yoursite.com/image.jpg) then add keywords to help AdBrite choose the right ads for the image.

To place the image on the page, you'll then need to paste a few lines of HTML where you'd like the photo to appear.

And that's it.

Market your website in the usual way and if someone clicks on the ad, you'll receive a share of the ad revenue. Just be sure to track your advertising statistics to make sure that the slower loading and image overlays aren't reducing your overall income.

There is something else that you can try though.

One of the features that PicBrite offers is the option for users to embed your image into their own websites.

That's usually a very bad idea. It means that someone is using your image for free.

But if the image contains an ad, then sharing that image can help you to win more views, more clicks and, hopefully, more money too.

You could then use BritePic to offer a gallery of ad-supported images to publishers looking for free photos. You'll have to niche your images very carefully to compete with the huge numbers of free, Creative Commons-licensed images on the Web but with careful targeting, you might find that you're making money by sharing your photos.

GETTING STARTED

Start by signing up at BritePic at www.britepic.com and placing ads on the images on a selection of your pages. Track the stats for a week and compare them to your ad earnings the previous week to see whether BritePic works for you.

Earn with Flickr

What It's All About

With more than three billion images, Flickr is probably now the main repository for photos on the Web. Photographers use the streams to show their works to each other, the groups to swap ideas and learn how to improve their skills, and the site's networking to make new friends and build contacts.

But while the site, which is now owned by Yahoo!, states specifically that it is not commercial, it's also used by buyers and photo editors looking for unique images for their books, magazines, websites and for advertising.

Some of the deals made between commercial users and amateur Flickr contributors include a billboard commission for Toyota, photos used on book covers, images used in Microsoft's Vista and plenty of commissions for magazines.

Clearly, the competition is going to be intense. But because few photographers on Flickr really understand how to market themselves, a little bit of care can go a very long way towards standing out on the site and putting your images in front of buyers.

What You'll Need to Shoot to Earn with Flickr

As always, you'll need to shoot good quality images, of course, but here again, it really helps to shoot unique images.

There are—literally—tens of millions of photographs of cats, dogs and other animals on Flickr. A quick look at Flickr's tag cloud will show you the most popular topics on the site, and therefore the subjects to avoid if you want your photographs to stand out.

As is so often the case, you'll do much better by focusing on a specialization and keywording those images carefully.

SUMMARY

Flickr is one of the few sites that can be said to have changed the way commercial photography works. The huge number of images on the site make it rich pickings for photo users looking for the kind of photos that they won't see offered by stock companies.

Those buyers don't care that the photographer they're dealing with is not a professional—in fact, when it comes to the negotiations, that might even be an advantage—what they really want to know is whether the picture is good enough to do the job.

But Flickr doesn't make it easy for users to track down contributors. The search function isn't very detailed, too many photographers upload every image they own to the site so that the best shots get buried and few make proper use of sets and collections.

If you can organize your images properly and network to make sure that people know where to find them, landing sales should just be a matter of time.

It doesn't have to be the only subject you shoot for Flickr—you can have different sets or collections for different topics—but you do want to make it as easy as possible for a photo buyer looking for images of butterflies, for example, or interior design to find you and your portfolio.

How to Create and Market Your Flickr Images

Flickr is free to join and sign up takes just minutes. It is however, worth paying the $24.95 annual fee for Pro membership.

This doesn't just give you additional storage space and better organization features—worth paying for alone—it also gives you stats, and they can be very valuable indeed.

Your Flickr stats will tell you which images have generated the most views and the most comments. Most importantly, they will also tell how people reached those images and what keywords they used to find them.

That's the sort of information that can help you to target your photo stream to pick up more viewers.

Keywording based on information gleaned from the stats isn't the only way to market your Flickr stream though. There are a number of other strategies that are at least as important.

(continued on next page)

TIPS
FOR SUCCESS
(continued)

Make the Comments Worth Reading

Commenting is an important part of networking but comments that say little more than "great capture" are worth nothing. Explain why the image is good, point to similar images the photographer might like to see and offer tips that could help her make it even better. Make your comments worth reading and you'll make your images worth looking at.

Network Constantly

Networking is a vital element in Flickr marketing. The more people that know you're on the site, the greater the number of views, faves and comments you'll receive and the larger your contact list will become.

Networking can be carried out by being active in groups but it's also done by leaving comments at the bottom of other photographers' photos. When you leave an interesting comment, the photographer is likely to leave you one in return.

Aim for the Explore Page

Each day, Flickr highlights the most popular images on the site. Appearing on the Explore page sends views through the roof but the choice of image is made automatically, based on an algorithm that considers a combination of views, faves and comments. It also takes into account the number of groups that an image has been submitted to, penalizing images entered into more than fifteen to twenty groups.

Market Offline Too

Keywording, networking and promoting particular images to build views and hit the Explore page all target users already on Flickr. But it's also important to bring in users from outside the site.

Even something as simple as including your Flickr URL on your Moo cards and email signatures can help to increase views—and the chances of making a sale.

GETTING STARTED

Starting with Flickr is easy. Just sign up at www.flickr.com. It's stopping that's hard. Sign up at the site, create sets and collections and begin uploading your images and networking with other photographers.

You can then start playing. Try geotagging to help people looking for images of locations find your photos, and place Creative Commons licenses on some of your lower-quality images. That will attract people looking for free photos. You can then offer them better versions for a fee.

Shoot for Social Networking Sites

DIFFICULTY

COMPETITION

INCOME POTENTIAL

$ $

What It's All About

Just about everyone has one these days. Whether you're a Facebook fan, a MySpace aficionado, a twitterer or a LinkedIn networker, you can't go too far without setting up an online networking profile.

And that means adding a picture.

Yes, the details about your education, work experience and everything you've been doing since day care are all important. But the first thing anyone ever looks at on a social networking site is the picture.

When you're just using the site to keep in touch with friends, the image doesn't matter too much. It's possible just to toss up anything on the hard drive that shows your face and doesn't make you look old.

But people who are using social networking for professional purposes—to market themselves or their products, network with other people in their industry or scout around for a job—need photos that are a little more serious.

They need pictures taken by someone with an understanding of portraiture and who knows how to create head shots that show them at their best. That's an opportunity for professionals and amateurs alike.

What You'll Need to Shoot to Earn with Social Networking Sites

Shooting for social networking sites doesn't leave a huge amount of room for creativity. You'll be shooting headshots. The faces have to be clear, the expressions welcoming and the overall impression relaxed and friendly.

That's not as easy as it sounds, of course. Usually, you'll be photographing people who aren't used to sitting in front of the lens, so you'll have to be able to put them at ease and create portraits that look professional . . . and

SUMMARY

Shooting for social networking has a huge potential demand. Facebook alone is said to have more than 120 million active members.

Only a tiny fraction of those members will feel that they need images better than those they already own but with numbers this big, even a small fraction limited to your local area can still give you a stream of fairly simple work.

The key will be to find people who might need your images—and persuade them that the value of showing a professional face on sites like LinkedIn and Facebook is worth more than the cost of the photography.

Just don't expect the stream of clients to be too free-flowing. These are likely to be occasional, fun jobs rather than the backbone of a photography business.

TIPS
FOR SUCCESS

Work the Clients' Network

Every time you complete a job, ask your clients to put in a word for you on their own network. As long as you're shooting good photos, your name should spread quickly, giving a quick burst of additional clients with each new upload.

Don't Depend on It

While the overall potential market for profile image is huge, as soon as you narrow it down to business users and locals, the numbers start to get significantly smaller. If you're in reasonably a large town, you should find there's work but it's going to be occasional not regular. Enjoy it when it comes in . . .

Upsell

. . . and make the most of it when it does. These are small jobs. They're unlikely to pay more than $100 although the entire work, including any travel and post-production is unlikely to take longer than 90 minutes.

But treat these jobs as introductions to better-paying work. Offer albums, business photos, advertising shots and even family portraits. Use this one small job as a step towards larger ones.

which still work when shrunk to fit a profile thumbnail. Cheesy glamour shots aren't really going to cut it.

How to Create and Market Social Networking Photography

The technical side to creating images for social networking is not very demanding. While access to a studio might make things easier, there's nothing wrong with shooting outside as long as the background isn't too busy. The shoots themselves wouldn't need to last more than about half an hour, the post-production shouldn't require much more than some light touching up and the photos can then be emailed to the client so you don't even have to worry about printing. (Although for an additional fee, you could also offer to upload the images yourself.)

The big challenge is going to be finding the clients. These are the two biggest options:

Network on Social Networking Sites

Meet someone on a social networking site and you'll know that they're the kind of person who understands the value of having an online presence.

That doesn't necessarily mean though that they'll appreciate the value of a good profile picture.

To find those people, you'll need to narrow down the search a bit. You'll need to look for people in your area and who are using the site primarily for business networking. That means focusing on LinkedIn, which is more for job-hunting than staying in touch with old friends, and Facebook groups such as alumni organizations and professional networks.

You can try placing an ad in a group promoting your services but in practice what you should find is that your work sells itself—especially if you ask your clients to lend a hand.

Photograph some friends with long contact lists for free and ask them to add a message on their wall or in their profile saying that you created the photo. That should spread your name along their networks.

BetterBusinessShots

BetterBusinessShots is an offshoot of LookBetterOnline which specializes in shooting profiles for social networking.

The company doesn't guarantee jobs but photographers are invited to submit an application. They'll then review your portraits but bear in mind that they do turn down about half of all photographers they consider. Your portfolio has to be good. If accepted, they'll send work your way as it comes in.

Packages begin at around $99 for a client but photographers only see a percentage of that so they recommend using these referrals as the basis for upselling. When someone comes to you for a profile photo, offer them family portraits, larger resolution images and more poses.

At the very least, BetterBusinessShots can give you ideas about pricing and packages.

GETTING STARTED

Begin by photographing some friends for free. Use those as sample images that show what you can do and ask them in return to recommend you on their social networking sites.

Make sure you choose people with very large contact lists! That kind of viral marketing could be exactly what you need to get this little venture moving.

But you can also contact LookBetterOnline at www.lookbetteronline.com and its sister sites at www.betterbusinessshots.com and www.bettertweetshots.com.

27 Put Your Pictures on Microstock Sites

DIFFICULTY

COMPETITION

INCOME POTENTIAL

What It's All About

One of the biggest changes to hit the photography world in the last few years has been the rise of microstock. While traditional stock companies have always been very selective in the photographers they accepted, microstock is open to anyone with sellable images.

The result has been a huge rise in supply . . . and a massive drop in prices.

Stock companies might demand hundreds and even thousands of dollars for an image depending on how the buyer plans to use it. Microstock companies charge as little as a dollar with the price rising with the image's size rather than its use.

For just a buck, it's possible to buy the right to use a photo hundreds of times.

Microstock makes up for those low prices though with large numbers of sales. Popular images can sell hundreds and occasionally thousands of licenses, generating a regular stream of income for the photographer. Top contributors working full-time are known to generate over $200,000 a year, although most photographers will see much less.

Microstock companies do screen images, rejecting as many as half of those submitted but their sites still represent one of the easiest opportunities for anyone with images that could sell.

What You'll Need to Shoot to Earn with Microstock Sites

In theory, just about any picture should be able to sell as a stock image. Provided the photograph meets the site's technical requirements—usually, that it has little or no 'noise,' and is at least two megapixels in size—it's likely to be accepted. But that doesn't mean it's likely to sell.

SUMMARY

Microstock's open submissions make it invaluable for photographers looking for their first sale. But while microstock sites will accept just about any image that the selectors believe could find a buyer, actually making sales—and making enough of them to justify the effort—requires a combination of the right images and the right marketing strategies.

It also requires constant work. Many microstock sites weigh their search results to favor new and popular images. If an image doesn't sell quickly, there's a good chance that it won't sell at all and will need to be replaced.

Microstock then does represent an opportunity, but it's not one that's effort-free.

Buyers often say that they'd really like to see natural, unposed images shot with regular-looking models. In practice though, given a choice, they tend to go for the sorts of slightly cheesy, posed shots that they find safe and comfortable.

Buyers also tend to go for "business" images. Microstock companies consistently report that people in suits and in office environments enjoy the highest demand so making sure that your submissions include plenty of those will increase your chances of making sales.

Another type of image that can sell well is photographic elements. Photos that show a series of dogs, for example, can be cut and used by designers in different ways, giving them more flexibility for their money.

The best way to learn what to shoot is to take a quick browse through the most popular images on any microstock site. That should reveal the difference between the sort of posed and planned compositions that actually sell and the sort of snaps and artistic shots that many photographers have on their hard drives.

How to Create and Market Microstock Images

Before you start shooting microstock images, it's important to understand the legal requirements of selling photos.

Any image that contains a recognizable person will require a model release.

TIPS
FOR SUCCESS

Diversify Your Channels

Although iStock is the granddaddy of microstock companies, and is now part of Getty, the granddaddy of traditional stock, it has plenty of rivals, including Dreamstime, Fotolia and Shutterstock. Many of those rivals offer exactly the same images from exactly the same photographers.

To differentiate themselves, companies offer higher rates and stronger promotions for photographers who agree to offer their images on an exclusive basis. While that would save time uploading, most photographers find that it pays more overall to spread their images among different sites where they can reach a larger market.

Plan Your Shots

Top photographers put a great deal of time and effort into researching and planning their shots. Yuri Arcurs, for example, perhaps the most successful microstock photographer, employs a team of twelve to help him put together complex shoots. You don't have to do that, especially at the beginning, but it does pay to do more than shoot randomly and hope that your images will sell.

(continued on next page)

TIPS

TIPS

FOR SUCCESS

(continued)

Look at the images that are selling on microstock sites and pay attention to the kinds of photos found in magazines and advertisements. There's a reason that many of the top microstock photographers started as graphic designers; they understand what buyers need.

Read Your Stats

The most important figure in microstock is always going to be the number at the bottom of your monthly check, but other figures are important too.

Pay attention to the percentage of photos in each collection that sells, the subjects of the images that sell the most as well as the number of views you receive for each sale. You'll want to try to raise those figures each month, even as you're increasing the size of your portfolio.

Many stock sites supply these for free—they're just small contracts in which the models states that they allow you to sell their image—but you will need them for photos that contain people. And they tend to be the photos that sell the most.

That means you'll also need to find models, a constant headache for many microstock photographers.

The easiest option is to turn to friends and family. They're always available, unlikely to refuse and won't charge. Other options though include offering free headshots to drama students and actors, and even families, in return for shoots.

You won't need to do any marketing of your microstock portfolio. The sites battle among themselves to bring in buyers and often promote subscription packages that keep those buyers locked in.

Top photographers though find that their customers tend to come straight back to them for images they can trust rather than browse through page after page of photos, so personal branding with a blog or a website can be helpful.

You can also place samples on your Flickr stream with a link back to your microstock inventory.

GETTING STARTED

Starting with microstock is fast and easy. Begin by browsing the most popular images at www.istock.com and www.dreamstime.com to see what kind of photos sell, then join and submit any images you have that you think could be commercial. It can take a little time for your photos to be approved so in the meantime, plan more compositions and get shooting. Keep your inventory growing, focus on shooting more of the type of images that sell and your income should grow too. You can also take a look at Yuri Arcurs' images at www.arcus.com.

Sell Photos and Win Commissions with PhotoShelter

DIFFICULTY

COMPETITION

INCOME POTENTIAL

$ $ $ $

What It's All About

Create your own website and you'll have the option of using your own domain, customizing it to suit your images and producing an entirely unique storefront for your photos.

But while showing images on a website is relatively easy, constructing systems that sell them—let alone sell and license them automatically—requires some sophisticated and expensive programming.

What many photographers end up with then is usually an electronic version of their print portfolio. Buyers and clients can look through their images and if they want to buy, use the contact page to make an offer or discuss an assignment.

It's a fairly clumsy way to work and for photographers who are often away shooting images, not constantly at their computer, or have day jobs that don't allow them to respond right away, a slow way to work too.

PhotoShelter aims to make the process both easier and more automated.

The service enables photographers to show off their portfolio but also provides a system that lets them license their photos at commercial prices. Buyers complete a form that asks how they intend to use the image and receive a price from fotoQuote, the industry standard software for the stock industry. They can then purchase a license to use the image without bothering the photographer.

Or alternatively, they can contact the photographer directly to renegotiate or discuss an assignment.

The system costs from nothing to $49.99 a month and can be a very powerful business tool for photographers.

TIPS
FOR SUCCESS

Shoot Well . . . Really Well

Probably the most important piece of advice for achieving success on PhotoShelter is to shoot excellent photos. Other photographers will so anything substandard is really going to stand out.

Upload your very best images, organize them into subjects for easy browsing, and describe and keyword them well, and you'll have your foot in the professional marketplace.

Charge the Full Price

And that means charging the full price for your images. Although PhotoShelter uses fotoQuote to produce the market rate for images, photographers are also free to set their own prices and to negotiate directly with buyers.

When you're not dependent on the income to pay the mortgage, there can be a temptation to lower the price just to win sales. But buyers on PhotoShelter expect to pay the full price and asking for anything less just flags you as unprofessional. Keep the lowballing for microstock; use PhotoShelter to sell your very best images at the full market rate.

SUMMARY

PhotoShelter is the independent photographer's alternative to microstock. Instead of receiving less than a dollar a license, you can receive the full market rate for your photos. But it's really aimed at professional photographers more than talented amateurs. The competition is going to be pretty intense—your pictures will be competing against those from award-winning professionals who travel the world on assignment—so they'll have to be professional quality to stand a chance of selling to a stock buyer.

And you'll also have to do your own marketing.

While microstock companies put a great deal of effort into bringing buyers to the site, if not to the inventories of individual photographers, PhotoShelter depends on photographers to bring their own customers. Often that means using the site as a way of licensing images automatically to regular buyers.

Photographers without regular buyers will need to find some.

What You'll Need to Shoot to Earn with PhotoShelter

Usually, to sell images you have to be sure they're good. To sell on PhotoShelter though, they have to be outstanding.

Although PhotoShelter is open to everyone and serves wedding photographers looking for clients as well as photojournalists looking for international assignments, it's really aimed at professionals with an impressive track record.

Buyers expect to see top-end images, and the prices reflect that quality.

If you do have images that good though, then you'll always be in with a chance of making a sale. Be sure you keyword them properly and include a detailed description of what the viewer is looking at. That information can help to land the sale, especially when the image is rare.

How to Create and Market PhotoShelter Images

PhotoShelter offers four different membership plans, ranging from a free trial membership that provides 150 megabytes of storage space and 30 percent sales transaction fee to a Pro membership that costs $49.99, allows

100 gigabytes of storage, a 10 percent transaction fee and listing in the photographer directory.

The best choice, especially for non-professionals, will be to begin with the free membership to get a feel for the site and what it can do then move up once you can see that it really can deliver sales.

That will only happen though if you market your portfolio.

Many photographers on the site simply tell their buyers, editors and clients where they can find their images on PhotoShelter. Those buyers are then free to check in and purchase whenever they want.

They also use their traditional website as a kind of sales channel. The site displays their best work and explains the sorts of images they shoot. It then directs buyers to the PhotoShelter collection where they can make purchases. That approach allows them to have both their own domain and still enjoy automated sales.

Photographers just starting out or amateurs with more enthusiasm than regular clients will always struggle a little on PhotoShelter.

Careful keywording will help to draw in buyers doing searches.

Blogging about your images, especially if they're carefully niched, will help to build a following that could include buyers willing to click a link to your PhotoShelter collection and make a purchase.

And networking on Flickr, then directing buyers from that site to PhotoShelter where they can make automated sales, might land a few deals, but Flickr buyers are often looking for bargains rather than full prices so those sales are unlikely to be more than occasional.

GETTING STARTED

Begin by signing up for free membership at www.photoshelter.com. Upload your best images and play with the various options the site provides. Once your collection is ready, tell any clients you have and link to it from your blog or website. Leave comments in other blog posts that discuss the subject of your images and include the link to your collection.

Once you've made your first sale, you'll understand how rewarding it can be to license an image at the full rate . . . and you'll be ready to move up to Standard or Pro membership. You can also take a look at the quote software at www.fotoquote.com.

It's Not Just the Sizzle that Sells on Zazzle

DIFFICULTY

COMPETITION

🐎 🐎 🐎 🐎

INCOME POTENTIAL

$ $

What It's All About

The Internet now contains a number of stores that allow photographers to turn their images into products. Each has its own specialties and its own unique characteristics.

Zazzle offers a huge range of different items on which it's possible to place images. We've already seen that those possibilities include mouse-pads, calendars and cards but the range of items stretches to include shoes, stamps, and even the bottom of skateboards. Contributors range from photographers and designers all the way to brands as big as Disney, Star Wars and other large firms.

Anyone can join and create their own store on the site by uploading their designs and choosing the products on which they want those images to appear. Contributors can then charge a price of their choice that takes into account the cost of production, leaving them with the difference as profit.

Zazzle then handles all of the logistics, collects the orders, creates the product and arranges the shipping, leaving the artist to do little more than shoot the images, handle the post-production and do the marketing.

What You'll Need to Shoot to Earn with Zazzle

According to Josh Elman, Zazzle's Head of Marketing, the highest-selling photography subjects on Zazzle include nature, travel and landscapes. Flower photographs in particular can do well.

But on Zazzle, it's not so much the images that are important as what you do with them.

While it's always crucial to shoot great pictures, Zazzle's products are really about design. Calendars and prints aside, the images are usually

SUMMARY

Zazzle offers a huge amount of flexibility for photographers with a creative bent. The range of products available makes it possible to target all sorts of different markets while the presence of branded goods also means that the site has its own flow of traffic.

Many contributors however struggle to generate sales on Zazzle. In part, that's because the site's open access means that not every Zazzle store contains attractive items. But it's also because Zazzle does depend on the contributors to do their own marketing.

Stand out with unique designs, create a community of niched potential buyers and market your store well though, and there's no reason why you couldn't be one of Zazzle's success stories.

TIPS
FOR SUCCESS

Lose the Borders

One of the most common mistakes that photographers make when they turn their images into designs is simply to paste them onto t-shirts and mugs without changing them.

Usually, a better option is to take away the borders and even remove the background so that all that's left is the subject of the image. It's easy to do in Photoshop and result will be a much more dramatic design.

Use the Profile

Zazzle doesn't supply too many marketing tools but your profile page is one of them. Personalize your products, talk about what you create and why you create it, and you'll go some way towards building a brand.

Price Competitively

Pricing is always going to be one of the biggest challenges of selling on Zazzle. With plenty of competition on the site, another design just a click away and a much cheaper t-shirt available at the mall, the temptation is to lower the price to stay competitive.

(continued on next page)

going to appear on items such as t-shirts and mugs rather than placed on the wall and admired. They often need to have an effect that goes beyond the beauty of the photograph itself and appeals to a particular group of buyers.

Rather than produce a wide range of designs based on images that you find attractive, aim to create a specialist store with a unique design line that will attract a particular group of buyers. You might limit the breadth of your market but the marketing will be much easier and the people who visit your store will be more likely to buy . . . and return to buy again.

How to Create and Market Zazzle Images

Zazzle places no restrictions on contributors. Anyone can join, pick from 250 different products, place their design and create a gallery that enables anyone to browse, shop and buy.

The whole process takes minutes and can be a lot of fun. Within a very short time, you can have an entire store filled with products ready to sell.

And there's a danger. While it's fun to play around with Zazzle's store, the huge number of products available—and the low quality of many of them—mean that it pays to think ahead. Once you're used to the site, decide which products you want to sell. (With basic t-shirts starting at $15.95 before your own profit margin, price will be an issue.) Next, spend time creating a line of unique designs that will fit those products.

TIPS

FOR SUCCESS

(continued)

But you're never going to be able to pitch lower than Walmart if only because Zazzle charges more for the blank product alone. A better option is to spend some time looking at what other producers are charging for similar items, and charge a price that's at least in the same range. When your designs are rare, they'll be seen to have exceptional value and you'll even be able to charge more.

Market like the Blazes

Success on Zazzle depends on good marketing. The site focuses its own marketing on bringing in producers but leaves it to the producers to bring in the buyers. Just creating good products and a well-designed gallery won't be enough to win sales. You have to tell people you're there too.

When you start marketing your store, you want to be ready with a full inventory of attractive, professional quality goods.

The marketing won't be easy. One option is to build a website around the subject of your images and drive traffic to your Zazzle store. So if you have created a line of products decorated with your images of surfers, you could create a website about surfing, show pictures of your products on your site and link to your Zazzle store so that users can buy them.

Marketing a website is much easier than marketing a Zazzle store.

Alternatively, you can strike deals with other bloggers and website owners. Ask them to advertise and recommend your products on their pages and give them a share of your profits.

Above all, try to turn your buyers into a community by keeping them informed of new releases, talking about how you created the photos and the designs and explain what they mean.

If customers feel that they're members of an exclusive club and that what they're buying is part of a story as well as an attractive product, they'll be more likely to keep buying.

GETTING STARTED

Begin by signing up at www.zazzle.com as a producer and play around with creating products. Until you start marketing no one will see them and you can always remove them later.

Once you've got a feel for the site, spend some time browsing other stores to see the designs on offer and the prices they're charging.

Finally, choose your product range, create your designs, build your store . . . and market!

et Crafty on Etsy

DIFFICULTY

COMPETITION

INCOME POTENTIAL

$ $

What It's All About

Zazzle is all about the design. They supply the products; the producers supply the decoration that makes the product worth buying.

Etsy specializes in craft. All of the products listed in its stores must be handmade. The site itself supplies nothing then other than a place to sell those goods online.

Most of the items displayed on Etsy then have little to do with photography. They're more likely to be handmade jewelry or knitted goods than coffee mugs with neat prints.

But Etsy does have a category for art and that category has a sub-category for photography. While shoppers might be looking for unique handmade products, it is possible to sell prints and other types of photographic art on Etsy.

The site differs from other product firms in another important way. While joining the site is free, because Etsy doesn't make any profits on production and printing in the way that Zazzle does, it charges a listing fee of 20 cents for every item placed on the site—whether it sells or not—and an additional 3.5 percent commission for every sale.

The listing fee does emphasize the uniqueness of each item but it also means that selling large numbers of photos could involve a certain amount of risk.

What You'll Need to Shoot to Earn with Etsy

Photography on Etsy is subdivided into a number of categories that include abstract, cyanotype, digital and lomography, as well as nature, pop and portrait.

SUMMARY

Because Etsy isn't really geared towards photography, you'll have to work particularly hard to bring in buyers. But it is possible. Photographers are creating galleries of prints on the site and marketing them to customers keen on buying unique items that are linked to an artist.

The advantage of using Etsy is that it's really the aesthetic that sells. The site may be about craft but what buyers are really looking for is low-cost art, one-of-a-kind items that can function as a talking point and which shows off their taste.

Prices too can reflect the rarity and skill of the image. At least one image on Etsy has been listed with an asking price of $60,000 and a number have four-figure price tags. Most works though sell for far less.

TIPS
FOR SUCCESS

Know the Cost of Production

One of the most costly—and very common—mistakes made by new contributors to Etsy is underestimating the cost of creating the products you want to sell.

That's a particular headache for photographers who need to know exactly how much it costs to print the photograph, frame it and ship it to wherever it needs to go. While Zazzle provides that expense as the basis of its product pricing, Etsy users have to discover the information themselves.

Photographers who have got that wrong have found themselves selling at a loss.

Use the Bio

The bio on Etsy is particularly important. Even more than on Zazzle, Etsy buyers want to feel that they're getting something that provides a connection to an artist. They want to feel that they're buying from a friend.

The more approachable you can make yourself in forum chats with customers, the more you're likely to sell.

And the more you reveal about yourself, and in particular your work, on your bio, the greater the understanding potential customers will feel for your art.

(continued on next page)

In theory then, a good photograph of a leaf or a landscape could be enough to land a sale. But you might find that you do better by using your photograph as a basis for further artistry.

Because buyers are looking for art, a clear sign of the artist in the work should make it easier to sell.

How to Create and Market Etsy Images

It's worth taking the time to browse the images on offer and read posts in the forums contributed by other photographers before you start offering images on Etsy.

It's a unique site with buyers looking for a very special kind of artistic product so you should put a lot of additional work into your photos before you list them.

Remember, you'll have to pay just to list your items and even if the individual amounts are small, those payments can quickly add up if you're constantly swapping images that don't sell for items that you hope will.

More importantly, one of the first steps you'll have to take when you register is to choose a username. That username will form part of your URL and will therefore be a vital branding tool.

Even before you register then, it's worth thinking about what you'd like your store to be called.

You'll be able to use that URL in links on your website, in the signature field of your email and in all of your marketing but one of the most power-

ful marketing tools on Etsy is actually the site's forums. Although these are dominated by other artists talking about their work and swapping useful advice about production and marketing, they're also used by buyers to chat with producers.

They can be valuable places to promote your art and build a connection with regular customers.

GETTING STARTED

This is one time when it pays to do some preparation before signing up at www.etsy.com.

Spend some time browsing as a buyer to see the types of items other sellers are offering and how they've personalized their stores. Decide what kind of products you want to offer, then choose a username that reflects your store.

Only then should you register as a seller and offer your products. And once you're in make use of the forums to pick up feedback and look for buyers.

TIPS

FOR SUCCESS

(continued)

Personalize Your Store

Etsy provides a number of tools to allow contributors to personalize their stores.

It's worth putting some effort into this too.

Buyers want their sellers to be artistic and creative. They'll expect to see that reflected in their store fronts as well as their products.

Follow Alchemy

Etsy also uses a service called "Alchemy" in which buyers can place requests for particular types of products and providers can then bid to create them.

Clearly, only a small fraction of those items are going to be photography-based but if there's any relation at all to photography you can consider projects like these a challenge. After all, you know there's a market!

Get Arty with RedBubble

DIFFICULTY

COMPETITION

INCOME POTENTIAL

What It's All About

Where Etsy is crafty, RedBubble is arty—and it's photography arty too. That makes it closer to Zazzle but the range of products is far more limited and there's a much greater emphasis on the creativity than on the items themselves.

In fact, the products are limited to t-shirts, wall art, calendars and cards. Photography though is an important part of all of those. According to Martin Hosking, the site's co-founder, photography is responsible for about for 40 percent of the roughly $2.5 million worth of sales that Red Bubble made in its second year.

In effect, RedBubble combines Etsy's emphasis on artistry with Zazzle's logistics. Contributors do have to produce unique designs and Red Bubble's customers are more likely to buy them because the images themselves are powerful and attractive than because they really need a new t-shirt or calendar.

Like Zazzle, RedBubble also handles all of the printing and mailing, leaving the contributor to focus on the image-making and marketing.

What You'll Need to Shoot to Earn with RedBubble

RedBubble's narrow range of products means that customers are always going to be choosing an image because it looks good rather than choosing an item that happens to have an attractive picture.

That makes it very difficult to tell what kind of images are most likely to sell and which are more likely to be left on the shelf. The appeal of an artwork is always very subjective.

One useful tool that RedBubble supplies though is the ability to browse images by popularity. That might provide a certain amount of insight into

SUMMARY

Selling on RedBubble feels very arty. The site even contains groups that enable artists to swap ideas and share images, and there's little of the kitschiness that can be found on some of Zazzle's stores.

If Zazzle can sometimes feel like a souvenir shop, RedBubble is closer to an online art fair.

But it's a fair dominated by sellers. Although RedBubble does put effort into search engine optimization, its marketing too is focused on bringing in artists rather than attracting buyers. That's the less fun side of RedBubble but if you are prepared to put in the effort, to build joint ventures with re-sellers and to promote the art you're placing on the site, it is possible to make money with RedBubble.

People are doing it, and when it happens to you, you'll be earning income not just from your photography but from your art too.

TIPS FOR SUCCESS

Be Selective

RedBubble is a store not an online portfolio. It's where you show your best work rather than a complete range of everything you've ever shot. You'll do much better creating a style that buyers will recognize and expect than throwing up every attractive image in the hope of making a sale.

And build your store slowly too. Upload just a few images at a time so that your work looks rare and valuable and take down work that doesn't sell so that only your best is always on show.

Create Themed Calendars

Calendars are among the biggest sellers on RedBubble, perhaps because they contain twelve images rather than one and last all year. But they have to be themed.

A sellable calendar needs to have twelve variations on one topic rather than twelve attractive pictures. Buyers are more likely purchase them and you'll find them easier to market to resellers.

Use the Widgets

RedBubble offers a number of widgets that producers can easily add to their websites, blogs and social

(continued on next page)

the sorts of images that buyers tend to purchase—and you'll find a mixture of landscapes, cute animals and surreal Photoshop creations—but ultimately, you'll probably be better off creating the sorts of photographic artworks that you treasure the most and making them available for purchase as cards, calendars, prints and t-shirts.

There's no guarantee they'll sell of course, but they're likely to have just as much chance as a picture created specifically for the market and at least you'll have had fun making it.

How to Create and Market RedBubble Images

Signing up to RedBubble is free and starting to sell your work is as simple as uploading a photo.

But that will just make it available for sale. To actually generate the sales you'll have to work a little harder. Tagging your images well is important and as always, it's a good idea to make use of the bio to tell buyers who you are so that they feel that they're buying not just a product but part of your artistic story.

You'll also need to keep your images big. Photos for greeting cards can be as small as 1 megapixel but large prints require as much as 10 megapixels while large posters can even require 35 megapixels. Make your images

TIPS

FOR SUCCESS

(continued)

networking pages.
These really are invaluable.
They make driving traffic to
your RedBubble store very
easy, and best of all, they
make it much easier for other
people to do it too. If you're
not using the widgets, you're
not making the most of your
marketing power.

Become a Groupie

You're not likely to find
too many customers in
the various groups on
RedBubble but you will
meet lots of like-minded
artists and that's almost as
important. They'll be able
to tell you about their own
experiences. They'll reveal
the methods that they're
using to drive sales and
they'll let you know which
types of images are currently
selling well.

Perhaps most
importantly, they'll keep
your enthusiasm high and
they'll make sure you stay
engaged.

At the very least that
means you won't give up,
even if it takes you a while to
make your first sale. At most,
it could help to spread word
of your work as people talk
about your images. That can
quickly give you a customer
base.

too small and you'll restrict even further the kinds of products they can be printed on.

Ultimately though, the success of your RedBubble art will depend on the marketing you do offline. Perhaps the most successful strategy that RedBubble sellers have found is to create calendars that convey a theme. Surf spots of America could work, for example, or photos of French chateaux. They then work hard to partner with sites that discuss that subject.

It's a method that initially takes time to implement but once established can result in some useful extra sales.

GETTING STARTED

Once you've spent some time browsing the most popular images in each of the main product types at www.redbubble.com, take some more time to do some selecting.

Upload the images that you're most proud of and write a good bio that explains what you want your art to do.

Then hit the groups and start spreading your widgets.

Earn in Your Coffee Break with CafePress

32

DIFFICULTY

COMPETITION

INCOME POTENTIAL

$

What It's All About

While Zazzle is broad and Etsy is arty, CafePress has a different kind of distinction.

It was first.

Founded in 1999 by Fred Durham and Maheesh Jain, the company has built a catalog of more than 150 million unique products. More than 2,000 new stores are added each day as well as 45,000 new items, many of which are displayed during the 11 million unique visits the site receives each month.

CafePress functions in much the same way as Zazzle, which was modeled on the online designer market. Anyone can create an online store for free, upload their designs and offer their products. CafePress handles the printing and logistics, and the seller can set a rate above the production cost to ensure a profit.

Where CafePress stands out is in its age and its size.

Its community of 6.5 million users provides a wealth of experience that new sellers can draw on to increase their sales and the company's brand and advertising network are both trusted and widespread enough to bring in buyers prepared to spend money.

With the right products and good marketing, some of that money could be coming to you too.

What You'll Need to Shoot to Earn with CafePress

Images that look good on t-shirts. Yes, CafePress sells all sorts of different products, including mousepads, mugs, clocks and calendars. But it's the t-shirts it's best known for.

TIPS
FOR SUCCESS

Go for Humor

There's no shortage of places to buy cool-looking t-shirts and often for prices cheaper than those available through CafePress. What you can offer in your store though are products that are completely unique, which can't be found anywhere else and which potential customers feel they simply must have.

Humor is often capable of creating that must-have appeal so if you can add a touch of whimsy to your products, you'll probably find them easier to sell.

Use the Forums

CafePress's strength in comparison to other product stores is its age and the size of its community. You can make the most of that community by playing an active role in the forum and by taking the time to browse the threads for marketing and store-building advice.

There's no reason to learn how to sell on the job when there are millions of people who can tell you what to do.

SUMMARY

CafePress may have been the first online mall to allow creative types to set up their own stores and sell online without any of the hassles of printing, posting and packing but its size and only offer limited help to the biggest challenge for sellers: promoting their store.

In fact, while CafePress's name might be well-known and its brand trusted, its reputation as a generalist—rather than a center of art and creativity like Etsy and RedBubble—may even make promoting artistic photographs harder than necessary.

And as always, the site leaves all of the promotional work to the sellers, forcing you to find a way to compete with the 2,000 other new stores that weren't there yesterday.

None of this means that you can't make money with CafePress. You can and people do. But it's unrealistic to expect to make piles of money with CafePress. It's free to use, easy to create your store and upload your designs, and if you can consider the marketing as a fun form of networking with people you want to shoot the breeze with anyway, you might even be able to write off the long promotional hours as entertainment rather than an expense.

But you can still only expect to pocket the odd bit of extra cash rather than a real income from the store. It won't pay your mortgage but CafePress might just feed your coffee habit.

That's a challenge for photographers because photographs rarely look good on t-shirts. The colors tend to look a little washed out and always end up a lot washed out. The design often looks like it's been pasted to someone's chest rather than an intrinsic part of the clothing design.

And photography doesn't have a great advantage on a t-shirt over a hand-drawn design.

There are a few ways to get around those problems.

Clipping the image foreground to remove the background usually helps to make the shirt itself part of the picture but you can do a lot more than that in Photoshop. There are all sorts of little tricks that you can use to make the design more cartoony, less static and more creative.

You can also aim at a tightly focused niche—and on CafePress, the tighter the better. Basic storefronts are free and Premium stores as little as $5 per month, so if you want to sell photo-decorated t-shirts to a market

bigger than your son's Scout troupe, you can always create a second store with a completely different set of products.

How to Create and Market Your Images on CafePress

Creating a storefront on CafePress is simple enough. Sign up by filling in a couple of quick forms and start with a Basic store to get a feel for the site. Premium stores give you fifteen-day free trial but you don't want to feel the clock's ticking while you're experimenting and seeing what the company can do for you.

Make sure you choose a shop ID and username that are short and easy to remember. If you feel you want to change it later, you're going to lose much of the marketing power you'll have picked up in your promotions.

You'll then be free to pick your products. You won't have your images ready at this stage but you will be able to see the range of products you can put them on and feel inspired.

You'll also be able to name and describe your products and perhaps most importantly, set your markup in three different ways.

Create your products, feel comfortable with the way the site works, then upgrade so that you can enjoy all of the marketing benefits that come with a Premium store.

The marketing will be a little harder. CafePress provides a number of suggestions that can help with search engine optimization but the best strategy is always going to be active in the community most likely to buy them.

If you've been shooting music-related images, for example, then participating in music forums and including your storefront URL in your signature will help to turn readers into buyers and make you that community's main supplier.

GETTING STARTED

The best way to start is to surf to www.cafepress.com and play around with products and store settings. Take a look at other stores to see the designs that people are putting up and the prices they're charging, and take the time to read the forum threads.

When you're ready to build a Premium store, try using one of the storefront templates available from www.cafetemplates.com and www. cptemplates.com.

33

Be Kind to Your Bank Account with ImageKind

DIFFICULTY

COMPETITION

INCOME POTENTIAL

$

What It's All About

CafePress's biggest challenge is that your photography-decorated t-shirts are going to be competing with neat little cartoons created by designers and illustrators.

Your artwork might look a little out of place on a site dominated by informal sketches and funny pictures.

That was what made ImageKind such an attractive purchase for Cafe-Press, which now owns it.

ImageKind is more like an online gallery than an online product store. The product range is much narrower than that available at a site like Cafe-Press and consists of custom frames, prints and posters, story frames, table-top frames, greeting cards and sample kits.

It's a place for selling art rather than a mall for moving the kinds of items you can find in any shopping center.

That makes it a lot more prestigious for art-oriented photographers than Zazzle or CafePress. Sellers can be reasonably sure that their customers aren't going to be stuffing their photograph in the washing machine or spilling ketchup down them.

They're going to be hanging them on the wall, placing them on their tables or sending them to their friends.

And they're going to be paying you for them too.

All of that makes ImageKind a very attractive option.

33 Be Kind to Your Bank Account with ImageKind

SUMMARY

But you've still got to make it work for you and that's where the tricky stuff kicks in. As always, ImageKind's marketing is focused on bringing in sellers. It relies on the sellers to bring in buyers.

It's better then to think of ImageKind not as a store which you can use to attract buyers but as a tool for delivering your framed prints to people who already want to buy them.

That's an important difference. It means that the real selling won't be taking place on the site. It will be taking place before the buyers reach the site, when they see your images on Flickr, your own website or in your pack of Moo cards.

You'll still be doing a lot of marketing—leave your ImageKind store on the Web and hope to earn from through-traffic and you'll earn just enough to pay for a free membership—but the marketing will only be using ImageKind to process the orders once the sale has been closed.

That doesn't mean it's not useful. ImageKind can certainly be useful and photographers are making money from it. In fact, it's about as useful as RedBubble and very similar to it.

What You'll Need to Shoot to Earn with ImageKind

You'll need to shoot images that sell.

Clearly, that's easier to say than to do and the only way to test whether or not your images can sell is to put them on the market and see if anyone buys them.

Make a mistake though—overrate the desirability of your images to buyers—and all the marketing you'll be doing to bring people to your ImageKind store will be a terrible waste of time and effort.

Rather than create a store with a bunch of untested images then, a better option might be to use ImageKind as another way to deliver images that you know already sell.

These are going to be art images (as opposed to the sorts of commercial photos usually sold as stock) so if you find that certain prints are selling well at art fairs or generating lots of interest on Flickr or on your website, then put them on ImageKind too. Those who said they liked them online can buy them and if you include your ImageKind address on your business cards, you can feel confident that you really are offering your most sellable images.

TIPS FOR SUCCESS

Don't Wait for ImageKind

ImageKind will only give you a store. You'll have to do all the marketing yourself. It's a simple truism but it's also one that far too many photographers on the site choose to ignore.

The marketing is just too much like hard work.

It might well be tough, but without doing the promotional stuff, you won't be making any sales.

Aim to be a Featured Artist

Unless you end up with your name, your face and your link emblazoned on ImageKind's home page.

That can only happen if you become a featured artist, and that too can only happen if you're making sales—and if you have more than a free account.

Start making money on ImageKind and the site might just help you to make more.

How to Create and Market
Your Images on ImageKind

ImageKind's store-building tools are all pretty intuitive and easy to use. The only difficulty you'll face is which kind of membership you want to purchase.

Like CafePress, ImageKind offers a limited free membership plan that gives you an opportunity to play with the site, get used to the way it works and feel comfortable with it before you start trying to make sales.

The best option is then to start moving up slowly by buying a Pro Account which costs $7.99 per month. The differences between the free account and the Pro account aren't huge and mostly concern the number of images you can offer and the way you offer them.

While the free account only lets you post 24 photographs, a Pro account allows you to put 50 images in each gallery and to create as many galleries as you want to show off different kinds of art.

More importantly, once you start paying, you'll be eligible for priority placement in search listings and as a featured artist.

In practice, the search listings are likely to be no more useful than the fact that you can use more tags and keywords to classify your work.

Very few buyers are going to be browsing the site looking for purchases unless other sellers have sent them there. And those buyers will be heading directly to those sellers' stores.

And sending buyers to your store is what you're going to have to be doing too.

Hand out cards at shows with your ImageKind URL. Place a link on your Flickr stream. Include the Web address in your email and forum signatures. And of course, send visitors from your website to your ImageKind store.

GETTING STARTED

Start by signing up at www.imagekind.com creating your own store, then spend some time reading the threads at Flickr's ImageKind group at www.flickr.com/groups/imagekind.

Together with the forums, they'll give you a wealth of great marketing advice.

Make Image Thieves Pay You with PicScout

DIFFICULTY

COMPETITION

INCOME POTENTIAL

What It's All About

Leave enough good images on the Internet for long enough and almost inevitably it will happen.

Someone will swipe one.

If you're lucky, it will just be some blogger looking for a free image to go with his blog post. But often the thief is looking for a bit more than an illustration; he's looking for a way to earn money. And he can do that with your photos.

Images posted on Flickr—kept small and protected with a watermark—have turned up on prints that have generated thousands of dollars for the thief with nothing going to the photographer.

Images been used without permission on photographic products, as Facebook avatars and on commercial websites that generate plenty of revenue with advertising and sales.

According to one estimate, an incredible 90 percent of all images used online were posted without the permission of the copyright-holder.

That leaves photographers with two problems: discovering when their images have been stolen; and taking the appropriate action when it happens.

Google Alerts can tell photographers when they receive a credit but they don't help if the thief didn't name the photographer. More often photographers are alerted by friends or admirers who know they work. And usually, the only possible response has been to write to the image thief, remind them that the image is copyright-protected and ask them to stop using it. For most image thieves, that tends to be enough to do the trick. Few people really understand copyright law and far too many feel that if an image is on the Internet then anyone can help themselves to it. Being told otherwise is often all it takes to get them to take the image down.

TIPS

FOR SUCCESS

Use PicScout as a Warning

PicScout can do more than gather unpaid licensing fees. One option is to use it to protect your images. Placing a notice near your photos that they are protected by PicScout may be enough to stop them being stolen in the first place.

Get Credit

Many of the people who use your images will have neither the resources nor the inclination to pay for a license. At first contact from PicScout, they'll simply apologize and remove the pictures.

Another option then is to allow them to use a low-res version of your picture in return for credit and a link back to your portfolio. You won't get paid but you will get some free advertising.

Gain Customers

Other image users will have a budget to pay for your photos—and to keep paying for them. Rather than heading straight to lawyers, large stock companies tend to see image thieves as potential customers. It's a much healthier, more profitable and less aggressive response.

But if someone has been earning money from your image, then it's only fair that you should receive your share. That's much harder to do with just an email or a letter.

PicScout is a service that aims to solve both of the problems faced by photographers. It constantly scans the Internet looking for the images that photographers have uploaded to the service and reports back whenever it finds a match. The searches are said to be 100 percent accurate.

Photographers can then choose to assign the case to one of PicScout's legal partners who will track down the image thief and recover payment on a no-win no-fee basis.

SUMMARY

PicScout is a fairly unique service (Attributor (www.attributor.com) does something similar but not as well). Its image tracking facility is able to find photos even after they've been altered and its legal partners are able to extract funds from copyright infringers with no risk to the photographer.

The company works with all of the major stock companies who use it to make sure that no one uses their images without payment but Pic-Scout also offers smaller programs for individual photographers. It does cost money but at just $14.95 to track up to 500 photos, it could be money well-spent.

But it's only going to work if you're posting the sorts of images that people might want to steal and if lots of people know that they're there.

PicScout is really a way for popular photographers to make more money from their images, to ensure that they're always paid and to win more customers than it is an additional revenue stream.

Nor is it an alternative to protecting your images. Even with PicScout's legal partners on your case, there's no guarantee that you'll receive payment and when the thieves are as small individual bloggers, it's rarely worth the hassle.

PicScout can be a very useful back-up for popular and commercial photographers but you'll need to already have a large and popular portfolio online to make the most of it.

What You'll Need to Shoot to Earn with PicScout

The best sign that you're producing the kinds of images that would allow you to earn with PicScout is that you're making sales. If people are buying

your images, then there's a good chance that some people will take them without paying for them too.

That might not mean purely commercial, stock-style images though.

Image thieves tend not to swipe photos from stock sites. The images there are protected (as much as they can be). Large stock companies are known to employ large law firms and to demand large fees for usage, while microstock sites charge so little that it's not worth stealing from them.

Image-swipers are more likely to take images that they spot on Google, on Flickr or on other websites. And they're likely too to steal images that are original, artistic and popular.

PicScout isn't the kind of service that you can target as a way of generating revenues. It's a way of collecting all of the money that you deserve from the use of your most popular images. Shoot images that people love and there's a good chance that you'll be able to bring in some extra revenue from PicScout.

How to Make the Most of PicScout

There's little that you can do to increase the chances that someone will steal your images so that you can use PicScout to recoup the fees. Nor would that be a good strategy to follow.

You'll always be better off protecting your images as much as possible and making it clear that they're available for licensing.

If you do find that your images are gaining plenty of views, generating lots of discussions—and that you occasionally find them scattered across the Web or used in ads without your permission—then uploading as many of them as possible to PicScout would be a good move.

GETTING STARTED

Begin by reviewing whether your images are being used—or are likely to be used—without your permission. Google your name to see if you're being credited for images you haven't authorized and look at the number of comments you're receiving on Flickr. A long list and plenty of faves is likely to attract the attention of image thieves. Sign up with a personal account at www.picscout.com, upload your images and watch what turns up.

35

Build Your Own Niche Stock Site

What It's All About

We've already seen that it's possible to build your own local stock site, but it's possible to niche your stock collection in all sorts of different ways. While focusing on one particular location certainly have its benefits—the subject of the images will be relatively accessible and the travel expenses low to name but two—the market will also be fairly limited.

You can easily be known as the photographer to contact of your area, but it's unlikely that you'll be contacted too often.

Local stock should usually be seen as one more revenue stream that you should be earning from rather than your main specialization.

It is possible however to build an entire career on the back of a particular niche.

Many professional photographers choose to specialize in underwater photography, aerial photography, surf photography or any one of a giant range of different specialties. They might occasionally shoot other things too but by being known for their expertise in one particular field, they become the first stop for buyers looking for those images.

The good news is that just about anyone can target a niche, and you don't need to be a professional to do so. We've come across photographers who regularly sell images of cars and others who specialize in slow motion photographs of water. Neither are professionals but both are known enough to sell their photographs.

The bad news is that selling your own stock isn't easy. You'll need a website that promotes your brand and a system that allows you to take orders.

And of course, you'll need a large collection high quality commercial images.

If you can put all of those things together though , you could well find yourself in every photography enthusiast's dream position: making money out of not one hobby but two.

SUMMARY

Creating the images for your own stock site is always going to be fun. You're going to be shooting the subjects that you enjoy anywhere, whether they're related to sports, nature or anything else. And the interest that you take in the subject will give you an advantage over a general photographer creating images for a broad stock portfolio.

Because you'll understand what you're looking at, you should be able to produce better images.

Sports photographers need to be able to predict what will happen next so that they can be in position. A photographer who loves the sport he shoots and understands how it works should always find himself landing the best shots.

But making those images available will be hard work. A niched field, by definition, will be small so it will help to get to know at least some of the major buyers. You'll need to promote yourself as a photographer, and you'll need a way to put your images into the hands of users.

What You'll Need to Shoot to Earn with a Niched Stock Site

You'll need to shoot lots of images—and lots of very specialized images too. Depending on the size of the niche, there might not be a huge amount of demand so you want to put yourself in the position of being the main photographer for your niche.

Whenever someone needs a photograph that matches your niche, you want them to know that they can turn to you. You want all of the main buyers in your field to understand that you'll have a photo depicting the subject they want and at the quality they want.

That means building a large inventory, carefully divided into sub-categories for easy browsing and fully explained with informative descriptions.

As always though, it also means shooting commercial images, photos that can take text, tell a story, express an emotion, and above all, sell a product.

TIPS
FOR SUCCESS

Shoot Commercial Images Not Realistic Images

Enthusiasts about a subject often want to shoot realistic images. They want to show rock climbing as it really is or the real, dirty face of drag racing. News editors might want images like that.

Stock users want images that people can recognize even if the scenes are clichéd and the subject unrealistic. Some niche photographers have even gone so far as to create two stock sites, one for realistic images and one for standard shots that sell.

For stock, formula sells.

Make Yourself Available for Commissions

Commissions always pay more than stock licenses and when you're a specialist, it's likely that clients will want you to shoot unique shots for them.

Even if you're not a professional, it's worth looking for a way to make time for these sorts of shoots and indicating that you're interested in taking them.

Don't forget that successful stock isn't about the image and it's not about the subject of the image; it's about what the image can do for the client. That's still true of niched stock photos.

How to Create and Market Niched Stock Images

Building your inventory of images shouldn't feel like work. In fact, it should simply be an extension of your hobby, a combination of your enthusiasm for photography and a love of your second activity.

It's the selling that's going to feel like work.

You will need a website. Even experienced professionals who have been shooting in their niches for decades now say that most of their work comes in through their websites.

Some of that might be through name recognition but some of that business is also likely to be a combination of a great portfolio and careful keywording.

But as we've seen, building a website that allows people to receive quotes based on usage and license your images automatically isn't easy. The simplest option then would be to use your website to create your brand, supply information about the type of images you shoot and send people to a PhotoShelter inventory to make the purchases.

You won't have the independence that comes from keeping everything on your own site but you will be up and running faster, and you'll be able to generate the sales with much less effort.

The alternative is to place all your images on your site and invite users to enquire about any photo they want to purchase then negotiate on a case-by-case basis.

The best way to market your niched stock images though is going to be through networking. When you're shooting, talk to other people involved in your activity. Let them know that your photos are available for sale and make sure that everyone also knows where they can see them. Moo cards could be very helpful here.

GETTING STARTED

Begin by building a website that explains your interest in the subject and include a small portfolio of your images. Indicate on the website that stock images are available at PhotoShelter. Build a PhotoShelter account that contains your stock and start networking. You can also see an example of a niche stock site at www.gregepperson.com.

Go Ethnic with GoGo Images

36

DIFFICULTY

📷 📷 📷 📷

COMPETITION

🐎 🐎

INCOME POTENTIAL

$ $ $ $

What It's All About

For image buyers, finding appropriate pictures can be a difficult process. Stock companies might offer millions of photos but they're often repetitive and formulaic and the searching is slow and time-consuming. When deadlines are tight and budgets even tighter, buyers want to be able to turn to a source they can trust and find the photos they need quickly.

We've already seen that one way to meet that demand is to market your own niched stock images.

Another approach is to submit your images to a niched stock company and have them do the marketing for you.

GoGo Images is a conventional stock company that specializes in supplying multicultural images. Its image categories include Latin, Black, Asian, Indian, Middle Eastern and Gay & Lesbian.

The aim is to supply localized images that multinational companies can use in their marketing around the world.

For photographers with access to multicultural models or who are based outside the United States, GoGo could represent a valuable opportunity.

SUMMARY

GoGo might specialize in multicultural scenes but it functions as a conventional stock company in every other way. Its prices—and therefore its commissions—are high but so are entry requirements.

Images have to be shot with at least a 12 megapixel camera using a full-frame sensor. This is photography for the professional or very keen enthusiast.

What You'll Need to Shoot to Earn with GoGo Images

The very minimum you'll need to shoot is photos with recognizably ethnic models. Those models don't need to be professional. Friends and family can do the trick, and some of GoGo's photographs use "street-casting," employing people they meet at random.

All of the images though will need model release forms.

GoGo is also selective. It wants photos that demonstrate high production values, creative compositions and technical excellence.

As always a good option is to spend some time browsing through the images available on the site. Although GoGo states that it prefers lifestyle and business images featuring at least one ethnic model, you'll find that not all of the images show people. GoGo also offers landscape photos from clearly identifiable destinations, broadening the opportunity a little.

In general though, the biggest opportunities are likely to be for standard business stock photos that happen to feature ethnic models.

How to Create and Market GoGo Stock Images

GoGo Images is a stock site. It doesn't sell artistic prints and its buyers aren't looking for pictures simply because they look good. The company wants commercial photos that editors and designers can use to promote products.

Like all stock images then, while it might be possible to sell snaps that you shot for fun and happen to have on your hard drive, you'll always do better with pre-planned compositions that consider the different possible end uses of the image.

Ask yourself what messages the image is communicating, how it would look on a brochure, an ad or a Web page and whether there's obvious space for text.

If GoGo accepts your photos, you won't need to do any more marketing of your own but that doesn't mean that shooting ethnic images doesn't demand any marketing at all.

You will, after all, need to sell yourself to the company, something that's best done with an excellent collection of photographs that fit neatly into the company's niche.

GETTING STARTED

As always, when you have a chance to browse the images on offer, it's worth spending some time to see what sells. GoGo Images does let you search through their inventory so take a look and see how close the images on the site match the sort of photos you own—or could produce.

You'll then need to put together a collection of at least 20 high res images and email a link to photographers@gogoimages.com.

Remember though that the Web page you're exhibiting should only contain the images that would interest the company. It's probably worth creating a special category on your website and placing the images there before you submit your link.

TIPS

FOR SUCCESS

(continued)

does sometimes feel that photographers aren't filling it in quickly enough.

Occasionally then, they will commission photographers to shoot specific images. The direction will be very tight but the shoot itself can be very lucrative.

There's little that you can do to put yourself in the running to win these kinds of shoots other than to produce exactly the sorts of images that GoGo is looking for and do it on a regular basis.

Shoot Often

And that regular basis is important. Stock libraries do need refreshing and buyers expect to see new photos each time they come back. Although it might be possible to send in whatever images you have available and leave them to sell, if ethnic images are your thing, you'll be better off shooting and submitting regularly.

Bear in mind though that stock shoots often cost money to organize. You'll have to pay for equipment, time and sometimes models too. Stock can be lucrative and the income from one image may continue to flow for some time, but it can sometimes take a while before you recoup the expenses you laid out to create the image.

37

Supply Science Pictures for Photo Researchers

DIFFICULTY

COMPETITION

INCOME POTENTIAL

$ $ $ $

What It's All About

GoGo Images are looking for photographs featuring multicultural models. But they're not the only stock site with an eye for an unfilled niche. Photo Researchers has been offering scientific photos for more than 50 years. They currently have more than 500 contributors who send in images covering topics that range from astronomy to zoology. Many of those images end up in textbooks.

Like GoGo Images, Photo Researchers charges buyers standard market rates. The average price for an image is around $450 although photographs can sell for as much $7,000 if they're going to be used to promote conventions. The photographer receives half the sales price.

Like traditional stock companies, breaking into Photo Researchers isn't easy. The company turns down about 75 percent of the images it receives, usually because they already have enough similar photos on the same theme.

Nonetheless, the Photo Researchers' inventory is still growing at an impressive rate of 4,000 new images a month.

What You'll Need to Shoot to Earn with Photo Researchers

Despite its specialization, Photo Researchers has a pretty broad range of images and not all of them are as difficult to shoot as close-ups of osteoblasts and osteoclasts.

There are also plenty of animals on the site, making Photo Researchers a possible resource for wildlife photographers. At least one highlighted photographer has a collection of classic car images and the company also

SUMMARY

Photo Researchers is a highly specialized niche stock site. In the past, most of the images it supplied came from doctors and scientists. Today, about 80 percent of contributors are photographers but it will still help to have the kind of access to scientific establishments that's very difficult for laymen to acquire.

You'll also need a good understanding of the subject.

Anyone with the right equipment can take a picture of the night sky. But at Photo Researchers, they'll expect you to be able to tell the buyer which part of the night sky they're looking at and the names of the stars in the photo.

That level of access and that level of knowledge are both rare. But they aren't impossible to find. Plenty of scientists have photography skills as well as access to laboratories, while there's also no shortage of amateur astronomers, botanists and even anthropologists and geographers who know their way around a camera.

Photo Researchers then, represents a rare opportunity for photographers with a scientific mind.

offers scenic images of cities, sites and national parks, as well as people, rocks and holidays.

In theory then, it might be possible to submit almost any kind of image to Photo Researchers and have it accepted as a scientific photograph. In practice, with the company not accepting images similar to those it already offers, you'll struggle to create a general image that it's prepared to accept.

And you still have to sell it too. Not surprisingly, the best performing images on the site are broadly scientific, with nature and behavioral sciences second.

Most contributors to Photo Researchers choose to specialize in one particular category, such as insects or astronomy. Few shoot across different specializations. The rarer the image, the greater the chances that Photo Researchers will accept it.

If you have knowledge about a particular scientific branch then the choice of images—and the opportunity offered by Photo Researchers—should be pretty clear. Otherwise, browsing the more general categories on the site might throw up some areas that you could contribute to.

TIPS
FOR SUCCESS

Be a Scientist

Okay, that's not so easy but knowing about a particular scientific field is always going to be the best way to make sales on Photo Researchers.

Many of the photographers who contribute to the site are professionals who also happen to be interested in a science such as botany, biology or astronomy. They have the technical skills to shoot good photos and the knowledge to explain the science.

Ideally, you'll have access to a lab but it is possible to have your images accepted and sold by picking up a scientific hobby.

Shoot Quantity

The subjects of the images—especially the hard science ones with the most demand—are so specific that the photographers are rarely able to shoot in bulk.

If you can find a way to shoot many images of your choice of scientific field—and to continue creating images within that field—you should find it easier to make sales.

(continued on next page)

Study the Site Carefully

This is always a good idea but it's particularly important on Photo Researchers because the subject of the images ranges so broadly from the very specific science shots to the more general images that anyone can take, even if they do require some careful describing. It is worth spending some time to see if there is a space for an image of your own scientific interest—or whether you can supply the more general photos.

How to Create and Market Images for Photo Researchers

For Photo Researchers, it's not just the image that's important but the information that comes with it. The company does offer scenes of sunsets, white water rafting and boats, for example, but the description that accompanies the image will explain where it was shot and what that viewer can see.

Because the images are more likely to be used in textbooks than advertising, it's the ability of the images to inform rather than promote that's vital.

General stock sites sell images of flowers, for example. Photo Researchers might offer similar images but they'll be close-ups of dewdrop stamen or crabapple blossom.

So the description is an important part of creating a sellable Photo Researchers image. Marketing the image though doesn't require any more than the usual strategy of leaving it to the stock site to place your picture in the hands of its customers.

As always it does help to have a website that shows off the best of your niched photos, and let buyers know that they can license them from Photo Researchers.

That will help you to build your brand, give Photo Researchers a place to go to learn more about you and make yourself available for commissions.

GETTING STARTED

Once you've spent some time examining the images at www.photo researchers.com, you'll probably have to spend even more time examining their contributors' guidelines at www.photoresearchers.com/contributors/. These are pretty detailed and need to be followed closely before submitting your images for review.

It's worth noting that for the more open categories of travel, wildlife and lifestyle Photo Researchers demands 400 images to review. For science, medicine and astronomy, they only require 100 sample images. Either way, you'll need to start with a pretty big portfolio.

Put Your Images in Hotels with Farmboy Fine Arts

DIFFICULTY

COMPETITION

INCOME POTENTIAL

$ $ $

What It's All About

Stock companies serve newspapers and magazines, ad companies and websites. But they aren't the only people who need images. The hospitality industry uses photography to decorate its walls, and interior designers can sometimes use photography too.

Farmboy Fine Arts is a Canadian design company that provides artwork primarily to the hospitality industry, placing images in hotels around the world. Their clients include Sheraton, Westin, Marriott, Trump, Caesars and Hyatt, as well as many independent boutique hotels.

For photographers, the firm operates in much the same way as a stock company. Photographers are free to send in their images which are then made available to clients. When a sale is made, the photographers are paid a royalty and a commission for each image licensed and for each time it's used.

One photograph used in multiple places in a hotel then would generate multiple payments.

It's open to all photographers, including non-professionals and you don't need a huge inventory to join.

What You'll Need to Shoot to Earn with Farmboy Fine Arts

Farmboy's Stockyard Collection—its inventory of submitted images—is divided into six categories: abstract; architecture; landscape; lifestyle; organic; still life; and technology.

The company tends not to accept images that are too "stocky" and occasionally issues call-outs for specific types of images demanded by a client.

TIPS

FOR SUCCESS

Submit Often

According to Todd Towers, Farmboy Fine Arts' President, photographers who license the most images through the company tend to be those who submit the most images and cover the largest number of subjects.

Quality always counts, but like a stock company, with Farmboy Fine Arts, quantity counts too.

Do the Call Outs

Whenever a company issues a call out for images, it's always worth paying attention. It's a bit like entering a competition but at least this is a competition which you know is going to award a prize.

Best of all, even if you don't win, the images stay on file and might net you a sale at some point in the future.

Try it Out and Pull the Pictures if it Doesn't Work

There are no fees for submitting images to Farmboy Fine Arts, but if the images don't sell, you won't be able to license them anywhere else.

On the other hand, if the images are just sitting on your hard drive, they're not going to sell anywhere else anyway.

(continued on next page)

SUMMARY

Farmboy Fine Arts provides a rare opportunity for photographers looking to earn money from their artistic images. Their open submission policy means that anyone can submit images for review, and there's certainly a sense of satisfaction that comes with knowing that your photos are hanging on a wall in a hotel somewhere.

But the rewards may be relatively low. Farmboy pays a commission based on its own gross profits. Photographers have reported incomes as low as $25 for each image and only $2 or $3 for each room in which the image is placed.

Farmboy might deal with art and sell to big clients but the prices and bulk deals it strikes may make it the microstock version of commercial art photography rather than a large commercial gallery.

And any images submitted also have to be exclusive. While you can sell an image submitted to Farmboy as a print, hang it in a gallery or exhibit it in a show, you can't license the image in any other way.

If an image doesn't sell though, you can remove it from Farmboy and try to license it elsewhere.

Farmboy Fine Arts then is a rare thing: an opportunity for any artistic photographers to make money. It's unlikely to make you rich however and it might tie up images that could be licensed to other buyers.

Photographs submitted as a result of a call-out and not used by the client are placed in the Stockyard collection.

Sometimes those call-outs can take the form of trends in hotel fashions. For example, Farmboy has been looking for city-specific images as well as works that are "edgy," "conceptual" and "art-driven." When you submit your work for review, Farmboy will tell you what sort of imagery works best for them so that you can narrow down future submissions.

In general, Farmboy is looking for artistic works—the kind that are most fun to produce and the hardest to sell.

How to Create and Market Images for Farmboy Fine Arts

Creating images for Farmboy Fine Arts is one time when you don't have to think about the message an image needs to put across or whether it could be used by a photo editor or a designer.

You just have to produce images that you think are attractive and which make you proud.

Either clients will buy them or they won't, but there's little you can do to influence their decision or to market the artworks you produce.

What you can do though is make sure that the images you submit for review are your very best and reflect the sorts of images you want to produce. Farmboy Fine Arts asks that photographers submit a selection of ten to twenty low resolution jpegs to stockyard@farmboyfinearts.com together with their contact information, or simply send them a link to their website/online portfolio.

As always, if you're sending a link, make sure that the portfolio you're showing them is geared towards the sorts of images that Farmboy Fine Arts is looking for. There's little point in showing them your portfolio of senior portraits.

They will then let you know which of your styles works best for them and assuming that your images are accepted, offer you an agreement. You will receive an artist code and you can begin submitting high resolution images.

After that, it's just a matter of waiting for the sales to come in.

GETTING STARTED

To get started with Farmboy Fine Arts, you'll only need between ten and twenty low resolution images. But they will, of course, need to be good.

If you're sending them by email, choose carefully. If you're planning to send a link, make sure that the link you're sending leads only to those images. While there's nothing wrong with the reviewers seeing your other works, if they have to click around to find the images that are relevant to them, they're more likely to simply click away.

Before you send an email saying, "look at my portfolio" then, take a look yourself and decide whether your art images are easy to browse. You can find the site at www.farmboyfinearts.com.

TIPS

FOR SUCCESS

(continued)

One strategy then is to submit your images to Farmboy Fine Arts and leave them there until you spot an opportunity elsewhere. At the very least, they'll be in the running to earn you money.

39

Auction Your Art on eBay

DIFFICULTY

COMPETITION

INCOME POTENTIAL

$ $ $ $

What It's All About

eBay is best known as a place to empty out your garage or find a buyer for your old baseball card collection. What few people know though is that it's also a useful spot for photographic artists looking for buyers.

"Photography" lies under the "Art" category and includes the ability for artists to sell their own work.

You'll have to handle the shipping yourself and decide on the lowest price you're prepared to accept for your work, but with plenty of people passing through the auction site, no agencies to take a cut of your sale and a completely open market, you'll soon know exactly how much your images are worth.

SUMMARY

eBay is a completely open marketplace. Anyone can place their works there and anyone can stop by to bid on them. It's a fantastic tool for learning about the true market value of art works in general and your photography in particular.

What you will find though is that the price of a piece of art depends on more than the way it looks. It depends on how you market your works and on your name as an artist too.

That means that selling your works successfully on eBay will take some effort.

You'll need the right images, of course, but you'll also have to work hard using eBay's marketing tools and a number of other sales strategies to ensure that the bids come in and the sales are made.

What You'll Need to Shoot to Earn with eBay

Whenever you're looking to sell artworks, there are no hard and fast rules. The images have to be technically good, of course, and they also have to be enticing, attractive and desirable.

You'll be selling your pictures as prints, so they need to be the sorts of images that people won't mind looking at on their walls day after day.

It's not always easy though to tell whether your own images are artistic enough—and commercial enough. Getting a second, and third, opinion about the quality of your work on Flickr might be helpful but ultimately eBay will tell you.

You might just have to pay a few listing fees to find out what sells and what doesn't—but that would still be a good purchase and a valuable education.

How to Create and Market Images for eBay

While you won't need to do anything too special to create your images for eBay, you will need to print them; selling digital images on eBay just doesn't work.

It's worth experimenting with printing before you start selling. You'll want to know which kind of paper is best for your type of photograph and how much the printing process will cost. Those expenses will need to be factored into the minimum price that you're prepared to accept.

Marketing the images once they're on eBay requires a range of different strategies.

The most important is to use eBay's feedback function. Trust is an important issue on eBay and positive feedback is vital for making sales.

Until you make your first sales, place testimonials from buyers outside eBay on your sales page. When you do win sales, be sure to ask for testimonials from buyers who you know were satisfied with their purchase.

It also helps to network. That won't just give you those all-important testimonials and feedback recommendations, they'll also give you a community of buyers. Successful eBay photography sellers talk about the cyber friends they've made by chatting (through email) with their customers.

It's a strategy that's rewarding financially and satisfying in terms of the support your customers will give you.

eBay can be a pretty fickle way to sell your art with bid numbers rising and falling depending on the state of the economy and all sorts of other factors that sometimes seem to be no more explainable than the weather.

TIPS
FOR SUCCESS

Buy First

The best way to understand how eBay works, what motivates buyers, how they approach auctions and what they're looking for on a sales page . . . is to become a buyer yourself.

Find some photographs that you'd like to own and join the auction. The bidding process on eBay can be pretty addictive—you really do want to know whether your offer is going to win and what's going to happen in the end—and there is a feeling that you're about to pick up a valuable work of art for a song.

That's a feeling that you want to instill in your buyers too. To understand it, it's worth spending some time—and a few dollars—building up your own photographic art collection.

Offer a Body of Work

One of the reasons that people will buy a photograph on eBay is that they feel they're getting a genuine work of art rather than just a lucky snap shot by someone who happened to be in a beautiful spot with a camera.

(continued on next page)

TIPS

Signing your works is one way to show that you're an artist, but another is to place a number of different works on eBay, even if you're just starting out.

Instead of posting one, two or three photographs at a time, place a dozen. You might only sell a couple of them, but you'll give buyers enough opportunity to judge the strength of your body of work and feel that they're getting a potentially valuable work from an artist on the up.

Go Long

Success on eBay takes time. Top sellers report that it took them several months of regular posting before they started to make sales. In the meantime, they experimented with different prices, different images and different approaches.

While there are things you can do to shorten the path towards your first sale—such as networking, creating good sales pages, and building feedback and testimonials—ultimately, selling on eBay is a learning process.

Don't be discouraged with your first failures. Place a new set of images and try again.

But loyal buyers will come back again and again to see what images you have available and whether they can snap up a bargain.

GETTING STARTED

Begin by playing on eBay as a buyer at www.eBay.com. Take part in auctions and try to build yourself a small collection of photography artworks. You can always put them back on eBay later if you want—who knows, you might even make a profit.

Next, take a look at the work of Sandra Russell, a photographer who sells on eBay, at www.ebsqart.com/Artists/cmd_889_profile_portfolio.htm.

Finally, print a number of your best images to understand how much the printing would cost and to have at least a small inventory ready, then place your first set of postings on eBay and see which images start to sell.

Market Your Images with Craigslist

DIFFICULTY

COMPETITION

INCOME POTENTIAL

$ $ $

What It's All About

When Craig Newmark launched Craigslist in 1995, his plan was simply to create an online noticeboard which geeks in San Francisco could use to advertise local community events.

The board grew. It began to cover more subjects. Soon, companies were using it to scout for employees and it was spreading across cities and around the world.

Craigslist now functions as a classified ad service in more than 550 cities and 50 countries. It's used to sell items from pets to ipods and promotes services from personal to paralegal.

And it helps photographers find work too.

Craigslist isn't the kind of place that newspaper photo editors use to track down photojournalists, and few celebrities use it to find photo-

SUMMARY

Craigslist can be a very useful sales tool for certain kinds of photography jobs. These aren't going to be the highest paying jobs in the world but they can be valuable revenue-generators, especially for enthusiasts looking to earn a little additional money from their photography skills rather than rely on their image-making income to pay their bills.

Customers tend to be buyers with small budgets who want images with the minimum of frills.

Persistence is important for success on Craigslist and a well-written ad will certainly help but you will need to be prepared to go out and shoot on location. Craigslist is a place to find photography jobs rather than generate sales of the images you already have.

TIPS

FOR SUCCESS

Do A/B Testing

Once you've found an ad that gets results, you won't need to change the wording or the images, except perhaps to add new testimonials as they come in. Earning from Craigslist will be as simple as copying and pasting your ad and fielding the enquiries.

But you have to find the right text first. One way to do that is to run two ads at the same time with different wording and different images. You'll soon discover which delivers the most results.

Keep at It

And once you've found an ad that works keep posting it.

Ads on Craigslist drop down the page pretty quickly, so you'll need put up a new one every couple of days or so to stay visible. Photographers have reported response rates of one sale every ten to fifteen ads so don't expect each post land a gig.

On the other hand, at those rates, you might expect land one job every two weeks or so.

(continued on next page)

graphers to shoot their weddings. You'll even struggle to sell prints on Craigslist.

But the site has proved to be a useful place to find low-budget wedding clients, small businesses and independent designers who need images, as well as models, head shot jobs and product shoots for websites.

It's free, it's quick and easy to use . . . and it pays.

What You'll Need to Shoot to Earn with Craigslist

While you might be able to sell landscape prints and usage licenses on Craigslist, the sales are likely to be quite a struggle and relatively rare. Most of the jobs you pick up on the site are likely to be for weddings and sometimes for headshots too.

It will help if you have done these sorts of jobs before. Craigslist does allow sellers to include images with their postings so placing samples of the work you've already done on your listing will help it to stand out and prove that you can do the job.

Because the sorts of people who look for photographers on Craigslist are hoping to find bargains though, there is a good chance that they might be fairly flexible in regards to experience.

In general, lowering your price to make up for a short client list isn't always a good strategy but on Craigslist, emphasizing the fact that your rates are low (without mentioning the fact that you're hoping to gather experience) can be one way of winning work.

How to Create and Market Images for Craigslist

Success on Craigslist means selling your services rather than selling your work so the only images you'd need to create would be the photos you plan to include in your ad. You probably have these already but you will need to choose them carefully.

You'll be better off posting four or five memorable images and including a link to your website where people can see more than uploading ten or twenty pictures that merge into each other and are quickly forgotten. If you're promoting your wedding photography services, then try to make sure that you include the sorts of photos that every wedding client wants, such as the formals and the couple looking romantic.

Clients on Craigslist might not have the budget to buy a special album or shoot their preparations but they will want the essentials.

No less important is the wording of the ad itself.

Craiglist ads tend to look pretty amateurish so a professionally written ad might well be all it takes to stand out and win you jobs. One option is simply to paste the blurb from your website with perhaps a few changes to make it suitable.

Another is to ask a professional copywriter to create the ad for you. You can find plenty of good writers on Elance.com (www.elance.com). While you will have to pay, you'll more than recover the price with your first job.

Or you can write the ad yourself. Use a headline that draws readers in and makes clear what you're offering ("Beautiful Wedding Photography for Small Wedding Budgets," could be enough to do the trick). Describe the services you're offering and what the client will receive as part of the package, and if you have testimonials from previous clients, include those too.

GETTING STARTED

Begin by picking four or five images that you'd like to use as samples. Write an ad that promotes your services (and don't forget to use spellcheck—nothing screams "amateur" louder than typos) and put it up at your local version of www.craigslist.com. Keep the ad up for a week and if you get a result, keep going. If you don't win a job, change the ad and try again or place two ads and see which one delivers first.

TIPS

FOR SUCCESS

(continued)

Use Different Ads for Different Services

Weddings aren't the only kinds of gigs you can land on Craigslist. There's no reason why you couldn't use the service to advertise your portraiture, actors' headshots and even product photography. But do use different, targeted ads for each service you're promoting.

A small business looking for a budget photographer to shoot their products for their website isn't going to read an ad for a wedding photographer, and placing a general ad for photography services gives photographers advertising specialized services an advantage.

It's free to advertise on Craigslist, so create one ad for each service you offer and keep them fresh.

Help Singles Find Love with LookBetterOnline

What It's All About

Spend any time surfing dating sites and you'll soon find yourself looking at a gallery of terrible images. Profile after profile feature snapshots, unfocused self-portraits, fuzzy webcam stills and pictures so old you can still see eighties leg-warmers hanging around the subject's ankles.

And yet these daters are paying around $25 a month and are hoping to find someone who will change their life.

A good profile picture then—a portrait that looks inviting, attractive and fun—would be something that every serious dater would be willing to pay for.

That was the idea that led Merav Knafo and Dave Coy, a former photographer, to create LookBetterOnline.com, a network of photographers that have agreed to shoot portraits of singles for a set fee.

Singles can select a package, choose a photographer in their area and make an appointment. The photographer then uploads the images to LookBetterOnline's website and at the end of the month, receives his or her commission.

If you're accepted, it's a painless way to accept a steady stream of one particular type of photography job.

What You'll Need to Shoot to Earn with LookBetterOnline

LookBetterOnline is pretty choosy about the photographers they accept. While anyone—including non-professionals—is free to apply, they will expect to see portraits that aren't just technically correct but also at least a little special.

SUMMARY

LookBetterOnline is a very neat service that's created an entirely new photography market. You won't need to do any marketing, and there are few things more enjoyable than seeing orders for profitable shoots landing by themselves with absolutely no effort at all.

The company is selective though and rejects around half the photographers who apply so you'll need to shoot well. And the rates aren't huge. Packages begin at $99 and you won't see all of that. LookBetterOnline sees itself as introducing photographers to clients rather than providing them with jobs. It will be up to you to turn those clients into higher payers by upselling and staying in touch.

Do the job right, after all, and you should be giving yourself a regular supply of potential wedding clients.

Display a portfolio of dull, cheesy portraits that look like they were shot in a shopping mall or taken off a passport and you're unlikely to join their list of photographers.

According to co-founder Merav Knafo, subjects should be looking straight at the camera, the shoot shouldn't be staged or too artistic and the portrait should appear as natural as possible.

That doesn't mean they can't be creative though. While you can certainly play with light and poses, the result should express character and above all, look friendly and inviting.

To gain a complete understanding of what LookBetterOnline is looking for, you can click the "choose a photographer" link on the site's home page and browse the samples of photographers who have already been accepted. If you can shoot images like those, you're in with a shout.

It's also worth pointing out that while your photos should look professional, your behavior needs to be professional too. Plenty of photographers have had their membership suspended for not responding to orders or missing bookings. To stay with the company, you will need to respond to messages promptly.

TIPS

FOR SUCCESS

Use LookBetterOnline as a Starting Point

A shoot for LookBetterOnline usually takes around an hour. Your commission for the shoot will be just enough to cover that time but it's not the sort of thing that's going to make you rich. That's why the company actually recommends that photographers try to sell their clients additional services once they have them in front of them.

Those services could a set of prints, extra shots, a CD filled with images of the shoot and anything else you can think of.

You should certainly regard every LookBetterOnline client as a future wedding photography client.

The most successful photographers on LookBetterOnline are those who see the company as the beginning of an opportunity rather than a stream of jobs.

Relax Your Subjects

The key to successfully shooting portraits for singles is to get them to relax. You'll be photographing people who aren't used to sitting in front of the lens, who will be worried about how the pictures are going to turn out and who will need plenty of direction.

(continued on next page)

TIPS

FOR SUCCESS

(continued)

LookBetterOnline's photographers use all sorts of methods to help their clients relax, from playing the client's choice of music to a pre-shoot chat to using a cable shutter release so that the photographer can talk and maintain eye contact.

You'll need to have a strategy that works for you.

Invest in the Bio

Unless you're the only LookBetterOnline photographer in your area, you will be competing for the attention of potential clients. The samples and testimonials will always be the most important factor in determining whether a client chooses you but your bio is important too.

An editor will tidy the text up for you before the bio is uploaded, but if you want to minimize the changes don't just copy and paste from your website. Explain why you're best suited to helping singles find love and what you're trying to do with your portraits.

How to Create and Market Images for LookBetterOnline

You won't need to market the services you provide for LookBetterOnline. The company has deals with a number of dating sites and does a pretty good job of marketing its services itself.

In fact, you'll be better off not marketing for LookBetterOnline.

Because you only receive a share of the fee paid, you'll earn more by asking your clients to send any friends who need their portraits taken directly to you. You'll be able to charge the same amount that LookBetterOnline charges—a fee that ranges from $99.99 to $199.99—but this time, you'll be able to pocket the entire amount.

Shooting the pictures though will take a little more thought.

Not all of LookBetterOnline's photographers have their own studios so you won't need to rent a space or invite clients into your home each time you win a job. Many photographers agree to travel to the client's home but if you don't have a studio you really should have a few scenic locations in mind that you can take clients to when the orders start coming in.

GETTING STARTED

You can apply to join LookBetterOnline by clicking the "photographers" link at the top right of www.lookbetteronline.com. You'll need to complete a brief application form that includes a request for your website URL so make sure that it contains some attractive portraits. If your images are good enough, they'll be in touch. www.datingheadshots.com offers a similar service but LookBetterOnline has a broader reach.

Take Your Cut with CutCaster

DIFFICULTY

COMPETITION

INCOME POTENTIAL

What It's All About

Perhaps the biggest challenge for photography enthusiasts who want to sell their images is knowing how much to charge for them. The correct price for an image is always the maximum that someone is willing to pay for it but how do you know if someone is offering too little if you don't how much buyers usually pay?

It's an obstacle that can cause problems for both sides.

Buyers use sellers' ignorance to snap up bargains on Flickr causing photographers to lose out. But buyers themselves sometimes can sometimes find themselves frozen out of deals because the seller has an unrealistic view of the value of his or her image. (Although in practice, most photography enthusiasts will take whatever deal they're offered. That just causes a whole bunch of new problems for professionals who find themselves priced out of markets that were previously willing to pay top-dollar for their photos.)

CutCaster is a stock site whose main advantage is that it tries to tackle the pricing problem head on. Rather than sell images at a low flat rate, like a microstock site, it uses an algorithm to suggest a price that the seller can choose to place on the image. The buyer is free to pitch lower than the asking price and the seller can ignore the algorithm to charge what he or she sees fit.

The result should be higher prices than you would get if you just left the selling to iStock and most importantly, a feeling that you are actually receiving what you're image is worth.

That's priceless.

TIPS
FOR SUCCESS

Keyword Carefully

Like all stock sites, keywording on CutCaster is critical. While you should be marketing your images yourself, you do want to get the full benefits of CutCaster's own marketing power—and certain keywords can also affect the algorithm's pricing.

Try to include as many relevant keyword terms as you can with all your images and check similar photos to make sure you haven't missed one.

Offer the Content They Want

CutCaster's "Desired Content" page may not be as dynamic as the prices on the site but it does have a trove of information about the sorts of images the company needs. Provide those pictures and you'll increase your chances of making sales.

SUMMARY

CutCaster was founded by a couple of Wall Street stock traders who wanted to bring the openness and dynamism of NASDAQ to the world of photography. The site might not look like something from Bloomberg, but the odd prices ($8.07 for a license of a photo of a white horse, for example) are a result of the algorithm playing with numbers to deliver something that's completely market-right.

But photographs aren't like shares in a company, which only have one use and whose value is tied directly to a company's earnings. The sorts of influences that can drive the price of a photograph up or down are opaque and that lack of clarity leads as many as 40 percent of CutCaster's contributors to ignore the automated pricing and put their own price tag on their images.

One of the reasons for that might be that the prices are fairly low—much lower than those that fotoQuote returns for contributors at PhotoShelter, for example. The prices of Royalty-Free licenses at CutCaster tends to range from $7 to $25.

That's still higher than you might earn for an image from a microstock company but CutCaster has a much smaller inventory than a large microstock firm—and far fewer customers.

CutCaster though certainly has its uses. Its algorithms provide a useful guide to prices that customers are willing to pay, its bidding process makes it easy to negotiate with buyers and its Studio storefronts allow photographers to keep their identity even as they add their images to a public inventory.

What You'll Need to Shoot to Earn from CutCaster

CutCaster isn't choosy about the images it accepts. There are no "gatekeepers," as the site puts it, to keep out people's images. There are however buyers and they tend not to be too interested in unfocused snaps with subject matter that no one can use.

Just because CutCaster will accept just about anything doesn't mean that you can sell just about anything on CutCaster. You still have to produce high quality, usable stock images that are well-tagged and easily used by designers and photo editors.

CutCaster's openness though does mean that you don't have to do too much to stand out on the site. Create a Studio (the site's term for a portfolio) that's filled with professional quality stock photographs and you'll give buyers a real benefit: a place they can rely on to supply the photographs they want without having to search through substandard shots.

As for the sorts of images you should be including in your portfolio, the old stock standards apply here too. CutCaster's list of desired photos includes action shots, places, healthcare, holiday themes and of course, corporate photos too.

To earn from CutCaster then, you'll need to shoot the kind of top quality stock photos that sell everywhere.

How to Create and Sell with CutCaster

Joining CutCaster is little more than a matter of complete a few quick forms. The site is free to join, earning its keep by taking a 60 percent cut of the sales price (or 50 percent for exclusive contributors.)

It's in the pricing that things get a little bit more complex. CutCaster's algorithm has a default starting price for photos of $5 which then rises or falls depending on a number of different factors. Lots of views and downloads, popular keywords, exclusivity and selling extended rights can all push the price up, while receiving a lower bid, a long time without a sale and uniqueness can all push the price down.

Ultimately though, it's best to use the algorithm as a guide to correct pricing. If you're prepared to accept the price it suggests, then leave it. If you think your image is worth more then turn it off, ask for more and see if the market agrees with you. It might but then again, you might have to lower the numbers in a few months' time.

Like all stock sites, CutCaster doesn't market to sellers specifically; it sells images to people who might need them. To sell *your* images then you'll need to tell people where they can find them . . . by placing your Studio's URL on your website, your Flickr stream and anywhere else potential buyers might see it.

That turns CutCaster into a tool, a way of transferring licenses and accepting payments and with such high commissions, a fairly expensive one. As you're earning with CutCaster then, pay attention to how many of the buyers are people you've brought in and how many come through the site's search engine.

GETTING STARTED

Getting started on CutCaster is as simple as surfing to www.cutcaster.com and opening a free account. Be sure too though to read the company's blog at cutcaster.wordpress.com and take a look at www.monkeybusinessimages.com to see one example of the sort of photographers contributing to the site.

Send Greetings with HarmonyWishes

DIFFICULTY

COMPETITION

INCOME POTENTIAL

$ $

What It's All About

HarmonyWishes is an online greeting card company that allows users to send fine art ecards customized with inspiring quotes, music and fonts to friends, family and clients.

The ecards are high quality both in terms of the images they contain and the decoration that comes with them. In part, that's because HarmonyWishes is very selective. Only a small fraction of the photographers who apply to the site have been selected and the size of each photographer's portfolio is kept deliberately small too.

Photographers may only upload six images per calendar quarter and all images are rotated every twelve months, although they may be resubmitted.

Customers pay an annual subscription fee of $19.95 that allows them to send as many ecards as they wish but the photographers themselves

SUMMARY

To charge photographers money to allow other people to pay to use their images sounds like a rough deal. In general, if someone is using your photos, they should be paying you. That's particularly true if they're paying someone else for the privilege.

For photographers then, HarmonyWishes can only justify itself if the photographers who use it are able to turn the fact that their photos—and their URLs—are now floating around the Web into income.

This is not a service that allows you to upload images and forget about them while the money rolls in. In addition to the sorts of cards that HarmonyWishes would want to accept, you'll need a website, you'll need products and you'll need sales copy that can turn visitors into buyers.

(continued on next page)

receive none of that money. In fact, they too have to pay the membership fee, although that also allows them to send cards.

The main benefits lie in the fact that the cards are sent with the photographer's name and URL.

In effect, HarmonyWishes charges $19.95 for a year of viral marketing.

What You'll Need to Shoot to Earn with HarmonyWishes

HarmonyWishes offers a very special range of images. Divided into three categories—belief; beauty; and being—the photos are meant to be positive and uplifting. Owner Meg Matlach has described the service as "the prayer flag of ecard sites."

She has also made it clear that it's not a dumping ground for unsold stock photographs.

Perhaps the most important characteristic of images offered by HarmonyWishes is that they're inspiring—and what they should inspire is a sense of harmony. So photographs of Buddha statues, exceptional landscapes and interesting activities or people could stand a good chance of being accepted.

Rejection is at least as likely to be because the subject doesn't fit the site's narrow needs as because of the quality of the image.

How to Create and Market Images for HarmonyWishes

There's little point in shooting images specifically for HarmonyWishes. The acceptance rate is relatively low and the difficulty of turning into customers any recipients who receive your card and visit your site mean that it's probably not worth setting out deliberately to make use of the service.

But if you do have the sort of beautiful, inspiring images that could fit HarmonyWishes, then it might be worth sending them in and signing up.

You will, of course, also need a website that can convert those visitors.

That means you'll need to have a range of different products that you can tempt people to buy. Printed postcards could be one option, prints and posters a couple of others. It's always a good idea to offer a range of different price points so that you have something for buyers of every budget.

One particularly good solution will be to use the URL on your card to guide viewers to a selection of images that they can purchase as a print-on-demand book such as those produced by Blurb or Lulu.

In effect, that would allow you to use HarmonyWishes as a marketing tool to spread samples from your products to a select market.

It is important to note though that HarmonyWishes's market is very select. The site has a very New Age-y feel so you will need those sorts of images to be accepted to HarmonyWishes and a large enough collection of them to be able to offer an entire product range.

GETTING STARTED

Before you apply to join HarmonyWishes, first browse their site to understand the sorts of images they offer, then browse your own site to make sure that you have products that could appeal to people who like those sorts of spiritually uplifting images.

If you match, hit the "submit images" link at www.harmonywishes.com, sign up and hope you're accepted.

TIPS

FOR SUCCESS
(continued)

Use the Cards for Your Own Marketing

One way to make sure that you are getting the most out of your annual subscription fee is to send out cards yourself. Mass emailing a sample image to clients and potential clients could be expensive itself, especially if you wanted to spruce up the picture with an attractive border and add text in a way that's inviting rather than disruptive.

Using HarmonyWishes to send your own cards to clients could be a valuable way to bring those clients back.

Use the Cards for Announcements

And you can also use the cards to make your own announcements and even send exhibition invitations.

Every time you create a new Blurb book, for example, or upload a new collection to Flickr, you could send out ecards from HarmonyWishes to let people know and bring in customers and traffic. Again, you'd still have to make the sales but HarmonyWishes could give you some valuable marketing.

Get Sticky with Stickers

DIFFICULTY

COMPETITION

INCOME POTENTIAL

$ $

What It's All About

We've seen that Moo's MiniCards could be a valuable way to spread your images and your name. But Moo cards, once given, tend to be stashed away in card holders or drawers. They have an impact at the time they're given but unless they're then pinned to a noticeboard or attached to a fridge door, there's always the chance that that impact will decline fairly quickly.

Stickers though tend to stick around. Placed on items that are used every day such as bags and notebooks, they act as a constant reminder of your talent. Featuring carefully chosen images and marketed to select audiences they can turn into useful little moneymakers.

There are a couple of very easy specialist options for producing your own stickers.

Moo supplies sticker books as well as cards. For $9.99, you get a fifteen-page sticker book with six stickers on each page. Each page is a removable tearsheet and can be distributed separately or you can personalize the book itself as a complete product.

Alternatively, Qoop lets photographers print 30 two-inch square stickers for $4.99 or eight larger stickers for the same prices.

What You'll Need to Shoot to Earn with Photographic Stickers

In theory, you can shoot anything you want and place any images you want on stickers. You can certainly have a great deal of fun playing around with different images and different effects.

Bear in mind though that the stickers are going to be pretty small. Moo's stickers are just 171 x 171 pixels so anything with lots of detail is going to look fairly unclear.

44 Get Sticky with Stickers

SUMMARY

Moo's stickerbooks in particular, are attractive and neat, and with the ability to include 90 different images in each pack, flexible too.

The benefits are two-fold. Photographers can use them to market their images, sticking them in places where their pictures are going to stay visible for a while.

And they can be sold as products too, especially to parents and grandparents of small children.

But reaping those benefits is not going to be too easy. There aren't many places to stick your photos that are appropriate and likely to be seen by clients or image buyers. And even at just over one cent per sticker, reselling stickerbooks for a profit is going to make them an expensive purchase, especially when parents are buying them for children.

The stickers themselves don't allow room for text so viewers will need to know that the images they depict are yours and, of course, it's one thing to show lots of people your pictures but if you don't have systems in place to sell them, then you're marketing for nothing.

On the other hand photographic stickers are creative, attractive and unique enough to stand out. They make fantastic gifts, beautiful products and as marketing tools, they're always unmissable. Used carefully and in conjunction with effective sales channels, they have the potential to be very effective.

One good option is to make use of the advantages of photographic printing. While it is possible to use cheaper printing services than those supplied by companies such as Moo and Qoop, it's likely that the quality will be lower and the color range more restricted. If you're paying for the higher quality, it's worth using images with bright colors and bold shapes.

Close-ups of flowers, for example, might work well but rather than shrink your images to fit, think about where and how you can crop them for the best effect.

Another approach is to create sticker sets. Photographers have created some very attractive—and desirable—sticker books based on images of dolls, pet hamsters and food. That makes them collectible, swappable . . . and sellable.

TIPS
FOR SUCCESS

Crop the Images You're Selling

If you're using stickers to sell photography products then create stickers from the images you're selling but crop them closely.

The stickers then will allow the recipient to own a small part of a beautiful image but they'll also create curiosity that will drive them to visit your portfolio to see the entire picture.

That does mean that you'll need to place them where they can also see how to view the remainder of the image. Attaching them to the back of business cards could work but so could envelopes and postcards.

Target Teachers and Parents

Children are nuts about stickers; grown-ups less so. But children have small budgets so if you're selling your stickerbooks, focus your marketing on parents and teachers. Emphasize that they're paying less than two cents a sticker and that the pictures are unique and exciting. Produce themed collections and older children in particular will want to keep up with their collection.

(continued on next page)

TIPS

FOR SUCCESS

(continued)

Refresh Your Collection

Themed stickerbooks can be very effective but only as long as there are more stickers to own. If your stickers are selling, keep producing new sets to maintain interest.

How to Create and Market Sticker Images

If you're using Moo to produce 90 different images, it will be time-consuming. You can upload multiple images at the same time but you will need to crop them to make them fit the sticker size.

And if you're creating a themed sticker book, you'll also need to shoot 90 different images. That's a lot of photography, so you may as well relax and enjoy it!

Moo does make it possible though to upload images directly from photo-sharing and social media sites, including Flickr and Facebook, so if you already have a good set of images then you might be able to save some time.

To create the stickers using Moo, simply click the stickerbooks link on the products page, upload, crop, personalize the covers with your name and URL, and start printing.

It's the marketing, of course, that's going to be tricky.

If you're using the images to market the photography products you already have available then you'll need to stick them where people already know where to find you. In effect, the stickers will allow you to show off your samples in places where you wouldn't normally be able to place an image. A number of photographers place them on the backs of envelopes, for example.

If you're planning to sell the stickerbooks either as complete books or individual tear sheets then you'll really need to choose your markets very carefully. Moo stickers have proved popular with teachers who use them as rewards. Themed stickerbooks can be marketed on specialized websites; you can try leaving comments with a link to a purchase page in forums and on blogs that discuss the subject. Create multiple books and you'll make the stickers tradable, ensuring repeat sales.

GETTING STARTED

Moo's Flickr group at www.flickr.com/groups/moo is filled with creative ideas. Start by reading the discussions and looking at the images, then choose 90 of your own pictures and create your first stickerbook. Or use www.qoop.com. You'll soon be hooked!

Connect with LinkedIn

45

DIFFICULTY

COMPETITION

INCOME POTENTIAL

$ $ $

What It's All About

Work and business have a habit of going not to the best person for the job but to the best person the buyer or hirer knows.

It's always much easier to give work to a friend, an acquaintance or even a friend of a friend if they come with references and a thumbs-up from someone you trust than to make a deal with a stranger and hope it all works out.

That's just as true of photography sales. Commissioning editors, in particular, say that they prefer to give work to a photographer they know; it's the best way to be sure that they're going to get back exactly the images they need.

None of this though is very helpful when you're not a full-time photographer with tons of experience and an address book full of buyers and clients. It just means that you're cut out of the loop whenever jobs that you can do are placed on offer or buyers are looking for prints to order or images to license.

LinkedIn provides one way to build lots of valuable connections fast.

It's not a sales channel. You won't be able to use LinkedIn to show off your images, license photos directly or offer prints. But you will be able to use it to build connections in the photography world, get to know potential buyers and increase your profile.

What You'll Need to Shoot to Earn with LinkedIn

LinkedIn is probably not the best place to get to know art buyers. It's a business-oriented site so you want to create the impression that you can create the sorts of pictures that companies need—stock images, product photos and perhaps photographs to decorate offices too.

TIPS
FOR SUCCESS

Use the Groups

There are now a number of photography groups active on LinkedIn. Some state explicitly that they don't want photographers soliciting for work but you shouldn't need to.

Join the discussions, ask questions and answer them when you can and you'll generate interest and bring potential buyers back to your profile.

Say What You're Working on Now

LinkedIn has copied Twitter, a service for sending short public messages, and now allows its members to write short posts that describe what they're working on now. It's not quite clear how many people read these posts—LinkedIn isn't the sort of site that people visit every day—but it does provide a useful way to keep your photography projects up to date.

Whenever you begin a new project, take a minute to describe what you're working on so that any connections who need similar work can get in touch and ask you to do the same thing for them.

(continued on next page)

SUMMARY

LinkedIn can be a useful way to get to know people who might be willing to ask you to shoot jobs or who could be looking for images for their businesses. It has advantages but it's not perfect.

Unlike other social networking sites such as Facebook or MySpace, LinkedIn users understand that other members on the site are using it for business. They won't be surprised or offended to find someone offering their services and they might not be unwilling to pass your name along to someone they know either.

But the connections have tended to be shallow. Facebook will allow you to show off your images, join groups and chat with other people—even if only a fraction of those people are potential buyers. LinkedIn has usually served as an opportunity to do little more than make an introduction. Its relatively new group service now allows members to do a little more than that . . . but you will be networking in a crowded room with a lot of competition.

Overall, LinkedIn is really a vital tool for anyone looking to network for business. You only need to create one connection to produce a steady stream of income.

You can only place one photo on your profile—and that's going to be yours—so you won't be able to show off your images. But you can place multiple websites URLs on your profile so it might be worth creating a unique website or even a blog that markets your photography as a business service, whether that's helping companies to market their own products or decorating their walls.

How to Create and Market Your LinkedIn Profile

LinkedIn offers a range of different account options from a free service that lets you sign up, create a profile, receive requests for introductions and send out up to five introduction messages at a time, to Pro membership that lets you issue 40 invitations—and costs $499.95 a year.

Create a free profile first then when you're ready to start actively networking, move up to a Business account that costs $24.95 a month but which also lets you view full profiles.

45 Connect with LinkedIn

What you put on that profile is always going to be vital. LinkedIn doesn't give you a great deal of flexibility. Its profiles are intended to be resumes rather than personal introductions.

For non-professional photographers, that creates an additional challenge. The experience and education fields will contain details of day jobs rather than the work you might have done as a photographer—or the work you would like to do as a photographer.

One option is to use LinkedIn solely as a tool for photography networking. You can use as many of the fields as possible to talk about your photography experience. So in the education field, you might list any workshops you've taken and under experience, you could describe any shoots you've done, work you've sold, websites through which you license your images and art fairs at which you've shown your photos.

But that would prevent you from using LinkedIn to further your own professional career so another option is to talk about photography only in the Additional Information section at the bottom of the profile. One profile would then be able to serve two purposes.

Marketing your LinkedIn profile and building those connections is all about networking but do make sure that your profile is public and that you've selected "Full View" so that everyone can see it. You should also change your LinkedIn URL so that it includes your full name. LinkedIn profiles tend to receive high returns on Google, something you can improve further by linking to your profile on your website or in blog comments.

GETTING STARTED

Start by signing up for a free profile at www.linkedin.com.
Complete your profile and start building your network. You might well be surprised by who you can find on the site!

TIPS

FOR SUCCESS

(continued)

Use LinkedIn for Background Checks

One of the more helpful uses of LinkedIn is the ability to perform background checks on people who have asked you to perform shoots for them, something that's especially important if they insist on paying on delivery of the images.

But you can also search on the site for any other clients you pick up. Shoot a wedding for someone, for example, and you'll be able to check who else they know . . . and whether they know the sort of people who might like to buy your images.

Find Local Distributors for Your Local Images

What It's All About

Start taking pictures and it won't be long before you have a hard drive filled with images of your local landmarks. They're easy to reach, you know the best times to shoot and you can return again and again until you find exactly the right time, the right angle and the right technique.

There's a good chance then that while your trip to Yosemite might have given you the best opportunity to produce beautiful landscape images, your best pictures were shot in the local wood, on the beach a short drive away or outside your local mission.

Selling those images might seem difficult. After all, there may be more beautiful locations in the world, but in fact there is a market for photographs of local images: locally.

Souvenir stores have to source postcards from local photographers and bookstores are often happy to offer posters, calendars and even professional quality photography books created by local authors. Because the scenes they depict have a special meaning to the people who see them—a meaning that goes beyond the photo itself—photographs have a local market.

But placing them in stores isn't easy. Target a branch of a large store and you'll have to talk to head office, the sort of place that handles calls from sellers every day and knows how to say "no."

But target a small independent store and you'll be in with a good shout—provided you prepare your pitch carefully.

SUMMARY

Get your images into local stores and you'll be well on your way towards generating a useful little additional revenue stream. You won't be able to find too many outlets so it's unlikely you'll be earning a fortune but you will have the satisfaction of being able to walk into a store and see your pictures on display. It shouldn't be too hard then to maneuver yourself into the position of being not just a local photographer but your area's photographer, the person who is known for recording the surrounding area in digital imagery.

But you'll need products—prints, calendars, cards and anything you else can think of that might sell—and you'll need the flexibility to be able to produce them regularly.

And you'll have to get them into the stores in the first place, a process which can be time-consuming, difficult and, if not done carefully, often fruitless.

What You'll Need to Shoot to Get Your Local Images into Local Stores

People will buy locally shot images for two reasons: they'll buy them because they're beautiful photographs; and they'll buy them because seeing their local area made to look beautiful gives them a sense of pride.

The images you'll need to shoot then should look familiar. Buyers should be able to recognize the scene they're looking at . . . and feel that they couldn't have shot a picture that good themselves.

The products themselves can be varied. Prints are always hard to sell but calendars tend to move quite well and postcards, even though they have low profit margins, are often good sellers too.

How to Create and Market Your Local Images to Local Outlets

Both creating your products and placing them in stores will represent a challenge.

Although there's a range of different printing options now that allow anyone to easily create products from canvas prints to postcards, the costs usually mean that the profit margins are tiny. The price will need to include your costs, your profits and an additional 30-50 percent for the store so

TIPS
FOR SUCCESS

Use Publicity

Stores don't want to waste valuable display space on items that they're not certain will sell so the more confident you can make the store owner that there is a market for your products, the higher the chances that they'll take them.

Few things inspire confidence more than a write up in a local newspaper, and it's really not as hard as it sounds.

The press is desperate for stories to write about so if you can turn your photography into a story that could interest a local audience and turn it into a press release, you should find that you get a write-up in the local newspaper. Show the article to the store owner and he'll know that you've already sparked interest and are starting to build a market.

Use Business Cards

You will need business cards for this sort of pitching. It shows that you're a professional and enables the store owner to keep in touch with you easily to let you know how the sales are going and place more orders.

(continued on next page)

TIPS

FOR SUCCESS

(continued)

This is an excellent use of Moo cards. Place some of your local images on the cards, give the store owner several to place on his office noticeboard and you'll be demonstrating the use and value of your images.

Promote Your Products

It's very tempting once your products are in the store to leave the store owner to do the selling. But it's a bad idea. The store owner will promote the store; you'll need to promote your products yourself.

When you pitch your products, indicate too that you'd be willing to promote your goods with talks on photography or local landmarks, or do signings.

It might help you to land the placement, win sales and turn yourself into a local celebrity too.

you'll need tell the store your wholesale price and recommended retail price. You'll usually have to sell large volumes of products to make a reasonable amount of money but when you're only selling in local stores that's a lot harder.

One solution is to create a product range in which the profits on some items are higher than on others and the low-cost items create a market for the more expensive products. Once people start buying your postcards, for example, they might be more likely to buy your calendars and your books. And your prints.

To place those products in stores, you'll need to make an appointment with the store's owners. Create a list of local, independently owned outlets that sell products similar to yours and hit the phones. Explain that you're a local photographer and that you have a specialist range of unique products that would appeal to their customers.

Not all will agree to meet you but when you turn up for those who do, make sure that you look professional, that you know your price points and can deliver in bulk if the products take off.

GETTING STARTED

The process of trying to get your products into local stores isn't long. Make a list of six to eight outlets that stock products similar enough to yours to be good prospects.

Create samples of the products you want to sell and calculate the price you'd need to wholesale and retail them. Don't create more than a sample line at this stage though. If they don't sell, you don't want to be stuck with them. And if you don't have business cards, then design and purchase a set, perhaps at www.moo.com. You'll need them!

Finally, hit the phones and start pitching for appointments. Sound confident and professional, and if you want to use publicity to promote your deals Paul Hartunian at www.hartunian.com has plenty of useful material.

Decorate Cafes and Restaurants with Your Photos

47

DIFFICULTY

COMPETITION

INCOME POTENTIAL

What It's All About

However you decide to sell your images and however great the satisfaction that comes with making a sale, there are few things more thrilling than seeing your photographs printed, framed and mounted on walls for the public to enjoy, admire . . . and buy.

But placing your photographs in galleries is notoriously difficult. Gallery owners, who depend on commissions, want to be certain that your images will sell so they'll be looking for a track record of previous exhibitions and sales. Just having great pictures may not be enough.

An alternative route that many photographers have taken recently is to mount their images in cafes and restaurants. These may not be as prestigious as galleries, but they're much easier to approach, they field fewer enquiries and the risk of an exhibition failing to make sales won't cost them anything.

In fact, a café that takes an artist's work can only gain. The owner gets some unique decoration for his walls, he picks up extra business from people coming to see the exhibition, he's seen as someone who supports local businesses and he may even receive a share of the sales revenue.

What You'll Need to Shoot to Show Your Images in Cafes and Restaurants

One important difference between galleries and cafes and restaurants is that galleries know their buyers. They know what local art collectors are looking for, they can bring in collectors interested in a particular type of image and they aren't afraid to offer works that are a little avant garde if they believe they can find an audience for it.

TIPS
FOR SUCCESS

Mark the Opening

The most important time for an exhibition—even one that takes place in a restaurant—is always the opening night, so make a big deal of it. Hold it on an evening that's usually quiet for the restaurant and work with them to bring people in.

Sell Postcards and Books

Not everyone who enjoys the sight of your photographs on the wall will want to buy a print but they might be willing to buy a postcard or a photography book. Ask the café owner if you can leave a few copies of each by the counter or somewhere else where they can be easily spotted, and let them earn from each sale.

Match Your Images to the Establishment

Some images are always going to better suited to some establishments than others. Although you should be able to pitch attractive landscape images just about anywhere, if you can match the subject of your photographs to the theme of the restaurant, you'll be helping with your branding and you'll be showing your images to a targeted market too.

SUMMARY

Cafes and restaurants now represent a huge opportunity for photographers looking for an easy way to land their first exhibitions. Provided your images are good enough and you prepare your pitch well, there's no reason why you shouldn't be able to persuade at least one café or restaurant owner to show your work.

And exhibitions like these can get results. It's not unreasonable to expect to make sales on the first day of the show and to generate dozens of sales in the days following.

While the way in might be relatively easy, a successful pitch will take a little work. More importantly, there will be plenty of work to do after you've won the agreement. The images will need to be prepared and the event itself will need to be publicized.

That's a responsibility that shouldn't be left to the café-owner.

Dining establishments—and their customers—are likely to be much more conservative. A café owner will want first to make sure that your photos will match his establishment. A collection of glamour or boudoir shots, for example, might be a difficult sell in a family restaurant. Beautiful images from your trip to Italy though could be an easy pitch to a local trattoria.

In general, you'll probably find that landscapes and nature images are the easiest to offer but don't be afraid to also look for themed cafes or even bars if you're looking to exhibit something a little more edgy.

How to Create and Market Your Café Exhibition

The easiest way to get your images on the walls of cafes and restaurants is to get to know the owners of cafes and restaurants.

If you're a regular at a local eating hole, get friendly with the staff. Talk about your photography and show them your images. It's not a process that will happen overnight but if you can generate interest in your work naturally, then you should find that the exhibition comes naturally too. Some photographers have even found that friendly owners have bought the images themselves to decorate their restaurants.

Cold pitches though aren't too hard to make either.

You'll need a portfolio ready to show off your pictures and it's a good idea to take at least one printed and framed sample so that the owner can imagine them hanging on his walls.

When you make your pitch, emphasize how much your images will match the café's atmosphere and talk too about how you'll be marketing the exhibition. If the owner feels that he's getting more customers as well as temporary décor, he'll see your offer as a free marketing proposal and one that's hard to turn down.

You'll then need to create all of the images and that will involve an expense. You'll have to pay for the images to be printed, mounted and framed, an investment that could be quite large depending on the number of images you're planning to exhibit.

Make sure then that those expenses are factored into the price of the images. It's unlikely that the exhibition will be a sellout so you'll want to recoup your expenses and generate a profit with just a few sales. Exactly how many will depend on the sort of customers the café has. You'll need low prices at a cheap café but you can charge a lot more if you can persuade a swanky restaurant to display your images.

To market the exhibition, you'll want to pull out all the stops.

Use a press release to bring the media in on opening night.

Create invitations and send them out to everyone on your mailing list, gallery owners, critics and local figures. Distribute them at art centers, museums and theaters.

Place announcements in the local media and use social media sites such as Flickr and Facebook to spread the word.

GETTING STARTED

Have a cup of coffee. In fact, have several. Take a tour of the cafes and restaurants in your area and see which ones are already exhibiting artists' works. Make a note too of any venues that have a connection with the subject of your images.

Print and frame one sample image, create a slideshow of your portfolio and hit the phones to make those appointments.

www.cafespot.net has a useful list of independent cafes to target.

Give Pictures to Non-Profits

DIFFICULTY

COMPETITION

INCOME POTENTIAL

$ $ $ $

What It's All About

Giving your images away can often be a bad idea. If someone is using your photos or enjoying them, then there's a chance that they might pay for them—and you should be paid for them.

Sometimes though an image donation can be a good way to create an opportunity for sales. Buy one, get one free offers have long been used by marketers to drum up business and free samples are often the only way to demonstrate to a potential buyer the benefits of the offer. Even stock companies today offer free low-quality images to persuade people to buy higher-quality versions.

Giving something away in the hope that the recipient will later pay can turn out to be a smart move then. But it's even better when the people you're giving your images to are also a cause that you support.

Working with non-profits can be very rewarding for photographers, both professionals and enthusiasts. Those rewards will always take the form of the help you're providing but they've also been known to take the form of referrals, purchases and even the beginnings of a whole new second career.

What You'll Need to Shoot to Earn from Non-Profits

The images you shoot will need to be directly related to the subject of the non-profit. But that still gives you a huge range of subjects—or non-profits—to choose from.

If you like shooting landscapes, for example, you could try teaming up with a local environmental group.

If you enjoy photographing wildlife, then volunteer with a conservation group.

SUMMARY

Non-profits really can be a huge source of work for photographers looking to earn income from their images. Plenty of pet photographers, for example, have seen their careers take off as result of the encouragement and referrals that they received while volunteering at animal shelters.

But while those opportunities are certainly there, it's not a good idea to rely on them.

To get these referrals and the publicity that comes from seeing your image printed, together with your name, in the group's newsletter and publicity materials, you will have to give up plenty of free time first. Nor are there any guarantees that that time will translate into paid work.

The best strategy then is to approach volunteering with your camera as a worthy thing to do in itself . . . and look for the opportunities as they arise.

And if children's portraits are more your thing, then you shouldn't have to look too far to find a charity that works with disadvantaged kids or poor families.

Those are the images you'll need to show other volunteers and officers at the organization so that they know you enjoy photography, that you'd be happy to put your photography skills to use on behalf of the organization . . . and that you are available for paid work too.

And if those hints work out, those are the sorts of images that you'll be shooting for the non-profit, and eventually for profit.

How to Create and Sell Images for Non-Profits

Call up a non-profit, even one that's directly in your field of interest, tell them that that you're a photographer and that you'd like to volunteer your services, and there's a good chance that you're going to be given a polite refusal.

Any group you call will already have its own way of sourcing images and an offer from a stranger, however talented or well-intentioned, is unlikely to persuade them to give up their trusted source for someone they don't know.

At best, you'll be asked to send your images in and told that they may use them in the future.

TIPS
FOR SUCCESS

It's All In the Networking

Once you're volunteering at a non-profit, it will be up to you to let people know that you're a photographer and that you're available for commissions or that your prints are for sell. The main form of marketing in this field is going to be word-of-mouth, so this is no time to be shy about your talent.

What you should find is that if your images are good, you'll get plenty of encouragement and because you're volunteering, people will want to see that you're rewarded.

Look for the Spiritual Rewards First

There are no guarantees here though. Not all non-profits will need images and not everyone will want to buy them. Always volunteer because you want to volunteer. Only when you're in should you try to use this part of your life to improve the rest of it.

(continued on next page)

TIPS
FOR SUCCESS

(continued)

Don't Wait for the Results

A non-profit can turn out to be a very valuable source of referrals and jobs but don't wait for those jobs to start coming in before you start marketing yourself. Launch your website. Start marketing for work. And tell the other volunteers what you're doing when you're not counting barn owls or entertaining children.

They'll be even more inclined to give you referrals when they see that you're serious about photography.

That's not the best way to profit from a non-profit.

A better option is to win trust first. Find a non-profit that you'd like to help, and volunteer. Do it because you'd really like to lend them a hand, and if you can also do that through photography, so much the better.

Once you're volunteering and making friends, let people know that you're a photography enthusiast. Bring your camera to work and show off your images. Let the organization's publicity and campaign managers know that you'd be happy to help out with creating images for their website, their blog, their grant proposals and their promotional materials.

And tell the other volunteers that if they know anyone who'd like their pet, their child or their family photographed, or who would like to buy a landscape photograph, you're available for occasional commissions and for purchasing prints.

Getting your foot in the door will be very easy. You will, after all, be offering your time for free. Moving from volunteering in the way that the organization would like you to volunteer to providing help with your camera will take a little maneuvering.

But in time, and with a lot of talking, it should happen and from there, you can find that your new little business line can go anywhere. Photographers who started at non-profits have been known to end up charging over $2,200 for a two-hour shoot.

GETTING STARTED

Kick-starting a photography business—even a small one—using non-profits is possible. Photographers have done it. But it's a process; it's not something that happens overnight. Begin then by finding a non-profit for which you'd like to volunteer. Give them a call and ask if they need any help.

Once you're in and lending a hand, begin your networking by offering to supply free images to the organization. Animal charities such as www.gadab.org might need portraits of strays, for example, while children's charities such as those listed at www.childrenscharities.org could want photographs of their activities. Become the group's photographer and it won't be long before you're everyone's photographer.

Understanding Niches

What It's All About

Photography is a very crowded industry, and one that's likely to become even more congested in the future. As the quality of cameras rises and their prices fall and as the barriers between image users and image producers continue to drop, so the competition will become increasingly tougher for photographers hoping to sell their photos.

Already the effects of that tightening competition can be seen in the falling prices of stock photography as well as the difficulty that photojournalists are having finding and keeping jobs. (Even *The New York Times* has begun telling its photographers to shoot video footage as well as stills.)

One way to dodge the competition is through increasing specialization. Instead of shooting portraits, you shoot portraits for online daters. Or you shoot them in a particular style. Or you only shoot the portraits of retirees or military personnel.

You might be restricting your market, but you'll be giving yourself an opportunity to dominate completely one small branch of photography.

Your marketing will be a lot easier, the satisfaction that comes from being the best in your field—even if that field is small—will be much greater and you'll be able to charge more for your perceived expertise.

All you have to do is find the right niche for you.

What You'll Need to Shoot to Earn from a Niche

You can shoot just about anything to earn from a niche. In fact, the more creative your specialization, the lower the number of competitors you have.

In general though, you can divide niches into subjects and styles. Subjects could include:

SUMMARY

Shooting in a niche is almost a necessity for photographers these days. Unless you have your own studio, whether it's in a mall or your town center, and can take a sizeable chunk of general business just because of your accessibility, carving out a niche for yourself will always make selling easier.

You'll become familiar to your market, your talent will become known through word-of-mouth and it won't be too long before you're able to pick and choose the work you want to do.

And the best thing about choosing to specialize is that you'll be shooting in a field that you genuinely enjoy.

Underwater Photography

Some photographers have carved niches for themselves by specializing in shooting models in swimming pools or sharks in the sea. You'll need special equipment but if you're into Scuba and swimming, it's one to consider.

Sports Photography

If you loved surfing as kid, or enjoy golf, or get a kick out of go-karting, you'll know more about that sport than most other photographers. That means you'll know the best locations, the best shots and the right people to shoot.

Slow Motion Photography

Another specialization that requires some special equipment but which can yield some spectacular results. It also offers the opportunity to specialize even further. One photographer has won some very valuable commissions based solely on the sculptures he creates with water drops.

As for styles, photographers have managed to build businesses large and small based on:

Photojournalism

Not just for news, there's now an entire school of wedding photography dedicated to shooting weddings naturally and informally. Other photo-

graphers create portraits by following their subjects like paparazzi to create natural-looking images.

Photoshop

Your photography can be just the start of your creativity. Photographers with design skills have won contracts from companies as large as Nike and Coca Cola by mixing their designs with their photographs.

Lighting

Light your images in a special, distinctive way and buyers will know what to expect from you.

Find a style or a subject that suits you and that you want to explore in detail, and if there's a market for it, you should come to dominate it.

How to Sell Your Niched Images

There's a huge range of different ways that you can sell niched images. Stock sites are one popular choice both through established stock companies and through sites built by the photographers themselves.

Approaching specialist stores can work too but as we've seen, the pricing is often difficult—profit margins are low so you'll often need to get your products in many stores to see any reasonable income—but once you've done the initial marketing, the revenues should be fairly stable.

Flickr too can be a great choice to show off your niched images. Creating a group on the site will portray you as an expert, and the site is often used by buyers looking for unique images. Just be sure to keyword your pictures to make them easy to find.

GETTING STARTED

Start by choosing a niche but don't think too hard about your selection.

Ideally, your choice of niche should grow organically out of your interests and the sorts of images you're shooting anyway rather than what you think will sell or what you believe other photographers are ignoring.

Once you've made your choice though, start shooting, upload them to www.flickr.com, create a group and start networking.

TIPS
FOR SUCCESS

Choose a Niche You Love

Finding a niche that hasn't been discovered already isn't easy. It's tempting then to leap on a good idea as soon as you have it. But the real secret of success in creating a specialization isn't just finding a niche you can conquer or one with a market.

It's having a passion for it.

You're going to become an expert in your niche, the person buyers turn to first when they want an image in your field. You'll be expected to know everything about it and always to produce top-quality images on your topic or in your style.

You'll be shooting these images a lot, so it pays to enjoy them!

Give Advice

And you won't just be shooting a lot of these kinds of images, you'll also know a lot about them.

Sharing that knowledge on a blog or on Flickr will show that you're the leading expert in the field. While it might create a certain amount of competition, it will also create interest and build a market—one that you dominate.

50

The Power of Upselling

What It's All About

The hardest part of selling anything is bringing in the customers. You have to identify your market, figure out what makes them buy and test different sales pitches until you're sure you're generating the highest conversion rates you can.

When you do land those customers, it pays to hold onto them—and to squeeze as much business out of them as they're willing to give.

Part of that comes from delivering great service. Promising just enough to win the job and delivering more than the customer expects is always a good strategy for turning customers into loyal clients. But part also comes from using the deal to deliver more than the customer expected to buy.

Wedding photographers do this all the time. They'll make a deal with the client to produce a set number of images or albums, but when they deliver at the end of the shoot, they'll also offer extra prints or copies of the

SUMMARY

Upselling is a standard marketing strategy used to increase the value of a deal. Done correctly, it can turn a small deal into a medium-sized purchase and a medium deal into a large one.

But it has to done carefully. The benefit of upselling is that you may end up selling more images but the risk is that you'll irritate the client and lose the chance of a referral that may have brought you even more income.

Reducing that risk requires a combination of timing, understanding your customers and providing a product range that makes your offers easy, persuasive and desirable.

pictures that didn't make the final cut. Often, the clients will end up paying more than they intended but still walk away happy with the purchase.

It's not a strategy that's restricted to wedding photographers though. Just about any photographer can do it and with almost every sale.

What You'll Need to Upsell

Perhaps the most important thing you'll need to upsell successfully is flexibility. You'll need to be able to break up your services and products into separate parts so that you can sell them as individual extras, or bundle them together to increase value.

So a pet photographer might offer different-priced packages made up of shoots of different durations and a variable number of prints. But at the time of delivery, she could point out the value of additional prints, prints of a larger size or a disc containing all of the outtakes.

A stock photographer could offer additional images at discounted rates or copy the major stock companies and offer subscriptions that lock in the customer in return for lower priced images.

A photographer selling a print could offer a smaller version of the image, a higher quality frame, postcards or a photography book at the point of sale.

As long as you have more than one type of product and your range comes with different prices, there's no limit to the creativity you can put into making additional offers when the time comes for the client to make the payment.

How to Upsell

How you make the offer is always going to be crucial. You've already persuaded the client that you can do the job they want. You've landed the sale and you're going to make money. You want the client to come back in the future and you want him to pass your name on to friends, family and colleagues too.

Create the impression that all you're interested in is the client's money rather than doing the job he wants and you put all of that good feeling and all of those potential benefits at risk.

The client has to feel that he's walking away with an even better deal than the one he signed up for in the first place. Ideally, he should feel that he's only receiving this better deal as a reward for signing up.

TIPS
FOR SUCCESS

Plan Ahead

While you don't want to look like you've planned extra deals in advance, that doesn't mean you shouldn't. In fact, you should know what sort of products you have available and which of them would be most likely to appeal to the client.

You don't want to lose a larger deal because you forgot that you could have offered more prints or a larger picture.

Start by Downselling

Offer a range of different packages and you'll be able to appeal to buyers with different budgets. Don't be too concerned then when a buyer takes your smallest offer.

It just means they trust you to do the work. They might still be willing to pay a little more to receive a little more.

Don't Push Too Hard

A successful upsell should really be the cherry on the cake but it's not the cake itself. The offer has to be seen as a way of giving the client extra so if he doesn't want it, back off.

The referral will always be worth more.

So value is going to be a vital part of successful upselling. If you're selling a print, for example, then good upselling would be to offer a second print at a lower price.

If you're closing a wedding package, then offering extra images at a lower price per shot than they're already receiving looks like a great deal.

And if you're selling a license for an image then suggesting a bulk offer could turn a deal for one picture into a deal for ten.

You can also offer services that you don't provide yourself in return for a commission. Wedding photographers, for example, often work with videographers and make-up artists while portrait photographers might offer the services of hair and make-up artists. Those are services that the client will need. You'll be helping her by providing a recommendation; you'll benefit by making a deal with the service provider.

When you make the offer is almost as important as the offer itself but it's also an element that's much harder to define with certainty. Because the client should feel that you're doing him a favor, you don't want to look as though you've prepared the deal in advance. You'll have look for an opening in the conversation that allows you to offer an extra naturally.

It's a skill that often comes with experience at closing deals and delivering products.

GETTING STARTED

Think about all the different ways that you can deliver your images or your services and break them into as many different parts as you can. Understand how much each would cost you and what your profit margin is on each item. Know how much you're prepared to cut the profits when you offer them as an addition to a sale you've already made.

www.californiaphotographer.com has a good range of packages that could easily be upsold during the purchase as does www.shinepetphotos.com.

Ultimately though, the only way to begin upselling is to start landing sales!

Turn Your Images into Prizes

DIFFICULTY

COMPETITION

INCOME POTENTIAL

What It's All About

We've seen that giving a sample away can sometimes be a good marketing strategy. It allows potential buyers to understand the benefits of your photography products and it can add extra value to their purchase.

There are all sorts of ways to hand out freebies from two-for-one offers to using Creative Commons licenses but one very effective way to hand out just a few samples of your images is to offer them as prizes.

This is a very special strategy that has some special effects. Because there will only be one winner (and perhaps a handful of runners-up) the costs will be low; you'll only be giving away a small number of items. And because they're rare and have to be worked for, your items appear to be particularly valuable.

Only a small percentage of the entrants will receive your prize but everyone who enters will want one.

Some of them will take the easy route and buy one, and that applies too to the people who see the competition and choose not to enter.

You might not be able to sell your image to a competition organizer as a prize but as a piece of marketing, it's an incredibly valuable way to bring in a quick burst of extra business.

What You'll Need to Shoot to Turn Your Images into Prizes

A photograph offered as a prize really needs to be beautiful. Or rather it has to appear beautiful to the competition's audience; different people are attracted to different aesthetics.

A competition promoted by a nature magazine for example would need a landscape image or a wildlife photograph. A contest run by a design

TIPS
FOR SUCCESS

Choose Your Partner Carefully

While you can create and run a competition yourself, pick a partner and you'll be able to benefit immediately from placing your name in front of a targeted audience. Just be careful you don't waste your time or your prize though. Choose publications that appeal to the same market as you.

Be Ready for the Sales

When the competition is announced, you should be ready for the burst of interest that follows. Make sure your website has products ready for sale and that you have a way of capturing contact details. And be ready again when you announce the winner.

SUMMARY

Seeing people compete for your photographs can be wonderfully satisfying and very rewarding. Even though the immediate result won't be a sale, the change in the way your images are perceived—from just another picture to a work that people are prepared to compete to own—can have a huge effect on your sales figures and the amount that you can charge for them.

But you have to find the right competitions with the right audience and the right size of audience too.

And you can't do it all the time.

Contests are useful as a boost to your usual ways of selling but they have to be kept occasional if your prizes are to remain desirable. That means they can only be used to deliver extra sales at certain times and improve your brand rather than deliver a steady stream of income.

magazine might do better with an architectural photograph or an image redesigned and worked on in Photoshop.

There is a great deal of flexibility then in the types of images you can offer. It's just a matter of matching the kinds of photographs you produce with the sorts of people who might like to own them.

You could even offer photography services rather than photographs themselves. Offer the prize of a free wedding shoot to a magazine aimed at brides, and you'd be placing your name and contact details in front of a targeted audience at a price you can easily measure but one that won't cost you a penny in cash.

You'll also need a contest. There's often a temptation to make that as simple as possible by asking a question that just about anyone can answer. But that lowers the perceived value of the prize: if you're practically giving your image or your service away, then how much can it be worth?

It's a better idea to make the contest challenging but winnable, and also related to the subject of your image. So a contest to win a landscape photograph could challenge people to send in their own low-res landscape shots.

A competition to win a photoshopped image could challenge entrants to name all the different shortcuts for a number of common Photoshop actions.

And a contest for photography services could ask that contestants submit their wedding plans with the prize going to the most creative couples.

Just bear in mind that today, information is only a Google away so be sure to focus your contest on your audience's ideas or skills rather than their knowledge.

How to Get Your Images into Competitions

Turning your images into prizes should be relatively simple. You are after all, giving something away for free so few people are going to turn it down. Publishers in particular have the opportunity to deliver something of real benefit to their audiences, ensuring that they remain interested, rewarding them for reading—and at no cost to themselves.

And with Internet publishing now available to anyone, giving individuals potentially huge and valuable audiences, the opportunities are almost endless when you're looking for the free publicity that a contest can bring:

Blogs

Blogs are probably the easiest place to offer your images as prizes. Bloggers rarely get a chance to reward their users so they'll almost always be happy to take up a photographer's offer with a free prize and say nice things about them—especially if the photographer is also willing to take on all of the hassle of receiving and judging the entries.

But you do have to make sure that you choose the right blog. It has to be one that has a large audience targeted to the subject of your photography. Many blogs are willing to display the number of subscribers they have and Alexa can provide a general picture of a site's popularity, but if a blog is publishing in your field and you don't know it, it's probably too small to be valuable.

Newspapers

Newspapers are a harder sell—they tend to have a better idea of the value of their audiences than bloggers—but local newspapers can be great targets. If you've been interviewed by your local press before, get back in touch with the reporter and ask if the newspaper would be interested in working together on a competition. The paper itself might even want to come up with a challenge that matches its own concerns.

Alternatively, you can just write a press release announcing the competition, send it to the media and hope they run it. If you can tie the

challenge to something that benefits the community, such as photographing a local wood or inspiring children to get creative, you'll increase your chances of success.

GETTING STARTED

Begin by looking for likely prospects for a competition. Blogs are always easiest so identify popular blogs in your field. Contact the publisher with a pitch for your competition, leaving yourself enough time to create the prize if it's not prepared already. www.newleafclothing.com is one company that has used print prizes to promote its business.

Sell to eBay Auctioneers

52

DIFFICULTY

COMPETITION

INCOME POTENTIAL

$

What It's All About

eBay can be a great place to sell prints and photographic art but it also offers another opportunity for photographers. Items are sold on the site based on how they look in their photographs as well as their descriptions.

In fact, those images may be even more important than the text in attracting bids and persuading buyers to offer higher prices.

And yet, spend any time at all on the site and it will quickly become clear that few sellers put any effort at all into photographing their items. Instead of professional-looking images that look as inviting as any catalog photo, they use blurry, amateur shots that hide the product's best features.

If your photographs of their products could bring them higher prices then you should haven't to work too hard at all to persuade those buyers to give you a share of those extra profits.

What You'll Need to Shoot to Photograph eBay Items

Once you've landed the gigs, you'll be photographing whatever items the eBay seller is offering. To get those gigs though, you'll need to show that you're capable of creating professional quality product photos.

Or at least photos of items similar to the seller's that are more inviting than his.

If you've done any product photography at all, then you'll already have the sort of portfolio that could land you the job. Driving enthusiasts with a collection of impressive car photos would have plenty of samples to show and the same is true for other high-ticket items such as boats and jewelry.

The photographs though will need to be significantly better than those already on eBay. You'll need to show the seller that your photographs will

SUMMARY

The idea at least is sound but this isn't a strategy that photographers generally follow, no doubt because of the difficulty of finding and persuading buyers to hire their services.

Although millions of people post items on eBay, only a small fraction of them do so on a regular basis, only a fraction of those people sell items that are high-priced enough to make hiring a photographer worthwhile …and only a small fraction of them will be local enough for it to be worth your while driving out to them.

That makes finding clients difficult but difficult isn't necessarily the same as impossible. If you can identify regular sellers on eBay who meet all of these criteria—and if you can show them that they'll make more money even after paying you a few bucks to shoot their pictures—you should be able to turn eBay sellers into your own regular buyers.

TIPS
FOR SUCCESS

Go for the Big Sellers

While doing these sorts of jobs occasionally might be fun, you really want to find a seller who sees eBay as a valuable and regular source of income. They'll understand the importance of doing everything they can to maximize their revenues and—more importantly— they'll have plenty of regular work in the future.

As you're looking for prospects then, be sure to check sellers' histories to see how frequently they post sales so that you can estimate how much work you might receive in the future.

Sell the Figures

This is one job where only the results of your images matter. Sellers will want to know how much extra money they're going to make by asking you to shoot their pictures.

If you can answer that question exactly and with evidence, you should have little problem converting a prospect.

(continued on next page)

stand out on the page and divert attention from similar items offered by competitors.

If you don't have a portfolio ready, then once you've identified potential local sellers, it shouldn't be too hard—and it should be fairly enjoyable—to create that portfolio by taking those photographs on spec.

You might not win the job, but you should get a chance to practice your product photography skills.

How to Shoot for eBay Sellers

Turning eBay sellers into clients will usually have two stages. Neither of them is easy.

The first is to identify likely prospects. That will involve browsing eBay for sellers in your area who regularly offer high-priced items and have poor photographs.

The second stage is persuading them to pay you to improve the look of their products.

The most persuasive argument you can make here will always be through figures. In an ideal situation, you'll be able to track the seller's sales prices and compare them to higher prices won by a seller of similar items. So you'd find a car seller with poor images who had sold a vehicle

for $10,000 and point out to him than another seller with good images had sold a similar car for $11,000.

How difficult would it be in a situation like that to persuade the seller to pay you $200 or more to produce better images for him in the future?

In practice, of course, it's never that easy. The items might not be exactly the same, the difference in the quality of the image might not be obvious and the price differences might not be that large.

But if you can spot differences like these, you'll have found yourself an opportunity. All you'll have to do is approach the seller, point out why he's not getting full value for his items and offer to solve the problem.

There is an easy way. A number of business have cropped up offering logistics solutions to eBay sellers. In return for a fee, they handle all of the packing and shipping on behalf of eBay sellers. Create a partnership with those businesses—in return for a commission—and you'll have someone to give you a hand with your marketing.

GETTING STARTED

The first step is going to be start browsing eBay for likely prospects. There won't be too many sellers who are local, regular sellers with poor pictures so it shouldn't take too long.

You'll then need to find sellers of similar items with better pictures and higher prices, and you'll need to create a portfolio of impressive images to show the prospect.

Finally, you'll need to make contact with the seller, showing him your images and stressing the real benefits of using your skills.

One option is to strike a deal with people who service eBay sellers, such as Skip McGrath at www.skipmcgrath.com. They have the list and you have a service that their list wants. There's a deal to be made there.

TIPS

FOR SUCCESS

(continued)

Aim for Your Specialty

These images are going to be very practical and it's unlikely that the profits are going to be huge. They'll always be limited by the difference between what the seller is earning now and what he could be earning with better pictures. So you may as well try to enjoy the shoot by picking subjects that you like photographing.

53

Cover the Earth with Your Pictures

COMPETITION

INCOME POTENTIAL

$ $

TIPS

FOR SUCCESS

Geotagging does represent a very useful opportunity but it does require some preparation.

Use the Descriptions and Titles

The description and titles of your images are always going to be vital. On Panoramio, that should consist of a clear indication of what the viewer is looking at. Buyers will want to know what they're buying and they'll want to feel that if they have any questions about the place or need more images that you can supply answers and a selection of pictures.

(continued on next page)

What It's All About

For photo editors, life has got a lot easier. They have a broader choice of images than ever before. They have a broader range of prices than ever before. And if they're looking for a picture of particular location, whether it's for a tourist brochure, for editorial use or for advertising, they can now pull up a digital map, head to that location and look through pictures shot in that very spot in the hope of finding one worth licensing.

They can do that by turning to the map feature in Flickr or they can open Google Earth and flip the world around until they reach the place they want to show.

SUMMARY

Geotagging images is always a good idea. On Flickr, it creates just one more way that buyers can skip the site's search feature and track down images faster.

On Google Earth, Panoramio, which is owned by Google, makes your images available to all of the millions of people who use and enjoy the program.

Each of these sites has advantages and disadvantages. Panoramio is very restrictive about the kinds of images that it places on Google Earth and does not allow any kind of advertising. That makes converting interested viewers into buyers difficult . . . although not impossible.

Flickr allows its members complete freedom to geotag any image and add it to its map but again, it does forbid explicit commercialism and, of course, those images won't reach Google Earth's masses of users.

The best strategy then is to place images of locations on both sites and make good use of the member profiles to turn viewers into customers.

For photographers—especially landscape and travel photographers—these programs represent a golden and free opportunity to place their photos in front of buyers.

What You'll Need to Shoot to Sell Geotagged Images

Flickr lets photographers put any image on its map but buyers looking for photos according to their locations are more likely to be seeking images which reveal something of the location. For a rural location, that's likely to be a landscape photo; for photos taken in exotic locations that could be any travel photo that tells viewers what the place looks like.

Panoramio is much more selective about the images it funnels to Google Earth. Its help page has a long list of images that the site refuses, including close-ups and pictures that contain people. In general, they'll only take outdoor images that complement Google's map.

How to Create and Sell Geotagged Images

Geotagging images is now much easier than it used to be. Flickr offers a link when you upload your photo that lets you place it directly on the map. Panoramio does the same thing and if your image contains EXIF data, it will even do it for you automatically.

The challenge will be with the sell.

Neither Flickr nor Google allow overt marketing. Panoramio gives specific example of advertising that it won't allow. Using the title of the image or its description to invite buyers to get in touch, for example, is a strict no-no.

But there are subtle ways around these restrictions which don't harm the character of either site, which allow you to make sales and which provide a way for buyers to obtain the images they need.

Both Flickr and Panoramio include the photographer's name and gallery link with the image. A buyer interested in a photo will click through to see a larger version. On Flickr, you could place a message in the image's description indicating that the photo is available for licensing; on Panoramio, you could do the same thing on your profile page.

TIPS FOR SUCCESS

(continued)

On Flickr, you can be a little more creative, pack in more information, and most importantly indicate that your pictures are for sale.

Use the Tags

And the tags are going to be important too. Although buyers are likely to simply open the map and start traveling, taking care to tag your images fully will increase the chances that your images will be found in a search, especially if buyers are looking for specific subjects such as "forest" or "bridge" rather than a specific location.

Work the Views

Both Flickr and Panoramio reward the most popular images by making them easier to find. On Flickr, that reward can take the form of exposure on the Explore page, a feature that massively boosts image views. On Panoramio, more than twenty variables, including views, favorites, comments and resolution, are all used to calculate the zoom level at which an image is viewable.

To improve the chances that a photograph will be seen and purchased then, it's not enough simply to upload it, however well you tag and describe it. You'll also have to promote it. On Flickr,

(continued on next page)

that means groups and networking; on Panoramio, it means commenting on other people's pictures to push up your own views, as well as linking to the image off the site too.

Focus on an Area

While there's nothing wrong with uploading all the landscape or travel images you have, if you can also portray yourself as an expert on one particular location, you'll turn yourself into the first stop for anyone looking for pictures of that topic. So in addition to uploading the images, write blog posts about them and link to them from your posts. Buyers will know that they can get more than an image from you; they can also pick up information and advice.

Use the Profile as a Sales Page

Flickr's bios are always good places to say a little about yourself and most importantly, to link to your own website to show off your commercial work. The profile pages on Panoramio can do the same thing but oddly, few people use them. They're seem to be keener just to put their images on the map.

That means it shouldn't take too much work to create a profile that stands out. Say a little about yourself, explain why you're an expert on the locations you've shot, refer viewers to your website if you have one and tell people how to get in touch.

GETTING STARTED

Sign up to both Flickr at www.flickr.com and Panoramio at www.panoramio.com and start uploading your images and placing them on the maps. Create a bio or profile page that explains that your images are available for licensing and tells people how to get in touch.

Once the images are online, begin promoting at least some of the photos you've uploaded by commenting on other people's images. Your comments should bring other photographers in to look at your own pictures, making them easier to find.

Earning from Photography Workshops

DIFFICULTY

COMPETITION

INCOME POTENTIAL

$ $ $

What It's All About

Even for professionals, photography can often be an unstable business. They can never know where their next job is coming from, how long their stock portfolio will sell for or how well their next exhibition will do.

Often, they try to get around that insecurity by teaching at least part of their time. Their knowledge and experience is valuable and by sharing it with students, they're able to turn that information into cash and give themselves at least one stable income stream.

And it's fun too.

This is a strategy that non-professionals can follow too. It's unlikely that you'll win a place on the university staff without a bunch of letters after your own name or plenty of time in the industry but there's no shortage of small colleges and adult education centers that are often on the lookout for teachers ready to give some of their time.

You could even find a venue and organize some workshops of your own.

You're not going to make a great deal of money out of the workshops themselves. In fact, it's possible that you'll have to do them on a voluntary basis—that's particularly true of your own workshops. But even if you're not being paid, workshops like these can be very useful ways to market your own photography products to an audience that trusts you and respects your talents.

What You'll Need to Shoot to Put on Photography Workshops

Unless you're an old pro hoping to teach to photography newbies then it's probably a good idea to steer clear of workshops that focus on the basics.

TIPS
FOR SUCCESS

Keep Your Course Focused

Browse through subjects offered in adult education centers and you'll find subjects like "Indian Vegetarian Cooking" rather than just "Cooking," and "Romantic Poetry" rather than just "Literature." Keep the subject of your course focused and you will reduce the size of your market, but you'll also have fewer competitors and students with a real passion for the subject.

Don't Sell, Teach

Your goal might be to sell your photo books or your manual on photographing whales but no one takes a class to receive a hard sell. Concentrate on teaching but keep the classes and courses short so that students go away inspired and keen to learn more. The only way they can do that is by buying your books. The sales should come naturally rather than as a result of a series of not-so-subtle hints from the front of the classroom.

(continued on next page)

SUMMARY

Teaching photography workshops can very enjoyable but it's not usually very lucrative. Some community and further education colleges might be willing to pay a small amount but not always and they don't always hire.

You might well be forced to organize your own workshops, relying on the course to create interest in your photography books and prints to generate income.

That sounds difficult but it doesn't have to be. Choose a good subject for your workshops and market it carefully and not only will you enjoy the lessons, you should also see plenty of your students asking to buy your products.

Best of all, teachers are automatically objects of respect. If you're looking to raise your status as a photographer then filling a room with students and telling them what you know about one aspect of photography is a very quick way to stand out from the crowd.

Lots of people know what an f-stop is, how the rule of thirds works and how to change a lens.

That sort of information they can read in a book for themselves or could be better taught by a professional photographer.

To build audiences for your workshops—especially if you're not a professional—it's a much better idea to focus on a particular subject.

The kinds of people who would want to turn up to a photography workshop on the weekend or in the evenings will probably know how to use their camera to take pictures. But they might not know the best ways to take pictures of wildlife or create portraits or edit their images in Photoshop.

The images that you'll need to shoot then should be of your specialization. You'll need to show those images to your class so that they can see what you're trying to do—and you'll also want to have them available in book form so that your class of photography enthusiasts with an interest in wildlife, portraiture or Photoshop can buy them.

How to Create and Earn from Photography Workshops

Putting on a photography workshop isn't difficult but it can be a lot of work. If you're looking to teach at a community college or adult education center,

you'll need to find your local sites and discover whether they have any information available for teachers, perhaps online or in their prospectuses. It's certainly possible that they won't, so you'll have to do a touch of quick digging of your own by calling the college's information office and asking. You should find that they're quite friendly and helpful.

If you don't have professional experience in the field you want to teach you'll probably have to show that you do know enough to teach. That will usually involve preparing a resume that emphasizes any teaching you've ever done—mentoring in the work environment could be a good start—as well as any professional experience related to your photography such as licensing prints, receiving occasional commissions from the media or running even a small photography business.

Even if you're accepted, the pay can be very small. In 2006, part-time self-enrichment teachers were barely averaging over $16 per hour. That just makes having a good line of products for your students to buy even more important.

It might also mean that it's worth skipping the effort involved of working with an education center—especially if the center also places restrictions on selling in the classroom—and organize your own workshop.

You should have little problem finding a room to rent for an hour or two once a week at a community center, and you'll be free then to include any content you want.

You'll also be free to mention your photography books and prints, and sell them at the end of the class or the course to anyone who wants to buy them. It's certainly possible that the extra freedom could result in you earning more than you would have done teaching at an official education center.

But you will have to market the course yourself, something you'll have to do with flyers, press releases, advertising and networking. Again, it's not difficult but it does take time and effort.

TIPS

FOR SUCCESS

(continued)

Create Textbooks

You could certainly use a print-on-demand publishing service like Blurb or Lulu to create products to sell to students but if you create an entire textbook—especially one that comes with all sorts of extras such as DVDs and supplementary products—you can charge hundreds of dollars. The professional speaking industry was built on this approach.

GETTING STARTED

Start teaching by learning. Take a photography workshop at an adult education center and pay attention to how the teacher interacts with the pupils and what the pupils are looking for. Then hit the phones to other education centers or find a venue of your own and start putting together your own course. You can find photography workshops at www.santafeworkshops.com and www.horizonworkshops.com among others.

55

Give Back to the Community

DIFFICULTY

COMPETITION

INCOME POTENTIAL

$ $ $

What It's All About

Giving away some images can help you to sell others. Sharing some of your knowledge might lead people to pay for more knowledge or for the pictures that knowledge produced.

And donating your skills to a non-profit can be a good way to get your name and your talent known among a select audience.

Some photographers though have gone even further. They've donated regular chunks of time to work with a community, teaching kids how to use cameras, document their neighborhood, improve their image and self-esteem, and pick up some valuable skills too.

The photographers who do this do it solely out of a sense of commitment. One, for example, saw a neighborhood that had been given a bad press and wanted to show it in a completely different light. So she organized workshops, taught local kids how to take pictures and organized an exhibition.

The intention might have been altruistic but the benefits in terms of exposure were worth a fortune.

The press—even the national press—falls over itself to cover stories like this and a photographer who might not be known outside his own family can be soon become known around the world.

What You'll Need to Shoot to Put on Community Events

There are all sorts of things you could shoot during a community event but none of them has to be related to what you've shot in the past. One of the big advantages of using your photography skills to benefit others is that your passion and your dedication will be more important than your portfolio.

SUMMARY

Running a community photography project can be a huge amount of work. It's a commitment that requires passion and creativity. You'll need to have the personality and the persuasive skills to keep people on board.

You'll need a plan for the project itself.

You'll have to build connections with businesses to find sponsors to cover the costs.

And you'll have to work the press so that the project picks up the publicity it deserves.

It's a giant undertaking and not one to be taken up lightly.

It's also not one to be taken up solely for the benefits to the photographer.

Run a successful community photography project, and your name should become better known, at least locally. But there are no guarantees other than that you'll have to work very hard to achieve that fame.

Except for one other guarantee. If the project is a success and you've started it because you wanted to give back to the community and chose photography to do so, the satisfaction will be far more valuable than any prints you sell or commissions you win as a result.

TIPS
FOR SUCCESS

Learn How to Write Press Releases

Good connections with the media will make your project easier and the results more satisfying. Learn how to write press releases and keep reporters informed.

Any photographer with any sort of background can use photography to help the community. And there are all sorts of ways you can do it:

Run a Contest

The easiest way to get a community involved in photography—whether that's a community in a children's home, an area or even a retirement home—is to put on a contest. You could provide a few basic photography lessons, give the participants a theme then let them loose to produce the best images they can. You could ask a local business to provide a prize in return for the publicity.

Shoot the Neighborhood

Or you could mount an exhibition of images of the local neighborhood. Ask the participants to shoot the parts of town that mean the most to them and explain why, then mount an exhibition when they're finished.

Shoot the Neighbors

Or you could focus on the people. Instead of challenging participants to photograph buildings and landscapes, teach them about portraiture and ask them to photograph the most important people in their lives.

Depending on who you're working with, you might have to supply the participants with cameras as well as photography knowledge.

Looking for sponsors is often as important—and difficult—an aspect of helping the community in this way as organizing the event itself.

How to Create and Earn from Community Events

Creating a community event is going to take a great deal of work. That workshould be enjoyable. It should certainly be rewarding. But it's not going to be easy.

You'll need to link up with community leaders, create a program that gets participants engaged and motivated, and which can benefit the community as a whole. Discussions with those community leaders should help you to produce an effective plan.

You'll then need to identify businesses that could act as sponsors. Some companies may be willing to supply cash, others could offer products as prizes or provide the use of cameras, photo editing software or even a display space. And as the project continues, you'll want to write press releases to the media to let them know what's happening and stay in contact with any reporters who cover the story. Those press reports are likely to bring in offers of help and raise your own profile too.

Income for yourself should be a result of organizing an event like this, but it shouldn't be the goal. In order to make the most of the publicity the event should pick up, you won't need to do anything too specific.

No one, after all, is going to hire you to put on a commercial photography event for a community.

But they might well want to know more about you. They'll want to know who you are, what your own photography is like and what you do when you're not helping disadvantaged kids to be creative or portraying a new side of a neighborhood with a bad reputation.

Before you send out your first press release then make sure that you have a good website that describes who you are, shows off your images, describes the sorts of photography you like to do and makes it easy for potential buyers to contact you.

55 Give Back to the Community

You can also use the site to post updates about your project, forcing those who are interested to look at you too. You should find that some of that interest turns into print and product sales, and commissions. At the very least, you'll end up with an enhanced reputation and a warm, fuzzy feeling that comes from helping others.

GETTING STARTED

Begin by identifying a group of people or an area you want to help. Make sure it's something you feel genuinely excited about. You'll have to pass that excitement onto the participants. Then get in touch and offer to lend a hand. Tory Read is one photographer who has done this. You can see her work at www.community-photography.com.

56

Barter Your Art

DIFFICULTY

COMPETITION

INCOME POTENTIAL

What It's All About

There are plenty of people who would love to own your photography, use your images or hire you to shoot their wedding, headshots or pets. Not all of them have the spare cash to pay you.

What they might have though is a service or an item that you need yourself.

Bartering might be older than money but it's a practice that hasn't disappeared. In fact, the Internet has made it easier than ever to find people willing to swap goods and services.

Every time cash becomes scarce, those barter agencies start buzzing.

SUMMARY

Bartering can make selling photography very easy. Some buyers may be more willing to give up their time than their money so swapping a print for a website design from a programmer, for example, may make both sides feel that they're getting something for nothing.

That's especially true when the time you're providing isn't time that would be used to earn money. If you have a full-time job and shoot on the weekends, for example, then agreeing to shoot someone's wedding in return for them painting your house gives you a fun job in return for something that otherwise might have cost a few thousand dollars.

There are just a couple of flies in the ointment though. While finding suitable swappers isn't too hard, exchanging items of roughly equal value can take some negotiation.

And the Internal Revenue Service still considers bartered items as taxable income.

For photographers who don't always need cash in return for their images, bartering can be a very good way to pick up something with real value in return for their photography.

What You'll Need to Shoot to Barter

You can barter any kind of image . . . as long as someone is willing to accept it. Framed prints, for example, could be swapped for just about anything. Artists have long used their works to pay their bills.

Usually though, photographers tend to swap their services in two common ways.

Images for Accommodation

Photographers who travel with some basic equipment, a way of showing off their portfolio—and a charming manner—have been known to pay off their accommodation expenses by persuading the hotel owner to let them shoot the hotel for their marketing material.

This isn't something that you're likely to be able to prepare in advance. But if you're staying in a small, independent hotel, a friendly chat with the owner could let you swap time in the town for time behind the camera, and a hotel bill for a set of images.

Headshots for Models

And one of the most common ways that photographers barter their services is by offering free headshots to actors and models willing to let them shoot them for stock images.

A number of leading microstock photographers do this and it can be a very useful way for photographers to keep their collections fresh with new faces, and for cash-strapped models and actors to get the photographs they need.

How to Find Barter Partners

Finding people to barter with these days really isn't difficult at all. Craigslist, in particular, has pretty much cornered the market with thousands of people using the site's barter category to offer and receive items and services.

Bartering is easy. Because you're not asking for money people will be much more willing to make a deal, especially if you're asking for something that's valuable to you but has less value to them.

But there are a number of steps you can take to make sure that you're getting the best out of the deal.

Understand the Value of the Transaction

Your photography services have a value. If you're offering models free headshots then what you're giving away has a value of several hundred dollars. That's what the model would have had to pay were you demanding cash.

Asking for a stock shoot in return is an easy exchange because the cost would have been about the same to you.

But if someone offers you a used car in return for a wedding shoot or a free product in return for some commercial photography, then you'll want to make sure that you're getting something of roughly equal value.

Similarly, you'll struggle to make deals if what you're demanding in return is worth much more than the services you're providing.

(continued on next page)

TIPS
FOR SUCCESS
(continued)

Your prints, for example, might be beautiful and valuable to you, but unless you can put a price tag on them based on previous sales, you might struggle to swap them for something with a concrete value.

Match Business Services with Business Services

One way to get around this problem is to focus your bartering on business services. It's always much easier for a business to put a price tag on the services it provides and because they'll be swapping time rather than cash, many small businesses in particular will be up for the deal.

Providing quality images for websites, architectural shots and even executive portraits can easily give you a new site of your own, a service for your car or consultancy that can improve your marketing.

Keep Your Wanted List Specific

Advertise your photography services and potential partners will wonder what they can offer in return without causing offence or risking rejection. Make it easier for them by telling them exactly what you're looking for—or at least, what you'd like the most.

You can use the site to advertise your own photography services in return for offers or you can browse the site regularly to see if anyone is looking for a photographer.

Both strategies can bring results.

There are also a number of websites that specialize in barter. Two of the best sites are TradeaFavor.com which works through Facebook, giving you access to a network as well as a service, and JoeBarter.com, where you can find photographers asking for free accommodation, furniture, kids' stuff, technical skills and just about anything else in return for wedding photography, portraits and headshots.

GETTING STARTED

Start with an ad on www.craigslist.com then move on to www.tradeafavor.com and www.joebarter.com. You can also place a message on your website announcing that you're willing to provide free headshots to models.

Don't be discouraged if you don't get a response right away—or if those responses yield nothing that you want. Just keep posting your ads so that they stay fresh and visible.

Market with the iPhone

DIFFICULTY

COMPETITION

INCOME POTENTIAL

$ $

What It's All About

To sell your images you're going to need people to see them. That's always a bit tricky. Millions of other people are showing off their pictures too and some of them are very good.

And even if you can bring people to look at your photographs, you have to make sure that they're the right people—the types who might be interested in writing a large check to own one of your prints or pay to purchase a license to use one (or more) of your images.

Marketing is a challenge for every photographer, and every photographer needs to make the most of every advantage they can get.

The iPhone is more than a tool a canny photographer can use to show off their photos. For the first time, it's possible to display your images on a mobile screen that's sharp enough and large enough to do them justice. And you can do that anywhere. Meet someone at a party and tell them you're a photographer, and when they ask what you shoot you'll be able to whip out your mobile and show them, explaining at the same time how you achieved the shot and why the images are important.

With the iPhone you can promote your photography anytime, anywhere.

Clearly, by itself, an iPhone is not going to make you money from your photography. You still need to have good images. And you will need to mix in the sorts of circles where buyers are likely to ask you about your photos.

If both of those conditions are true for you though—and you should certainly have the first—then carrying your portfolio in your pocket could land you some very useful sales.

TIPS
FOR SUCCESS

Don't Spend a Lot of Money

You could end up spending a lot of money on an iPhone-optimized website, just as you could choose to toss a small fortune at a developer to create a Flash-based website with tons of bells and whistles.

But neither is a good idea. Any online portfolio should simply show your images, and allow the viewer to understand what your pictures look like and what kind of photography you shoot.

If you can do that with a five-dollar template, then don't spend hundreds to get the same thing.

Circulate

There's very little marketing you can do to bring people into your iPhone portfolio. Including the URL on your business or Moo cards could help—they might just look at it before they reach their computer but the best channel is going to be word-of-mouth . . . your word-of-mouth. So go to parties, talk up your photography and show off your photos. You never know where it might lead.

SUMMARY

iPhone marketing isn't easy. If creating a unique website can be expensive and difficult, then optimizing one to fit the iPhone's unique screen is likely to set you back even more (although there is a cheaper option if you're willing to use a template.)

As an expense, it's only worth paying for a unique optimization if there's a good chance that you're going to be bumping into people who want to see your portfolio and who aren't sitting in front of a computer at the time.

That's clearly not going to be everyone but it will be some people, especially those with active social lives and social circles that stretch to include creative types.

For everyone else, an iPhone-optimized portfolio will be a neat exhibition space and an interesting luxury.

What You'll Need to Market Your Images on the iPhone

To show off your own photos while you're downing the canapés at someone else's exhibition opening, you'll really need three things: a great portfolio; someone worth showing it to; and a website that's been designed specifically for the iPhone.

The first of those isn't as easy as it sounds and is closely connected to the second. The kind of photographers that usually offer iPhone-optimized websites tend to be those who shoot for the media and for large corporate clients. Their portfolios are filled with tearsheets and professional images shot on commissioned shoots that allow the buyer to understand what they would be getting by hiring the photographer.

You don't have to have a portfolio like this, of course. There's no reason why you couldn't put your portfolio of enthusiastic nature shots or amateur car photography on your iPhone too. It would be a neat thing to show to your friends but you won't make much money out of it.

How to Create and Show Your iPhone Portfolio

There's a really easy way to create an iPhone-based picture portfolio. You can create a folder called "portfolio" on your computer, stuff it with your best photos and upload it to your iPhone.

But that's not going to be too impressive and anyone you show it too will wonder why you're walking around with your best images on your mobile phone.

It also needs you to be present to show off your pictures.

Far more impressive and more useful is to optimize your website for the iPhone's small screen. That means using big buttons instead of small text links, aligning everything horizontally so that browsers can scroll through your images by simply moving their finger and ditching any flash-y or complex programming that might frighten the iPhone Safari's inner workings.

A decent Web programmer should be able to do this for you—for a fee. But you can also buy The Turning Gate's iPhone Portfolio and do it yourself. It won't be as neat as having your very own, uniquely designed iPhone portfolio but it will only cost five dollars and it's certainly impressive enough.

Bringing people into your iPhone portfolio is going to be much harder.

A portfolio isn't the sort of thing that people turn back to again and again, nor is it something that they need to look at right away. Photographers who have used iPhone portfolios say that the biggest advantage of having their site optimized for their mobile device is that it's a great way to show people interested their work.

They have to be present, in person, with the person they're trying to impress.

Your iPhone portfolio then isn't going to be something you're going to market. It's going to be something that you show—and to show it you're going to have to be present with people you think might be interested in buying or exhibiting your images.

So if your social circle doesn't usually include gallery owners and photo editors, you might want to expand it by going to galleries and being friendly. It won't be as useful or effective as making an appointment and showing off your portfolio, resume and artist's statement in the usual way, but the casual encounter could make an impression that grows into something more formal.

GETTING STARTED

You can get started right away by surfing to www.theturninggate.net and downloading an iPhone Portfolio template. But you should also look at photographers Sacha Dean Biyan and Simon Winnall's mobile sites www.eccentris.com/mobile/index.html and www.simonwinnall.com/iphone.html.

58 Use Direct Marketing

DIFFICULTY

COMPETITION

INCOME POTENTIAL

What It's All About

As a sales strategy it's about as old as soap company-sponsored television shows and about as traditional as the two-for-one offer. For as long as mail boxes have been sitting outside people's homes, entrepreneurs and business owners have been trying to stuff them with information about their products and services.

And they're still doing it, even in the days of email.

In fact, email may even have given old fashioned direct mail marketing a new lease on life. The inconvenience of having to delete so many spam messages every day—and the fact that the content of so many of them is so distasteful—means that many marketers have turned back to the tried and tested strategy of sending a leaflet or a brochure to a well-chosen address.

The conversion rate might be low and it's certainly not a free option. But the fact that it's been shown to work means that it's not a strategy that anyone who wants to make money from their photography can choose to ignore completely.

What You'll Need to Shoot to Benefit from Direct Marketing

You can use direct marketing to sell all sorts of photography services. You could use it to sell portrait services. You could use it to pitch your commercial photography skills. You could even use it to promote your pregnancy, child or family photographs.

But you'll really want to pick a service that has as broad a demand as possible. When you're looking at conversion rates that are unlikely to be higher than one in a hundred and have a good chance of being four times

SUMMARY

Direct marketing works. But mostly it doesn't. The average response rate to an average direct mail campaign is somewhere between 0.25 and 1 percent.

Almost everything you send out will receive barely a glance before it hits the bottom of the recycle bin.

But as long as that one sale in 400 pays for the campaign and gives you a profit, then direct marketing is worth doing.

Making sure that happens will depend on a number of factors. It will depend on the people you target. It will depend on the material you send them. And it will depend on your ability to crunch the numbers so that your costs are more than balanced by the value of the services you're selling.

Get all of those factors right and you should find that direct marketing is an invaluable way of earning from your photography skills.

lower, you don't want to offer a service that only one in a hundred people are ever going to want anyway.

Only a relatively small number of people tend to be interested in buying prints or photography books, for example, so pitching those might be a bad idea. Anyone though might want a portrait either for themselves or their business, and if you use a commercial rather than a consumer list then every recipient could be interested in your ability to shoot their products.

Of course, you're not going to be able to send your entire portfolio through the mail. The best option is likely to be a postcard. It's relatively cheap and still gives you the chance to put one killer image on the front to show off your skills while telling people where to look online to find more and make a booking.

You just need to make sure that the image you're offering matches the sorts of services your recipients are likely to want.

How to Create and Direct Market Your Photography Skills

The bad news is that direct marketing costs money. Sending 1,000 postcards will cost around $500 for the cards, printing and mailing alone. The

TIPS
FOR SUCCESS

Offer Discounts

One strategy your copywriter should be following is creating a sense of urgency. That's usually done by offering time-limited discounts and making the recipient feel that what they've received in their mailbox isn't another flyer but an opportunity to buy something they need at a bargain rate.

So make the discount clear and link it to your postcard. Include a code that customers can quote when they call to enquire, or set up a special landing page for buyers who come in as a result of the card. Make them feel special and they'll be more likely to buy.

Track the Figures Closely

And those codes will help you track the results. Direct marketing is a numbers game. The costs are fixed and predictable so you'll know very quickly if it's profitable. Be sure to track your conversion rates, pay attention to the number of cards going out and note too the types of people who place orders so that you can better your target your next campaign.

addresses of business recipients will cost around 7 cents each depending on the amount you order and there will be extra costs if you want to tweak the list based on demographics and list data.

So doing the math is going to be vital. If your conversion rate is only one in 400 and it costs you $228 to reach those 400 people, then the service you're selling will have to cost much more than that to be worthwhile.

A wedding shoot might do that. A single portrait shoot not so much.

The good news is that because you're paying, the direct mail company will be willing to help make sure that everything goes to plan and goes easily too. After all, if you do make money, you'll be back for more.

So feel free to explain who you're aiming your service at and ask for advice about what kind of list to use to maximize your returns.

More difficult will be designing the piece of marketing material you send.

Direct mail companies offer all kinds of different products. Postcards are going to be the cheapest but you can also opt for brochures, booklets, calendars, door hangers, newsletters, greeting cards and whole load of other things that will cost you far more money than a simple piece of cardboard with one of your pictures on one side and some text on the other.

Unless you've got a good reason for splashing out more cash then, a postcard should be fine. Try to make your image good enough to keep though. Rather than simply use an example of your work, make your image so interesting that recipients will give it more than a glance and may even want to stick it on their noticeboards. You'll only have a fraction of a second to attract someone's attention, so make sure your image is strong enough to hold onto it.

The back of the postcard will need to contain your contact details, and your website URL would be useful too so that recipients know where to go to learn more. It will also need some sales copy.

That's worth paying for. You want to create an impression of professionalism and unless you have a natural way with words that's only going to come by using a professional wordsmith to make your pitch. When you explain to your copywriter what you need though try to make sure he delivers a template that you can change easily in the future so that you don't have to pay again for every mailout.

GETTING STARTED

The Direct Marketing Association has some useful information at www.the-dma.org. www.directmail.com can give you an instant quote and get you started and www.elance.com is a good place to find a copywriter to talk up your skills.

59

Sell Your Images with Subscriptions

DIFFICULTY

COMPETITION

INCOME POTENTIAL

$ $ $

What It's All About

There are many different ways of selling your images. You can swap cash for framed prints, give quotes based on what the buyer wants to do with the shot or take commissions for exclusive shoots and unique images.

Those are all the standard ways in which photographers and buyers make deals but there is another method too. It's a little unusual and it's not a model that's suitable for every type of photograph and every type of format.

Sell subscriptions that allow buyers access to your images and you'll give yourself a steady revenue stream, lock them in as customers and leave yourself free to shoot and produce pictures without having to worry too much about looking for new buyers.

SUMMARY

Selling subscriptions is a little like picking old-fashioned artistic patrons. You'll still be shooting for an audience but because you know you have a market for every image you produce, you can concentrate on the photography instead of on the selling.

Usually though, subscriptions take time to sell. You'll need a large enough portfolio for buyers to understand what they'll be picking up in the future and those images will need to be unique enough for buyers to understand the advantages of locking themselves out of other suppliers.

Pull it off though, and not only will you get money for your images, you might even be able to land something even more valuable: an element of artistic freedom too.

You'll need loyal customers and you'll have to do a fair amount of ground work to bring in the subscribers at the beginning, but once you have enough people paying you a fixed rate to access your photos, you'll be earning regular money shooting the images that you—and they—want.

What You'll Need to Shoot to Earn with Subscriptions

This is a model that can only work for buyers who need a steady stream of images. Art photographers looking to sell prints, for example, will always struggle to persuade buyers to pay repeatedly for a series of photographs that they haven't yet seen. Their interest in your photos might be unlimited but their wall space isn't.

In practice then, subscription models are mostly used in stock photography. The demand among buyers is constant and subscriptions provide customers with access to a trusted source at a reduced rate.

Both those elements are key.

The two benefits that will persuade buyers that it's worth committing to a single supplier are the time saved searching through other sources; and the money saved by buying in bulk in advance.

It's a model that large companies have used to great effect to turn occasional buyers into loyal customers—and it's a model that independent photographers have used on their own stock sites too.

Another niche which uses subscription models is computer wallpapers. These are always difficult to sell because of the size of the competition from free suppliers. Buyers are willing to pay for unique, desirable images however, especially when they can treat those images as disposable, swapping them for a new photo whenever they feel like a change.

How to Create and Market Image Subscriptions

Adding a subscription service to your own stock site will require a certain amount of technical wizardry. Not only will you need to have your own stock site in place but you'll also need to have the ability to take automated payments and monitor use of the subscriptions.

If you're not a programmer, you'll need to find—and pay—one to do that for you.

But you'll have to decide for yourself what kind of subscription model you want. There are various options. You can suggest that buyers pay

TIPS
FOR SUCCESS

Be Reliable

For customers, buying a subscription to a photo supplier is a risk. They're betting their subscription fee that you'll be able to supply them with the images they need whenever they need them.

To win subscriptions then, you're going to have to win their trust.

That happens when you post an inventory or a portfolio of professional quality work. It happens when you don't cut corners and make sub-standard work available to people who have already paid. And it happens too when you answer questions quickly and deliver a high level of customer service.

Make the Savings Clear

Reliability will be one sales point. That will turn a potential customer into a real customer. But by itself, it's not enough to turn a buyer into a subscriber. Someone sold on the quality and reliability of your images can still choose to pay for them one at a time.

(continued on next page)

TIPS

FOR SUCCESS

(continued)

To turn a buyer into a subscriber then, you'll need to emphasize how much the buyer is saving when he commits to paying on a regular basis. You won't need to do any more than put the amount of the savings in big letters next to each subscription offer.

Offer Different Plans

Buyers have different image needs and different budgets. By offering a range of different subscription plans in a range of different prices, you'll be able to capture more of your potential customers.

monthly, quarterly or annually. You can limit the number of images those subscriptions purchase or, more rarely, provide a kind of all-you-can-eat buffet of photographs. And you can choose to renew the subscription automatically when it ends or send a reminder that forces the subscriber to take action.

Most important of all, you have to set a price point that makes the subscription attractive and worthwhile but is also profitable for you.

The best way to reach decisions on all of those issues is to look at what competitors are doing. iStock, for example, limits subscribers paying an annualized $108 per month to ten credits a day, increasing the limit to 60 credits per day for $561 per month. Getty, the main supplier of Rights Managed stock images, demands $1,999 for a year's supply of Web images and $2,499 for print images. And Vlad Gerasimov, a creator of computer wallpapers, lets his subscribers take all the wallpapers they want for an annual fee of just $19.99 or a lifetime subscription of $29.99. With 11,000 subscribers that's a model that's allowed him to work full-time on his designs and his photography, adding as many or as few new designs each month as he wants.

Although regular income is always going to be the biggest benefit for photographers using a subscription model, another more surprising benefit is the ease with which subscriptions can sell.

Because subscriptions work best with unique or niched image collections, recommendations tend to spread by word of mouth within a community.

And because you'll be asking for less per image than you would if you were selling the pictures per download, emphasizing the savings makes for an easily identifiable sales point.

GETTING STARTED

The first step towards creating a subscription program for your own images is to look at the various models available. You can find Getty's regionalized subscription plans at www.gettyimages.com. Vlad Gerasimov's open plan for his wallpapers can be seen at www.vladstudio.com. And Vlad himself took his plan from www.digitalblasphemy.com.

Sell Exclusive Wholesale Licenses

DIFFICULTY

COMPETITION

INCOME POTENTIAL

What It's All About

For most photographers, persuading a seller to take their images and place them in front of buyers is hard work. The seller has to consider the risk. If the images don't sell, they'll be left with a pile of unsold stock. They'll also have wasted display space and time on items for which there's no demand.

And with so much competition around, they'll need a good reason to stock your images rather than someone else's.

Sometimes though, a photographer can get lucky. He or she can have such unique images and such a fantastic track record of delivering sales that sellers will compete to stock their images.

When that happens—and it does happen—the photographer can create a whole new model.

Instead of demanding a share of the sales revenues as they come in, the photographer can ask for a fee upfront in return for becoming an exclusive regional supplier.

The photographer receives some guaranteed income, the freedom to shoot without having to worry about the marketing, and the ability to pick a partner with the best distribution system.

If the system works, it's a model that can be repeated across different regions.

And the seller receives exclusive access to images that it can be certain of selling, provided the marketing is right.

What You'll Need to Shoot to Sell Exclusive Licenses

You'll need to produce images that are rare, unusual—and in high demand.

That's not a combination that's easy to find. Any niche with high demand is likely to quickly find itself inundated with photographers, talented and otherwise, ready to supply them.

TIPS
FOR SUCCESS

Sell Sets

Make it as easy as possible for wholesalers to sell your products. Bear in mind that they're likely to have different kinds of customers, from those with big budgets prepared to buy expensive prints to casual shoppers looking for postcards.

Create a product range that stretches to every kind of pocket and you'll reassure wholesalers that they'll be able to use your images to satisfy every market.

Focus on the Niches

The hardest part of this strategy is finding a niche that wants your images and which has room for you to dominate. David Kirkland does this by focusing on a region. You can do the same thing—or look to dominate a subject, a style or a technique.

SUMMARY

This is a model that some photographers are following but it's clearly not a model that every photographer is going to be able to use.

It's certainly not a model that a new photographer can benefit from.

Before you can expect wholesalers to be willing to pay tens of thousands of dollars to exclude the possibility of competitors supplying your photos, you'll need to be able to reassure them that they'll see that money back. That means you'll already have placed your images in stores, and you'll have seen them fly reliably off the shelves.

Rather than use this system as a way to kick-start your photography sales then, you'll need to see it as a way of guaranteeing income from future sales that you would have probably made anyway, simplifying your distribution channels and taking an established photography business to a new level.

Easier, although still not easy, is to rely on building your name as a brand to sell your images instead of looking for a popular topic that other photographers have missed.

This is easiest to do in art photography. Well-known photographic artists tend to form exclusive relationships with particular galleries and agents, swapping the possibility of increasing sales by showing at lots of different places in return for careers advice, higher commissions and the rarity produced from exclusivity.

Photographers with a reputation for producing an outstanding range of photographic products—such as car photography books, calendars showing beautiful landscape images or greeting cards decorated with images of technology products—can create a version of that model by agreeing to provide those products to a wholesaler on an exclusive basis in return for a fee.

David Kirkland, a travel photographer, is using this model to supply postcards, souvenir and travel images in four regions: Australia, Vanuatu, Sarawak and Somoa.

Find small regions that are easy to dominate, and you might be able to follow his model exactly.

How to Create and Market Your Exclusive Licenses

Because these models are so rare, formulating a license agreement is not going to be a great deal easier than shooting the kinds of images you can sell with one.

The agreement will need to define the region of exclusivity as well as exactly what you'll be supplying, how often and in what quantities.

Even harder still will be placing a value on the exclusivity you're offering. You'll need to justify the price by calculating how much the buyer would lose if you were to sell your images to other wholesalers or directly to retailers.

The only relatively easy part of this venture perhaps will be marketing it. You'll want to stress the following:

Your Proven Record

Buyers will only be prepared to pay for exclusive licenses if they're reasonably certain that they'll be seeing that money back. That's only going to happen if you can show them that your images do sell.

Your marketing material—your website—will need to point out that your calendars are the most popular in their field, your postcards the dominant items in the Galapagos souvenir stores or your books printed and sold by the thousand.

The Rapidly Increasing Demand

And you'll need to show that that the demand is going to increase too. Telling a potential buyer that other people are making money will suggest that they're going to make money too. Tell them that the sales are increasing and that there's potential for a great deal more growth and you'll suggest they're getting a bargain.

Your Reliability

Finally, you'll also want to show that the buyer can depend on you to supply the goods that will allow him to profit from his investment. Indicate that your images sell regularly and you'll imply that you supply them regularly too.

GETTING STARTED

Before you can start using this model, you'll need to have regular sales in a particular topic or area. When you have those sales, you can use David Kirkland's offer to formulate your own. You can find it at: www. kirklandphotos.com/davidKirkland/jointVenture.asp.

Give Homeless People Prints to Sell

DIFFICULTY

COMPETITION

INCOME POTENTIAL

What It's All About

The underclass is a popular topic for photographers. They make for good photojournalism, their stories are often written in their faces which make for arresting portraits and a project made up of images of drug addicts, prostitutes or beggars can help to bring attention to an important topic too often ignored.

Projects like these also provide another way for a photographer to give back.

Usually, that happens simply by forcing the public to face an issue. Sometimes, it also happens because the photographer pays the homeless person for their time, or at least buys them a cup of coffee or a hot meal.

But there is another way to use photography to help homeless people— and possibly help yourself too.

Give homeless people your postcards to sell and you'll provide them with a way to earn a little money instead of relying on begging. You'll also spread your name among lovers of photography and if you were to take a share of the revenues, some profits too.

What You'll Need to Shoot for the Homeless to Sell

Newspapers such as *The Big Issue*, sold on the street by homeless people, tend to contain two kinds of content.

Some articles will be directly related to the homeless experience. They'll talk about life on the street, problems of alcoholism or homeless people's stories. But they also carry the same sorts of articles as other publications: celebrity interviews, news and cultural stories.

It's likely than that photography products would sell in the same way.

TIPS
FOR SUCCESS

Use Different Cards for Different Sellers

Try giving each seller a different set of images. Buyers then will be less likely to grow tired of looking at the same pictures in different locations, and you might even create a desire to collect them.

Get the Press on Your Side

The media will be vital in spreading your name. Once the project is up and running, send out a press release to your local newspaper explaining what you're trying to do. You should find that you're pushing at an open door. Reporters will have seen the pictures and they'll want to know what lies behind them.

Get Feedback from Sellers

Sellers will be able to tell you what kind of images are selling the most and what attracts the attention of passers-by. They'll help you to focus on printing the most sellable images.

(continued on next page)

SUMMARY

Although plenty of photographers have trained their lenses at the faces of people who live on the streets, we're not aware of anyone who has actually seen their own prints as a way of helping the homeless to make money. This is not a tested model then, and there are certainly no guarantees that it would work.

Nor is it likely that the benefits would spread beyond enhancing your profile and improving your image.

While you could take back some profits from the sales, you'd probably be better off making sure that your name and contact details are on the back of the images, then telling the press what you're doing.

The publicity should do a great deal to make your prints more valuable and easier to sell.

More importantly, the benefits to the sellers would be enormous. People are much more likely to give if they can see they're getting something in return and the homeless people themselves would be able to generate at least a little income while maintaining their dignity by selling real products rather than simply begging.

Even if the results don't include direct profits, supplying postcards to homeless people to sell could still be very beneficial.

Some images could be directly related to homelessness. They could show portraits of homeless people, pictures of shelters or even images of homeless people's pet dogs.

Other photos though could just be beautiful pictures. Landscapes could do well, urban architecture might sell to buyers in the cities but photographs of flowers, trees and wildlife could all be general enough to build a market.

If the pictures are attractive enough, people will want to buy them—and they'll be even more motivated to buy them when they know that the two or three bucks they're paying will be helping someone who needs it too.

How to Create and Earn by Providing Images to the Homeless

You'll need to do three things to make providing images to the homeless work.

You'll need to print lots of postcards with a good variety of images.

You'll need to distribute them to the homeless people in your area.

And you'll need a way to profit from the increased interest in your own photography that the scheme is likely to bring.

Printing postcards will be the easiest of those three. There are plenty of options that allow photographers to print postcards in bulk at relatively cheap rates. Initially, that means you'll have to take on the printing costs. Once the postcards start selling, you could ask the sellers to return enough of the sales price to cover printing costs, allowing them to keep the extra.

They'll probably find that buyers also allow them to keep the change.

Distributing the postcards to sellers shouldn't be too difficult either. Every small town has its collection of homeless people so stopping for a chat and offering them a bag full of postcards to sell shouldn't be too much of a challenge. Just don't forget to arrange a regular time to distribute more cards, discover which prints are the most popular and collect the printing fees.

Benefitting from the sales yourself will be the hardest part but even that shouldn't be too tricky. While you could ask for a share of the profits, that would leave you open to charges of exploitation which would do you more harm than good.

A much better solution is to make sure that your name is printed on the back of the postcards and the URL of your website too. Your website could also include a section that explains what you're trying to do and why you're doing it.

And, of course, it would offer large sized prints and calendars to postcard owners who wanted bigger versions of your images.

TIPS

FOR SUCCESS

(continued)

Treat Your Sellers with Respect

You might be lending a hand to people who need it, but your sellers are really joint venture partners rather than charity cases. They're helping themselves and they're helping you too. Treat them respectfully and they'll want to continue working with you.

GETTING STARTED

Start by stopping. Next time you pass a homeless person in your town, stop for a chat. Explain that you're a photographer and ask if he'd be interested in selling your postcards in return only for the printing costs. Once he agrees, print your images and start selling! You can see *The Big Issue*, which is sold by homeless people, at www.bigissue.com.

62

Team Up with Sales Reps

DIFFICULTY

COMPETITION

INCOME POTENTIAL

$ $ $ $

What It's All About

To earn money with photography, you need to be able to do two things.

You have to be able to shoot great pictures that people will actually want to buy.

And you have to be able to put those images in front of buyers and persuade them to give you their cash.

Usually, photographers are good at the first challenge. The second one not so much.

Photographers often create valuable image after valuable image but because they don't know how to market them—or because they simply aren't very good at talking to buyers—those images stay on their hard drives. Worse, jobs that they could be shooting for fees go to less talented photographers simply because those photographers are better at putting themselves forward.

One solution that some photographers have found to this problem is to outsource all of their marketing to a partner who can specialize in the sales stuff. The photographer does the shooting, the marketing partner does the marketing and the two share the income.

The result should be more work and more sales overall, and a higher income for everyone—and both partners doing what they enjoy the most.

What You'll Need to Shoot to Team up with a Sales Rep

To make a partnership work, you'll need to shoot the sorts of images that can be sold for a reasonably high price. It's unlikely that you'll find a partner willing to help you hawk the occasional print.

62 Team Up with Sales Reps

SUMMARY

Professional photojournalists and other assignment photographers have long used agencies to find them work but those agencies tend to be extremely selective about the quality of the photographers they take on.

Unless you have a track record of working with top-level clients and a hugely impressive portfolio, you'll always struggle to beat the rest of the pack and win the attention of a large agency.

Teaming up with a marketing expert though can be the perfect solution to a problem faced by almost every photographer who wants to sell their images or pitch for jobs.

Photographers want to be out shooting. They don't usually want to be cold calling potential clients, working on their search engine optimization or tracking the results of various marketing streams. But there are plenty of people who get a kick out of doing just that.

If you know someone who would be willing to work with you to sell your images and your services in return for a share of the income, you might have found an easy way to market yourself.

But it won't be a free way. While you reduce your risk of losing money by missing opportunities, you have to hand over a large share of your revenues to compensate for their own risk. You might even have to give them as much as half of the fee or sales price.

That's money that you might have been able to keep for yourself had you been able to market for yourself too.

It's also unlikely—although not impossible—that any partner would be able to work with you full-time, not unless the income you can make as a photographer would be enough to support two people. More usually, you can expect to be competing for your partner's attention with all of the other projects he or she is doing.

But partnering like this is something that photographers have done and even if the partnership doesn't always last forever, it can survive long enough for the photographer to build a portfolio and even a loyal client base.

One field in which photographers have used this system is travel photography. The marketing partner lands the gigs in return for a fairly large cut of the fee and the photographer travels around the world taking pictures of hotels.

TIPS
FOR SUCCESS

Focus on the Big Stuff

There's little point in asking a partner to help you to sell the occasional license or even win the odd wedding gig. The partner isn't likely to feel motivated enough to push too hard and without that persistent door-knocking, the sales will be hard to come by.
Use a partner to land the really big jobs that you'd struggle to get yourself and which yield fees large enough to share.

Make the Most of it

Partnerships like these don't always last the length of a photographer's career. Almost inevitably, either the photographer finds that he doesn't need a partner to help him land gigs any more or the marketing partner finds that he can earn more selling something else. Use your partnership then to build a foundation for a future photography business and enjoy it while it lasts.

There's no reason though that the system couldn't work for other types of relatively high-priced photography such as weddings, fashion shoots or advertising.

Because your photography is likely to be more flexible than the marketer's contacts though, rather than think about what kind of images you should be shooting, a better approach might be to consider what types of market your partner could easily penetrate.

A partner with contacts in interior design, for example, might be able to sell your artworks on a regular basis.

Someone with lots of contacts with ad firms might be able to get you jobs that their regular photographers can't do.

A marketing expert who knows plenty of spa owners might be able to get you regular gigs shooting images for their marketing material.

Think about what sort of jobs your partner could land you; then think about whether you could shoot for that sort of market.

How to Create a Partnership with a Sales Rep

The biggest challenge, of course, is going to be finding a suitable partner.

The easiest method is to look to the people you know. So much of this partnership is going to be dependent on trust—you have to trust the marketer to land the sales; the marketer has to trust that you have the photography skills to satisfy the client—that working with a friend is always going to be the most obvious way in.

If you have a friend with a background in marketing and a head for closing deals—and if he admires your photography—try suggesting it to him. He might even find the idea fun.

The only alternative is to advertise for a partner but that's unlikely to yield good results. The sort of people who are willing to market a photographer they don't know solely in the hope of winning an occasional commission is likely to be the sort of person who hasn't been able to find a permanent job himself.

What are the chances he'll find you one?

GETTING STARTED

Begin with a chat. Ask yourself which of your friends has the knowledge to sell your photography services and the time and interest to do so. Then put forward your proposal. This is a strategy that has been used by Jeremy Mason McGraw. You can see his work at www.jeremymasonmcgraw.com.

Match Your Skill with Digital Artists

DIFFICULTY

COMPETITION

INCOME POTENTIAL

$ $ $

What It's All About

The art involved in creating a good photograph never stopped at the shutter release button. Once, photographers could still look forward to happy hours in a dark room, timing chemicals and hanging up prints to dry.

Today, they can look forward to just as much time sitting in front of a computer, playing with graphics programs to clean up their images.

But programs like Photoshop can do a lot more than change the format of an image or correct small mistakes in exposure or noise levels.

They can be used to create entirely new images.

A number of designers have built their careers by re-processing their photographs in Photoshop. The results are often psychedelic, unique and characteristic of the artist while still preserving the image that acted as a foundation for the piece.

Creating works like these though requires two different sets of skills.

They require the photographic skills needed to capture a great composition; and they need the digital skills necessary to rework the image into something unique and even more interesting.

If you can find someone with the digital skills, you can supply the photography and split the profits.

What You'll Need to Shoot to Team Up with a Digital Artist

Because most digital artists can usually find their own way around a digital camera, the sorts of images that you supply will need to be a bit special.

That might mean a special style but because your style is likely to be covered by the artist's digital work, it's likely that you'll find it easier to supply images of a certain subject that the artist himself can't reach—

TIPS

Be Professional

The artist you're approaching might be well established with a long list of big clients to his name, but he's going to prefer working with someone of equal status—or at least equal ability.

Before you make your approach then, make sure that your own website looks professional. When you ask the digital artist what he thinks of your images—and what he would do with them—you'll need to create a great first impression.

Find Someone with Good Marketing

Ideally, the partner you find won't just be a whiz with Photoshop, he will also be a whiz with marketing. Or at least he'll be a whiz with regular buyers keen to pick up whatever he brings to the market and a way of getting his products there.

As you're looking for artists to join up with, pay attention to their stores as well as their designs.

SUMMARY

The biggest challenge of this partnership is that the quality of photography necessary to rework a picture digitally doesn't always have to be particularly high. That means that designers are often skilled enough with a camera to shoot their own pictures, making up for any imperfections with a few mouse clicks.

But that's not true of every designer and it certainly isn't true of every type of image.

There are still opportunities here for photographers with the right images and designers with the appropriate sets of skills.

Those opportunities can be even more valuable if the designer you're working with already has sales channels in place and a market to sell to.

underwater photography, for example, or pictures of Burmese temples, Appalachian huts or urban night scenes. The artist might not be able to create the images herself because she doesn't know how or because she's unable to reach their geographic locations.

The sort of work the artist can supply might vary too. Some artists might want to completely rework the image, creating an entirely new piece. Others might simply be able to change the background, digitizing it so that it can work as computer wallpaper or animating it into a screensaver.

As long as the result is also sellable and that both creators receive full credit—and a share of the revenues—then it will be up to the two partners to figure out what each side needs.

Those discussions will also have to include the kinds of products that would result from the cooperation, a decision that will have to be based in part on the type of image being produced and in part on the sales channels already in place.

A designer with a track record of selling design books for example would be better off publishing your joint works in book form than trying to sell prints to an audience not used to buying his works that way. A designer used to selling stock however, would be better off adding the images to his stock portfolio and either paying you a flat fee for the image or sharing the royalties.

Whatever images you decide to shoot and however you decide is the best way to sell them, it's also likely that the arrangement will work best

over a short period. You'll be working on a project together rather than building a career together.

This is a creative partnership, after all, and both partners will have plenty of ideas that they'll want to follow up on their own.

How to Create a Partnership with a Digital Artist

This is a slightly unusual partnership so cold pitching is unlikely to yield big results. You'll have to warm the prospect up first by showing an interest in the artist's work and by building an interest in your own.

Not only should that be relatively easy but the process of doing it might even help to prepare a market.

That's because savvy digital artists are likely to be users of social media sites like Facebook and Twitter. By becoming their friend or follower and taking part in their group discussions, you'll be able to chat with the artist directly.

Don't rush straight into your pitch though. Talk to the artist about his work first. Leave comments when he puts up new products on Zazzle or his website or wherever he's selling.

Then ask the artist a question about your own work. Only when you're reasonably confident that you won't be rejected should you suggest working together on a specific project.

GETTING STARTED

Finding a partner like this is a bit of a process. You'll need to spend time browsing artists' portfolios for likely candidates and checking their websites. Art product sites like www.zazzle.com and www.imagekind. com can be good places to look and because you can also leave comments on their profile pages, they can also let you start chatting.

Wherever you find your artist though make sure that you have a similar outlet for your images.

So if you find a likely partner on Zazzle, create a Zazzle account. If the artist only has a website, put up a website of your own. It will help to show that you're on a similar level.

Reach for the Stars with Dance Schools

DIFFICULTY

COMPETITION

INCOME POTENTIAL

$ $ $ $

What It's All About

It's well-known that parents of high school students are prepared to pay for photos of their children before they graduate. Hhigh schools aren't the only places that children take classes though and other schools can often yield much more attractive images.

Dance schools, for example, create fantastic opportunities for beautiful portraits—and a chance for both you and the school to earn a little extra revenue.

If a photographer can make a deal with a high school to shoot the school's students, sharing the revenues, then there's no reason you couldn't make the same deal with the owner of a dance school.

SUMMARY

Creating a joint venture with a dance school could turn out to be very remunerative. Although dance classes might not have a huge number of students, owners should be keen on any revenues they can land and parents will be keen to own pictures of their children in costume and doing their routines.

And the shooting should be fun too.

While high school portraits usually mean sitting a child in a chair just long enough to snap their head and shoulders, photographing dance students will mean shooting action shoots that capture the grace of the movement as well as the face of the dancer.

For some schools these gigs happen more than once a year, plus there are competitions, and you can try to land deals with more than one school—all of which could be valuable revenue streams.

204

(P) PHOTOPRENEUR

What You'll Need to Shoot to Team up with a Dance School

In the end, you'll be shooting pictures of children dancing. To sell, those photos will need to be stylish and beautiful, reflecting the skills the children have learned and their abilities to dance, but they'll also need to show clearly the face of the child in the picture.

Parents won't be interested in buying photograph of a child dancing. They'll want to buy a picture of *their* child dancing.

That's straightforward enough. Harder though will be to persuade the owner of the dance school that you have the skills and the experience necessary to create those pictures.

You might find that when you make your pitch, the dance school owner will look at any quality images you show her and agree to the deal. There is currently very little competition in this field so if she can see that you know your way around a camera and that the idea is sound, she'll assume that you can create effective pictures.

She'll also have little to lose. Her only risk will be to let a photographer loose in her studio during one of the classes. The revenues will be coming from the parents, not from the dance school.

But you can increase your chances of winning an agreement if you can also show that you have experience of shooting theatrical imagery.

Theaters often hire photographers to shoot rehearsals for their publicity material and to record the performance. Those might be difficult to persuade though so you could try the drama department at your child's school especially if he or she is performing.

But neither of these may be necessary. Working with a dance school provides such useful benefits for both sides, that simply showing your portfolio should be enough to land you the job. And once you've both earned money, you should find that it becomes a regular, annual gig.

How to Create a Partnership with a Dance School

Creating the partnership will depend on your ability to make a good proposal to the owner of the dance school. Call ahead rather than drop in; teachers are likely to be busy when they're in the studio. Explain that you're a photographer, that you'd like to work with the school to provide parents with pictures of their children and that you'd like to meet to discuss it.

TIPS
FOR SUCCESS

Use Figures to Make Your Pitch

It's not always easy to estimate future earnings when you're proposing a joint venture but statistics for school photographs are well-known and the figures for dance schools—where the images are more dramatic—should be even higher.

If you can tell the dance school owner exactly how much they can expect to earn from the shoot, you'll make the pitch much more persuasive.

Stress Your Photos' Marketing Power

Money though isn't the only benefit that your photography will bring. It will also function as an additional service that the school can offer parents, and it will help the school to sell itself.

Remind the school's owner that parents will be showing off their child's picture and in the process showing off their school.

(continued on next page)

TIPS

FOR SUCCESS

(continued)

Upsell to Maximize Earnings

The standard product for a shoot like this is a print that parents can frame and place on their mantelpiece, but as you're shooting try to think of other uses that parents might want for their images.

If you can give the parents additional choices of digital wallpapers for the computers or mobile phones, framed prints from which you make a profit on the frame or additional prints for an extra fee, you can raise your 80 percent take-up rate to 120 percent or higher.

When you do meet, begin by asking about the school rather than launching into your pitch. Ask how many students the school has and how often it brings in a new intake. That will let you calculate the amount of revenue you'll both be able to earn.

High school portraits tend to sell for around $25 so you should be able to charge about the same price for dance school pictures. Take-up for those sorts of pictures usually ranges from 70 percent to 85 percent, depending on location.

You'll be shooting pictures that parents won't be able to take themselves so when you make your pitch, you can use figures at the higher end of the scale.

The share returned to the school varies by location too. Some schools expect as little as 10 percent while others may demand as much as 40 or even 50 percent.

You'll be creating fewer pictures so to make the shoot worth the school's time, you'll probably have to give them more than the minimum.

If a dance school has 30 students then and 80 percent of the parents buy a picture at $25, total revenues would be $600. You might agree to give the school $200, giving yourself $400 minus printing costs for enjoyable work that shouldn't take you longer than an hour.

GETTING STARTED

Begin by making a list of all the dance schools in your area. www.danceschools.net should help you. Try to include every school to which you're prepared to travel. Gather all the information you can about the school. Websites should tell you who to call and might even indicate the number of children the school accepts, giving you an indication of the amount you can expect to earn from each school.

Call one school at a time to make your pitch. Each pitch should teach you a little more about what you need to say to win the job.

Entertain in Waiting Rooms

DIFFICULTY

COMPETITION

INCOME POTENTIAL

$ $ $

What It's All About

One of the biggest challenges involved in marketing anything is persuading potential buyers to stop and look at your product. With a million-and-one things always competing for people's time, a product has to really stand out if it's to attract attention—and be gripping if it's to hold onto that attention.

There are a few places though where people don't have anything to do, where their attention has nowhere to go and where they'll be grateful for an entertaining diversion.

Medical and dental waiting rooms, for example, are filled with nervous patients trying not to hear the sound of the drill in the next room and leafing bored through old copies of magazines.

If you can put your photo books in front of them at that time and make those books available for sale, you'll have a captive audience.

What You'll Need to Shoot to Team Up with a Surgery

In theory, you could shoot any collection of images, publish them, place the book in a waiting room and expect people to leaf through it.

If they're prepared to pick up a month-old copy of *People* magazine, they'll certainly pick up a book of beautiful pictures.

But you don't just want people to look at your images, you want people to buy them too. That will only happen if your images are interesting and desirable enough for people to want to take away with them.

A collection of landscape photographs then will need to be beautiful enough for readers to want to look at again and again. A book of niched images such as car photography or wildlife pictures will have to be inter-

TIPS
FOR SUCCESS

Know Your Audience

While you can put any collection of images in front of people with nothing to do, you'll probably get the best results by matching the content of the images to the types of people attending the clinic.

Clinics in wealthy areas, for example, are more likely to have richer clients who can afford to buy prints and are less likely to blanch at paying $30 or more for a photography book. The website that those readers visit when they pick up your card then can afford to offer higher priced items.

If you're placing your photos in clinics used by students, however, you might do better by offering posters or postcards on the website rather than expensive prints.

(continued on next page)

SUMMARY

The fact that people in waiting rooms have nothing to do and are desperate for a distraction solves one major marketing problem. But it does leave a couple more.

The first is that people waiting for a dentist aren't necessarily going to be thinking of buying a photography book or picking up a print.

They're going to be wondering how many cavities are going to need filling and just how much the treatment is going to hurt—and going to cost.

That's not an impossible obstacle. Some people will still be interested in buying and it is possible, by choosing the right surgeries and the right images, to raise your conversion rates and generate sales.

The other is that you have to persuade the surgeries to let you place your books in their waiting rooms. But again, that shouldn't be too difficult. It won't cost them anything after all. A visit and a chat should be enough to put your photography in front of people who want to see it—and perhaps even buy it.

esting enough to hold people's attention through the wait and still leave them wanting more.

One way to do that is to make sure you include plenty of text next to each image describing the picture and explaining its importance. That's a good idea anyway in photography books because it slows down the reading and helps the viewer to feel that he's getting value for money.

When you're putting the book in a waiting room though, it's particularly important because you don't want the reader to finish the book before the appointment. You want him to put it down reluctantly and with a desire to read more. Reading always takes longer than looking at pictures so plenty of text should be helpful.

An alternative approach though is to forget about selling copies of the book and use the publication to sell prints or commissions. So a baby photographer could create a book filled with baby portraits for women to look through at a gynecologist's clinic and leave his business card on the counter for them to take away with them.

A landscape photographer could create a book filled with beautiful pictures of trees and hills and place flyers on the table indicating that prints are available for sale.

You'll have to decide which method works best for you and for that particular surgery.

How to Create a Partnership with a Surgery

You shouldn't find it too difficult to persuade receptionists to let you place your book of photographs in their waiting rooms—although they might have to ask permission from the doctors or dentists first. They won't be paying for it and anything that makes the waiting time more pleasant will be of benefit to them as well as the patients.

Where you will struggle though is persuading them to take orders of the books for you. Few will be willing to stock copies and take payments on your behalf.

A better option will be to offer the receptionist the book for free and also ask if you can leave some cards on the counter with your contact details or the URL of your Blurb page so that interested readers can order a copy of their own.

GETTING STARTED

Before you can begin working with surgeries and clinics, you'll need to have a product to sell. If you're planning to use the book to generate commissions, you won't need more than a collection of sample images that you can put together in book form with your contact details. If you're hoping to sell prints, you'll need an online portfolio that allows people to choose the prints they want to purchase.

Most photography website templates include a printing and framing service.

If you want to sell photography books, you'll need to create the book first. Both www.lulu.com and www.blurb.com let you create photography books that customers can order online.

Once you've created your products, start with your own doctor's or dentist's clinic. You might know the receptionists there already so either stop by or wait until your next appointment and ask if you can leave a copy of your book and some business cards behind. Then start hitting the other clinics in your neighborhood.

TIPS
FOR SUCCESS
(continued)

Create Promotional Copies

As people are reading your book—and enjoying it for free—you'll want to remind them constantly that your images are also available for a price. Print-on-demand publishers make even tiny runs of one copy for each waiting room worthwhile so you can create promotional copies that include a one-line sales message on each page.

Sentences as simple as "This book is available for sale at www.yourwebsite.com", "To commission John Smith for your baby photos, call 123 4567" or "These images are available as framed prints at www.yourwebsite.com" could be enough to turn readers into buyers.

Help Members of Craft Organizations

DIFFICULTY

COMPETITION

INCOME POTENTIAL

$ $

What It's All About

The biggest challenge of creating joint ventures is that each partnership has to be negotiated separately. You have to decide what you want out of the relationship, what you're prepared to supply in return, the minimum you're prepared to accept that would make the partnership worthwhile and how to approach the potential partner.

That can all require a little work but it is a vital part of selling photography on a regular basis and the results make it all worthwhile.

It would be much easier though if you could skip all that work and create a relationship with one group that represents a bunch of other partners.

Craft organizations are one way to do that.

Their members create products that they often want to sell and for which they need photographs.

The organizations are usually happy to provide their members with a valuable service, especially if it comes at an apparently discounted rate, and they're usually short enough of cash to appreciate a share of the revenues.

A partnership with a knitting club, an origami organization, a jewelry-making circle or any other craft group could provide a quick burst of income when you create the partnership and a steady flow of revenue as you build relationships with the group's members.

What You'll Need to Shoot to Team Up with a Craft Organization

You might feel that the sort of photography skills you need to shoot jewelry, cakes or hand-made furniture are all fairly similar. If you're talented and skilled enough to shoot one you should be able to shoot them all.

66 Help Members of Craft Organizations

SUMMARY

Land a deal with an organization that has plenty of members who need photography services and you'll make finding clients very easy.

Share the profits and they'll even do the marketing for you.

You will need to come up with a good deal though. The organization will want its members to feel that they're getting a reward for belonging to the group and that they couldn't get this deal anywhere else.

You'll also need to persuade them that the services you provide will be of real benefit to them. That will be easier to do if you choose a craft that is sold through catalogs or online—or through any medium that relies on pictures to make the sales. Scrapbooking, for example, might be popular but because the books themselves aren't usually sold you might want to focus on any groups you can find that create borders or decorations that go into the books rather than the scrapbookers themselves.

In practice though, you shouldn't find that persuading craft organizations to put your services in front of their members is very difficult. As long as they don't have to pay anything in advance and the offer appears to be unique to the group's members, they should be very happy to make the introduction.

When you make your approach to a craft organization though, you will need to show that you're capable of creating exactly the kind of images that the organization's members need. It will help then to prepare a portfolio of images directly related to the organization.

That shouldn't be too difficult either nor should it take too long.

If you were planning to approach a woodworking club, you would only need to create a handful of well-shot photographs of wooden tables, chairs and ornaments.

If your target was a beading organization, you could take a few impressive photos of necklaces and bracelets.

And if you wanted to help quilters sell their work, you could pull out some quilts and shoot them in a way that beats the sorts of photos that an average photographer would produce.

If you have those sorts of photographs buried on your hard drive already, you won't have to do any additional work at all. And if you don't, the sample images shouldn't take you more than a few hours of happy shooting to produce.

TIPS FOR SUCCESS

Offer Photography Days

Instead of inviting group members to call and claim their discount—which requires them to take action—offer to turn up to one of the group's meetings at which people will bring the products they want photographed. It will be much harder to refuse when you're present, with your camera, shooting other people's products.

Get Involved First

Craft organizations tend to be quite cliquey so they're likely to be much more sympathetic to photographers who have shown a genuine interest, understanding and appreciation of the kind of work they produce. Perhaps the best way to win these kinds of jobs then is to choose a craft you actually enjoy and attend a few meetings first.

Use the Partnership to Find Clients

You might make a little money from the initial marketing of your partnership, but ideally, you'll want anyone whose products you shoot to come back to you regularly for more. Treat your first shoot as a discounted sample then and invite each client to call you again.

How to Create a Partnership with a Craft Organization

Because local craft organizations tend to be fairly small, you should be able to expect a reply even from a cold approach by email. That's especially true if you make the benefits of your pitch clear.

Begin by praising the organization and its work. Show that you understand the work it does and that you love the products that its members create. The organization is likely to feel happier giving work to someone who appreciates the sort of craft it specializes in.

Then explain that you're a photographer and that you'd like to offer your services to help its members make money from their creations. Tell them that you can photograph their products in exactly the way that websites and catalogs need and—most importantly—that you'd be prepared to do it at a special rate for the organization's members.

In addition, in return for working together to help those members, you would be prepared to give the organization a share of the revenues.

The size of that share will depend on how you're planning to create the photos and the likelihood that you'll be able to turn a single offer into continuous work. If you're simply shooting products created at the end of a special project, then few people are likely to continue creating and the chances of landing regular clients would be small. You might then want give the organization a relatively small share such as 10 or 20 percent. If the organization's members create many products and on a regular basis, increasing the chances that some of them will become regular clients, then it may be worth offering the organization a larger share—perhaps as much as 50 percent—of the revenues for the first shoot.

GETTING STARTED

The best way to begin is to choose a craft that you're genuinely interested in. Shoot some sample images, then find the name of the group's contact and send an email message containing your offer. www.craftsreport.com has a list of craft organizations and the American Craft Council at www.craftcouncil.org may be useful too. Attend a few of the group's meetings and make it known that you're a photographer and that you're prepared to offer a discounted rate.

Work with Hotels

67

DIFFICULTY

COMPETITION

INCOME POTENTIAL

What It's All About

The benefits of most joint ventures are clear. You supply a service, the partner brings a market and you both split the revenues.

Sometimes though, you can really get lucky. You can find a partner that lets you supply a whole range of different services and cash in on a number of different markets in a number of different ways.

There aren't too many potential partners as flexible and powerful as this but hotels are one of them.

If you can create a relationship with a hotel, you can benefit in no less than five different ways:

Temporary Exhibitions

Hotels have the space to hold exhibitions. They have rooms that can fit plenty of people milling around with canapés and they have the wall space too.

Most though will recognize the value of that space and prefer to charge an artist for the room, but if you can build a good relationship with the owner of a small, independently-owned hotel, they may be willing to provide a space that would otherwise be empty in return for a share of the sales.

Prints on Walls

An exhibition may take up a valuable room, but hotels may also be willing to hang your pictures permanently . . . complete with price tag. Every time they sell a print, you replace it with a new one and they get a commission.

TIPS
FOR SUCCESS

Match the Images to the Hotel

Hotels don't usually form partnerships with photographers but they will be interested in any service that can enhance their own marketing and bring in guests.

An exhibition of photographs that fit a hotel's theme then won't just give you a free space to show your works and generate revenue for the hotel; it will also help to burnish the hotel's image and bring in more of the sort of guests it's trying to win.

The branding power of an exhibition is a strong sales point during a pitch.

Emphasize Your Own Marketing

And your own marketing is going to be a strong point too. If you can tell the hotel's owner that you'll be bringing art lovers into the hotel—people who will be looking to hold events or recommend a place to stay for friends and family—they'll understand that in return for improving the look of their walls and winning commissions on sales, they'll also be getting some free marketing.

That's not going to be easy to turn down.

Postcards and Photography Books

Tourists who stay in hotels are often keen to buy postcards, either as souvenirs or to send home, and books containing images and explanations of the sights they've come to see. If the hotel has a store, you can ask if they're willing to stock them. If not, the hotel might be willing to make them available at the registration counter.

Wedding Referrals

Hotels are also used to hosting events such as weddings where photographers will be working too. Offer the hotel's events manager a commission for each referral he brings you when making a booking and you could give yourself a steady stream of wedding photography business.

Marketing Images

This is less of a joint venture than an opportunity that could result from a close relationship with a hotel. Work with a hotel long enough and there's a good chance that you will be the photographer they turn to when they need images for their marketing material.

You could also offer this service as part of the benefits of forming a joint venture.

SUMMARY

Get your foot in the door of a hotel and all sorts of opportunities can open up. But it won't be easy. While large hotels might provide bigger markets and greater visibility, they'll often have rigid procedures that don't allow them to open their wall space to local artists or use an empty room as a temporary gallery.

The owners of independent, boutique hotels on the other hand will have the flexibility to make agreements with photographers and may even consider such deals as good for their image.

Target those sorts of hotels in your neighborhood and you could find that you have a regular place to exhibit your work, space to sell them all the time and a store from which people can buy the smaller versions of your photos.

What You'll Need to Shoot to Team Up with a Hotel

The sort of images that might interest the owner of a hotel will depend on the kind of partnerships you're looking to create.

If you're simply suggesting that an events manager recommend your service in return for a commission then you'll need to prove that you really can shoot beautiful wedding images. A good-sized pile of testimonials and recommendations would be helpful too.

For exhibitions, wall space, postcards and books though, you'll probably find your pitching easier if you can offer images that are directly related to the image of the hotel. You can pick up a clue to what those sorts of images might be by looking at the hotel's marketing material. If the hotel emphasizes that it's close to a wildlife reserve or near good hiking trails, you could show the owner a portfolio of wildlife or landscape images. If the hotel stresses its downtown location, you could show them your collection of street photography. If its biggest selling point is its modern style, you might do well with some more artistic images.

Once you land the partnership though, you'll be able to track the sales to see which kinds of images are selling best.

How to Create a Partnership with a Hotel

Proposing a joint venture shouldn't be too difficult, provided (as always when you're proposing a joint venture) that refusal doesn't offend and you have a thick enough skin to slough off a rejection.

Call ahead and ask for an appointment with the manager. Explain that you're a photographer and that you have some business ideas that you'd like to discuss briefly with him.

When you do meet, pick just one form of joint venture to begin with. Placing your images on the walls with price tags could be a good bet—it demands the least from the hotel and delivers the highest potential rewards. If that partnership works then you'll have enough of a relationship with the hotel to start talking about other partnerships such as exhibitions and wedding referrals.

GETTING STARTED

The best way to start is to visit your local hotels. Take a look at their websites and stop by to check out their reception areas and event halls. Pay attention to the sales points that they stress in their own marketing material and the sort of atmosphere they're trying to put across. Two places to look are www.hotelbook.com and www.smalleleganthotels.com.

Choose one hotel, make an appointment to speak to the manager and put together a portfolio to demonstrate. Start with something simple like temporarily hanging your images in the reception area and emphasize the income and marketing value of even a small exhibition.

Makeover Your Income by Partnering with a Beauty Salon

68

DIFFICULTY

COMPETITION

INCOME POTENTIAL

What It's All About

Think of joint venture partners for a photographer, and framers, wedding planners or cafes will probably come quickly to mind. But there are plenty of other options that have the potential to sell images and generate revenue for someone who loves taking pictures.

A beauty salon might appear to have little to do with photography but its walls are often decorated with posters shot by photographers and most importantly, its clients are often the same as the people who want pictures taken for their weddings and their portraits.

With a little creativity, it's possible for photographers and beauty salons to create deals in which they share each other's clients, sell images in return for fees and free decoration, and work together to create beautiful photographs that people will treasure and buy.

What You'll Need to Shoot to Earn with a Beauty Salon

One of the strengths of teaming up with a beauty salon is that there are so many different ways for both sides to earn from the relationship:

Mount an Exhibition

Perhaps the easiest is to use the salon's walls to mount an exhibition. Beauty salons are filled with people with nothing to look at but old magazines and a reflection of themselves with wet hair.

Ask the owner if he'd like to put some of your pictures on the wall in return for a share of the sales and while you'd be getting a free exhibition, he'd also be receiving free decoration.

TIPS

FOR SUCCESS

Build the Relationship First

One of the advantages of working with a beauty salon owner is that the deals are so easy to make.

You probably know the owner of your beauty salon and you probably know all sorts of things about him or her. After all, when you're sitting in the chair there's little to do but chat.

Most of that chat though is going to be small talk. There's a big difference between talking about your vacation and breaking a deal to share your clients. So take it slowly. You might need more than one visit to form a solid enough relationship on which to build a strong joint venture but it's worth the investment!

Take More Than One Deal

And one of the other advantages is the range of benefits on offer.

Once you've built that joint venture then, don't settle for just one benefit. Cement the relationship even further by adding more details so that you can both make even more money.

When a joint venture like this can deliver so many benefits, why waste any of them?

(continued on next page)

SUMMARY

Beauty salons might not be the most obvious places to look for joint ventures, but that's just part of their advantages.

They do offer a wide range of different opportunities and because so many photographers ignore them, you should face little competition when you make your pitch.

The owners of beauty salons won't have heard it all before and as long as you point out that there are no costs and plenty of benefits, you shouldn't find the joint venture too hard a sale.

Best of all perhaps, that sale will be easier still for clients of beauty salons. Sit in a chair while someone cuts and shapes your hair, and you'll have a golden opportunity to talk about your work, your images and how those photographs could help the salon.

Most joint ventures are formed on the basis of the personal relationship between the two partners. A beauty salon may be one of the easiest ways to form that relationship and few joint ventures offer such a broad range of profitable opportunities.

Those images could be of anything but you'll probably find the salon owner most amenable to images related to beauty or fashion.

Pitch for Wedding Photos

One client base shared by both photographers and beauty salon owners is wedding clients. Begin swapping wedding stories with the owner of your beauty salon and you'll quickly build a special relationship with them.

It shouldn't take too much to win an agreement to refer clients to each other, although you might need to show the salon owner your portfolio first.

Take Help for Portraits

Portrait subjects are another shared client base. Many of the portrait photographers used by LookBetterOnline, for example, also offer hair and make-up services for an additional fee.

If you're offering portrait services then, many of your clients will need someone to help them look their best. Offer that service through your beauty salon partner—and take a commission for the introduction.

How to Create and Market Your Beauty Salon Joint Venture

Joint ventures with the owners of beauty salons are among the easiest to create. You might even be able to agree to the deal in principle while getting your hair cut. That will just leave the details to be figured out later: the size of the commission for portrait referrals, the exchange of piles of business cards for wedding clients, and the types of images and sales fees for exhibitions.

And you'll also need to figure out the marketing.

That's another strength of a joint venture—because two of you will be doing the marketing, you get to double your promotional power.

An exhibition could be promoted with invitations sent to the beauty salon's customers, as well as press releases and invitations to local cultural dignitaries such as critics, gallery owners and collectors.

Your portrait deal could be cross-marketed by supplying the beauty salon with pictures of the clients you've both helped so that both of you get to show off your work to potential new customers.

And promoting a wedding photography deal wouldn't take any more than a recommendation during a chat with a client. That's not a deal you'd need to push too hard to achieve.

GETTING STARTED

Joint ventures like these start with a trip to the beauty salon. If you don't need a haircut just yet though, you can take a look at how many photographers at www.lookbetteronline.com also offer beauty services, and the Professional Beauty Association at www.probeauty.org may give you some good places to look for potential partners.

TIPS
FOR SUCCESS
(continued)

Do the Promotional Work

A joint venture is only a framework that delivers benefits. To receive those benefits, you have to put that framework into action. Rely on your partner to do all of the marketing work, and inevitably, you'll end up with one disappointed partner—and one broken relationship.

Write the press releases, send the invitations, print the pictures to put on the walls and tell your clients about your partner's work. It's the only way to get the same attention in return.

Illustrate the Work of Local Authors

What It's All About

Photography is creative work. That's what makes it so much fun. But that's also what makes it so hard to sell. When you can take an image in any direction you want—and try to—the result will always be a lack of predictability.

Buyers, however, usually want reliability.

It's not just photographers who struggle to turn their creativity into a revenue-generator though. Writers too have to battle with publishers or worse, face the challenges of self-marketing.

SUMMARY

Writers aren't the most obvious partners for photography joint ventures, nor are they necessarily the most profitable. But they can be among the most enjoyable.

You'll be working with another creative person on a project that could be more artistic, more successful and more satisfying than anything either of you could have produced alone. That's always a good benchmark for a joint venture partner.

But joint ventures like these aren't easy to create. Your town is always going to have more picture framers and beauty salons than writers on the up. You'll need to find someone whose work matches your own, get to know them, get them to know your work and build enough of a relationship for both sides to want to turn it into a working relationship.

If you can find a suitable partner though, you might well find that you have more than a joint venture. You'll have the beginnings of a beautiful creative relationship.

Team up with a writer then and you can share the challenge—and share each other's successes too.

What You'll Need to Shoot to Build a Joint Venture with a Writer

Although a partnership with a writer is likely to be creative first and profitable hopefully, there are still a number of directions the joint venture can take—and a range of different types of images you can shoot.

Create a Story Book Together

Perhaps the most obvious approach—and the one that is used in the publishing industry, especially to create children's books—is for a writer and a photographer to create a story together.

The writer provides the text and the photographer shoots the images that illustrate the text.

It's a little like a photo editor commissioning a photographer to shoot for a story—but there's no editor and no salary. On the other hand, there is complete collaboration and an equal share of the royalties if the book is published and sold.

Illustrate Poetry

A more creative project would be to provide artistic photographs to accompany a book of poems. Poetry is a notoriously hard sell but a book of poetry that also contains inspiring images looks like a very different kind of project.

You'd need to find a poet whose work you admire and a way of publishing the book too; Blurb could help with that. But few poets ever make a great deal of money, and that's likely to be true of photographers who work with poets.

This is definitely a job you do for love rather than the money.

Mount Exhibitions

One way to make an illustrated poetry book easier to sell would be to use the book as the catalog of an exhibition. That would invert the relationship

between the photographer and the writer. Rather than your images illustrating the poems, the poems would explain the images.

The catalog—or book—would then redress that balance.

An exhibition like this wouldn't just be fun to put on, it would also bring in twice as many visitors as an individual show—and without you having to share your space with another photographer.

How to Create and Market Your Joint Venture with an Author

The best way to create any joint venture is to create a good relationship first with the potential partner.

Often, those relationships are formed at business conferences or other forums where entrepreneurs come together with the understanding that they're building professional networks.

Authors though—and photographers too—rarely attend such business conferences and they tend not to be looking for professional relationships. They'd prefer to have a creative partnership that enhances their work.

One way to find writers then—if you don't know any—is at book readings. These tend to be pretty informal affairs where you can ask questions and chat with the writer. Follow up your question with an email to the writer, pitching your joint venture idea and see what happens.

If you can come up with an idea that builds on the work the writer has done and moves it into a direction he couldn't have taken alone, you'll increase the chances that you'll win an agreement.

You can also attend writers' circles and workshops, and catch a new writer on the way up.

How you market the joint venture will depend on the project. Story and poetry books you might want to pitch to publishers with a professional proposal, but an exhibition can be promoted with the usual array of targeted invitations.

Bear in mind that you and the writer will be aiming at different markets—the writer will want publishing executives to see your show; you'll want art buyers and gallery owners—but be prepared to benefit from their audience too. Publishers also print photography books, and they need images for their book covers as well.

69 Illustrate the Work of Local Authors

GETTING STARTED

Photographer George Ancona started his career by teaming up with a writer. You can see his work at www.georgeancona.com. And www. writers-circles.com has a directory of writers' circles that could provide rich pickings for potential partners.

70

Make a Nursery Bloom

DIFFICULTY

COMPETITION

INCOME POTENTIAL

$ $

What It's All About

If pets, children and landscapes are among the most popular of subjects for photography enthusiasts, flowers can't be far behind. Beautiful in themselves, they demand very little from the photographer beyond framing, focusing and depth of field to produce images that are full of color, filled with interesting shapes and which are easy on the eye.

Those images though, tend to look fairly similar. Once you've seen one close-up of a daffodil, you've seen them all. Selling them then can be difficult too. Stock sites already have all the flowers and trees they need while print images have to compete with thousands of others—and the knowledge that the buyers might be able to produce similar images themselves.

Forming a partnership with a nursery though can open up all sorts of opportunities for photographers who enjoy taking pictures of flowers. Because you can be certain that the images will be shown to people who

SUMMARY

Joint ventures like these are unusual. But that doesn't mean they can't be successful. Nurseries should be happy to take part in a venture that's related to their field while teaming up with one will enable you to step away from the competition and appeal directly to the most dedicated of flower-lovers.

The range of different types of joint ventures you could produce with a florist will also give you multiple ways of earning money.

And most importantly, you'll be able to shoot a subject that you enjoy, in the way that enjoy it—and get paid for it too.

understand flowers and enjoy looking at them, you can be reasonably confident of making sales.

And because nurseries are rarely approached about the idea of teaming up with photographers, if you make the right offer, you should be able to win the joint venture.

What You'll Need to Shoot to Build a Joint Venture with a Nursery

Like any good potential partner, a joint venture with a nursery provides a wealth of different options:

Exhibitions

People who buy flowers may well be interested in buying pictures of flowers. They'll certainly be interested in looking at pictures of flowers and a nursery that shows those images is able to portray itself as more than a supplier of garden goods.

It creates the impression that it's a company with a genuine passion for flowers and an understanding of them.

To create exhibitions like these, you won't have to do any more than shoot beautiful pictures of flowers or gardens—and find a nursery with enough wall space to hold your frames.

Contests

Alternatively, you can choose to show the pictures of flowers that other people have shot. Offer to work with the nursery to run a garden photography contest. They'd send out information to their customers explaining how to take part, supply a prize and provide a space for winning entrants to be exhibited.

You get to be the judge.

You won't make any direct sales as a result of running a competition like this, but you will get to position yourself above every other flower enthusiast with a camera.

When people see that you're judging their images, they'll assume that you know enough to sit in judgment on them. You'll brand yourself as an expert flower photographer, and that will make your own photography books, prints and products easier to sell.

TIPS
FOR SUCCESS

Stress the Lack of Risk

Despite their advantages, nurseries rarely form joint ventures with photographers so you'll need to take the lead. Stress that there will be no risks at all for the nursery and that you'll be prepared to do all of the legwork.

The nursery only has to supply the walls for the exhibition, the customer list for the contest or the payment system for the book. Make it as easy for your partner as possible and you'll make the deal more attractive.

Start with the Book

And the easiest form of joint ventures might well be to supply a photography book. Nurseries are used to selling items and paying suppliers so adding one more won't make too much difference.

Once they've agreed, you can suggest an exhibition to increase sales and bring customers in.

Flower Books

And of course, you can also publish your own flower photography books and invite the nursery to stock them. Order a bulk amount from Blurb, ask the nursery to place them next to the cash desk and share the profits.

That turns you into a supplier rather than a joint venture partner—and you'll have to take risk when you order in advance—but if the photographs are attractive enough, you'll both be making money.

You can increase the chances that you'll make money by including images of gardens as well as flowers alone to give gardeners ideas, and also by offering seasonal books so that products are available that match their mood.

Catalogs

All of these joint ventures might result in a useful bonus. When the nursery needs images for its brochures, marketing material and catalogs, you'll be the first photographer they think of.

The goal of your joint ventures might be to profit both sides, but it could well result in you becoming the nursery's photographer.

How to Create and Market Your Nursery Joint Venture

Before you can create a joint venture with a nursery—even for a contest—you'll need to have a portfolio of floral images. You'll need to show that you really are part of the nursery's community, and that you can appeal to their audience.

Once you have that portfolio, call the nursery and ask to make an appointment with the manager. Explain what you have in mind and emphasize the benefits the partnership will bring to the nursery.

Do be prepared for rejection though. It's always hardest to build joint ventures with people you don't know. An alternative—and more effective—approach then, would be to build the relationship first by being a regular customer of the nursery.

It's not worth doing that just to get a joint venture, but if you are into gardening then talk to the people at the nursery so that they know who you are and how much you like flowers before you make your pitch. The progression from customer to partner will feel much more natural.

70 Make a Nursery Bloom

Once you have the joint venture, invitations can bring people into exhibitions; flyers, notices and press releases can deliver entrants to a competition; and posters can help to sell your book.

GETTING STARTED

Photographer Tony Howell offers some wonderful examples of flower photography at www.tonyhowell.co.uk, while GardenGuides.com at www.gardenguides.com has a long list of nurseries for you to pick your partner from.

71

Create a Style

What It's All About

Success at selling photography depends on trust. Clients who commission you will trust you to create exactly the photos they want.

Sales partners working with you will trust you to supply the sorts of images that will please the customers they're referring.

Even stock clients will put their trust in you as a regular and reliable source of exactly the photos they need.

Building that trust will require a good portfolio, of course, but it also depends on showing the buyer that they can know what to expect. They might appreciate your talent and your creativity but when buyers are paying for a photo that they want to use, they don't want to be surprised.

SUMMARY

Developing a unique style is another way of working within a niche. A style you can call your own will enable you to stand out from other photographers and give you something to bring to the market.

But unlike a subject niche, a style can spread across different topics.

You might be asked—or you can choose yourself—to shoot wedding photos, landscapes or any other type of image in the style you've created. While that might give you greater flexibility in the range of jobs you can accept, the downside of having a recognizable style is that it won't be suitable for every job.

There is also the risk that you'll be pigeonholed not just as someone who can shoot a particular kind of image, but as someone who can only shoot a particular kind of image.

On the other hand, if that style is delivering a steady flow of work and sales, that might not matter too much.

One way to build that trust is to create a distinctive style, a way of shooting that's predictable and easy to recognize.

If buyers know that they can always receive a certain kind of image from you, you'll be the first place they turn whenever they need a photo that matches that look.

What You'll Need to Shoot to Develop Your Own Style

You can have a lot of fun trying to come up with different ways of producing your own style. You can also use up a lot of time and produce a pile of images that are all style and no content.

To cut down on the experimentation and make the focusing easier here are three areas you might want to look:

Colors

One easy way to define a style is to go colorful. Restricting your palette might be a little difficult but adding extra colors or emphasizing certain tones during post-production could produce interesting and unique results. Designers and photographers have managed to create big names and land even bigger clients by carefully adding Photoshopped colored flashes to their images.

Lighting

Special lighting can be a bit more photographic. There are some photographers' images that you can recognize immediately just by the way they're lit and the mood the lighting creates.

You could try creating a unique style then based on shadows, brightness and light-induced atmosphere.

Action Shots

Or you could shoot your models and your subjects with particular looks. Some photographers are known for creating their image in a natural photojournalistic style while others pose them in set ways. You don't even have to limit this approach to human models. Pet photographers have built careers with unique approaches to shooting animals.

TIPS
FOR SUCCESS

Shoot in Different Styles

While your style should be unique and distinctively you, there's no law that says you only have to shoot in one style. In fact, it's a good idea to use a number of different styles, including generic approaches, so that buyers and clients also understand that you can shoot in a number of different ways.

Some may ask you to produce images for them because of your landmark style; others may hear of you because of your landmark style but they'll hire you and buy your photos because of your talent.

Find a Style You're Passionate About

To create a distinctive style that's all your own, you'll have to shoot a lot of pictures in it. And to turn that style into revenue, you'll have to accept lots of commissions for that style too.

It's a good idea then to choose a style that you really do like playing around with. You want to enjoy your work, not see it as a chore.

Although, if you do get bored with your current style, there's no reason you can't create a new one.

These suggestions certainly aren't meant to be exhaustive so if you have a stylistic approach you've been keen to try, feel free! It will be all you.

How to Create and Market a Style

There are two aspects to owning a recognizable style: that your style is unique; and that it's recognizable.

Building the style itself should be enjoyable. You'll need an approach to photography that you find particularly interesting and challenging, something you can explore, build on and experiment with. Something, most importantly, that you won't get bored shooting.

You'll then need to create lots of great images that embody that style. Place them on your website, promote them as a collection on Flickr and talk about how you shot them and why you shot them in the way you did.

If the images are good and the style interesting enough, you should find that you prompt a discussion. Other photographers will want to know more about how exactly you shot the images and what kind of equipment you used. They'll want to see more pictures shot in a similar style and they'll leave comments pointing out the elements that they liked the best.

It won't happen overnight and it will take a fair amount of marketing, but in time, you should find that your name becomes associated with that particular way of shooting. You can even expect other photographers to produce copy-cat images that spread your name even further.

The result should be that buyers ask you to produce photographs that reflect your style for use in their own marketing campaigns or for their events.

GETTING STARTED

Before you can begin developing your own style, spend some time looking at the distinctive styles of other well-known photographers, both photography giants such as Ansel Adams and Richard Avedon and less famous artists such as Rebekka Gudsleifdottir at www. www. rebekkagudleifs.com and music photographer Joey Lawrence at www. joeyl.com. Pay attention to what makes their photographs unique and easy to recognize.

Then have fun experimenting. Ideally, your style will be something that grows organically out of what you're trying to do with your images, so enjoy the experimentation. If your experiments work, you should find yourself building that distinct look.

Shooting Textures

72

DIFFICULTY

COMPETITION

INCOME POTENTIAL

$ $ $ $

What It's All About

They might not look like the most exciting images in the world to shoot, but photographing textures can be testing, rewarding and even remunerative too. Whether you're trying to capture the roughness of tree bark, the smoothness of fur, the coarseness of rusting iron or the patterns on the surface of a lake, the challenge can be exciting and the results often more pleasing than you might expect.

And there is a market for images like these. Designers use plain textures as backgrounds for their own work and artists use them as starting points to create whole new pieces.

SUMMARY

Shooting textures well is a great photographic challenge. It's especially important to get the lighting right as well as the focus and the composition, and it's often particularly difficult to fix any technical problems in post-production.

Selling the final results—however attractive they might be—isn't too easy.

These aren't the sorts of images that you're likely to be commissioned to shoot, nor will people be lining up to buy framed prints showing the surface of a table.

But microstock images depicting nothing but a texture have been known to sell thousands of downloads each. (One has sold over 4,200 licenses alone, generating thousands of dollars in income for its creator.)

Produce beautiful and usable textures and there's no reason that you too shouldn't be able to earn from this kind of photography.

(continued on next page)

It's unlikely—although not impossible—that you'll be able to sell photographs of texture as prints but can certainly sell licenses for images like these and they can be beautiful enough to deliver a great of creative satisfaction too.

What You'll Need to Shoot to Create Textured Images

For textures, the subject of the image itself isn't always what matters the most. It's the effect that will usually sell the picture. Often, you'll be looking to create pictures that are rough or smooth, industrial or natural, even or undulating, etc.

The material you use to create the pictures with those effects may not be particularly important. So you could find yourself photographing the surface of a wall, for example, shooting a close-up of a tiled floor, creating a composition of the sea or even going macro on the material of your office chair.

That isn't always the case though. Some of the biggest-selling texture images depict different kinds of paper or material. Designers buy images like these to superimpose their own designs on while creating the impression that it was printed on parchment, an old scroll or the front of a t-shirt.

One way to generate ideas for texture images then is to consider the types of surfaces on which messages and designs might be printed. Those could include tarmac, the sides of buses, painted walls or wooden boards.

You can also think about the kinds of textures that would make useful backgrounds for ads and marketing messages. What impression would a natural texture such as a leaf create for a shampoo advertisement? What other kinds of textures would help other products?

If you can provide answers to those questions, you can generate ideas for photographs that designers would be prepared to buy.

How to Create and Market Textured Images

Shooting textures is a very special photographic challenge that requires a good understanding of lighting and focus.

If you're shooting outdoors—to photograph sand dunes, for example, or snow—the best time is usually early morning or late evening when the sun can create shadows of even low ridges. For shooting indoors, you'll probably find that direct rather than diffuse light gives the best effect.

72 | Shooting Textures

Texture is also often shown in close-ups although wide angles can create good effects for some natural surfaces.

You can also try combining different textures in the same image such as stone and water or material and metal. Bear in mind though that these might be difficult to sell unless you market them as elements. Buyers would in effect be getting two textures for the price of one.

When it comes to selling the textures, stock licensing is always going to be the best option. Microstock sites like iStockPhoto have a good selection of texture images, many of which seem to sell quite well.

You will have to be careful with your tagging and keywording when uploading texture photos to stock sites though. Include the subject as well as the color and adjectives that describe the texture in more general terms such as "background" and "texture."

In addition to placing the images on stock sites, you could also license the images through your own website or offer subscription-based deals to regular buyers, producing a certain number of images each month.

Or you could even team up with a designer and share the revenues on artworks. You could supply the texture and the designer would add his own digital magic to create an entirely new picture which could be licensed as backgrounds or printed and sold as art.

Perhaps the biggest challenge to marketing texture images though is that there's a huge number of free photos available at sites like ImageAfter.com and TextureHound.com. Often those are poor quality, which only helps to make your much better images stand out, but you might find it worthwhile to place a few sample images in some free banks provided you make it clear where users can find better quality commercial images.

GETTING STARTED

Take a look at the backgrounds and textures on www.istockphoto.com by doing a search for "textures." Organize the results by downloads to see which kinds of images are selling the most. Then break out your light stand and start shooting!

TIPS
FOR SUCCESS
(continued)

Don't Rely on Microstock

Microstock is always going to be the easiest way to sell your texture images; you can just upload them and leave them. But if you really want to make the most of this type of photography, don't stop there. A subscription model can be a great way to bring in regular income. Build your own website, allow users to take low res images for free but charge a monthly fee—$24.95 is usually a good amount—for designers to download all the textures they want.

Get the Lighting Right

The biggest technical challenge involved in shooting textures is getting the lighting right. Invest the time in learning and experimenting with different light levels and angles to get the effects you want.

73

Become a Paparazzi!

What It's All About

Celebrities may hate them but they know they come with the territory . . . together with the limousines, the bodyguards and the house in the Bel Air. Paparazzi are intrusive, driven and dedicated. They take pictures of the stars beaming on the red carpet, in bikinis on the beach and in embarrassing poses just about anywhere they can grab them.

And the photographers sometimes find that with the right shot—especially the sort that can break a career or destroy a marriage—they can earn a small fortune. Rates paid to amateurs have typically ranged from around $120 to as much $12,000. Others have sold for much more. Sales of $50,000 are not unknown.

While photojournalism is on the way down, photographs of celebrities are on the way up. Some of the highest-selling magazines on the racks are dedicated to stars, and mainstream tabloids will pay giant sums for rare photos of movie actors, television celebrities and singers you may never even have heard of.

For buyers, these are golden times. The pictures most in demand are those that catch the star at on off-guard moment—stuffing a sub into their mouth in a café or rolling over on the sun lounger—but professional photographers can't be everywhere. Members of the public however are everywhere and most of them have cameras in their pockets, even if they're only on their phones.

That means there's now a greater chance that if a celebrity slips up, someone will be on hand to capture the moment, giving them a front page story—and a big check for the person with the camera.

SUMMARY

Paparazzi have a bad reputation, one they only partly deserve. While many will do (almost) anything to get the picture, celebrities understand that having their face in the papers is often better than not being in the papers at all.

Celebrity snappers then can be seen to be doing the star a favor by giving them free publicity and making their name known. That is, after all, why even big names turn up to red carpet premieres.

Of course, the real money isn't in the planned events like award ceremonies and movie openings. It's in the unplanned moments such as a star couple kissing on their hotel balcony or a drunk starlet falling out of a nightclub. Those are the images the subjects don't usually want the public to see so in selling them you're going to have to accept that you're going to make at least one person very unhappy.

If that's a price you're prepared to pay, then taking paparazzi shots—and getting paid large sums for them—is something that anyone can do. Buyers are only interested in the picture you're offering at the moment not your portfolio of previous work so you won't need a long track record ... or any track record at all in fact.

You'll just have to find the celebrity.

What You'll Need to Shoot to Create Paparazzi Images

Clearly, you'll need to shoot pictures of stars and the more famous, the better. But you'll have to do a bit more than that. What the press really wants are photos of celebrities in off-guard moments. Image libraries are full of posed publicity photos of stars looking their best so they don't need any more of those.

Nor do they need a picture of some daytime soap star standing next to someone in a mall to take a souvenir shot.

But they will take Lindsay Lohan crashed on the pavement, David Beckham kissing his assistant or Tom Cruise doing just about anything.

A general rule of thumb used by paparazzi buyers is that the less a celebrity would like the photo, the more it's likely to be worth.

The quality of the pictures doesn't have to be huge either. Although better quality images will be easier to sell, it's the subject that counts in

TIPS
FOR SUCCESS

Move Fast

The public is fickle and can change its mind about a star very quickly. Celebrity photos therefore need to be submitted right away. As soon as you've taken the shot, you should be on the phone to an agency or submitting the image immediately.

Paparazzi photos don't grow old. They just disappear.

Obey the Law

In general, if a celebrity is in a public place, they're fair game. But you have to be in a public place too. You can't go clambering into someone's back yard or trampling over private property to get a snap, even if it is a shot of a lifetime. It's unlikely that you'll be able to sell it and even if you did, the court case would eat up all of your earnings. Star photos might be expensive but so are star lawyers.

Keep a Camera with You

You don't need to lug around thousands of dollars' worth of professional gear to take paparazzi pictures; you just have to be in the right place at the right time and with some means of recording the moment. If you're anywhere with a chance of a star appearing, make sure you've got a camera with you otherwise you'll just waste the chance.

these kinds of photos. Even a camera phone image can be good enough if the subject is embarrassing enough.

How to Create and Market Paparazzi Photos

The biggest challenge for paparazzi snappers is finding the celebrities. Professional paparazzi spend most of their days driving around, following tips provided by celebrity insiders and hanging out in bushes in the hope of catching enough of a celebrity glimpse to get the picture that will pay their rent.

That means you've really got two options.

You can do the same thing as the pros: generate contacts in the celebrity world to tell you where the stars are; drive from place to place to find a star at a party; wait outside nightclubs in the early hours; and stand in line at red carpet events in the hope of capturing a special moment that everyone else misses.

Or you can just make sure you have a camera with you at all times, hang out in places where you're likely to see a star and take any picture you see. LA beaches are always possible spots but there are plenty of other places where particular celebrities like to go.

And of course, it's always possible that you'll get lucky, snap a celebrity without planning to, and end up with a valuable image looking for a market.

Reaching that market is now easier than ever. Big Pictures, one of the world's biggest suppliers of paparazzi images, is happy to accept images from anyone who wants to send them in. Demotix will also act as an agent for citizen paparazzi.

GETTING STARTED

This is really a job that only people in star capitals can do. If you live in New York, London, Los Angeles or Aspen then you can begin by waiting outside a star magnet such as a swanky restaurant or an exclusive nightclub to try to get a shot. If you land something, the easiest way to deliver it to the media is to use a couple of websites.

Register with Big Pictures at www.mrpaparazzi.com or upload your photos at www.demotix.com.

Shoot for Bounties

DIFFICULTY

COMPETITION

INCOME POTENTIAL

$ $

What It's All About

There have always been two approaches to selling photos. You can either create images and find people willing to buy them; or you can hope that buyers commission you to shoot pictures specifically for them.

Those could include photos shot at a wedding, as well as images for advertising or news stories for magazines.

But there's now a third way of shooting for a targeted audience: shooting for a bounty.

A buyer will announce that he's looking for a certain kind of image, he'll declare how much he's willing to pay for the picture, and photographers will be free to send in their images.

The buyer will then choose the photographer who submits the most suitable picture.

Unlike shooting on spec, you can be certain that this time at least there is a buyer waiting for the picture.

What You'll Need to Shoot to Create Bounty Images

The kinds of images demanded by bounty hunters have ranged from specific buildings in certain towns to generic shots of famous landmarks. You'll find that people ask for such a huge range of different subjects that you'll just have to keep checking to see what's currently in demand.

Callouts issued by established stock sites however tend to be both tougher and more specific. Buyers will usually have little problem sourcing standard images of towns or places so the company will only need to use callouts to find very particular pictures. The callouts on FotoLibra, for example, have included "Leeds shopping," "Nigerian schoolrooms," and "knights jousting." The company reports that all of its callouts have results

TIPS
FOR SUCCESS

Don't Go out of Your Way

It's rare for a bounty placed on a site like Craigslist or Elance to pay a great deal of money. In fact, you'll usually find that if you calculate the cost of travel and time, it's not worth making a special trip to a photograph an image demanded by a buyer. If you don't have the photo on your hard drive, you'll have to decide whether to follow up the request.

Submit High Quality Images

The image demanded might be strange and the tone might be desperate but assume a high response rate. The winner won't be the first person to send in a suitable picture. It will be the person who sends in the best suitable picture.

SUMMARY

Bounty shooting sounds like a good solution to the problem every photographer faces when making a photograph available for sale: whether anyone would want to buy it.

Before you post your pictures of office telephones on a microstock site, for example, you can have no idea whether there will be any demand for images like those. If a buyer posts a notice asking for images of office telephones though, you can be sure that your picture would have at least one buyer. It just has to be better than everyone else's to nab the sale.

In practice, bounty shooting hasn't always lived up to its promise. The number of requests posted on websites by image users has turned out to be relatively small and the prices offered for the photos barely worth the effort of shooting them.

If you happened to have a suitable picture already on your hard drive, then it might have been an easy $10-$50 but in general, the higher the price, the lower the chance that you'd have an image available and the more work you'd have to put into creating one. The result has been that websites dedicated to offering bounties for photographs, such as GoSee4Me and SpyMedia, have had a tendency to close down almost as quickly as they appear.

A more stable approach to shooting for bounties then is to pay attention to callouts. These are calls made by stock companies for specific photographs that clients need and which they currently can't supply. Suitable pictures are offered to the client for sale while unsold photographs are usually added to the company's inventory and may be sold in the future.

You'll need to join the stock site to have access to this kind of information but the callouts can be valuable ways to discover which specific images clients are looking for.

in sales although the number of submissions varies with the difficulty of the subject. A call for "colorful greeting cards," for example, yielded 529 submissions. The call for Nigerian schoolrooms only produced around twelve pictures.

You can never tell what sort of images buyers might be willing to pay a bounty for or what you could be shooting.

Ideally though you'll want to find that the picture in demand is one you've already shot!

How to Create and Sell Bounty Photos

Bounties are really too rare—and too low-paying—to be able to rely on. But if you're looking to earn a little extra, occasional income then it is worth keeping an eye on those places where requests might be posted. These include:

Craigslist

Requests for images do turn up sometimes on Craigslist but because it's organized by location, the site can be a difficult place to search. You might do best by looking at the biggest cities such as New York, San Francisco and Los Angeles to see if anyone has placed an ad.

You'll also have to do this regularly. Any notice placed on the most popular Craigslist sites is likely to get plenty of replies and be pushed down the page pretty quickly.

Elance

Like Craigslist, Elance isn't a service dedicated to photography and certainly not to image bounties but it does sometimes advertise requests for certain kinds of images. You will need a paid membership to answer these ads and it won't be worth signing up solely for the chance to pick up the odd bounty. If you've joined anyway to pitch for image editing or other services though then it is worth keeping an eye out for image requests.

Farmboy Fine Arts

Farmboy Fine Arts is a design firm that supplies prints to hotels, spas and casinos. Photographers whose images have been accepted to the company's inventory may also receive callouts for specific image themes requested by clients.

FotoLibra

And FotoLibra does the same thing. Register on the site as a buyer—which costs nothing—and you'll receive a notification each time the company issues a callout. The competition is likely to be pretty intense and will come

from both talented enthusiasts and professionals but the company will pay full market rates based on image use.

Once you find an ad you can respond to , it will just be a matter of sending in your image and hoping you land the sale!

GETTING STARTED

Start making searches for bounties a regular part of your image marketing. Good places to look include www.elance.com, www.craigslist.com, www.farmboyfinearts.com and www.fotolibra.com.

Earn Real Income from Real Estate

DIFFICULTY

COMPETITION

INCOME POTENTIAL

What It's All About

All sorts of products are sold based on the strength of the images used in their advertising. Advertising companies understand this and are prepared to pay photographers thousands of dollars for photographs that can help to generate sales of a product that could be worth millions.

Real estate agents however often miss the importance of a good photograph even though the products they're selling also carry seven-figure price tags.

That opportunity isn't always lost though, nor should it be. Plenty of real estate professionals have come to recognize that a professional quality photograph of a home they're trying to sell can bring in more buyers and

SUMMARY

Shooting for real estate professionals can bring real benefits and should be able to generate real cash. And because those benefits are measurable, it should be fairly simple for a photographer to point out the value of their images and claim their share of the rewards.

In practice though, it's not always that easy.

Just as many homeowners like to feel that they can sell their property themselves, so many real estate professionals believe that they don't need to hire a photographer to take pictures of the properties they represent. They simply need to bring a camera the first time they come to look at the property.

The challenge for photographers will be to persuade the real estate professionals that the images they'll produce will bring them more money than they would otherwise have earned.

Use Figures When You Can

The images you'll be producing for real estate professionals have to be functional; they need to be able to generate faster sales and for higher prices than the real state professional would have been able to land otherwise. If you've got the figures to back up your claim, you shouldn't have any problem landing sales. If you don't, try offering one free shoot to let the company understand the value of your service.

Offer Panoramas

The biggest objection you're likely to come across when pitching these services is that the Realtors can shoot the photos themselves. They won't be able to shoot panoramas though, and those can be very effective tools for potential buyers.

They're also much easier to create than they look, even if the skills they demand are more technical than creative.

(continued on next page)

higher prices. They are prepared to pay a photographer to shoot photographs of rooms and external views.

What You'll Need to Shoot to Create Real Estate Images

You're going to be shooting two kinds of photographs: interiors of rooms; and exteriors of buildings.

Each of those types of shots will demand some very special skills.

Professional architectural photographers can sometimes spend days waiting for light to strike a building in exactly the right way and at exactly the right time to produce the perfect image. You're not going to have the time to keep coming back so you'll have to make do with whatever light you've got.

You'll then have to struggle with the ethics of post-production.

Photographers who shoot buildings have been known to make slight adjustments to completed photos. They've made the grass in the front yard greener, for example, removed items sitting on the front lawn or turned an overcast sky into a sunny day.

As long as the grass is usually green and the sun does sometimes shine, there's little ethically wrong with improving the quality of the pictures. Add an extra garage or make the building appear larger and it's unlikely that visitors are going to become buyers.

Shooting internals offers a different kind of challenge. While you can bring your own lighting equipment, you will have to put a lot of thought into avoiding reflections—especially of yourself and your camera!

That can be a real challenge in rooms filled with windows, a large television and plenty of reflective surfaces.

There is also a third type of image you might want to offer real estate professionals: 360 degree panoramic photos. These will involve standing in the middle of a room with a special lens and shooting everything you see. You'll then need to put the image together and when you upload it to a website, the viewer will be able to look in a complete circle, zoom forward and backwards and even look up and down.

Technically, these images aren't very difficult to produce, although they are a little dull to shoot. They have the advantage of allowing the potential buyer to see more of the property than he would otherwise be able to do and they look like something the real estate professional wouldn't be able to shoot for himself.

How to Create and Sell Real Estate Photos

Real estate professionals who do make use of professional photographers often do it through an agency such as Obeo which provides entire packages of marketing materials for the real estate profession.

You could therefore try approaching one of those agencies.

Alternatively, you can try making a direct approach to a local real estate company. One real estate professional advises setting up a meeting to pitch your services (and arrive with an armful of bagels and coffee). It might also be a good idea to offer a free sample or short-term discount to show what you can do and let the clients feel the benefits.

You can also try making contact with real estate agents during an open house to begin the relationship.

Pricing should be based on the number of rooms and also on the size of the property. Low-priced homes will have smaller budgets for marketing and photographers.

GETTING STARTED

The best way to begin is probably to call your local real estate office and ask for an appointment. Turn up to the meeting with refreshments, make a pitch that points out the real material benefits of your images and if you don't have figures to quote, offer to do the first shoot for free.

To see what agencies, you can take a look at www.obeo.com, while for help creating panoramas check out www.tourbuzz.net and www.360cities.net.

TIPS
FOR SUCCESS

(continued)

Work with Agencies

Pitching to individual real estate companies shouldn't be too difficult. Realtors tend to be concerned primarily with figures so if you can show them your photography will give them larger commissions, you should be able to land the gigs.

But it can take time and effort so if you can work with agencies that supply marketing services to real estate companies, you should find yourself picking up more work more regularly.

You can also try pitching to franchises of large real estate firms. Land one office and you might find it easier to land more.

76

Road Testing Car Photography

DIFFICULTY

COMPETITION

INCOME POTENTIAL

$ $ $

What It's All About

For many enthusiasts, photography is their most important pastime. They shoot every weekend, take their camera wherever they go and work constantly to improve their technique and produce better images.

It's also an expensive pastime and by the time they've finished paying for the lenses, lighting equipment and all the other gear, there's little money left over for other interests.

Some enthusiasts though are able to spread their interests even further. In addition to being nuts about taking pictures, they're also crazy about cars. And they dream not just about being paid for their passion for photography but also earning from their love of automobiles.

Some have managed to do it. Auto magazines and car sellers need professional images of models that show the vehicles at their best and are shot by someone who understands what other enthusiasts want to see.

For those photographers and motor enthusiasts who have been able to find buyers for their photos, car photography represents a double opportunity: a chance to get paid for satisfying not one passion but two.

What You'll Need to Shoot to Become a Car Photographer

You'll need to shoot pictures of cars, of course, but you'll have to do more than that.

You'll need to shoot lots of pictures of cars.

Photographers aren't difficult to find. Photographers who know how to photograph cars are hard to find so to win gigs as a car photographer you'll have to make clear that you know what makes a car beautiful, how to shoot particular models, what kind of backgrounds to use and what sort

SUMMARY

There is a market for professional quality pictures of cars. Magazine racks are filled with car magazines, owners of rare models can want top quality images that help them to sell their collector's pieces and those with the strongest interest will be interested in buying prints, books, posters and calendars featuring dream cars.

But there's also a lot of competition. The images in magazines tend to be supplied by experienced professionals. Calendar racks and poster bins tend to be stuffed with pictures of cars, making it hard to break in and in a way that can compete with bulk printing prices. Framed prints have a limited market.

While photographers struggle to make themselves noticed and generate sales though, buyers too can battle to find photographers who understand what they're shooting, know how to make a car look its best and who are affordable.

The result is that amateur photographers who have displayed ability and understanding, and who have managed to make the right contacts among buyers, have found their phones ringing when even top magazines have needed car photographs.

of picture is most likely to make another car enthusiast's heart skip a beat.

The difficulty is going to be finding lots of cars to shoot and shooting them in a way that makes them appear dramatic.

Even a Ferrari can look a little bland if it's shot sitting next to the kerb.

Race tracks are certainly one place you can look but car shows make for rich hunting grounds and should be a regular part of your car-shooting routine.

How to Create and Sell Car Photos

One of the most exciting things about taking pictures of cars is that the images can be sold in a bunch of different ways. Unfortunately each of those ways requires a different strategy:

TIPS
FOR SUCCESS

Go Where the Cars Are

When it comes to earning with car photography, a great deal will depend on the images in your portfolio. Commissioning editors will want to see that you really do know how to shoot great motoring pictures while buyers will only be willing to pay for outstanding images. That means getting out to where the great cars are. For enthusiasts, attending races and car shows really should be more of a pleasure than a chore.

Spread Your Images Around

Once you've taken your pictures, you'll need to make sure that people can see them. One semi-professional photographer used framed copies of his images to decorate the corridors of the engineering company where he worked and left a copy of his photography book on the table in reception. The more eyeballs you can attract, the more you'll be known and the greater the chances of making sales and winning commissions.

(continued on next page)

Magazine Commissions

The most prestigious outlet for your car images is auto magazines, who will use them in their features and, if you're really lucky, on their covers. Not surprisingly, these are also the hardest kinds of jobs to win.

The best option is to make a connection with auto magazine editors. That's not easy to do but it has happened for amateur photographers at car fairs and on Flickr.

Car Sellers

A good picture should help car sellers pick up higher prices when the models are rare and the sticker price particularly large. Look on eBay for local sellers of rare cars and point out the benefits of better images.

If you can show that your photograph will add more to the sales price of a car than you're charging to shoot it then you should find yourself winning a steady stream of jobs.

Posters, Calendars and Prints

The biggest difficulty for selling posters is getting the pricing right. The more you print, the lower costs will be per unit but the more you'll have to pay in advance. Publishing companies will always be able to distribute their posters to more stores for a lower price.

A better option then might be to stick to print-on-demand online. You won't make a huge amount of money doing this, but you will be able to target your marketing to websites interested in particular models.

Books

Books featuring car photography might be an easier sell, if only because buyers are getting more images for their buck. They also give you an opportunity to show off your expertise by adding lots of text about the different models shown on the pages.

Even if you don't make many sales, passing them out to editors and other buyers could be a way to make your name known.

GETTING STARTED

The easiest way to begin as a car photographer is by creating a collection on Flickr to show off your car images. Join group discussions and give advice to others to show off your expertise. Be sure to attend car shows and race events and make a point of talking to motoring reporters. They're just as enthusiastic about cars as you and they know the people who need the images. Also check out www.andreasreinhold.com. Andreas is an amateur photographer whose car images regularly appear in magazines.

TIPS

FOR SUCCESS

(continued)

Flickr

Flickr can be one good solution. A well-organized collection of selected images and participation in specialist groups can go a long way towards building your name and even winning commissions.

77

Shooting the Great Outdoors

DIFFICULTY

COMPETITION

INCOME POTENTIAL

What It's All About

One of the hardest fields in photography to make money out of is landscape photography. Just about every enthusiast has a folder on their hard drive filled with beautiful pictures of sunsets, beaches and trees. The photographs can be stunning, the subject outstanding and the technique absolutely perfect.

But exactly the same can be said of millions of other photos.

Target specialized niches related to outdoor activities though and you'll be able to offer not just landscape photographs but climbing photos, adventure photos or mountain photos.

The harder the photos were to obtain and the more specialized the knowledge needed to obtain them, the easier they'll be to sell and the higher the prices you can achieve for them.

That does mean doing a lot more than taking a camera with you next time you take the dog for a walk. It means taking the camera with you next time you go rock climbing in Yosemite, kayaking down a river or bungee jumping off a bridge.

If you're into outdoor adventures and you know your way around a camera, you should find that you can create specialized photography products that people will want to buy.

What You'll Need to Shoot to Become an Outdoors Photographer

To make money as an outdoors photographer, you'll need to shoot the kinds of pictures that are difficult for the average photographer to create. That will usually mean combining your photography knowledge with your

SUMMARY

While nicheing your outdoor photographs will enable you to stand out from the masses of competition you'll otherwise have to fight, it will also reduce the size of your market. There's a limited demand for images of rock climbing, for example.

To make the most of the demand that exists then, you'll need to make your images available in a wide variety of different ways.

Successful outdoors photographers create their own stock sites. They try to put their postcards in stores and they nurture relationships with commissioning editors to win regular shoots.

For professionals, the commissions are always the best-paying jobs; for amateur enthusiasts with less time available for traveling, stock is likely to be a more realistic option.

understanding of a particular type of adventure, such as snowboarding, white water rafting or ice climbing.

If you can produce lots of high quality images in your niche, you'll have the opportunity to brand yourself as the leading photography expert in that particular field, winning you commissions when editors are creating stories and licenses when designers need dramatic pictures for their ads.

But for adventure images, the photographs will often need to be dramatic.

At least one adventure photographer has found that realistic shots don't sell. Images that are more stereotypical, that can portray a feeling or an emotion or tell a story directly and with a glance often make much better stock photos.

To sell the images you shoot during your outdoor activities then, you'll need to do activities that require at least a little training. You'll need to be able to shoot professional quality photos.

And you'll have to shoot images that are descriptive enough to work in ads, photos that would make beautiful prints and postcards, and shots that are dramatic enough to work in magazines.

Make the Pictures Different

Every trip to the Great Outdoors will yield all sorts of opportunities for all sorts of different pictures. You might be able to grab a dramatic shot of someone hanging from a rope over a ravine one minute and a beautiful sunset behind the mountains the next.

Shoot them all and any other kind of image you can capture. You'll want each trip to give you as wide a variety of images as possible.

Sell in Different Ways

And offer those images in all sorts of different ways too. The market for outdoors photography is fairly small, so you'll want to have as many different revenue streams as possible.

How to Create and Sell Outdoor Photos

There's little point in trying to learn an outdoors activity specifically to make money shooting them. It's likely to be easier to learn to shoot something you love than to learn how to rock climb and love shooting it.

The best way to create these kinds of images then is to bring your camera with when you do them anyway. That's the easy bit and the part you're probably already doing.

The tricky bit is selling them. There are a number of strategies that photographer use to do that:

Stock Sites

Perhaps the easiest is to submit them to stock sites. iStock, for example, has a little over 4,600 photographs tagged "rock climbing" with the most popular selling over 2,300 licenses. A search for "landscape" however turns up more than 215,000 images.

Creating specialized stock images like these then can provide much smaller competition while still generating useful sales. And while microstock could be a good place to start, the paucity of competition may even lead to a spot with a traditional stock company or an open source licensee such as PhotoShelter or fotoLibra.

Postcards

As always, postcards are a tough sell. But because the topic of your postcards is going to be particularly dramatic, unusual and often linked to a location, you might find that it's not too difficult to persuade local retailers to stock them. Some outdoors photographers have reported that postcard sales have become their second highest revenue-earners after commissions, even if setting up the sales channels does take a great deal of effort.

Pitching to Commissioning Editors

Become well known—and have a website that makes it easy for those who have heard of you to find and contact you—and you should find that the commissions flow in by themselves.

Until then though, you can try pitching to editors. Before you head out onto the river or pack the ropes and your lenses for your next climbing trip,

call an adventure magazine, ask to speak to one of the editors—you can find their names on the magazine masthead—tell them where you're going and explain that you're a photographer. They won't make you an offer but they might agree to look at the pictures when you get back. Once they've bought once, there's a good chance that they'll buy again—and commission you too.

GETTING STARTED

Get outdoors and get shooting. And when you have your images, make them available for sale. You can upload them to iStock at www.istockphoto.com and take a look at www.gregepperson.com and www.joshmcculloch.com to see how two adventure photographers are marketing their images through their own websites.

78

Fish for Earnings with Underwater Photography

DIFFICULTY

COMPETITION

INCOME POTENTIAL

$ $ $ $

What It's All About

Successful commercial photography is really all about capturing a shot that no one else can take. Usually, that's because other photographers lack the talent or the eye or the technical skills. Sometimes though it can be because photographers just can't reach the locations.

Only trained rock climbers can take pictures from the top of a mountain. Only experienced sailors can capture the view from the bows of a yacht.

And only someone who knows their way around scuba equipment can take sellable pictures underwater.

This is the kind of work that does require some very specialized knowledge. It's expensive to do and it can be dangerous. But it can also be hugely satisfying and—if you can land the work—very rewarding too.

And it is possible both to reduce the risk and lower the dangers . . . and make the marketing a little easier too. While most underwater photography is done in the sea some photographers have taken to the swimming pool where they generate very comfortable incomes shooting models and babies in the water.

What You'll Need to Shoot to Become an Underwater Photographer

You'll need to shoot sharks. You'll need to shoot them at very close range and the bigger they are, the sharper their teeth and the nearer they are to your lens, the better.

Actually, you don't have to do that but the underwater images most in demand do tend to be extreme types: sharks, whales, manta rays and other things you might want to keep a safe distance from.

78 Fish for Earnings with Underwater Photography

SUMMARY

Underwater photography can be a little like nature photography: you'll have to know where to go, what you're planning to shoot when you get there, how you're going to shoot it and who you're going to sell it to because the high cost of photographing in the sea usually means that shooting on spec is a very big gamble (unless of course you were planning to do it anyway and for fun.)

Shooting in a swimming pool may be a little easier. It would certainly be cheaper than flying out to a reef somewhere but it's still not going to be simple. While there is a market for photographing babies in water, and shooting models floating at the bottom of a pool can create some fascinating effects, the work can still be dangerous for the subjects so you will need to know what you're doing.

If you are keen on water though, if you have equipment that can work in the wet and if you know how to light under the waves, underwater photography can be both fun and profitable.

Fortunately, if you're a little faint-hearted there are plenty of alternative options.

Fish

Perhaps the easiest is to take pictures of tropical fish, reefs, and arms and legs splashing around under the waves. You might not even need to pull on an air tank to take pictures like these. If you have a waterproof camera and a snorkel, you could shoot them while on vacation and offer them to a stock site.

In general though, demand for images like these tend to be fairly low so you can't count on making a lot of sales from them . . . even if you also don't have to put a great deal of effort into creating them.

Babies

Some parents like to begin their child's swimming lessons before they can even walk. Those are memorable moments that they might well be willing to pay to see captured.

TIPS
FOR SUCCESS

Aim for Science Stock

While there is some demand for underwater images as stock, that demand is fairly limited and not something you want to rely on. A better option than submitting all of your snorkeling and vacation images to a stock site and hoping to make the odd sale could be to submit them to a science stock site.

These tend to produce higher rates, offer lower competition and attract targeted buyers. You will need to know exactly what you're shooting though, ideally including the names of the fish as well as the location of the shoot.

Look for Joint Ventures

Shooting in the sea is expensive and difficult but hiring a swimming pool isn't easy either. Some photographers find that they have to shoot through the night because it's the only time the pool is available.

Creating a partnership that puts you in the pool with your camera during a swimming class in return for the opportunity to sell prints and split the revenues can help to remove those costs while still getting the lens wet.

Models

If you're looking for a special style that's all your own, you can do worse than put your models at the bottom of a swimming pool while their clothes float around them. It's an approach that more than one professional photographer has taken.

For a non-professional though it's an approach that really does look like a non-starter . . . unless you're working with a friend who's as comfortable under the waves as you are. Otherwise you're going to need a team of other swimmers on hand with air tanks, as well as the access to a swimming pool and insurance costs that will make your eyes water.

How to Create and Sell Underwater Photos

This is one type of photography that does require at least some special equipment. In addition to underwater camera equipment, you might also need a wetsuit, buoyancy gear, special lighting and air tanks. That can all amount quite a large investment so you'll need to be certain that this a type of photography you want to specialize in before you start buying. A better way to begin might be to work as an assistant to an underwater photographer to make sure that you like it and understand exactly what's involved.

Selling the images will happen in a number of different ways. The highest paying underwater photography jobs are commissioned shoots. While word-of-mouth remains an important way of distributing them, even experienced professionals now say that much of their work comes in through their websites.

Images taken for fun could be licensed as stock and baby portraits shot underwater could be offered as a unique service but you'd probably do better teaming up with baby swimming instructors. That would save you the difficulty of finding a swimming pool and marketing to the parents, even if you did have to share the revenues with the instructor.

GETTING STARTED

If you're really serious about earning money from underwater photography then be prepared for a slow start. Dive, take pictures, build an online portfolio and pitch for jobs from specialist magazines and publications. If you can specialize in a particular kind of underwater shoot such as archeological digs or wrecks, you might find it easier to win commissions.

If you only want to shoot occasionally or if you already have attractive underwater images available you can try offering them at www.photoresearchers.com or www.sciencephoto.com, both of which are scientific stock companies.

And if you prefer to stick to swimming pools, take a look at the images of Zena Holloway at www.zenaholloway.com. They should inspire you to dive right in.

79

Reveal Hidden Secrets

DIFFICULTY

COMPETITION

INCOME POTENTIAL

$ $ $

What It's All About

Part of the value of an image will always be determined by its rarity. That rarity could be caused by its beauty; if few photographers can take a picture as beautiful as yours, buyers will always be prepared to pay more for it.

It might be caused by the technical challenge involved in creating the picture. Aerial photography and underwater photographs, for example, are both relatively rare because relatively few photographers have the skills needed to shoot them.

And the rarity could simply be because few people even knew the subjects existed.

A number of photographers have made names for themselves shooting pictures of sites that usually remain unseen. In doing so, they reveal hidden secrets, generate curiosity in their images, become masters of their niches and find it fairly simple to sell books and win commissions.

What You'll Need to Shoot to Sell Hidden Scenes

The kinds of "hidden" images that photographers are producing vary tremendously. Troy Paiva, for example, is famous for his photographs of American ghost towns. He drives out into the desert or wanders around deserted buildings at night taking carefully lit pictures of the ruins. The results are both aesthetic and interesting.

Trevor Paglen, on the other hand, is known for dragging large telephoto lenses out to the perimeters of secret military bases such as Area 51 and shooting what happens on the other sides of the fence.

But you don't have to follow the tumbleweed or risk a run-in with the CIA. The inner cities are filled with places that few people see, such as

SUMMARY

Shooting images like these might not demand any special photography skills or require any special techniques. But it will require some special knowledge.

You'll have to know the subjects exist and you'll have to know how to reach them.

It will help too if you have a passion for bringing them to public attention.

The benefits though can be huge. The rarity of the images you bring back will mean that they generate plenty of curiosity. The media will be keen to print them—and to write about the person who created them too.

Depending on the subject, you might find that you build up a community of fans interested in your work, making it easy to sell books and posters. And if it's a subject with very broad interest, you could even find yourself winning commissions too.

The only challenge will be finding subjects to shoot.

squats, red light districts and rooftops. The suburbs have backyards, lofts and basements. And the countryside has woods, mountaintops and islands.

The key to success in this field though will be producing a unique idea of your own—and ideally, one that's hard for others to copy without a great deal of dedication and knowledge.

How to Create and Sell Hidden Photos

How you create images like these will depend entirely on the subjects you've chosen. Troy Paiva has to drive into the desert for hours to find the ghost towns and junk yards that he uses in his images. Trevor Paglen has to climb to the top of mountains with a telescope on his back to take pictures of military bases.

If you were shooting in squats however, you might just need to get friendly with plenty of squatters.

Whatever you choose, it's likely that you'll need to consider the permission of the owner of the property you're shooting. Even abandoned sites have owners and before you can sell the images, you'll need to discover

TIPS
FOR SUCCESS

*Take Your
Permissions with You*

If you're shooting on private property, then you will need authorization from the owners first. Make you sure you have that authorization in writing and keep it with you during the shoot. It's not unknown for the police to roll up when photographers are shooting in unusual places so you'll need to know your rights and prove that right is on your side.

Check the Competition

If your images take off, you can expect lots of people to want to take the same kinds of picture. Being the first will give you a big advantage but if your subject is easy to reach, you could find yourself squeezed out by a surge in supply.

As you're considering which subjects to shoot, consider how big the competition is likely to be when your pictures start to sell.

(continued on next page)

TIPS

FOR SUCCESS

(continued)

Use Flickr to Build a Community

Much of your success at making money out of these pictures will be your ability to attract a core group of "fans" who will be interested in all the pictures you produce. That should happen naturally. As you bring your unique pictures into the open, curiosity should attract a certain number of viewers and encourage them to want to see more.

One place to turn that curiosity into a community is on Flickr. Start uploading your images to the site, and network to build views and hit the Explore page. You should find that people start asking you questions and spread the word very quickly.

When you bring out your book, you'll have a market ready to buy.

who they are, and obtain their authorization. If you're planning to shoot on the site—rather than shooting the site from a public place—you'll even need to obtain that permission before you enter the property.

You really don't want to be stopped by the police wandering around an abandoned property in the wrong end of town in the middle of the night.

Selling the images will be a little easier. Photographers who create images like these have managed to win exhibitions of their work, especially when they've been able to tie the images to a political comment. Once you have a portfolio, you could ask a gallery or any space used for political action to host your show where you could sell postcards and books.

The books themselves could make good products and for topics as rare as these, it might even be worth pitching to a traditional publishing company rather than using a print-on-demand service. They'll have a much wider reach and while you'll still be expected to do some of the marketing, they might have a budget to help with the sales too.

Before heading out to a shoot, you can also try calling magazines to see if they're interested in the running the pictures and a story. Not only will you get paid for the article, you'll also generate plenty of publicity that will help you to sell more products in the future.

GETTING STARTED

This is a strategy that's not going to lead to piles of cash immediately. You'll need to begin by producing an idea for a subject to shoot. That should come from a topic that interests you, that you've been thinking about for a while and which you'd like to explore in detail. It should also be something that would interest other people who will wish that they could see what you're shooting too. Once you've produced your idea, you'll need to start taking the pictures and you'll need to plan too how you're going to sell them.

A couple of good places to look for ideas are Troy Paiva's website at www.troypaiva.com and Trevor Paglen's site at www.paglen.com.

Make Money Fast with High Speed Photography

80

DIFFICULTY

COMPETITION

INCOME POTENTIAL

$ $ $

What It's All About

High speed photography involves using special equipment to capture an event that's usually too fast to be seen by the human eye. The result can be dramatic pictures of droplets hitting water, bullets striking apples and race cars streaming past a background of colored blur.

It's a specialization that requires a great deal of practice, some technical knowledge and a lot of patience.

The images may be sold as prints but more often high-speed shoots are commissioned by ad firms looking for eye-catching photographs to be used in commercials, especially in the drinks industry.

Even amateur photographers who have mastered these skills have found art directors knocking at their doors with commissions and large checks.

SUMMARY

While high speed photography does require a great deal of technical knowledge, it's knowledge that anyone can acquire and many people do. The strobes and triggers, while specialized, are also easily obtained and affordable.

As a result, there's no shortage of photos of water droplets and bullets.

To be successful as a high speed photographer then, you'll need to do one of two things.

You'll either need to add some impressive creativity to your technical knowledge. Or you'll need to do some pretty keen marketing.

Neither of those will be easy but both are possible and could result in plenty of print sales and even commissions from ad agencies.

TIPS
FOR SUCCESS

Be Creative

While high speed photography does demand special technical skills, they're skills that lots of people possess. Many of those people though possess those skills within a very limited range; they shoot good water drops or take exciting images of eggs being shot but that's all.

To stand out, you'll need to step out with creative ideas for unique high speed subjects.

Share the Techniques

And once you figure out how to take those shots, share the knowledge. You might not want to give away all your trade secrets but you should be willing to take people behind the scenes, if only to show them how difficult it all is.

That openness will help to attract the attention of other high speed photographers, and that in turn will help to spread your name.

What You'll Need to Shoot to Sell High Speed Photography

Selling high speed photography photos requires overcoming two challenges: you have to acquire the technical skills necessary to create each shot; and you have to come up with ideas that haven't been done before.

Whenever photographers start experimenting with high speed photography they almost inevitably start shooting water droplets and gunshots. Those are both good subjects on which to cut your teeth and the ability to shoot them should be a part of your repertoire. Even though they're fairly common, ad companies do still use them. Commercials based on high speed photography have depicted bottles of fizzy water surrounded by bubbles, and water sculpture to look like a martini glass for a Smirnoff ad.

Stick with water and bullets though and you'll be entering a crowded field. You might be able to land commissions and sell prints but you'll find it much easier if you can take high speed pictures of subjects that other people ignore, such as balloons popping or insects in flight.

The more creative you can be with your high speed photos, the easier you'll find it to generate interest and make sales.

How to Create and Sell High Speed Photos

Both creating and selling high speed photographs will be fairly difficult. To set up the shoots you'll need to use special strobe lights and triggers that will set your camera rolling and the lights flashing as soon as you release the water droplet or fire the gun.

You'll also need structures to hold your equipment in place and ensure the shoot is repeatable. You're unlikely to land the shot you want first time!

There are no shortage of books that can help to get to grips with the techniques you'll need to master, and if you have questions, Flickr's high speed photography groups contain a bunch of friendly people who can tell you what to do, where to turn and what the problem might be.

As soon as you start moving off the beaten path though—and producing unique pictures that are easier to market—you'll be on your own. It will be up to you not just to figure out what kind of pictures you want to shoot, but how to overcome the technical challenge of actually shooting them.

Creating sellable high speed photographs then requires artistic creativity and technical ingenuity too.

Selling the images though is a little more straightforward. Because the images are going to be relatively unusual, you might find that landing exhibitions could be easier, especially if you approach cafes and bars that might welcome pictures of liquid shapes.

You might even find that when the show is over, they're your biggest customers.

Winning commissions, which is always where the big money lies, will take longer and unless you already have a solid client base, will likely involve building a name for yourself from the bottom up.

The best approach to doing that is with a combination of Flickr networking and website marketing.

Shoot unique high speed images and when you have a large enough collection upload them to a website where you explain how you shot them and what you're trying to do with your photos. Place some of the images in a Flickr set and submit them to high speed photography groups.

You should find that other photographers fave your shots, leave comments and quiz you about how you shot them. Soon, you'll be seen as an expert on this aspect of high speed photography.

If that attention doesn't result in enquiries from photography magazines, you can try pitching them a story explaining how to shoot images like yours to spread your name even further.

In the end, you should find that art directors consider you their first choice when they want images like those you're known for specializing in—and better still, your images inspire them to produce ad designs based on your images.

GETTING STARTED

To begin, you'll need to load up on strobes and triggers. Martin Waugh, who shoots high speed photography images for corporate clients, has suggested the Quaketronics kit available at www.quaketronics.com/flashkit/ as a low cost way to start at just $125.

Other gear is available at www.hiviz.com and you can also check out Martin's own work at www.liquidsculpture.com.

81

Spread Your Name with Detailed Panoramas

DIFFICULTY

COMPETITION

INCOME POTENTIAL

$ $

What It's All About

If you're really looking to stand out by creating unique images then you can do a lot worse than produce enormous, detailed, panoramic photos.

These are giant images—photos as large as two gigapixels aren't unknown—but which are packed with clear, tiny details so that even when they're displayed on a gallery wall, it's still possible to use a magnifying glass to see all of the different elements with crystal clarity.

Photos like these are not easy to produce. You won't need a special camera to create them but you will need plenty of time and some special software. The pictures are actually made up of hundreds of smaller photos seamlessly stitched together.

While the financial outlay is fairly small—once you've paid for the standard photography equipment and a lens with a very long focal length—you can expect to spend a long time on a shoot and an even longer amount of time putting all the images together. Or better still, letting a software program put it together for you.

What You'll Need to Shoot to Sell Detailed Panoramic Images

You'll need to shoot big pictures. Really big pictures. And to make the most of the size of those pictures, you'll need to shoot scenes that are packed with interesting details.

One of the most successful of these kinds of photos depicted the Reading Room at the Library of Congress. The image was detailed enough to

SUMMARY

High speed photography offers a giant technical challenge, but it's one whose basic solution is well-known and enough photographers are doing it to help you through the initial stages.

Only a handful of photographers though produce detailed panoramic photos. Plenty produce panoramas but few have the patience or the know-how to create the kinds of pictures that can fill a wall and still be as clear as a standard-sized print. If you run into difficulties, you'll be largely on your own.

Nor is the shooting particularly exciting. Because the photos are constructed as mosaics, you'll be taking lots of small pictures of specific areas and you won't be able to see the full power of the result until you've printed the picture in full size.

And to enjoy it, you'll need somewhere to display it.

At that point though, you'll know you've created a truly unique image and one that's almost guaranteed to attract attention.

Photographers who do this sort of work are often able to mount exhibitions and the prints can go for fairly large sums.

read the names on the spines of the books on the other side of the room. Museum entrances and railway stations have also worked well.

Scenes like these though present special problems. They may have differing depths of field and the movement of people across a room being shot over several hours can create some strange results.

Rather than overcome these difficulties, some photographers have chosen to shoot only flat surfaces that remain static such as murals and paintings.

The best images though are always going to be those that are packed with masses of tiny details so that the viewer always feels that there's more to see and more to enjoy. If you can find scenes like these—and figure out how to shoot them—you should have a sellable photo, or at least one that will attract plenty of attention.

How to Create and Sell Detailed Panoramic Photos

Creating detailed mosaics requires a number of elements. The camera itself doesn't have to be any more complex than a standard DSLR but you will

TIPS FOR SUCCESS

Go for Detail, Not Size

These kinds of images are their best when printed big. But they're not impressive because of their size—it's no big deal to print a big picture—but because of their detail.

If you can stuff the images with all sorts of little details, whether those are books on shelves, faces in an audience or birds on a rock, you'll make the shot far more interesting.

Pay Attention to the Seams

The hardest part of creating panoramic mosaics is knitting together pieces. Inevitably you find that if the vertical edges match, the horizontal edges don't. Max Lyons, perhaps the world's leading panoramic photographer, sells the software he created to knit the mosaics together. It's probably the easiest way to make sure that the final picture has a smooth surface.

(continued on next page)

TIPS

FOR SUCCESS

(continued)

Get the Permissions You Need First

There's a good chance that you'll need to obtain authorization before you can start shooting, although it depends on the location. That authorization is valuable and shows that you're serious. Try to obtain it before you start pitching the idea of an exhibition to galleries and venues. They'll see that you're going to produce the pictures and they'll be able to start planning right away.

need a lens with a very long focal length and, of course, a tripod. You'll need the software to stitch very large images together and a way of printing the pictures once they're completed. An Oce Lightjet seems to be one of the few printers capable of printing in the required detail.

More importantly, you'll need the patience to move the camera a set distance for each shot, take the picture and move it again until you've captured the entire scene.

And most importantly of all, you'll need the right subjects to shoot too.

While you might want to start by photographing a flat static surface such as the wall of a building or a painting, eventually you'll want to produce images that are more interesting and which make better use of the technique.

Taking those pictures though will often require seeking permission from the property owner, a process which, while not too difficult, may involve some negotiating.

Selling the pictures too can represent something of a challenge. Because these images really have to be displayed to be seen at their best, rather than shooting and pitching, which is how exhibitions are usually won, you might want to pitch the idea first, generate interest and then shoot.

To win the pitch you will need to have some sample images that you can display though, and you'll need to be able to show gallery owners that you will be able to shoot the scenes you want to exhibit.

You can then use the exhibition to sell copies of the prints themselves and even though photography books won't be able to capture the full power of the photo, the detail in the images can make them look like good value for money.

GETTING STARTED

Begin by taking a look at Max Lyons' images at www.maxlyons.net to see just how impressive these images can be. Then purchase his mosaic assembly software at www.tawbaware.com/ptasmblr.htm. Unless you really feel like doing the assembly by hand, you're going to need it!

Find a wall or a landscape or something equally simple and which doesn't require permission to shoot. Build up a portfolio then start approaching museums, concert halls and other places that could make great subjects for a shoot.

Sell Your Landscape Images

82

DIFFICULTY

COMPETITION

INCOME POTENTIAL

$

What It's All About

Enthusiasts keen to earn from their photography are usually faced with one supreme challenge.

There are an awful lot of them.

That means there are an awful lot of images available and a much more limited number of buyers willing to purchase them. Few specializations though have as wide a gap between supply and demand as landscape photography.

Just about every photographer does it at some point. Good views are easy to find. You don't need a model release to sell the results. And you

SUMMARY

The best way to sell your landscape images will always be as framed prints, ready to be hung on the wall and admired. That is possible and with a little effort and perhaps a certain element of financial risk, there's no reason why that shouldn't happen to you too, provided your images are good enough.

But that's not the only way to sell your landscape images.

In fact, the more creative you can be with the uses of your landscapes, the greater the opportunities you'll give yourself to make money out of them. The sales might not always be as prestigious as you might like but they will deliver money and that's always rewarding.

The size of the competition though does mean that you'll always struggle to make large sums of money by selling landscapes. This really is one field in which you have to look at the satisfaction of taking a beautiful image as the biggest prize—and regard any money they bring in as a bonus.

Sell the Same Image in Different Ways

Landscape images are so difficult to sell that you have to use as many different outlets as you can. You might find that you become a master of one type of sales channel but always keep the other options open too.

Do it for Fun

And focus on enjoying this kind of photography. Landscape images that are exciting and eye-catching will always sell best. If they excite you, they're more likely to excite a potential buyer.

might not need too much skill to take the sort of picture that's as breath-taking as the sunset, the hills or the forest itself.

But however attractive your picture of some natural beauty spot, there are always a million others vying for the attention of a buyer.

Landscape photographs though do sell, and they sell in all sorts of different ways. While you might not be able to make a fortune out of the images you shot on your last camping trip, you might just be able to make some bucks back by doing something you love.

What You'll Need to Shoot to Sell Landscape Images

It has to be scenery, of course, but more importantly it has to be good: technically perfect, creatively composed and so expressive that the viewer has to tear himself away.

And ideally, the images have to be unique too.

That's not easy considering the number of times just about every type of landscape has been shot but you'll always do better if you can bring a new perspective on a familiar view.

How to Create and Sell Landscape Photos

Because the chances of making sales are so low, the best approach to landscape photography is to create the images that make you proudest. Then look to sell them. There are a number of different ways to do that.

Art Fairs

Galleries might be the most prestigious places to sell your prints but they're also the hardest. An easier method—and a good way to build a name and a resume that will interest gallery owners—is to show at art fairs. Juried fairs in particular can be very helpful.

While there is a very good chance of making high-value sales at an art fair, you will have to invest in display materials to exhibit your work. That's money you should get back as you continue to attend art fairs though. Landscape images do sell here.

eBay

They also sell on eBay but you might have to work a little harder. The site does allow artists to sell their own works and plenty of photographers use the auctions to find buyers.

You'll need to understand how exactly the site operates and upload lots of different prints to show a body of work. It's rarely the landscape alone that will make the sale on eBay; it's the connection you build with buyers and the story you weave around the images.

Books

That's true too of photography books but they really have to bring something new to the reader. Beth Dow, the winner of Blurb's photography book competition, for example, shot the sort of British national parks that have been photographed thousands of times before but by doing it in a unique way and tying the images together she was able to produce a book that was a work of art in itself. A landscape has to be more than a collection of your finest images; it has to be story told in beautiful imagery.

Elements

While microstock sites do sell landscape images, they already have plenty of them and they're only prepared to take new photos that they don't already possess. Many sites, in fact, state explicitly that they're not interested in any more pictures of sunsets, beaches and trees.

But one of the highest-selling microstock images—with more than 14,000 downloads—is a landscape image showing a girl blowing a dandelion in front of a rural background.

That image is made up of two elements: the foreground and the background. The two might not have been pasted together but the image does suggest that placing something in the foreground of your landscape images can give it a whole new message—and whole new commercial use.

Geotagging

It doesn't usually matter where precisely a beautiful image was shot. The image is a description of beauty not of a place. But it does describe a

location too so geotagging your images and placing them on Flickr's map and Google Earth may be another way to sell them.

While few buyers search for landscape images on maps, buyers looking for shots of locations to license are more likely to purchase a beautiful shot than a plain one.

GETTING STARTED

Get out there and shoot. Then look at these Web pages for some examples of how to sell them:

www.istockphoto.com/file_closeup.php?id=1921014 is Eva Serrabassa's top-selling microstock compostion.

www.festivalnet.com will help you to find art fairs across the country.

www.bethdow.com shows sample images from her award-winning landscape photography book.

Sell Your Wildlife Images

83

DIFFICULTY

COMPETITION

INCOME POTENTIAL

$ $

What It's All About

Few pictures are more satisfying to shoot and produce more dramatic results than wildlife images. Whether you're sitting by a lake and photographing ducks swooping in to land or hiding in the savanna shooting lions stalking their prey, you can never be certain what sort of shot you'll end up with and what kind of scene you'll end up shooting.

It's all the more exciting then when what you produce is a striking image of a striking animal.

But if photographing wildlife is a challenge, it's nothing compared to the difficulty involved in selling the images. It can happen and sometimes for fairly large sums but there is always a lot of competition and relatively little demand.

If you can manage to find outlets for your images though, you'll be earning money for taking pictures and hanging out with animals.

What You'll Need to Shoot to Sell Wildlife Images

In general, the rarer or more dangerous the animal you've photographed, the easier the image is likely to be to sell. A photograph of a lion leaping on an antelope will always be more valuable than a shot of a cat catching a mouse—provided that both images are perfectly shot.

Nicheing can help here too. If you can make yourself known as a specialist—whether you choose to specialize in photographing snails, bats or giraffes—whenever someone needs an expert picture in your specialization, you should be the one they turn to.

SUMMARY

Wildlife photography is one of those niches in which the gap between professional and amateur is particularly clear. Professionals understand where to find the wildlife they need to photograph and they understand too what they have to do to get the shots. The result is that they produce large numbers of beautiful wildlife images on a consistent basis.

Amateurs and semi-pros on the other hand might get lucky occasionally. They might stumble upon an owl while walking in the woods or take a handful of great pictures while camping in a national park.

While the photos themselves might be outstanding, they need to be even more outstanding than the images a stock agency already has if that agency is to take them. Often, the photos are good, but not good enough.

And unless the photographer is be able to produce them repeatedly—at a rate of around 200 a quarter—an agency is unlikely to be interested in representing the photographer's works.

Commissions from magazines too are very unlikely go to anyone other than well-known professionals.

For a part-time photographer then, the cards seem stacked. They don't have the reliability to break into agencies, they're not known enough to appeal to magazine editors, and it's very difficult to reach the sorts of places that are going to produce the best images.

Success as a wildlife photographer then will require skills and determination. But no less importantly, it will also require the drive to market yourself well.

How to Create and Sell Wildlife Photos

How you create wildlife photos will depend on the sort of animals you're shooting. You might find yourself sitting in a hide for hours on end, squinting through a telephoto lens and waiting for something to happen so that you can shoot off a bunch of frames.

Or you might have to create a special set in your garage and mount your camera and macro lens on a frame to document insects going about their business.

Part of becoming a wildlife photographer will involve knowing how to capture the animal at all the best moments as well as how to use the camera.

Part of becoming a successful wildlife photographer though involves knowing how to sell the images once you've produced them. You've got several options:

Stock

Shooting great wildlife images does not, unfortunately, provide a way into the major stock companies. They'll still want to see high-resolution photos that are better than those they're already offering and from a photographer who can supply them on a regular basis.

And while microstock might be an option, in practice, there isn't a huge demand for these kinds of photos on microstock, and the trouble and expense that's often involved in shooting them would make it a poor investment.

Art Prints

Most wildlife photographers though really want to see their pictures printed and hanging on the walls. When the photos are this dramatic and this beautiful, it's entirely understandable.

But it's also very difficult. Art fairs are one possibility, but bear in mind that you're unlikely to be the only photographer offering wildlife picture. If you can connect the animals you've photographed to the theme or location of the fair, you might be in with a better shot.

Similarly, while approaching galleries is often disheartening, a themed set of wildlife photographs, depicting bears, for example, or ants, might be an easier sell.

Contests

One very good way to turn your images into cash though isn't to sell them at all; it's to enter them into competitions. There are plenty of wildlife photography contests that are open to amateurs as well as to professionals and some of them carry prestigious titles and valuable prizes.

The chances of you winning, of course, are very small. But they're fun to enter and if you do win, the boost to your confidence, to your reputation and to your chances of selling prints and even winning commissions can be huge.

Charity

Giving your images to charity—whether as part of a charity auction or by holding an entire charity exhibition—won't make you any money but it might just help you over the first wildlife photography hurdle: being unknown. Choose a charity that's related to wildlife and especially the kinds of animals you've photographed and you'll be appealing to a targeted market and showing that you're willing to contribute. That's the kind of approach that can make you known and make people willing to contribute to you in return.

GETTING STARTED

NHPA is a stock company that specializes in wildlife photography. They're a good place to start if you're looking to license your images. You can find them at www.nhpa.co.uk. For photography contests, the UK's Natural History Museum organizes one prestigious contest at www.nhm.ac.uk while the American National Wildlife Federation also organizes an annual contest.

The master of wildlife photography though is probably National Geographic. They have readers' contests and their pictures are always a good place to see how the pros do it. Take a look at www.nationalgeographic.com.

How to Sell Your Vacation Photos

DIFFICULTY

COMPETITION

INCOME POTENTIAL

$

What It's All About

Photography enthusiasts take all sorts of pictures and for all sorts of reasons. Some people love shooting landscapes, others prefer to take pictures of streets or people. Many can't keep their lenses away from their cats.

Everyone though, enthusiast, professional, amateur and occasional snapper, takes pictures while they're on vacation.

Those aren't usually the sort of photographs that are in any way sellable. The number of people willing to pay for a print of a group of standing in front of the Eiffel Tower is never going to be higher than the number of people in the group. Vacation pictures are about sparking memories and recording private moments rather than producing commercial photographic products.

SUMMARY

Selling vacation photos presents two challenges: the photographs are rarely very good; and there are an awful lot of them.

Clearly then, you're not going to be able to sell all of your vacation photos and you're not going to be able to sell them as vacation photos.

Instead, you'll have to sort through your images and try to pick out the outstanding shots that aren't tied to your personal experience. While you might be able to sell some of them for relatively large sums—if you're able to market them as prints, for example, or create popular photography books—unless you take vacations frequently, this is not a process that's going to be easily repeatable.

It's also unlikely that the results will be huge, but when you're not expecting anything from the vacation except a tan and a smile, every extra buck feels like a bonus.

TIPS
FOR SUCCESS

Plan Ahead

Usually, very few vacation photos are sellable so if you're hoping to make sales, it pays to plan before you leave. Know what you want to shoot before you get there and know too where you're going to sell them. The result will be shots that you took while on vacation rather than vacation photos themselves.

Tell Stories

Vacation photos are meant to tell the story of your vacation, which tends to be the sort of thing that has your friends looking at their watches and mentioning they should be leaving. Few people will be interested in the story of your trip; lots of people though will be interested in the story of the places you visited. Treat your vacation as a chance to do travel photography and you'll increase the chances that you'll be back with sellable images.

But sometimes a vacationer will come back with a sellable image. It's an image that could be of use to a designer looking for a background, a shot beautiful enough to sell as a print or a depiction of a place that's rarely seen and only occasionally photographed.

Produce shots like these while you're on vacation and you'll only have to deliver them to buyers to pay for at least part of your trip.

What You'll Need to Shoot to Sell Vacation Images

If you're hoping to make sales, the images you shoot while on vacation need to be not-vacation pictures. They have to be images that look like they were shot by a professional photographer on assignment for an ad company, a photojournalist creating a story for a magazine or a stock photographer with a budget to shoot in exotic locations.

You'll struggle to get anything for standard vacation pictures but you might be able to sell these:

Landscapes

Landscape images are always difficult to sell but they do sell. They sell as prints online, they sell at art fairs and they sell sometimes as stock. A vacation then can be seen as an opportunity stock up on shots of palm trees, cityscapes and romantic street scenes.

Themes

Vacation photos are usually meant to spark your own memories of the places you visited. People who weren't with you though will need you to spell out what you saw in detail. Instead of shooting one picture of the Djmaa el Fna, for example, shoot a string of images that allow you to represent the market's entire experience.

Buyers might not be willing to buy your vacation snaps of your trip to Morocco but they might be willing to pay for a book offering a photographic journey through the Maghreb.

Landmarks

You'll have to look hard to find a stock company that doesn't already have a stack of pictures of the Statue of Liberty or Shanghai's television tower.

Usually, those companies—and this includes microstock companies—will only be willing to add to that pile if what you're submitting is better than the images they're already offering.

A better bet then is to offer landmarks that are slightly more offbeat such as Burmese temples or Icelandic glaciers. The market for them may be smaller but so is the competition—and the chances that the stock company already has enough of them.

Events

You just have to be lucky here . . . or rather unlucky. Should a tsunami hit while you're lying on the beach, a terrorist attack take place while you're in a café or a demonstration march past as you're walking down the street, then the images you take may be worth something to a news site like Demotix.

Just make sure you don't get hurt taking them. The shot might be once in a lifetime but the money is never worth taking risks for.

How to Create and Sell Vacation Photos

The best way to create sellable vacation photos is to think ahead. Instead of returning from your trip and sorting through your shots to see if any could be converted into cash, think about where you're going and try to plan shots that could result in commercial images.

You can use Flickr's map to look for good places to shoot in the area and predict the kinds of landscapes you'll find when you arrive. Reading about the sites will help you to select themes for a photography book and plan the sorts of images that will help to tell the story.

You can also try calling travel magazines, telling them that you're a photographer and asking if they want images from the places you're going. At best, you'll receive an agreement to look at the pictures when you get back but if you also ask what kind of pictures they're looking for, you'll increase the chances of selling them.

Landscapes could be best kept for art fairs but if you can shoot them as travel photos rather than vacation photos, you may be able to find a place to mount them as an exhibition. Any site related to your vacation spot could be a good bet. So you could approach an Italian restaurant to mount an exhibition images taken in Florence or ask a New Age store to show the pictures you took in Nepal. Make print-on-demand photo books available

in those locations and people whose budgets—or walls—don't stretch to prints can still take your images home with them.

GETTING STARTED

If you're planning a trip, use Flickr's map at www.flickr.com to scout for good shooting spots near where you'll be staying. The forum at www.lonelyplanet.com is also useful for asking about places to shoot and equipment to take. If you're looking to sell pictures, www.studentraveler.com pays a small amount for images. www.perfectworld.se, a travel stock site, pays more.

Sell Your Family Photos

DIFFICULTY

COMPETITION

INCOME POTENTIAL

$ $

What It's All About

If selling vacation photos is difficult, selling your family photos is a mountain of a challenge. Again, you're certainly not going to be able to sell all of them. Even fewer people will be interested in buying a picture of your brother-in-law asleep on the sofa than paying for a picture of you on the beach in Cancun.

But take a look through the portfolios of leading stock portfolios and you'll find that the friends and relatives of the leading photographers turn up again and again.

You might also find pictures of other families who received free portraits in return for the photographer's right to sell a number of shots as stock images.

SUMMARY

One of the biggest difficulties for photography enthusiasts hoping to make a little money out of their hobby is finding people to shoot. Models can be expensive and good ones aren't always easy to find. When you're not certain you're going to see the cash again, they can make practice and improvement an expensive prospect.

Shooting family members appears to be a great deal easier. They're always around, they don't charge, you know they won't disappear on you and they might even be enthusiastic to lend a hand.

You will still need model releases for them though—and that includes pictures of children—but that's the smallest of the hurdles you'll have to face.

A far bigger hurdle will be shooting the kinds of images that people want to buy.

TIPS
FOR SUCCESS

Serve Your Family with Cheese

Image buyers have been known to tell producers that they want natural, unposed shots with real-looking people rather than carefully-coiffed models.

They've then been known to go ahead and buy the same safe, cheesy images that they've always bought.

When you're looking to make a little money, play it safe and offer the sorts of images you know sell: the kind of cheesy, posed, one-message shots that buyers purchase. That will mean planning the shoot, ordering the kids about and leaving the family portraits behind, but it might just deliver sales.

Don't Forget the Model Releases

You will need model releases for any image that contains a recognizable person, even if those people are your close relatives and you know they won't mind. Some stock companies might even ask that you upload them together with the images.

(continued on next page)

The standard snaps that most people shoot of their families then are not going to be sellable. But pictures of your family can be, provided you shoot them in such a way that buyers can use them to sell products rather than in a way that helps you to remember your time with them.

What You'll Need to Shoot to Sell Family Photos

For the most part, you're going to be shooting stock images. They're not going to be the kinds of natural, laid back, slightly embarrassing photos that most people shoot of their families.

They'll need to be posed and planned. Rather than portray a family, they'll need to portray one particular idea of family life, such as the family dinner, a board game or a family picnic.

The participants will often be smiling and the result might look nothing like any family occasion you've ever known. But it's not really meant to be realistic any more than a dramatic scene in a play is meant to portray a real-life event.

A stock image, even when it's depicting a family, is meant to communicate a message rather than reflect reality.

There aren't too many alternatives to stock as an outlet for family photos but get creative and you might be able to produce ideas for themes that could work as photo books, exhibitions or both. Rather than try to sell images of *your* family, for example, which wouldn't interest anyone who isn't related to you, you could present the same pictures as a photographic documentary of a typical mid-Western family or urban living or whatever it may be.

Turn your family into a representative of other families or a particular way of living and you might be able to turn them into a commercial—and artistic—photographic project.

How to Create and Sell Family Photos

It's unlikely that many of the images currently filed under "family" on your hard drive are going to be sellable. Certainly, none of them are going to be sellable without model releases from everyone involved.

To create sellable family photos, you're going to need to plan your shoot and pose people.

Stock photographers—even leading microstock photographers—tend to do this as part of a professional shoot, and that's not a bad way to create

pictures of your family that can make money. But you might also be able to combine a family event with a stock shoot.

Take your kids to the park, for example, and the experience should be fun for everyone. Take your camera as well, and an idea of the sorts of images you'd like to take home with you, and the event could be profitable too . . . provided, of course, that you can persuade the kids to pose and play along.

Selling those sorts of pictures will usually involve little more than uploading them to a stock company with plenty of family-related tags and keywords to make them easy to find.

If you're looking to do something a little more creative however, you'll need to plan out the project, how you're going to shoot it and what you want to do with it. Flickr can function as a good place to prime the market. Tell other photographers what you're planning to do and upload a few pictures at a time to generate curiosity and pick up feedback and attention.

That publicity can give you buyers for the print-on-demand book and may even help you to find an exhibition space too.

GETTING STARTED

The best place to start is probably at www.istock.com. Search for "families" and compare the best-selling images to those you have on your hard drive. Also take a look at how top microstock photographer, Andres Rodriguez, advertises for models on his website www.andresrodriguez. co.uk. This book: www.blurb.com/bookstore/detail/528782 by Martin Vivian Pearse provides one good example of how family photos can be turned into a project of general interest.

TIPS

FOR SUCCESS

(continued)

Offer Free Family Portraits

While shots of your family are always going to be the easiest to produce, taking pictures of other people's families will make a pleasant change and, more importantly, give your portfolio a more varied feel.

Friends' families are often willing to help out but one strategy followed by many stock photographers is to offer free prints to any family willing to allow them to be photographed for a stock portfolio for an hour or two. They'll get the kind of portraits that might have cost them a few hundred bucks while you'll get shots that would have cost more in modeling fees for the time taken to shoot them.

Prime Your Markets for Projects

Shooting family-based projects will be a harder sell but it could be a lot more interesting. Preparing the market by telling people what you're doing and getting them involved by contributing stories of your own will help to attract attention. That following in turn will help you to land exhibition space and book sales.

86

Selling Pet Photos

DIFFICULTY

COMPETITION

INCOME POTENTIAL

$ $ $ $

What It's All About

For animal lovers, the idea of being paid to spend time with cats and dogs, and create portraits of people's pets sounds like a perfect way to earn money.

It is, and it's also possible.

Plenty of photography enthusiasts have managed to make the leap from animal-loving hobbyists to both part-time and full-time professional pet photography.

And even those who choose only to photograph pets outside their work hours have sometimes managed to charge thousands of dollars for two-hour shoots.

This is one field which is relatively easy to break into, which can generate real cash—and can also be a huge amount of fun to do.

SUMMARY

Pet photography isn't for everyone. You'll need mastery of the camera, of course, but that's something that anyone with an interest in photography can accomplish.

Much harder is to have a way with animals, to understand how they behave, to know how to win their trust and to recognize their personalities so that you can capture them with the lens.

That's the kind of thing that can only develop from a real love of animals.

If you do have that passion for cats, dogs and other creatures, then moving into paid pet photography really shouldn't be too difficult. Mostly, it will rely on a combination of beautiful imagery and careful networking among pet owners and other animal lovers.

What You'll Need to Shoot to Sell Pet Photos

Before they start selling their photos, pet photographers tend to shoot lots of pictures of animals. They do it for fun because as photographers, they like taking pictures, and as animal lovers, they naturally find their lenses pointing at their furry friends.

In practice though, you're likely to find yourself shooting the following:

Cats and Dogs

These are easy to find and therefore among the most popular of subjects for animal-loving photographers. Flickr alone has more than 2.5 million images tagged with the keyword "cat." You might have noticed too that stores are stuffed with calendars and cards showing balls of fur in strange poses or twelve pictures of Dobermans doing odd things.

Competing with those kinds of products is always going to be difficult and you'll also need the permission of the animal's owner to make sales. The major publishers produce in bulk and can therefore usually charge less than you'll be able to charge to print in small batches. And they will also have filled the obvious niches, leaving you with little room to outflank them.

Cats and dogs are easy to shoot and may be popular but they're good for practice not sales.

Horses

That's true too of horses. They're not pets exactly, but they are much loved by their owners and they can make beautiful photographs. They're harder to come by—unlike a cat, you won't find one in an urban apartment—so talented, capable horse photographers are relatively rare too, an advantage if you can fill that position.

But again, horse pictures are popular products for publishers so attempting to sell calendars or other horsey products will always be difficult.

Exotic Pets

A little easier—if you can find them—are exotic pets. The advantage of semi-professional photographers is that because they don't need giant markets to earn a decent income, they can conquer small niches that the

TIPS
FOR SUCCESS

Start with Non-Profits

Word-of-mouth marketing is hugely important in pet photography but the word being passed around won't just be that you're a fantastic photographer but that you're wonderful with animals too. Spend time volunteering at an animal charity and you'll get a chance to meet other animal lovers and pet owners, show off your skills, get your pet images shown to even more animal lovers (for free) in the group's marketing material and enjoy lots of free practice too.

Practice

And that practice is important. Photographing animals requires some special knowledge that can only be picked up by spending time with them and trying to capture them at special moments. Even if you're not getting paid just yet, it's worth taking as many pictures of your friends' furry pals as you can.

(continued on next page)

Upsell

You'll want to offer a range of packages that allow you to market your services to all sorts of different buyers at different prices. When you come to deliver the images though, you can also try upselling by offering elements from other packages a la carte for discounted prices. Done carefully, you'll be able to squeeze a little more money out of each commission.

large providers leave behind. If you know people who keep snakes, iguanas, parakeets or spiders—and you can market pictures of them to other people who like them—you'll have an edge which could give you a steady stream of income.

How to Create and Sell Pet Photos

Because images of most pets are already available as products, the real money for pet photographers lies in commissioned portraiture. Rates for this sort of work vary, and need to so that pet owners with budgets that range from modest mutt to pampered pedigree can pay the amounts that suit their pockets. Some non-professional pet photographers have been known to charge over $2,000 for a two-hour shoot. The difference between the packages is usually the number and sizes of prints and images delivered rather than the duration of the shoot or the number of animals being photographed. Most shoots last one to two hours and involve no more than two animals.

Selling pet images then is less likely to be an issue than selling your pet photography services. That's going to require a good website that shows your images, describes your approach and allows potential clients to make contact. Marketing that site through paid advertising, link exchanges and comments on animal-centered forums could all help to bring in jobs.

Word-of-mouth marketing though is going to be even more important and is often how pet photographers find new work: animal-lovers like to show the pictures you've created to their friends and family who will call you in turn. You can encourage them to do that by giving them some free postcards to share with others or stick to their office noticeboards with your contact details at the bottom.

Craigslist may also be a useful way to offer your lower-priced packages.

Focusing on selling pet photography services rather than products will allow you to sidestep large suppliers but you'll still be competing with other pet photographers in your area. The best way to stand out is by shooting in a unique style so that clients will understand exactly what they'll receive and feel that they're getting images that are as special as their pets.

GETTING STARTED

Photograph animals—as many as you can. That will let you get a feel for pet photography and an understanding of how hard it can be sometimes. To find animals to photograph, volunteer at a shelter by looking at www. animalshelter.org or www.adoptapet.com. And make sure too that you take a look at Los Angeles pet photographer Grace Chon's website www. shinepetphotos.com to see how to market a unique style and offer packages even while holding down a full-time job.

Shoot School Student Photos

DIFFICULTY

COMPETITION

INCOME POTENTIAL

What It's All About

They might not be the most exciting pictures in the world. They might not be the most artistic, the most creative or the sort of images that are going to give you the greatest satisfaction to shoot.

But school portraits could well be the most profitable.

It's all in the numbers. Professional school photographers usually spend just 30-40 seconds shooting a student, allowing them to schedule 90 students per camera per hour.

The average cost per print is around $25 and the fundraising contribution to the school can be as low as 10 percent in some areas. The take-up rate among parents is often higher than 85 percent.

In theory then, an elementary school with 400 students could generate $7,650 of revenue in just under five hours of shooting time.

In practice, of course, the profits are usually lower. Printing costs will eat into the revenues, take-up may be lower and the fundraising contribution higher, and you'll often need an assistant. For large schools, you might even need a second team.

On the other hand, portraits are only part of the photography needs of a school. Do a good job with those and might find yourself earning even more with events and yearbooks.

What You'll Need to Shoot to Sell School Portraits

Usually, to sell a photograph it has to be exceptional. Not in the case of school portraits. These tend to be pretty simple, little more than a head and shoulders shot of someone sitting directly in front of the camera.

Photos like these leave little room for creativity.

SUMMARY

High school photography might be one of the most profitable of photography niches but it's also probably one the least exciting. While that might not bother you very much—after all, it's seasonal, not daily work—more worrying is the difficulty of breaking into it. Schools usually prefer to work with large companies who can get through the shoot quickly and with minimum fuss, and if they already have someone they're satisfied with, you'll struggle to prise them away.

If you can manage to get your foot in the door though, even if it's just a small school, you should find that the opportunity pays in spades . . . and can help you move on to the next school.

In fact, schools are going to be looking for consistency more than anything else. They'll want to see that you can shoot hundreds of people in the space of just a few hours and get every one right. You might not get a second chance to photograph a student—and if you do, you won't earn more from it—so you'll have to be able to nail it within just a few seconds before moving on to the next one.

More challenging than the photography though will be the system you have in place to record the names of the subjects, store the pictures and take and fulfill orders.

How to Create and Sell School Portraits

Shooting the portraits themselves then won't be difficult. The camera and lighting will be static, the subjects will sit on the stool opposite you at a fixed distance so all you'll have to do is make sure the image is centered and release the shutter.

It's the organization that's going to be a killer.

This is not the sort of thing you want to learn on the job. Trying to control 50 or 60 students waiting for their turn to have their picture taken isn't something you want to do without at least some experience under your belt, so a good option is to spend some time assisting a school photographer first. That will show you what exactly will be involved and how you're going to do it.

TIPS
FOR SUCCESS

Offer Proof Programs

School photographers tend to offer two programs. Prepay programs are the fastest and most traditional approach and are used in 75 percent of US schools. Parents are issued an order form a week before the shoot and payments are made in advance. It's simple and convenient, allowing for a fast turnaround of images, advance payment for the photographer and efficient commission payments for the school.

But Proof programs have been shown to produce higher sales averages and greater customer satisfaction—when the quality of the photography is particularly high and especially when you allow multiple poses for each student. Instead of paying in advance, students are given proofs that they can return with their order choices. It allows parents to see before they buy but requires a lot more work from the school.

(continued on next page)

TIPS

FOR SUCCESS

(continued)

Don't Try to Do it All Yourself

School photographers tend not to work alone. This is one time when you will need an assistant, not just to herd the students towards the lens and keep them in order while they're waiting but also to deal with all of the administrative tasks that will take up most of the time in school photography.

That will give you an added expense but you'll be able to afford it, and the fact that other photographers will be looking for assistants too during the fall shooting season can give you a way in.

Don't Start Until You're Ready

But school photography isn't really a job for novices. If you can't land an assistantship with a school photographer then cut your teeth by approaching pre-schools or by taking a workshop.

You should know what you're going to do and how you're going to do it before you start marketing to schools.

Eventually, you might even find yourself put in charge of a second team during a shoot at a large school, giving you precisely the sort of experience you need.

Finding a photographer specifically to lend a hand during a school shoot won't be easy though, especially if you're doing it with the goal of one day stealing his client. An easier option then might be to start small. You could even try starting as small as a pre-school. The images might not be exactly the same but it will give you a good portfolio and you'll be able skip around the larger competition fighting for a place in bigger schools, at least until you're ready to move up.

Alternatively, another good idea is to take a workshop dedicated to school photography.

These are probably worth doing anyway. They won't just teach you how to take the pictures, they'll also show you how to deal with all of the challenges—and the marketing hurdles—involved in making money as a school photographer.

GETTING STARTED

The best way to start as a school photographer is by assisting one. But you'll have to be assisting a photographer already to enjoy that benefit. Pre-schools, ballet schools and other types of classes could also give you some useful paid practice, or you could take a dedicated school photography workshop. Marathon Press, a photography marketing service, offers a DVD workshop series available at www.marathonpress. com.

Alternatively, school photography company SchoolPhotoPRO often advertises for photographers and places listings on its website www. schoolphotopro.com. Coffeepond Photography at www.coffeepond. com also looks for help during the busiest times.

License Your Food Photos

DIFFICULTY

COMPETITION

INCOME POTENTIAL

$ $ $

What It's All About

Cooking can be fun. Shooting images for recipes you've enjoyed cooking can be even more fun. And eating what you've been cooking should be the most fun of all.

But food photography is a niche in its own right and one that many professional photographers earn a good living from. Some of them do it on commission from magazines, recipe book publishers and restaurants. Others specialize in shooting food for stock libraries.

And many get the best of both worlds by taking both approaches.

For enthusiasts, winning commissions won't be easy. It can happen in time, once you've shown that you can land the shot, that you're reliable and available.

SUMMARY

Shooting food stock requires skills, planning and preparation. You'll have to know how to present the food, how to light and shoot it, and how to get around practical problems such as ice cream melting under lights or gravy congealing as it cools.

You'll also have to create a channel to license the images and you'll have to keep up with changing fashions in food photography. (A quick browse through an old recipe book or family magazine will show just how much food photography has changed in the last few years and how much it will continue to change as you continue to shoot.)

But for many photographers, specializing in photographing food provides a challenge that's interesting, exciting and remunerative too.

And with some careful marketing, it's a niche that's open to any photographer with the right skills, talent and dedication.

TIPS
FOR SUCCESS

Learn to Cook

Cooking food might not be quite the same as photographing it but it will give you an appreciation of ingredients, of food, and of what makes something look good for the camera. And you'll get to eat too.

Learn Photoshop

Much food stock is going to end up being used in print. While that might mean higher fees, it also means that the image has to be very high quality and lit at levels good enough for printing. You'll need to know how to set the light at those levels before add them to your library.

Deal with the Organizational Work

In addition to making food look nice, shooting it and selling the licenses, you'll also have to deal with a range of other tricky administrative tasks that fall on every stock photographer. You'll need to be able to keyword, answer clients, manage the books and wash up too.

But until then, you might find it easier to focus on food stock photography. Sell the images yourself and no one will care about the photographer.

They'll only want to know how good the food looks.

What You'll Need to Shoot to License Food Photos

You'll need to shoot food, obviously, but the kind of food you'll be shooting will vary tremendously. Stock outlets usually have plenty of pictures of raw ingredients so unless you're going to shoot them in a unique way—perhaps against a background that makes them particularly useful in an ethnic context or prepped for use rather than in their whole state—you might want to steer clear of these kinds of traditional still lifes.

A better option is likely to be to find yourself a niche within food photography.

If you can become known as the main source of images of Indian cooking, for example, or the go-to guy for desserts then you should be able to give yourself a steady stream of sales—even if the shooting becomes a little monotonous.

That doesn't mean you won't be able to shoot other types of food as well. Being a specialist doesn't stop you from offering general shots too. But it does mean that you'll be able to stand out in the market and provide a reason for buyers to remember you.

And it will also make it easier to fill gaps in the market, because that's always going to be one of the biggest challenges of food photography. The most popular food items—spaghetti, breakfast cereals, ice cream sundaes etc.—have already been photographed almost as many times as they've been eaten. Stock companies aren't really going to be looking for too many more of them, even if their popularity does mean that they also have a relatively large number of buyers. While you might be able to come up with off-beat food ideas that few other photographers have thought of—Peruvian guinea pigs perhaps, or Cantonese snake stew—it's unlikely that images like these are going to find many buyers (and the ingredients could be a pain to track down too.)

One way to overcome that challenge is to pay attention to stock company call-outs. Even if you don't want to contribute to that particular company, they will alert you to gaps in the market.

How to Create and License Food Photos

Creating sellable food photos is going to be almost as difficult as finding buyers for them. In fact, it could even be more difficult.

There is a real skill involved in making food look appealing to the lens. As one food photographer has pointed out, a chef plates a dish to make it look attractive at a particular height, a particular angle and in a way that complements the aroma and taste. A photographer, however, will usually shoot from much closer to the food than a diner's eyes and at a more oblique angle. And of course, there's no scent—or appetite—to pull the viewer in.

Making food look good for a shoot is so difficult in fact, that many food photographers use professional food stylists. They don't just cook up the food that the photographer is going to be shooting—letting the photographer focus on setting up the lights and the setting—they make it presentable for the lens too.

Usually, the process involves working with stand-in food while the photographer arranges the shot. The spot is marked and the dish cleaned out before the real stuff is added so that it's still steaming, glistening and appetizing when the photographer takes the shot.

Finding a food stylist isn't easy however and neither is finding a budget for one if you're not a professional or have a client ready and willing to pick up the tab. If you are going to do this yourself, do spend time looking at professional food stock images to see what the food should look like—and how it differs from simply photographing a plate.

To sell licenses for the images, you've really got just two choices.

One option is to offer them to a stock company, either a general one or a specialist food stock site. Unless you're dealing with microstock, you can expect the demands to be pretty high. Each company will vary but you can expect them to ask for large, high resolution images and on a regular basis.

The alternative is to set up your own stock site. The engineering might not be too easy (although Photoshop offers one workaround) but the marketing will be simpler. Some good search engine optimization could be enough to get you making at least some sales. Buyers do shop for food images with Google.

GETTING STARTED

Take a look at the work of Tim Hill, a UK-based food photographer with his own stock site at www.fabfoodpix.com, and check out too the requirements and images at www.stockfood.com and www.food photolibrary.com.

Take a Twist on Portraiture

89

DIFFICULTY

COMPETITION

INCOME POTENTIAL

$ $ $

What It's All About

Portraiture is part of the bread and butter of professional photography. It's one of those services that any decent photographer can provide and which people are always willing to pay for, whether they're pregnant women looking for a souvenir of some magic, painful months, a new parent looking for a better shot of their baby than they can make themselves or an entire family forced to sit still just long enough to watch the birdie.

But that just means that portrait photographers face a ton of competition, not least from budget shooters in Walmart prepared to take someone's picture for a song.

SUMMARY

Portraiture pays but it doesn't always pay a huge amount of money. A simple shoot in Walmart, for example, that delivers 30 prints can cost as little as six bucks.

Those aren't prices that many photographers are going to be interested in competing with directly.

To compete indirectly, you'll need to be creative. You'll have to come up with novel ways of putting people's looks on a screen and in print.

The shooting will be as difficult as you want to make it. The marketing should be the usual combination of website promotions, advertising and word-of-mouth, coupled with joint ventures whenever appropriate.

It's the creativity that's going to be the biggest challenge.

But if you can overcome it and come up with a way of shooting portraits that no one has ever done before, you could find that your services market themselves.

TIPS

FOR SUCCESS

Be Original, Not Outrageous

To conquer a niche, your portraiture will need to be different. But there's a fine line between offering interesting portraits and offering unsellable portraits.

Before you begin marketing do plenty of testing. Shoot your friends and check their reactions. They might be polite enough to praise the images but are they impressed enough to print and display them?

Don't Fear High Prices

You'll be offering a unique service and your clients will be looking for something different and original. They will be prepared to pay for that originality and you should be prepared to position yourself as an elite portrait photographer.

The large companies have sewn up portraiture for the masses. Shooting in a unique style will give you a smaller market but use high prices to make it a market with money.

One way to apply your portraiture skills in a way that wins jobs then is to come up with an entirely new approach. If you can become known as the main supplier of one particular type of portrait photography then you'll be able to stand out in the market and win a steady stream of clients hoping for your approach to shooting faces.

What You'll Need to Shoot to Sell Unique Portraits

You're going to be shooting people, of course, but it's the way you shoot them that counts here. Your goal will be to create a style that's so different and so unique that you're no longer competing with the sorts of mall photographers who are willing to shoot for change and then try to generate real profits through upselling.

People will be coming to you for an image that's different, original and outstanding.

There are all kinds of approaches you can take to make that happen. One photographer shoots in a paparazzi style, for example. He ask his clients to tell him where they'll be at certain times of day and he takes their picture surreptitiously as they drink coffee or carry their shopping. The result is a set of portraits that show them as they really are, not posing in a studio.

Other photographers have used unusual poses or special lighting effects to create images that have little in common with those made in a standard portrait studio.

You could also consider focusing on communities. Bikers, musicians, outdoors enthusiasts or athletes could want portraits that show not just what they look like but what they like to do; it's an important part of who they are.

Specialize in a way of photographing a particular community and while you'll have narrowed the market, you'll be able to take a larger percentage of it, generate greater loyalty and land more referrals.

How to Create and Market Your Unique Portraits

The type of unique portraits you produce will be tied up in the way you plan to market them. Unless you're willing to shoot for as little as six bucks, the portraits will be more expensive than standard portraits so you're already making them a harder sale.

89 Take a Twist on Portraiture

Come up with a portrait idea that's so outrageous and unusual that no one actually wants them and you'll make them an impossible sale.

When you're looking for an idea then, begin with the unique styles that you not only enjoy experimenting with but which has generated good feedback. Or pay attention to the sorts of people who make up your social circle.

You'll always find it easier to build a portfolio and referral network if you begin by shooting people you know.

So if you sing in a choir in your spare time, for example, take some unique portraits of some of the other choir members in mid-song. You might not be able to ask your own choir members to pay for portraits—they would be friends, after all—but you can use them to build a portfolio that you can then take to other choirs and use your subjects' connections to other musical groups too.

That sort word-of-mouth marketing will be invaluable, but while your portraits should be unusual, your marketing methods should be traditional.

A website is likely going to be your most powerful marketing tool. It will allow you to show off your samples, explain your approach and even take bookings.

Publicity can work very well here too. Write a press release describing the sorts of images you're shooting and a little local media attention will do wonders for your conversion rates.

And for portraits that focus on communities, community tools such as Facebook and Twitter can help to spread the message that you're the group's expert photographer.

GETTING STARTED

Before you can start marketing an unusual portrait service, you'll need to test different ideas to see which are the easiest to shoot, the most popular, have the greatest potential and offer the right price points.

And before you can do that, you'll need to develop those ideas.

Take a look at Izaz Rony's paparazzi portraiture at www.methodizaz.com and you can also try browsing the odd shots in Flickr's two "unusual portrait groups" at www.flickr.com/groups/unusual_portrait/ and www.flickr.com/groups/46738328@N00/.

90

Shoot the Stars as a Set Photographer

DIFFICULTY

COMPETITION

INCOME POTENTIAL

$

What It's All About

There are few better places to work than in the dramatic arts. You get to hang around with creative people. You get to help produce a work of art that other people will appreciate and enjoy. And while the hours might be long, it never quite feels like work.

For photographers, that usually means giving up the still shots and heading for the big movie camera. The skills are similar: you'll still be worrying about lighting, focus, depth of field, and composition, but you'll also be concerned about movement, both your own and that of the actors.

The two fields might be related but cinematography is a whole different ball game altogether.

Still photography though does have a place in the dramatic arts. You can often find a still photographer both on a movie set and in the theater. They'll be documenting the making of a work and they'll be creating the still shots that will one day end up being used on DVD covers, posters and other marketing material.

As photography gigs go, few are more fun or deliver bigger bragging rights.

What You'll Need to Shoot to Earn as a Set Photographer

Set photographers (or "Unit Stills Photographers" as they're called in the movies) generally shoot two different kinds of pictures for two different kinds usages.

Documentary images are meant to record the creation and development of a dramatic artwork. That's particularly important in the theater

SUMMARY

All of that fun though tends to come at a price. Shooting the stills for a film or a play might pay very little. In fact, initially, it might pay nothing at all. It's unlikely that without connections you're going to get a call from Tom Cruise asking you to spend a few days on set taking pictures of his new movie.

Without a track record and an address book filled with the names of actors, directors, producers and scriptwriters, it will be more likely that you'll be taking pictures of student films and the sets of local amateur dramatic companies.

Everyone has to start somewhere.

Eventually though you might well find that those connections start to bring in paid work, that the movies and performances grow larger and with them, the pay, the satisfaction . . . and even those bragging rights too.

where once the last performance has been completed, there's no further record of how the play was performed or even what it looked like.

The photographer's job then will be to shoot the rehearsals, create a record of the costumes and the sets and create a pile of images that future thespians can look back on to see how other people put on the same play.

The other part of the job is to create promotional images, and these are often a lot more fun to shoot. They're usually a lot more arty and they're meant to attract eyes and hold the viewer's attention in the way a good photograph should.

See an image you've shot on the cover of a DVD box and you can't help but feel proud.

How to Create Images on a Set and How to Win the Jobs

Shooting on a film set does require a special set of skills, and more importantly, some specialized knowledge. A number of top theatrical photographers, for example, come in to the profession from another theatrical specialty. The commercial photos used to promote the Broadway show "Cats," for example, were shot by John Napier, the show's scenic and costume designer.

TIPS

FOR SUCCESS

Get Involved

The good news is that the dramatic world is a fairly open one . . . provided you're not expecting to get paid. There are plenty of amateur dramatic companies that could use the help of a volunteer who knows how to handle lights, build sets or even act if that interests you too.

Show that you're willing to give up your time because you enjoy the theater, and you should find that your volunteerism soon gives you the knowledge you need for the job, as well as the sort of valuable contact list that can help you to win the paid stuff in the future.

Do Headshots

If you're mixing in the theatrical world, it won't hurt to earn a bit of money by helping actors with their headshots. Those are usually a useful income stream for photographers but for photographers who also want to shoot the actors in action, they can also be a way in.

As you're doing the head and shoulders, make it known that you'd love to shoot them in action too.

Most importantly, you have to know what's happening on the stage or the set and what's going to happen too so that you can be ready for the shot.

Perhaps most important of all, you have to know what not to do. Get in the way of all of the other people on a film set, for example, and you'll quickly make enemies of people you really need on your side and spreading your name around the community.

That means you won't usually be able to shoot when the cameras are rolling and you'll have to make sure that you're never standing in the shot, so pay attention to where the lens is pointing.

And you'll have to get used to the fact that of the two lens-holders on the set, you're always going to be the least important. When the actors kiss, the stuntman flies or the cars shoot down the road, the other cameraman will have the best view while you have to make the best of second best.

None of that though is particularly difficult. It's the sort of thing you can learn by spending time on movie sets and in theaters, and by applying a touch of common sense too, always a useful thing for a photographer to have.

But that's where the Catch 22 starts. You won't be able to find jobs like these unless you've spent some time on sets and in the theater, and got to know the directors and producers who need them.

And you won't be able to get to know those directors and producers unless you've spent time on sets and in the theater.

That's why set photographers are often not professional photographers who pitch their services to movie companies and theaters but dramatic professionals, especially designers, who also know their way around a camera.

The best way to become a set photographer then is to volunteer at your local theater. Get involved with a drama group. Try to land a role putting up lights for a low-budget movie shot by students at a nearby film school.

These jobs almost always come through word-of-mouth. To win them you'll need to know people so that your name ends up being passed from mouth to ear.

GETTING STARTED

Maine Media Workshops at www.theworkshops.com offers movie photography workshops (for a little over $1,000). Take a look too at the work of Dan Turkewitz at www.celluloidglory.com and Richard Finkelstein at www.rfdesigns.org.

Score with Sports Photography

91

DIFFICULTY

COMPETITION

INCOME POTENTIAL

$ $ $

What It's All About

A game of sports contains all of the elements that go into a great photograph. There's drama and movement, color and action. And there's the challenge of capturing in a split-second an expression or a position which can summarize an entire match.

Toss in the grandstand seats and the free tickets, and it's little wonder that sports photography is such a desirable field for photographers to break into.

It would be nice to say that the digital revolution, with its easier access to top-of-the-range cameras and multiple outlets, has made sports photography an easier field to break into.

It hasn't. The images that appear in newspapers and on news sites are still shot by professionals who have been doing it for years. And "sports photographer wanted" is rarely the sort of notice you see on Monster.com.

Becoming a professional sports photographer then will always be a hard slog, one that involves learning the ropes and building connections.

Selling occasional sports images will require creativity both in the shots you capture and the way you sell them.

If you can pull both those things off though, you could find yourself earning from one of photography's most enjoyable specializations.

What You'll Need to Shoot to Earn as a Sports Photographer

You'll need to shoot a lot. Sports photography is a skill. You have to develop the techniques that allows you to capture the action and create a sellable picture.

That can only come with practice and experience.

TIPS

FOR SUCCESS

Know the Sport

Rather than aiming to become a sports photographer, aim to become the photographer of a particular sport. That won't just make the marketing easier, it will also make your photography better.

Sports photography relies on anticipation; you have to be ready for the shot before the action has happened. Specialize in one sport and you'll get to know both the buyers and the shots.

Don't Limit Your Sales Channels

This is such a competitive field that if you want to make money, you'll need to do it every way you can. So don't rely on the media to put your photos on their pages. Create photo books, stickers, posters and anything else that you can sell.

SUMMARY

To become a professional sports photographer takes years. You'll have to study photography, take giant piles of pictures, perhaps start with a local newspaper and work your way up by building contacts and a portfolio in the same way that every career-minded professional works their way up the ladder.

If you're simply looking to take pictures of leaping basketball players or sliding baseball players and sell them for a little bit of money, you just have to know how to take the right pictures—and how to sell them.

It won't be easy. The biggest markets are always going to be for photos of the biggest players and the biggest teams. Those will also be the images that will fetch the biggest prices . . . and therefore they'll be the places where you'd be competing against the big names in sports photography.

As they'll also have the biggest lenses and the best places to take pictures, a better option will be to focus on the games with a smaller but no less loyal fan base.

You won't make as much money and any money you do make won't be too regular. But the photography will be fun and you will have the ability to generate income in all sorts of different ways.

In practice, whichever sport you choose to photograph, you're going to find yourself shooting three kinds of photographs.

Portraits

Sports is as much about people as it is about pitches. Supporters want to see their favorite players. They want to see what they look like, how they develop and what they were doing during the game (and even after it.) If you can put yourself in the position of becoming the official photographer for a local team, you can create a stream of posters, cards and stickers that you can sell, sharing the profits with the club and the players.

News Shots

The size of the media outlet that covers a team will depend on the size of the team itself. The Lakers will always attract the biggest photographers

shooting for national and international news organizations. Move down through the leagues, and you'll find that even the smallest of teams can generate interest from someone.

Pictures of college teams in action might be in demand at a college newspaper. High school teams might win reports in local newspapers. Shooting well for those sorts of publications can be one way to earn as a sports photographer.

Stock Photos

There's a demand too for sports images in stock photography. These are perhaps the easiest to shoot, although getting model releases might be a little harder if you don't know the players.

Pictures like these aren't about a particular team or a particular player. They need to express the essence of the sport itself or even an emotion associated with sport such as victory, teamwork or defeat. They might not be realistic in the same way that a shot from a match will be but they can still be fun to shoot and remunerative too.

How to Create and Sell Sports Photos

Creating sports photos is simple enough. Head off to a sports match, ideally an amateur game in a park where you can get right up next to the pitch, and practice your skills. You'll probably need to invest in some good lenses, in particular, a fast telephoto but the more you shoot and the more you review your shots, the better your sports photography should become.

Selling the images is going to be the difficult bit.

If you can land the model permissions then stock is probably going to be the easiest outlet. Microstock companies have open doors and the best-selling sports images have sold several thousand licenses each.

If you want to sell to the media, you might try talking to the sports editor at your local newspaper and asking if they'd be interested in images from a particular team's game. Bear in mind though, that they have very little room for sports photographs, that their own photographer will have priority—and will be at the biggest game—and that images of a match grow cold very quickly.

An alternative option is to use the image to bring in viewers and earn from the advertising. Instead of selling your photos, put them on a website dedicated to a particular team, market the site based on the photos and fill

it with targeted ads and affiliate products. People won't be taking away your pictures but you'll still be taking them—and earning from them.

GETTING STARTED

Begin by heading to a park and taking pictures. And if it's raining, read www.sportsshooter.com or take a look at Brad Mangin's sports images—and how he sells them—at www.manginphotography.com.

Clean Up with Forensic Photography

92

DIFFICULTY

COMPETITION

INCOME POTENTIAL

$ $ $

What It's All About

They're a standard part of every cop show. As the detective looks around the crime scene and interrogates the jogger who found the body, a white-clad figure in the background is always snapping away at different angles, recording the scene for posterity and for evidence.

The subjects are never particularly enticing. Photographers like these are shooting dead bodies, blood splatter and bullet holes. They aren't images they're going to sell—forensic photographers tend to be salaried and shoot as part of their work as crime scene analysts—but they may help to solve a crime, which could be rewarding enough.

SUMMARY

As a career choice forensic photography may be reasonably remunerative; you'll be paid a relatively good wage but it's unlikely to be too satisfying for a creative photographer who gets a kick out of shooting beautiful photos. No one is going to hang these kinds of photos on their wall.

Nor is there much room here for a freelancer or photography enthusiast. This is the sort of work that's usually handed out to people already employed in law enforcement, although law firms may sometimes send a photographer to a crime scene too. After all, it's work that requires some very specialized knowledge: you'll need to know not just how to take pictures but how to take pictures that can function as evidence in a court of law.

Stay Together

The images you'll be shooting or analyzing as a forensic photographer are going to be disturbing. It's not unknown for forensic photographers to suffer from a kind of post-traumatic stress disorder.

If you're planning to do this sort of work for a long time, make sure that you can leave it behind, that you have a support network and that you don't let it get you down!

Know the Law

Being a successful forensic photography requires mastery of two sets of skills. You'll need to know how to take pictures of small items so that they are clear and easily recognizable, and do it under pressure. Or, as a forensic photoshopper, you'll need to know how to access details in images that you didn't even know were present.

Both of those kinds of skills require practice and talent.

But you'll also need to know about the Federal Rules of Evidence, chain of custody and how your county's Superior Court works. That's information that can be easily learned but you will need to learn it.

What You'll Need to Shoot to Earn as a Forensic Photographer

Usually, forensic photographers get stuck shooting the kinds of things that most people really don't want to be looking at through their viewfinder—or at all. Crime scenes aren't usually pretty places and the images that come out of them aren't attractive. Nor are they going to bring in too many random viewers.

The subjects of the images might include bullet fragments, blood spatter, wounds, bullet holes, and hairs, as well as crime scene locations such as bathrooms, bedrooms, vehicle interiors and shopping centers. All of those items have to be shot clearly so that they're well-lit and in focus.

The images have to be strong enough to leave no doubt at all about their subjects when presented in court or pored over by investigators.

There is an alternative approach though. Rather than earning from taking the pictures—which will require turning up to a crime scene on short notice and getting close to dead bodies while trying not to get in the way of crime scene analysts—you can earn from analyzing the images that come back.

"Forensic Photoshop" as one expert has called it doesn't require shooting at all but it does still demand the sorts of imaging skills that photographers have at least a basic grounding in.

You'll be presented with an image—perhaps even a security camera video—related to a crime and asked to bring out elements that can help during an investigation.

Again, there's little creativity here—forensic photography isn't the field for photographers who like to see the product of their skills in galleries—but there is a technical challenge and that's often enough to interest many photographers.

The pay too, especially if you're called as an expert witness to describe what can be seen in an image, can be very remunerative. A forensic photoshopper in private practice—that is, not employed by a law enforcement agency—can expect to earn around $350 per hour for time in front of the computer, rising to $450 per hour for court time, plus expenses.

How to Create and Market Forensic Photography Services

Creating the images will require a great deal of care. Crime scenes are sensitive places filled with other professionals trying to do their work.

They're also temporary. Sites are cleaned up quickly. The evidence is removed, and marks and wounds repaired . . . or buried.

You'll only get one chance to land the photo. Get it wrong, and you won't have created an unsellable image; you might have helped someone get away with murder. Fortunately, there are courses that teach photographers exactly what to do when faced with a crime scene.

Forensic Photoshop is a little easier. There is a standard workflow that involves cleaning up images, resetting the light levels and highlighting the details to bring out the fine points that the investigator is looking for.

While this kinds of work does require a high level of technical expertise, the responsibility is much lighter. Fail to find what the investigator is looking for and he can turn to another specialist for a second opinion. It's not unknown for an image to be analyzed by five different experts before someone finds the right process to reveal the required level of detail.

Naturally, if you can save the investigators the trouble of going through six different experts, you'll be the first person they turn to next time.

Marketing both of these services though is going to be very difficult. Much of this work in-house, often as an adjunct to a crime scene analyst's regular work. A full-time investigator may simply be made responsible for doing the photography at the scene of a crime while many police departments have a professional technician on staff to analyze images.

There is some freelance work available though, often for law firms looking for an independent analysis or their own set of images. To land those sorts of jobs, you might find yourself competing with retired officers or those with private businesses who have not just experience but more importantly, close connections with clients.

It's those connections that are always going to be the best way to find work, so you'll have to network, join professional associations and take any workshops that you can find to pick up the networking knowledge as well as the photography and legal understanding.

GETTING STARTED

Start by doing the research. Alexander Jason is a forensic photographer and has an informative website at www.alexanderjason.com. Jim Hoerricks is the author of the Blurb best-seller *Forensic Photoshop* and has a website at www.forensicphotoshopbook.com.

Forensic Magazine at www.forensicmag.com has some job listings and the International Association for Identification, an organization for crime scene professionals can be found at www.theiai.org.

93

Earn with Event Photography

DIFFICULTY

COMPETITION

INCOME POTENTIAL

What It's All About

For many professional photographers, event photography is the bread and butter of their jobs, the gig that lands the most commissions and the one for which there seems to be constant demand.

It's an occasional job so while some photographers are able to bring in enough work to live on, for others, shooting during the odd evening or on the weekends is enough to earn a little extra cash from their photography while still holding down a day job.

Nor is it the most demanding of photography specialties. While you will need to know what to expect, what sort of images the bride and groom will want, how to shoot the formals and how to package and market your services, event photography holds few secrets.

If you can learn what f-stops are for, you can learn how to shoot weddings . . . as well as bar mitzvahs, confirmations, engagement parties, retirement parties and anything else that brings people together for moments that need recording.

Master this little niche and you'll always have one way of making money from photography.

What You'll Need to Shoot to Earn with Event Photography

To win event photography jobs, you're going to need to photograph events —the familiar job-seeker's Catch 22. Fortunately, breaking the circle isn't too difficult.

There are two main routes to building up the experience—and the portfolio—necessary to win paid event photography jobs.

93 Earn with Event Photography

SUMMARY

Event photography might be a standard part of many professional photographers' moneymaking toolkits but it's still not an easy tool to employ. The competition is intense and while the amounts charged for a shoot might run into thousands of dollars, by the time you've factored in the costs of travel, editing, printing and shooting, as well as the equipment and marketing needed to land those jobs, the profits are often very small.

The average salary for a wedding photographer can be as little as around $30,000.

But that average hides a lot of detail. Work part-time as a way of earning some extra cash, getting paid to take pictures and eating lots of free wedding food, and a low income might not bother you.

Take exceptional pictures in a unique style and pitch your services to the well-heeled looking for a unique album and you could find that you're one of the highly-paid event photographers pushing the average up.

One of the advantages of event photography isn't just that it's a service that any photographer can supply; it's a service that any photographer can offer to supply in any way that he or she wants.

The first is to work as an assistant. For photography students learning the ropes, that's rarely a challenge. Assistantships like these are part of the learning experience and they usually have the time and the inclination to lend a professional a hand.

For part-timers though, assistantships are often a little more challenging. They take up time that could be spent shooting, working or with family. They often take the other route then and accept invitations from friends and family to bring their camera to a low-budget wedding or anniversary party.

Those sorts of unpaid gigs can deliver experience that's just as valuable as an assistantship. They'll still give you a portfolio that you can use to bring in other work and because the clients aren't paying, there will be few complaints if the images aren't entirely up to scratch.

How to Create and Market Event Photography

Creating event photographs will involve little more than taking your camera and your equipment to the event, shooting all of the important moments and certainly all of the important people, making sure you get

everyone together for the formals, grabbing shots of the wedding dress, the cake, the rings, the best man and the maid of honor, the dancing and the food. It will involve knowing how to handle a bride who's experiencing the most nerve-wracking day of her life and how to light your subjects without blinding the priest or tripping over the groom's father with a lighting cable.

And it should involve creating pictures that are more than staple wedding snaps but which express your style and show clearly that none of the guests could have created the album you're delivering.

Part of that will come through the technical excellence of your work. The photos you deliver will have to be professional quality. They'll need to be focused, well-composed, properly lit and expressive. But part of it should also come through your creativity.

If you can find a new spin on the event photography standards—the held hands, the family formals, the vows, etc.—then you'll give potential clients a reason to hire you rather than one of the dozens of other event photographers pitching for work in your area.

And they'll be pitching for it in all sorts of ways, from flyers and brochures to Yellow Pages listings and newspaper ads. Even Craigslist has now become a very effective way to win low-budget wedding jobs provided you're prepared to refresh the ad on a regular basis. Usually though, wedding jobs come in one of two ways.

Websites now are a prime source of work, especially if you have a good, professional-looking portfolio, search engine optimization and a clear way for potential clients to contact you.

But perhaps the most important method to attract new clients is through word-of-mouth. Event photography requires such a high level of trust that clients usually begin their search by asking their friends and family for recommendations.

You want to make sure that you're receiving those recommendations. You can even encourage them by giving your clients extra prints with your name and contact details on them to share with their friends—especially prints of any unmarried couples you saw at the wedding.

GETTING STARTED

The Society of Wedding and Portrait Photographers at www.swpp.co.uk is packed with useful information about getting started as an event photographer, while the Wedding Photojournalists Association at www. wpja.com offers advice about one stylish way of shooting weddings.

Give Yourself a Treat with Children's Photography

DIFFICULTY

COMPETITION

INCOME POTENTIAL

$ $

What It's All About

Give a mom a camera and inevitably she'll end up with a folder filled with images of her children. If she gets really carried away, she might even create another folder filled with pictures of her friends' children.

And if she really enjoys taking those pictures, she might want to continue creating folders filled with pictures of clients' children, images she was paid to produce that capture the personality of the child and which give her as much pleasure to create as the client gets out of viewing.

Children's photography requires some special skills. As well as mastering all of the technical skills necessary for every kind of portrait photography, you'll need to know how to get the most out of some of the most difficult of subjects.

You'll need to know how to stop them becoming bored, how to keep them happy, and which sort of images the client would treasure most.

You'll also need to know how to find clients and how to charge them too.

For photographers who enjoy being around children and get a kick out of taking pictures of little ones, children's photography can represent another opportunity to combine two passions into one revenue-generating pastime.

TIPS
FOR SUCCESS

Develop a Style

Now that just about everyone owns a digital camera and photographs their children all the time, to win jobs children's photographers have to do more than show that they have some fancy equipment. They have to produce pictures of children that the parents themselves couldn't create.

That's not going to be easy. It will take a special style, a way of capturing children's personalities or a method of presenting a mood that you have developed or in which you specialize. Offer images like these and you will always find it easier to win jobs.

Go Where the Kids Go

One of the things that makes marketing children's photography relatively easy is that children—and their parents—tend to congregate in certain areas. Take your children and your camera to a playground and other parents will notice that you're putting more effort than usual into taking their pictures. Show them the results, offer to shoot their children too and email the images.

(continued on next page)

SUMMARY

Children's photography is a professional niche which keeps a number of full-time photographers in work. But plenty of enthusiasts do it on a part-time basis too, taking occasional jobs as they come in and applying the skills they've learned photographing their own children to bringing the same benefits to other parents.

That does mean that it's a niche with plenty of competition. Every portrait photographer—and that means just about every professional photographer—also markets themselves as a photographer of children's portraits and just about every enthusiast who is also a photographer feels that they can sell their services.

The good news is that while the competition is pretty stiff, the market is broad too and children's photographers rarely have to look too hard to find jobs—provided that they don't have to rely on them to pay the mortgage. Parents' networks are so well connected and so easy for other parents to break into that word of a talented children's photographer can spread quickly, leading to plenty of referrals and commissions.

What You'll Need to Shoot to Earn with Children's Photography

Anyone can point a lens at a child, wave a chocolate bar and persuade them to sit still—or at least smile long enough for a fast shutter speed to capture it. As a children's photographer though, you'll have to go a little further than shooting the sort of pictures that every parent can create of their kids.

You'll need to create images that express something unique about their children. That could be the result of a technical skill, a special stylistic approach or just a way that you have with little ones that puts them at ease and has them performing for your lens.

You want potential clients to look at your portfolio and realize that they're seeing images that they couldn't shoot themselves, special keepsakes of their children that only you can supply.

If that sounds like a challenge, overcoming it is part of what makes children's photography so enjoyable!

94 Give Yourself a Treat with Children's Photography

How to Create and Market Children's Photography

Just as pet photography will require mastering some special techniques to keep your subjects calm, still and ready to be photographed (and in a way that you want to shoot them) so the same is true of children.

You might choose to bring children into a studio—even a home studio—where the lights are easy to control and the props are ready to hand. But shooting the children doing what they like to do most could make for a more enjoyable—and easier—shoot.

Taking your subjects to the playground, for example, and capturing them flying down the slide or clambering up the climbing frame, could produce some unique and interesting portraits that reflect the child's personality. Photographing them in their own living rooms or playing with their siblings could work too. Developing your approach will take practice but if you have children of your own, that's practice you're likely to be doing anyway.

Children's photography is a rare example of a niche that's difficult to market but which tends to bring in jobs on its own. Ask a parent if they'd like to hire a professional children's photographer, and most will point to their own camera and suggest that they're capable of shooting their own pictures . . . and for free.

But should a friend show them pictures of their own children shot by a professional photographer and recommend your services, your photography won't just look impressive, it will look like something they simply must have.

In practice then, you'll probably find that while you can market your children's photography services through a website, through Craigslist, through flyers and notices in playgrounds, you'll probably find that much of your work comes through networking and referrals.

And of course, you can also stretch the concept of children's photography to include stock photography. You'll still need model releases—and from the parents this time—and the pictures won't be of the children themselves but rather use them to portray an action or describe a mood. But if you're capable of managing children on a portrait shoot, you should also be able to control on a stock shoot.

And using your portfolio to offer free portraits might just help to persuade the parents to let you shoot their children for free.

TIPS FOR SUCCESS
(continued)

And when you send them the picture, make it clear that you take commissions and ask them to pass your name along to their friends.

They've just received a free sample so as long as you've shot an impressive picture, you should expect some free referrals in return.

GETTING STARTED

Kym Marson is a children's photographer whose website www.kymmarson.com provides just one example of the sort of unique photographs that a children's photographer should produce—and the way to market them.

www.specialkidsphotography.com offers a different take on children's photography, and The International Registry of Children's Photographers at www.irocp.com provides a wealth of information and tries to bring suppliers and buyers together.

Make Money with Blurb

DIFFICULTY

COMPETITION

INCOME POTENTIAL

$ $ $

What It's All About

Until recently, photography books were the preserve of established professional photographers. They cost a fortune to print, appealed to relatively small markets, often came with giant price tags and were such a big risk for publishers that if the photographer's name wasn't well-known they wouldn't want anything to do with them.

Changes in printing technology—and most importantly, printing costs—mean that's all different now.

It's possible to create and print just one copy of a photography book and make it available at a price that even a casual buyer can afford to purchase.

And the main place to do this is through Blurb, a print-on-demand photography book company.

Founded in 2005 by Eileen Gittins, a photographer, former Kodak executive and serial entrepreneur, the company allows photographers to download BookSmart, their design software, for free then upload the finished book to its website. Photographers can then order as many copies as they want, paying the cost of production, or allow others to purchase the book paying a set price.

The printing costs depend on the size of the book and its format but range from $12.95 for a square softcover of up to 40 pages to $74.95 for an image-wrapped hardcover book of up to 440 pages. A discount of 10 percent is then applied to book orders of 10-199 copies, 15 percent for 200-400 copies and possibly more for even larger print runs.

Few companies have done more to democratize photography's moneymaking potential than Blurb. Microstock has allowed anyone to receive royalties from their images but Blurb enables them to become published authors of their own photography books.

SUMMARY

There is however a difference between publishing a photography book and selling one. Although there are thousands of photography books available on Blurb's online bookstore only a fraction of them actually generate revenue.

Many, of course, were never intended to make money. They were put together and printed to function as a kind of private photo album, a way for friends and family to share their images. Others though were intended to make sales. The reason that they don't make those sales is that the photographers don't market them.

If you want to make money out of your photography books, you'll need to pick the right subjects, shoot the right images, post them in the right order and find places to sell them too.

What You'll Need to Shoot to Sell Blurb Books

The quality of the images alone is never enough to sell a photography book. And unless you're already famous, your name won't be sufficient to move copies either.

You will need good photos but you'll also need photos of subjects that you can easily sell.

Niched topics then are one way to make money with Blurb books. A car photographer, for example, would be able to put together his photographs of muscle cars, ask the owners for permission, and make his book available for selling not just through Blurb but also on websites and at outlets related to the subject.

As long as more people are interested in the topic than the photographer alone, a book containing beautiful images should always be a relatively easy sell.

An alternative to selling niched books to a select market is to offer a book of one event to a highly focused market with a very strong interest.

One of the most popular topics on Blurb is books of wedding photography. They're often created by the couple themselves to allow other family members to own a souvenir of their big day but wedding photographers could also offer to create them for their clients for a fee, and make them available for sale on Blurb's website for a profit.

Other photographers have made hundreds of dollars by putting their children's school yearbooks on Blurb, while a printed book can also make a very impressive portfolio.

How to Create and Sell Blurb Books

Creating a Blurb book can be a lot of fun. Blurb's BookSmart program costs nothing and is easy to use. Creating a photography book that's enjoyable to read and look at though—and then to sell it—is a much bigger challenge.

To make it enjoyable, you'll need your book to tell a story. Every book should tell a story and that includes photography books. A successful photography book should begin with establishing shots that create the context, move into the images that make up the meat of the book and end with an image that summarizes the reader's journey and leaves an impression. White space is important to set off the images, and the book as a whole should have a rhythm so that the reader is drawn through the pages rather than forced to stop and start.

That's the kind of thing that takes a little planning and experimentation but it produces much better results than a random scattering of pictures, however beautiful.

The easiest way to market the book is likely to be online. Write to publishers of websites that discuss the topic of your book and offer them affiliate commissions in return for sales. Discuss the book on Flickr groups and place sample images in your stream to attract views and feedback, and generate interest. And sell it on your own website, of course, too.

But don't forget offline outlets. Bulk ordering might be risky but it lowers the price of each copy and means you can sell them for a profit at art fairs, in stores and at other targeted events.

GETTING STARTED

Begin by downloading Blurb's BookSmart software at www.blurb.com/create/book/download and play around with it a little before you upload your first book.

Also spend time browsing Blurb's bookstore to see the sorts of books on offer and it's also a good idea to pick up Beth Dow's award-winning Blurb book "In the Garden" to see one great example of an effective photography publication.

You can find her book in the bookstore and her website at www.beth-dow.com.

96

Turn Your Pictures into Stories

DIFFICULTY

COMPETITION

INCOME POTENTIAL

$ $ $

What It's All About

The photos in a photography book should be arranged in such a way that they tell a story. That story is usually very simple. It could be a depiction of the feelings inspired by a walk in a national park. It could be the tale of the American muscle car. Or it could simply be the story of a wedding, the best day in someone's life.

The images themselves will be strong enough to stand alone. The narrative will emerge as a result of the way they're ordered.

It's also possible though to use images deliberately to tell a story. A number of photographers have done this. Targeting the children's market, they've published books that have attempted to use photographs to teach children about a particular subject—life in Mexico, for example, or the Thanksgiving feast.

Or they've tried to entertain them by combining imagery with cartoon-style graphics to create a narrative book that's both realistic and fun to read.

Neither of these choices is particularly easy. But a few photographers are making good livings out of books like these—and they're almost as much fun to produce as they are to read.

What You'll Need to Shoot to Sell Photographic Books

Photographers who create photographic books have really taken one of two paths: they've either created didactic children's books and used their images to illustrate their text; or they've published entertaining books and told the story entirely through images, adding graphic elements to make them more interesting.

ⓟ PHOTOPRENEUR

96 Turn Your Pictures into Stories

SUMMARY

Creating photographic picture books requires a broad range of skills, of which photography is only one.

You may need writing skills to tell the story the images are portraying. Or you may need post-production and artistic knowledge to add cartoon elements to your photographs and give them a whole new look.

More importantly, you'll need to be able to construct stories, understand how to pace them, build drama and interest, and encourage readers to keep going.

All of that is hard enough but because these sorts of books are difficult—although not impossible—to publish yourself, you'll also have to be able to persuade a publisher to take you on.

And that can be very difficult indeed.

This is not the sort of thing that someone should give up their day job to start doing. But if you can produce photographic picture books, persuade a publisher to print them and find that they sell, it could well be the sort of thing that you could end up swapping your day job to do.

To create the first kind of book, you'll probably need about 50 images to fit onto the book's 48 pages plus front and back covers. It's not unknown to have to shoot around 1,800 photos to get those 50 usable shots.

The topics themselves could vary tremendously. Books like these have covered subjects as broad as Native American powwows and piñata-makers. They're planned out so that all the main elements are included but often, the photographer will focus on a child as a point of identity for the reader. He might also find that spending time with the subjects and the people involved opens up all sorts of new avenues for the book.

For the second type, there's really no limit at all to the kinds of shots you could be taking as long as you can turn them into a story. One author took pictures of his local neighborhood, cleaned them up on Photoshop, added some cartoons and ended up with an award-winning children's book which was later turned into an animated DVD.

How to Create and Sell Photographic Books

Successful photographic books require a number of elements: they need to have good pictures; they need to have a good story; and they need to have a process to turn that story into a finished book.

TIPS
FOR SUCCESS

It's All About the Story

Usually for photographers, the image is everything. In photographic books though, the image is just the means to the end.

The end is to describe a story that other people will find interesting and enjoyable to read. Bounce your story idea off potential readers, plan the pictures out before you start shooting and make sure that the narrative works above all else.

Look for Models You Can Repeat

The real advantage of books like these isn't that one of them will become a best-seller, netting you a steady stream of royalties to see you into old age—that's pretty unlikely. It's that once you've created a system for creating one book that sells, it should be easy to create a series of books in the same way.

As you're thinking of your idea for a photographic story then, think too about how you're going to create it . . . and how you can adapt that process to other story ideas.

George Ancona, for example, started his career as a graphic designer and draws on that experience to sketch out his books before he starts shooting. He decides whether the book should be vertical or horizontal, what sort of images he needs and whether they should be colored or subdued, have large images or small pictures. It's a process that he's used on most of the 113 photographic books for children that he's created.

That level of planning even before you pick up a camera is probably the right approach for any kind of photographic book.

Creating the book will be difficult. It's going to require some smart thinking and a lot of creativity. The shoot itself could take you into the heart of someone else's community, although it could just as easily take you no further than the end of the road . . . and then to your copy of Photoshop.

Even harder though will be pitching the book to publishers.

You'll need to present a professional proposal explaining exactly what the book contains and what sort of competition is already out there.

And you'll have to be prepared to take a lot of rejection because pitching books to publishers is never easy.

There are a couple of short cuts you might want to take. George Ancona got his start when a children's writer asked him to produce the images for a book she was working on. If you know a writer who already has publishing contacts, you might be able to ride into publishing on his or her coattails by working together on a book in a similar way.

Otherwise, you can try self-publishing. That will get you in print but it's usually expensive and risky, and the distribution is difficult too. Get picked up by a major publisher and you'll be in bookstores across the country.

GETTING STARTED

Every good book begins with a story you want to tell, so start thinking of your first story. And in the meantime, get inspiration by looking at George Ancona's work at www.georgeancona.com and Mo Willems "Knuffle Bunny" books at www.mowillems.com.

Turn Your Pictures into Coloring Books

DIFFICULTY

COMPETITION

INCOME POTENTIAL

$

What It's All About

Creating attractive images means mastering photography. It means understanding composition, depth of field and lighting. It means combining creativity with the technical craft required to control a camera in order to produce unique, beautiful photographs.

And if you can't do all that, there's always Photoshop.

Few photographers will be happy to rely on image editing software to correct their mistakes but Photoshop isn't just there to adjust white balance and filter out noise. It can also allow photographers to do all sorts of things with their images that they just wouldn't have been able to do otherwise—and that includes creating photographic products that they can make available for sale.

One of those techniques will remove the color from your images and emphasize the lines, turning them into pages that children can color in. It's not difficult to do—it might even be fun—and the result might just be a product that customers are willing to buy.

What You'll Need to Shoot to Sell Photographic Coloring Books

If you're just looking to amuse your kids, then you have a lot of fun taking pictures of your pet dog, their toys, grandma and grandpa and anything else that the children would recognize and enjoy coloring in. But you're not going to make any money that way.

And you'll also struggle to make sales photographing balls and cars, and turning them into coloring books for stores to sell. They'll always be able to buy bulk from wholesalers at a cheaper price.

A better option then is to photograph businesses.

TIPS

FOR SUCCESS

Include the Logo and Key Products in the Images

Products like these have two key sales points: they improve the experience of customers, making them more likely to return; and they function as marketing materials, allowing the parents to take home items that will remind them of the company long after the transaction.

Any coloring book can supply the first point. Only the kind of unique coloring book that you're offering can supply the second.

When you're making your pitch, point out that one image will be of the outside of the company so that the name is clear and ask which are their most recognizable products so that you can be sure to shoot those too.

Keep the Pages Separate

Coloring books are usually stapled together but it's a better idea to keep pages unbound and held together only with a simple cardboard folder. That will enable parents to place the finished pictures on walls and fridge doors where the company name and product will remain visible.

Don't forget to point that feature out to the company too.

(continued on next page)

SUMMARY

Creating the pages won't be difficult but selling them will require some careful targeting and plenty of thought. Coloring books usually have simple outlines that cost dimes to produce. The books themselves are cheap and they have to be to compete with all of the free coloring pages available for printing from the Web.

Using photography as a way to get around a lack of drawing talent then is unlikely to be a profitable venture. The costs involved in taking the pictures, playing with Photoshop and printing and binding the pages will not allow you to compete with coloring books available in stores.

Instead, if you're looking to make money from your photographic coloring books rather than just entertain your own kids, you'll have to create specific pictures of selected subjects and sell them to niche markets.

It's still unlikely that you'll make a huge amount of money doing this but you might make a little and once you've done the initial shoot, you could find that the repeat orders generate a tidy profit and a steady income stream.

Large companies that deal with families often hand out free goodie bags. Those aren't just intended to prevent children getting bored, they're also marketing tools intended to make a good impression on the parents and leave the name of their company stuck to the fridge door.

Taking pictures of banks and restaurants might not be a great deal of fun but it could be much more profitable. Once you've done the initial shoot, you should find that the business will continue buying, allowing you to generate a profit from the print run.

How to Create and Sell Photographic Coloring Books

Creating photographic coloring books is remarkably easy. In Photoshop, open the image and size it to fit your paper. Create a duplicate layer then open Filter > Sketch > Photocopy. Reduce the Detail level as low as possible and set the Darkness at a level just high enough to see the outlines you want to keep.

(P) PHOTOPRENEUR

Next, go to Layers–>New Adjustment Layer–>Levels and raise the shadow levels to improve the clarity of the lines. You can also decrease the highlight levels to remove noise in the remainder of the image.

Finally, print the image in black and white.

You can even do the same thing using the free GIMP imaging software. Instead of the tools described for Photoshop, use those under Filters > Artistic > Photocopy and Tools > Color Tools > Levels.

To sell the images, you're going to have to work a little harder and you're going to have to wear out the shoe leather. The product you'll be offering will be a collection of a dozen or so images that feature the company's name and signature products. And you'll be offering them to businesses which cater to families and in which children are at risk of growing bored.

Family-oriented cafes and restaurants will make good choices but you can also try local bank branches, medical waiting rooms and even auto repair shops, hairdressers, pre-schools and travel agents.

Begin by creating a sample collection for one business, then pitch it to other companies, pointing out that the booklet will make waiting a more pleasant experience for families and that the name and product placement will make for good marketing.

Price the booklets above the cost of production to ensure you receive a profit but you might want to skip the costs involved in shooting the pictures in the first place. Ideally, the business will run through plenty of these booklets, order in bulk and continue placing repeat orders.

TIPS

FOR SUCCESS

(continued)

Focus on Repeat Orders

The big advantage of this kind of product is that businesses that cater to plenty of families are going to run out of them pretty quickly. That means they'll need to keep re-ordering them and once you've done the initial shoot, printing and delivery should be very simple.

This is an opportunity to earn almost effortless residual income from your images so aim to keep a customer for years rather than make just the one sale.

GETTING STARTED

Begin by finding a friendly business that will allow you to shoot the samples, perhaps in return for a free set of 30 or so booklets. You can also look at www.fototiller.com to find more detailed instructions on how to create the images and www.corel.com/content/pdf/paintshop/tutorials/299ColoringBook.pdf to see how to do the same thing with Corel.

98

Create Your Own Photography Magazine

DIFFICULTY

COMPETITION

INCOME POTENTIAL

$

What It's All About

Publishing your images in your own photography book will always be a useful way to showcase your work and generate a little cash. It's prestigious, it's exciting and with the right images and the right marketing, it can even be profitable too.

If publishing is your thing though, you might want to consider printing and selling other people's photographs. Not as books—that could be very risky and leave you with little to do but the marketing—but in a photo magazine.

This isn't going to be a way for you to sell your own photos but it could be a way to earn from photography. You'll get to choose the images and set the topics. If the magazine sells, you'll make a profit.

And having power over other people's images will make certain that lots of people are looking at your own pictures too.

What You'll Need to Shoot to Sell Your Own Photography Magazine

You won't need to shoot anything to sell your photography magazine but you will need plenty of other photographers to shoot for you.

Or rather you'll need them to contribute the images they already have because unless you're prepared to pay for the images—something you won't need to do until you're really making money—it's unlikely that people are going to go too far out of their way to create images.

When the only reward is publication, they'll just want to see their best pictures in print.

You though will want to see more than just good pictures on a page. After all, there's no shortage of websites where photography-lovers can see

SUMMARY

Creating your own photography magazine will require a lot of work. You'll need to think up ideas, sort through thousands of submitted images, edit the text that contributors submit with their photos, lay everything out and make it all ready for printing and publishing.

That could be fun, but it's certainly going to take effort. Even harder will be making money out of it.

Publishing is a notoriously difficult business to succeed in. Most new magazines close down within a short time of opening, crippled by fixed costs and unstable incomes. You can improve your own chances by doing all of the work yourself, but that will increase the workload. Reduce the effort by printing quarterly instead of monthly and you'll weaken the connection to your readers and by reducing the chances that a photographer will be published, lower the number and quality of submissions too.

And, of course, you'll have to find distributors too.

There are ways make it all easier, remove start-up costs and reduce risk but there's no effort-free (or pain-free) way to produce your own photography magazine.

The rewards though in terms of the satisfaction of working with photography and the possibility of earning money from it can certainly make it all worthwhile.

TIPS
FOR SUCCESS

Make Sure Your Own Portfolio is Good

You won't be selling images of your own in your magazine—and giving yourself preferential treatment is a bad idea—but inevitably, people will want to know who the publisher is and what his or her images look like.

Make sure you have a good portfolio and use the magazine to build interest in your images and win sales and commissions.

Take Subscriptions

Even keen readers often forget to buy a copy of their favorite magazines from one month to the next. And one missed month often leads to two, and then a lost reader.

When you tell people about your magazine offer them a discount—and price your magazine so that you can work those discounts in—for a year's subscription. For a print-on-demand magazine, that might mean placing the orders yourself but keeping your readers and being paid in advance will make it worth the effort.

good photos. To persuade people to pick up your magazine—and more importantly, buy it—you'll need to offer them something that they can't easily find elsewhere.

Part of that will be the pleasure of seeing an image in print rather than on the screen. But a large part of it too will be the themes you've selected, the types of images you've chosen and the explanatory text that surrounds the pictures.

So while you won't need to shoot any images, you will need to come up with good ideas for stories. You'll want to post unusual images that photography-lovers will find interesting but won't usually stumble upon. And you'll need to offer tips that help photographers to produce photos as beautiful as those they're looking it.

You won't just be offering a collection of beautiful photographs; you'll be selling valuable knowledge too, even if it has been supplied free of charge by your contributors.

How to Create and Sell Your Own Photography Magazine

Creating your own photography magazine presents three major challenges: generating submissions; publication; and distribution.

Picking up submissions will be the easiest challenge to overcome. Even though any photographer can now put their images online for anyone to see, there is still no greater endorsement of a photographer's skill and ability than seeing it in print.

Tell people that you're putting together a photography magazine and that you're looking for images on certain themes and you can expect to be inundated with submissions.

One way to make sure that happens is to create a Flickr group for the magazine and invite people to join, especially those who already have images on the site related to that month's theme. You can even use the group pool as the main submission channel.

Publication is a little harder. National magazines rarely sell out; they usually print far more than they sell and pulp the remainder, a level of waste they can afford because of their large print runs. For a small operation, print-on-demand is likelier to be a more cost-effective route, coupled with small runs whenever you can find an offline outlet. At least one publication uses Lulu to print its magazine in the form of a paperback book but MagCloud, run by HP, is even better and allows you to charge just 20 cents per page plus shipping to cover the costs.

The biggest challenge is always going to be distribution. You'll struggle to get the magazine in bookstores but you can start by marketing online—through a dedicated website, Flickr and networking among other photography enthusiasts—then approach small outlets in your area. Independent bookstores are a good choice and so are camera stores but for both of these you'll need to print in advance, adding an element of risk to your expenditures.

GETTING STARTED

Take a look at U&I Magazine at www.uandimag.com. Published by amateur photographer Taku, the magazine is sold through Lulu (www.lulu.com), one way of creating your own magazine. www.jpgmag.com provides another, more democratic approach, although its financial troubles might not make it the best model to copy, and www.cloudmag.com is perhaps the best place to go when your content is ready to print.

99

Make Your First Sale

DIFFICULTY

COMPETITION

INCOME POTENTIAL

 $ $

What It's All About

Selling your images is a challenge. There are thousands of other photographers who are at least as talented as you and who have pictures that are at least as good as yours pushing their photos in front of the same small group of buyers.

Persuading those buyers to give their cash to you instead of someone else can look daunting.

And to make real money out of your photography, it's something that you'll have to do again and again and again.

The good news is that the first sale is always the hardest. Once someone has bought an image from you, you understand that your photography has commercial value.

You understand how to negotiate and how to deliver.

You understand exactly what your images are worth.

And you understand how to show them to buyers and persuade those buyers to pay.

Once you've made your first sale, the rest become a great deal easier.

What You'll Need to Shoot to Make Your First Sale

Photographers have found that their first sales have come from a huge range of different types of images. Some have found that their landscape prints were picked up in exhibitions or online product stores. Others uploaded images—either shots they already owned or deliberately produced stock photos—to microstock sites and earned a few cents from the sale.

A number simply placed their vacation photos on Flickr and found that a publication wanted to use them, while at least one Flickr photogra-

SUMMARY

The first step only appears and feels like the hardest. In fact, the challenges that you have to overcome to land your first buyer will be no different to those you have to meet to land your second, third or thirty-third.

You'll still have to shoot good images.

You'll still have to put them where buyers can see them.

You still have to indicate that they're available for sale, and you still have to agree a price, deliver the image and accept the money.

As long as your images are good though, everything else is technical—and easily repeatable too.

TIPS
FOR SUCCESS

Do the Work

Whatever type of image you decide to shoot and however you decide to make it available to buyers, you'll have to promote it. That's usually the less enjoyable side of earning with photography and it's often where photographers trip up.

You'll need to let people know where the image is.

You'll need to tell them what the image is.

And you'll need to make it clear that it's available for sale.

Charge the Right Price

And you'll need to charge for it too.

One of the most common mistakes made by photographers faced with someone keen to use their image for the first time is to give it away in return for publication.

If someone wants to use your photo commercially, they're going to make money out of it. You then, should also make money out of it.

Fail to charge for your photo's usage rights and you're not just giving money away, you're also giving away an opportunity to make your first photography sale.

pher saw his self-portrait used on the cover of a book, a deal that led to an agreement with the book's author to supply more cover photos.

There are no rules about which types of images you can sell. Some types of photos will clearly be easier to sell than others—good microstock will tend to sell faster than art prints; a well-marketed Flickr image may find a buyer before a news photo—but ultimately, if the image is good enough, and you put it where buyers can see it, you should sell it.

So beware of shooting photography that you don't like just to make sales. Commercial photography is hard enough without enjoying it as well.

And the best reward of selling your images is being paid not for the photo but to do what you love.

How to Create and Market Your First Photo Sale

Any of the suggestions in this book could be used to generate your first photo sale but there are a number of entry points that might well be easier than others.

You might find that none of these suit your particular type of photography, in which case there are plenty of other suggestions here that you can use, but all of these have proved to be places where photographer have made their first sales—and they're easy to use.

Café Exhibitions

You'll need a portfolio and you'll need to be prepared to lay out the cash on printing and framing but if you can persuade a café owner to show off your

images—and if your images suit the café's clientele—there's every reason to believe that some of those images will end up being sold.

In fact, you could find that you get not one sale, but dozens of them.

Microstock

Microstock is perhaps the easiest entry point for photographers with usable images but the photos do have to be commercial. Although some of the strangest shots have sold on microstock sites—as well as more traditional photo libraries such as FotoLibra—in general, the images that sell as stock look like stock.

Upload that image to a microstock site and there is a good chance that you'll make your first sale. But your first sale will also net you little more than a few cents.

It's the repeat sales rather than the first sale that provides the most satisfaction for microstock.

Product Stores

Selling through a product store is a little more satisfying. The image will be one you've created to look good rather than be useful but to make the sale you'll need to do some careful promotional work.

There could be a long gap between uploading the image and making it available for sale—whether that's as a print, on a t-shirt or decorating any other product—and the sale itself.

GETTING STARTED

You can get started by talking to a local café owner, uploading images to a microstock site like www.istock.com or www.dreamstime.com, or by optimizing your Flickr stream at www.flickr.com so that your images can easily be found by buyers.

Conclusion

In this book, we've looked at 99 different ways to make money from your photos. Those ways have ranged from traditional stock photography and gallery sales to Flickr streams and Zazzle stores. We've explained how each of those channels works, how to make the most of them, and how to take your first steps towards your first sales.

Whichever channels you choose to sell your images, there are two things that will always remain true.

First, you'll need to put your images in front of buyers. It's not enough to take pictures to win sales. You have to show them to potential clients too, and you have to do it in a way that makes the decision to buy as simple as possible. Marketing is almost as important a part of earning money with photography as the photography itself.

Secondly, and even more importantly, you have to shoot good pictures. There are few fields more competitive than photography and only the very best images are ever going to find buyers. To shoot well, you'll need talent but you'll also need practice and knowledge.

You can learn more about the opportunities available to photographers —and how to use them—on our blog (blogs.photopreneur.com) and from our other photography books at www.photopreneur.com.

Whether you're making sales or not though, you'll need to continue shooting. You'll need to keep honing your skills, learning new techniques, and looking for new photography challenges.

And you should be doing that not because some of those images may find buyers but because you love it.

Photography may be a profession but it's also a hobby, an interest and a passion. It's that passion combined with talent and skill that creates sellable images.

There's just one more thing you need to do to land sales: You have to take action. That starts now . . . with a picture you love and a pitch to a buyer.

Featured Titles
from Photopreneur